100 DAYS

IN PHOTOGRAPHS

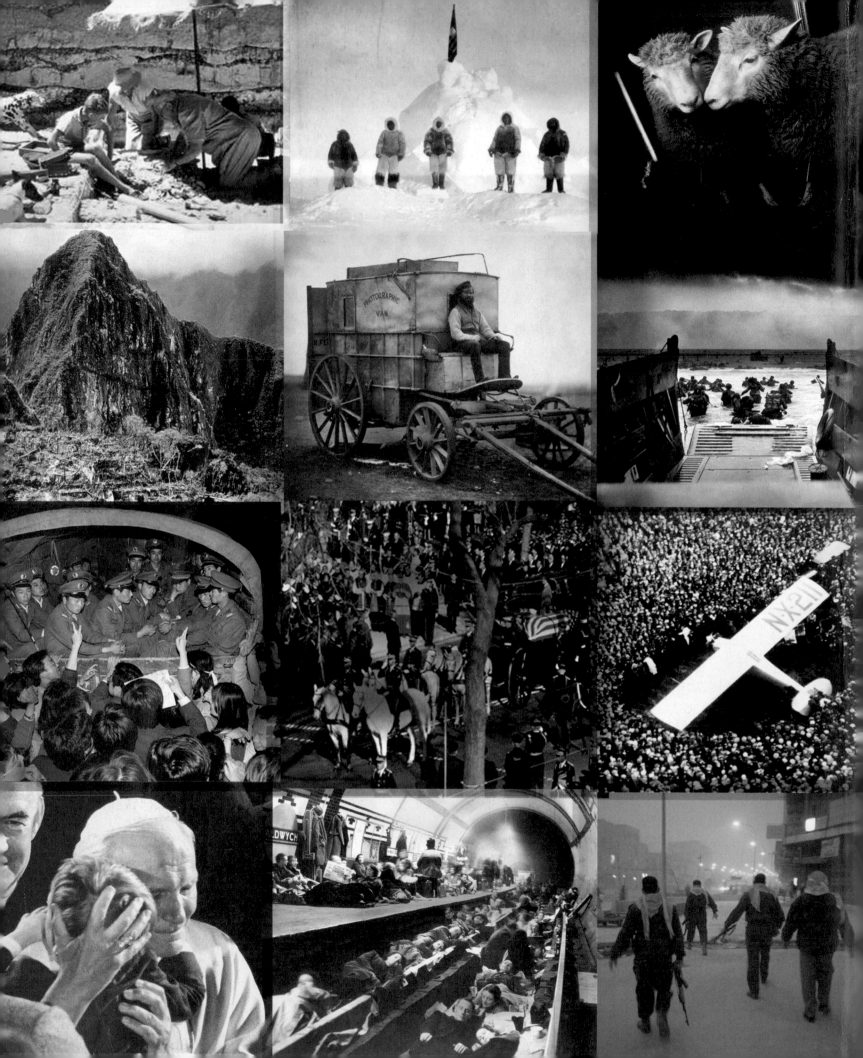

100 DAYS

IN PHOTOGRAPHS

PIVOTAL EVENTS THAT CHANGED THE WORLD

NICK YAPP

FOREWORD BY DOUGLAS BRINKLEY INTRODUCTION BY CHRIS JOHNS

NATIONAL GEOGRAPHIC

WASHINGTON, D.C.

CONTENTS

pages 6–7: Some of the first tributes
to Princess Diana on the day of her
death, London, August 31, 1997.
pages 8–9: Police hold back fans
as the Beatles drive to Buckingham
Palace to receive their MBEs,
October 21, 1965.

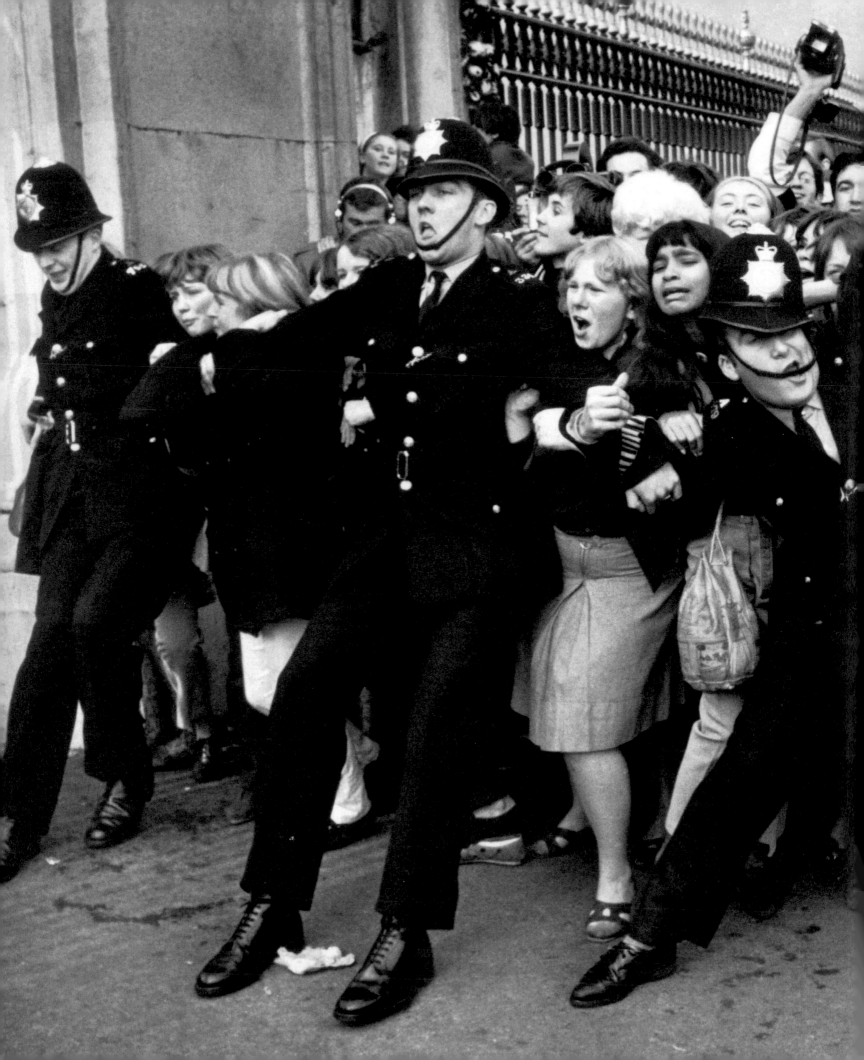

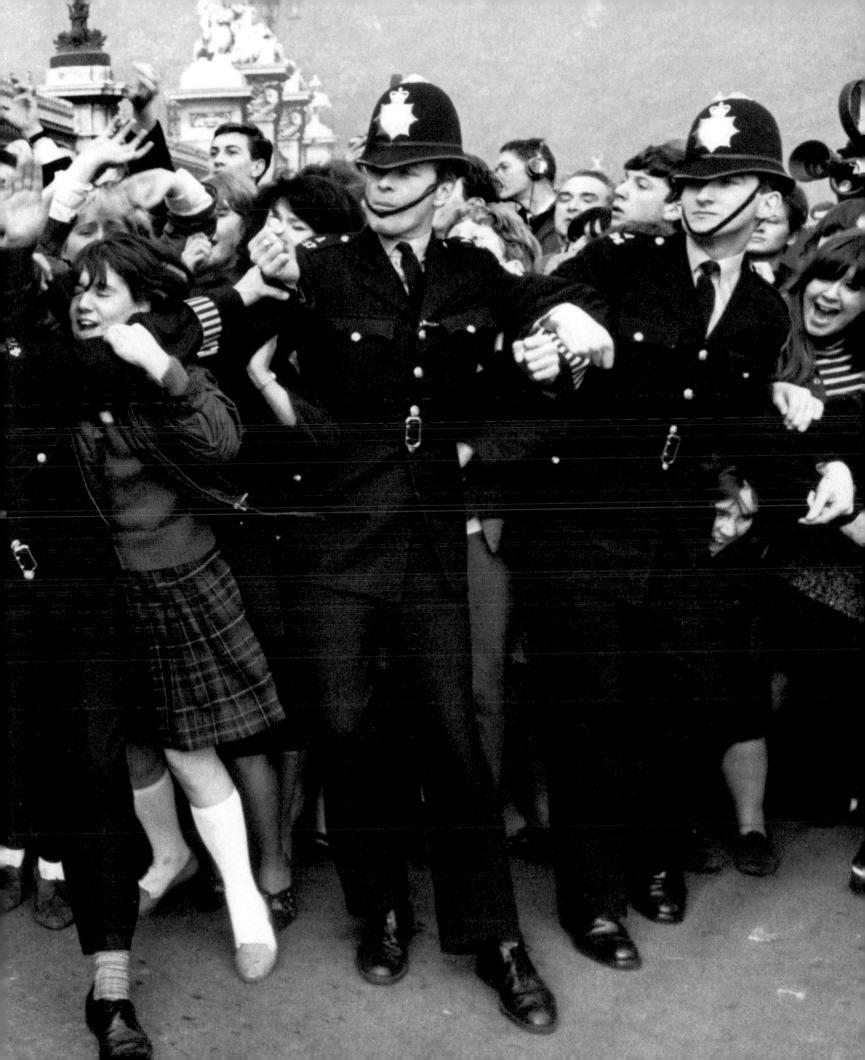

Staring at the September 2005 image of a Hurricane-Katrina damaged New Orleans rooftop in *100 Days in Photographs*, I felt as if I were reliving a nightmare. I had foolishly stayed for the Category 3 storm, sequestered with my family in a high-rise along the Mississippi River until it passed. Luckily, we survived. Unfortunately, I still live in a state of disbelief and denial about the storm. After the tailwinds died down and we evacuated to safe harbor, what stayed with me—really lingered—was the suspension of time that had occurred. My inner clock froze around 8:30 a.m. on August 29 of that year and it hasn't budged much since. As a father of three, I forcefully moved on. Had to. Forward motion, pushing into the future, seemed my best gambit. I was willing to be an eyewitness, but not a person whose entire life was damaged by the Thing.

So it was with genuine surprise that the photograph by David J. Phillip, encountered in these pages, made me cry, touching an emotion I had buried since entering the Katrina frozen-clock zone. While watching four or five harrowing Katrina documentaries, I had felt immune to the disaster. (Although a lump rose in my throat at seeing the film footage of the Lower Ninth and Lakeview underwater.) Then this simple image of the forlorn roof, not at all graphic, cut like a knife. For painted in white on the rooftop was the simple saying: "Love You Kid." It was dated 9-3.

While huddling around a generator in that high-rise lobby as the Katrina winds ripped through New Orleans, I kept telling my terrified daughter, "Love you kid," in rote fashion. I don't really know where I picked up the "kid" slang. Whenever I said the phrase to her, I felt vaguely disingenuous.

But they were the only three words that seemed to comfort her. Numb with terror, angry at myself for having placed my family at risk, I tried to be reassuring. When death knocks at your door, your reaction is to reassure the ones you love, to express pure love as fast and as often as possible.

I first encountered this Katrina photograph in a set of color galleys *National Geographic* sent me for *100 Days in Photographs*. Over the years I've worked with the Society's Book Division on a number of fine projects, notably traveling the length of the Mississippi River with them in 2000. I was sure the specially chosen images in this volume would be great. When the galley arrived, in fact, I tossed it into my SUV and drove to a nearby coffee shop to relax, to peruse what I imagined would be extraordinary and visually entertaining images, a historical slide show to break up the monotony of a Memorial Day weekend in Central Texas.

At first the photographs, accompanied by elegant Nick Yapp prose, inspired. For example, the Crystal Palace at the Great Exhibition in 1851, and tightrope artist Charles Blondin crossing Niagara Falls in 1859. Then the battlefield-strewn picture of Civil War dead caused a wave of melancholia. Then Wounded Knee. Then the Paris Commune siege of 1871. At intervals between these were the occasional uplifting photographs—Lindbergh crossing the Atlantic Ocean, the conquest of Mount Everest, Jonas Salk and his welcome vaccine against polio. But mainly there was tragedy or despair. There were the upbeat moments: Elvis Presley on the *Ed Sullivan Show* and the first walk on the moon. But it is hard to get jazzed up by the lofty pop tune "Blue Suede Shoes" when you've just seen an atomic bomb annihilating

Hiroshima. And the destruction wrought at the Battle of Stalingrad simply overwhelms the smiling face of Neil Armstrong. Somehow the reader can't smell the happy photographs in *100 Days*. I—like most readers—jerked my head away from the stench of the World Trade Center collapsing in a roar of toxic smoke. It's too painful to relive.

Still, the more upbeat photographs come as welcome relief. It doesn't hurt to remember that Pope John Paul II hugged a child suffering from AIDS and that the Berlin Wall came down courtesy of the proletarian sledgehammer blows of determined Germans. When we see Nelson Mandela wave a victorious fist, human rights truly seem to be on the march. Even seeing Richard Nixon using chopsticks in China made me smile. (Realizing the rank absurdity of life usually does.)

But back to those haunting photographs, taken generation after generation. They warrant deep reflection. Take Gerard Klijn's photograph of famine in Biafra. Just seeing those malnourished children, some with potbellies, others walking skeletons, made me feel ashamed. Although this picture was taken in 1967, it could have been snapped yesterday in Sudan or Angola or Togo. Virtually every week Nicholas Kristoff in the *New York Times* op-ed page pleads with readers to help end the civil war in Darfur, for the children's sake. His clarion calls, however, don't affect me as viscerally as Klijn's photograph does. The image is a stark, haunting reminder of the troubling laws and processes of a physical world that anyone with a conscience can't ignore. Pope John Paul II said, "We must see another's poverty as our own and be convinced that the poor can wait no longer."

Everyone who reads *100 Days in Photographs* will have a personal favorite, an historical image that speaks directly to the heart. A couple of these images, however, speak directly to the future. Take, for example, Dolly the cloned sheep, by Stephen Ferry. Ostensibly it's a simple photo of the first mammal to be cloned from cells of another adult. The fact that scientists were able to produce a sheep in this manner had a jolting effect on biological research. Dolly is dead now, but her picture is very much alive. Only time will tell whether her advent advanced medicine or detracted from humanism.

Every picture in this book is essentially a time capsule that tells a story. Photography is a window onto our collective souls and struggles. The images lift past events up, out of obscurity. They hold our attention in a fast-paced society where a billion emails ricochet around the world every minute. All the photographers represented in this volume should be considered artists. First-rate ones. While luck and spontaneity are often a photographer's guiding star, to be successful they must also be fully informed about the cross-currents of the times. Besides being photographers, they are first and foremost human beings. And I couldn't help but wonder what kind of deep scars these talented people carried from documenting war and disease and death.

The light and shadows in each photograph in *100 Days*, even in a simple shot of a sheep reflected in a mirror, are testimonials to an ever-evolving art form that teaches us about ourselves. Pictorial eloquence and stark realism leap out from these pages. And all we can do is be grateful for the discovery and recognition. ■

Douglas Brinkley
Austin, Texas, June 1, 2007

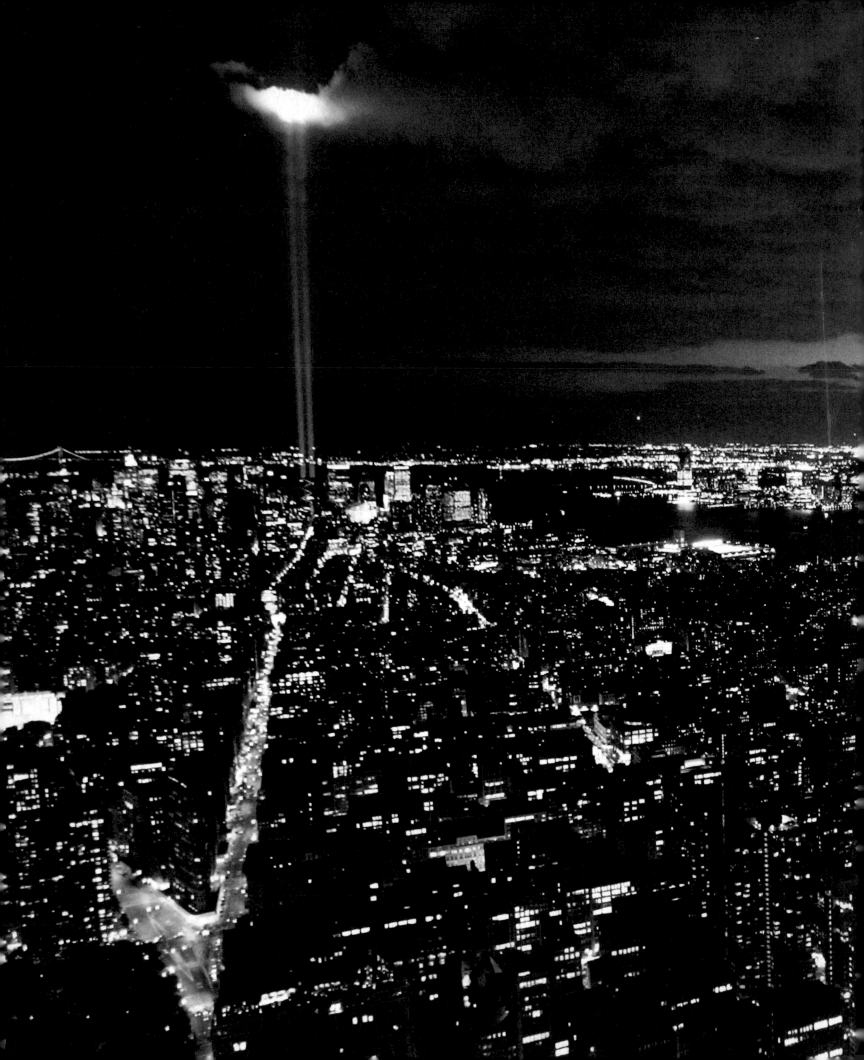

Photography is a special magic. I remember standing in the red glow of a darkroom light, bent over a metal tray, watching in amazement as an image slowly materialized on the glossy paper swimming in the chemical bath. It wasn't much of a photograph, merely a shot of plants in the greenhouse where I worked at Oregon State University. The camera wasn't much to speak of either—an old, clunky twin reflex that used two-and-a-quarter square-inch film—but I was thrilled beyond belief. Even today, 35 years later, I can summon the sense of wonder at the alchemy that enabled me to capture this chapter in my life and share it with family and friends. They could look at the image and see where I worked. They could see the way the sea of plants lined up in neat rows, the rusty sprinklers, the windows streaked with grime. A simple photograph, but to me, profound. I had discovered a new skill and way to tell a story. I was in thrall to photography.

Later, when I became a professional photographer and traveled the world to tell stories about distant people and places, I discovered more magic. I learned about looking through the viewfinder and living in the moment. Athletes call it being in the zone. Senses sharpen. Distractions vanish. Concentration intensifies. Nothing exists except the image in the viewfinder. An athlete in the zone wins and sets records. A photographer in the zone makes memorable photographs.

The photographs in this book are compounded of that magic. They were made by photographers in the right place, at the right time, who witnessed and captured history on film. This book is a collaboration between two archives: Getty Images and the National Geographic Image Collection. Practically every history-making moment from the past 150-years appears here. Many of the photographs are icons, but there are surprises, too.

Consider the photographs by Hiram Bingham that appear on pages 78–81. In 1911, Bingham peered through the drizzle that pelted a ridge high in the Andes and saw that the stories about the lost city of the Incas were true. He had, in his words, found the "rugged masonry of a bygone race." Bingham had slogged through 50 miles of tangled, steamy, snake-filled jungle in southern Peru and discovered Machu Picchu. But discovery was not enough. Others must experience and witness, too. He set his Kodak Authographic Special on top of a tripod, looked through the camera and framed the broad sweep of an ancient stone terrace back dropped by the jagged profile of Huayna Picchu. Then he photographed the inner wall of a temple, the remains of a bath house, and a view of the ruins west of the mountain peak. In all, Bingham made 30 photographs, which he carefully numbered and described. In April, 1913, National Geographic published them all, devoting the entire issue, 186 pages, to the story. Those black-and-white photographs say what words can not. That, too, is a kind of magic.

But let's return to the dark room. Only this time, it's not the dark room filled with the sharp smell of processing chemicals of my college years. This is a dark room at National Geographic headquarters in Washington where I work.

pages 12–13: The end of the Berlin Wall, November 9, 1989
pages 14–15: The Tribute of Light at the World Trade Center, September 11, 2006

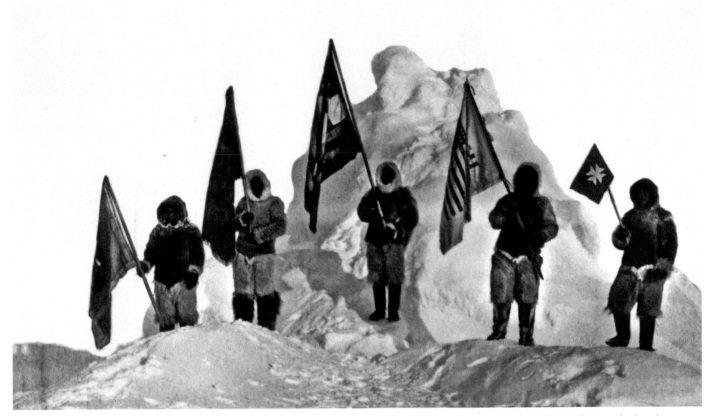

Members of Robert E. Peary's North Pole expedition, April 6, 1906: (*left to right*) Ooqueah, Ootah, Henson, Egingwah, Seegloo

Instead of the dim red light thrown off by a bulb, the light comes from a projector, which flashes photograph after photograph onto a white screen. Alexandra Boulat is speaking softly about the images she's made in Baghdad. A soft French accent inflects her words; passion fills her voice. The images are like none I've ever seen. Because of them, I am a witness to her experience. Even more so, I am witness to the experience of the Iraqi people whose lives she has documented. The photographs are a bridge connecting me to these people, a bridge to the experience of humanity in all its joy, sorrow and uncertainty.

Although 90 years separate Bingham's Machu Picchu from Boulat's Baghdad, their images are a part of *100 Days in Photographs* because they document pivotal events in history. Bingham and Boulat were in the right place at the right time, but there is more to it than that. Bingham and Boulat were driven by passion, curiosity, and the desire to share what they saw and felt. They looked through the camera. They lived the moment. They made magic happen. ▪

Chris Johns
Editor in Chief, NATIONAL GEOGRAPHIC

About This Book

This book was conceived between two of the world's authorities on photographs: Getty Images and the National Geographic Society. The partnership is unprecedented, and the editors worked to reflect that in these pages—in pictures, design, and words. Our joint mission was to take readers on a compelling walk through history to glimpse 100 days of events—not always the easily recognized, iconic moments that history books tell us "changed the world," but often the little known events that effected other events. To tell these stories we showcased the images in large format with four kinds of text that welcome you into the image, surround you with voices, and take you behind the camera: First, an eyewitness quote sets the stage for an event; next, a colorful essay gives the photograph's context in history; then, a short sidebar tells the story of photography during that era; finally, a contemporary note reveals excerpts from speeches, newspapers, and journals. The effect is a visual walk through history and the history of photography from 1851 to now. There are no chapter breaks because we wanted to show you how history is a continuous story of the world in pictures. If we fulfill our mission, the reader will close this book, walk away, and view the world as another page.

"An Arabian Nights structure, which belongs more to
an enchanted land than to this gross material world of ours...."

[May 1, 1851]

THE GREAT EXHIBITION OPENS

Held in London, England, the Great Exhibition of the Works of Industry of All Nations was designed to be a showcase of the British Empire. It was the brainchild of Prince Albert, consort of Queen Victoria, fleshed out by Henry Cole, critic, writer, and publisher of the world's first Christmas card, and realized by Joseph Paxton.

Paxton had built a glass house to accommodate the Duke of Devonshire's *Victoria regia* water lily, and observed that its ribbed leaves were strong enough to bear the weight of his young daughter. Paxton scribbled a design for a palace of glass inspired by the lily and showed it to Cole and the Prince.

An 18-acre site was chosen in London's Hyde Park, and over nine months, starting in August 1850, the Crystal Palace was built from 1,060 iron columns, 2,224 trellis girders, 30 miles of guttering, 202 miles of sash bar, and almost one million square feet of glass. Opening day was May 1, 1851, when the Crystal Palace was filled with wonders as well as curiosities. There was a fountain of eau de Cologne perfume, the Koh-i-Noor diamond, a collapsible piano for gentlemen's yachts, and a sportsman's knife with 80 blades. The 90,000 visitors a day could wonder at an elephant and musical instruments from India; Samuel Colt's repeating firearms; and Dr. Grey's walking stick, which held medical instruments, medicines, and an enema.

The importance of the Great Exhibition lay not in the splendor of its displays, nor its considerable profits—some £186,000, sufficient to finance the establishment of the Royal Albert Hall, the Natural History Museum, the Science Museum, and the Victoria and Albert Museum. More than that, in a century where a state of war was the natural relationship between so many countries, the Great Exhibition looked to safer and more lucrative forms of competition.

The Crystal Palace nears completion in London's Hyde Park.

Early photography

In 1851, photography was in its infancy. Frederick Scott Archer had just invented the revolutionary wet plate process: A glass plate was coated with a light-sensitive emulsion, inserted into the camera while wet, exposed, and developed immediately. Exposure time was long, from 20 seconds to 5 minutes, depending upon the detail wanted. Buildings, such as the Crystal Palace, were popular photographic subjects, because, unlike flags blowing in the wind, they didn't move. The crisp detail of this photograph indicates that it had a long exposure time. It was probably shot on a day when the exhibition was closed to the public. If there had been people present during the exposure time, their movements in that minutes-long period would have made them appear as ghostly forms.

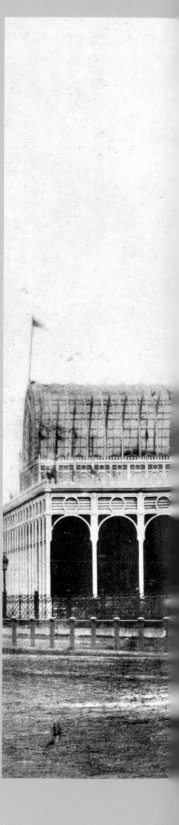

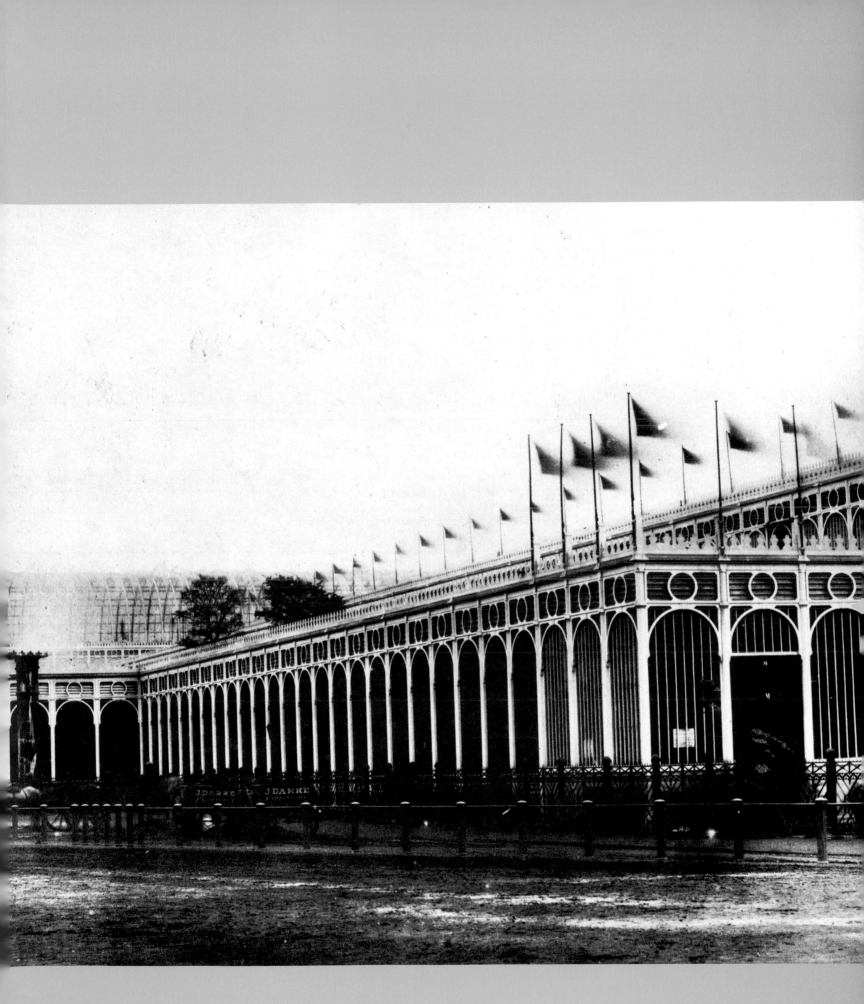

"We could scarcely believe the evidence of our senses!
Surely that handful of men are not going to charge
an army in position? Alas! it was all too true...."

WILLIAM HOWARD RUSSELL'S EYEWITNESS ACCOUNT FOR
THE TIMES OF LONDON, NOVEMBER 14, 1854

[October 25, 1854]

BALACLAVA AND THE CHARGE OF THE LIGHT BRIGADE

From the beginning, the Crimean War (1854–1856) was a mess. Its architect was recently self-appointed Emperor of France, Napoleon III, a man intent on redrawing the map of Europe and the Middle East. In 1852 he demanded that the keys to the Holy Places in Jerusalem be taken from the Orthodox clergy, who were protected by Russia, and handed to the Latin clergy, whom he had taken under his own wing. In response, Tsar Nicholas I began to stir up trouble in the Balkans, threatening the already tottering Turkish Ottoman Empire. Hostilities broke out between Russia and Turkey on November 30, 1853. Seeking to prevent growth of Russian power in the Black Sea, France and Britain allied with Turkey. They declared war on Russia in 1854; the battleground was the Crimean peninsula.

The war's pivotal conflict, the day-long Battle of Balaclava, had three stages. The first was an attack by the Russians on a comparatively small British and Turkish force defending the British base. The second was a spectacular charge by 900 British Heavy Brigade cavalrymen under Gen. James Scarlett that defeated a Russian force of 3,000. The final stage has passed into legend as one of the greatest blunders in military history, the Charge of the Light Brigade.

The British cavalry was commanded by Lord Lucan, who detested Lord Raglan, the leader of the British forces. Lucan received a message: "Lord Raglan wishes the cavalry to advance rapidly to the front, and try to prevent the enemy carrying away the guns.... Immediate." The order was brought to Lucan by a Capt. Nolan. Lucan told Nolan that he did not know what Raglan was referring to, for there were no guns in sight, and the only ones that Lucan was aware of were the Russian batteries at the eastern end of a narrow valley nearby. In fact, Raglan meant English guns that had been captured by the Russians from the Turks. Lucan asked Nolan which guns he was to

The Valley of the Shadow of Death, scene of the Light Brigade's fatal charge

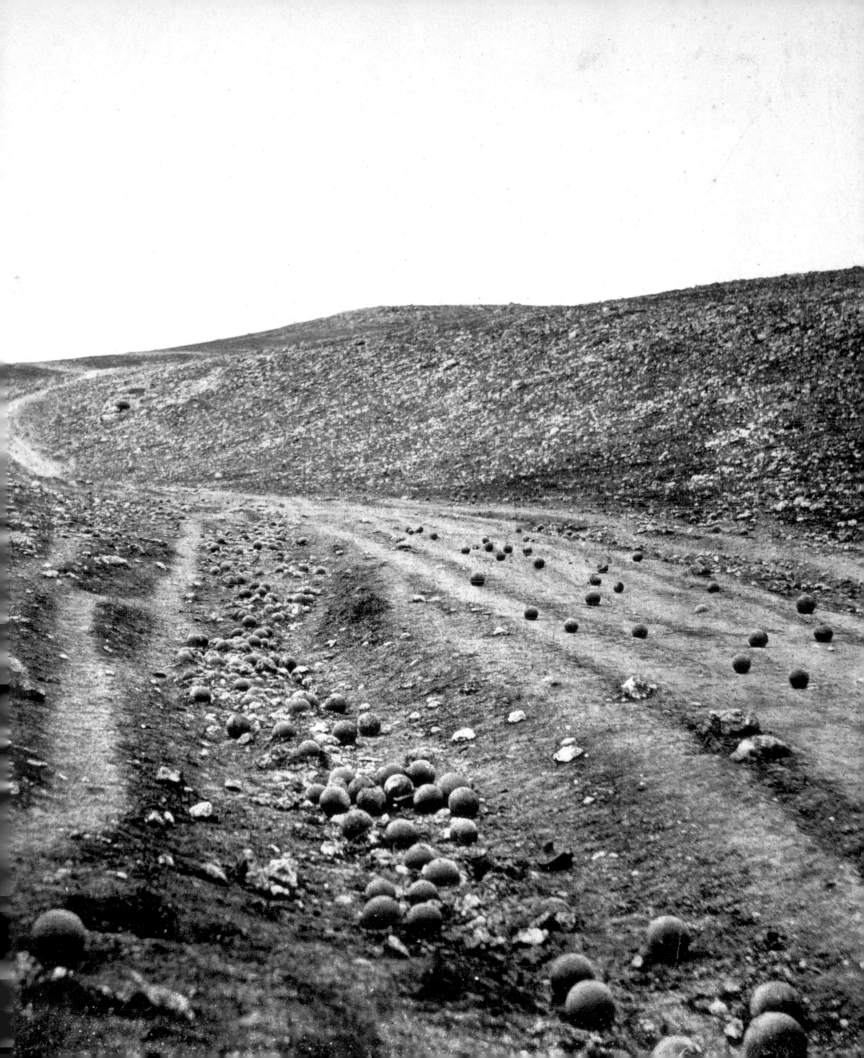

British officers from the 14th Regiment

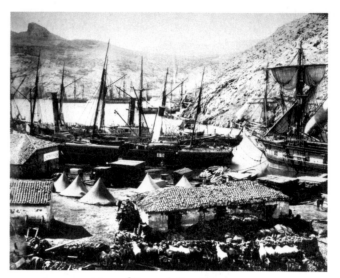

View of Cossack Bay, Balaclava

attack. Nolan waved his arm in a wide arc, and cried: "There, my lord, is your enemy. There are your guns." Lucan assumed the Light Brigade was to attack the Russian guns. So he ordered the Light Brigade off, in the wrong direction, to capture the wrong guns. When the charge was made, Nolan galloped frantically across the front of the advancing horsemen, trying to wave them back; but he was killed before he could make himself understood.

In "The Charge of the Light Brigade," the dramatic poem by Alfred Lord Tennyson, the valley is described as "half a league" (roughly one-and-a-half miles) long. Russian guns looked down on it from both sides, and further armaments were ranged along the eastern end. "Into the jaws of death" rode the 600 soldiers of the Light Brigade. They were commanded by the Earl of Cardigan, one of the most hated men in England—arrogant, selfish, narrow-minded, cruel, petulant, and pedantic—and an implacable enemy of Lucan. But Cardigan had been fuming at enforced inactivity all day, and was prepared to obey Lucan's preposterous order.

Cardigan drew up the Light Brigade in two lines. The first consisted of the 13th Light Dragoons, the 11th Hussars, and the 17th Lancers; the second comprised the 4th Light Dragoons and the 8th Hussars. Cardigan himself rode at their head. The valley was eerily calm: All that could be heard was the jingle of the horses' bridles. And then the guns crashed out. Round-shot, grapeshot, and shells tore through the lines of the Light Brigade, which in response merely closed ranks and trotted on its deadly way—to decimation.

First war photographer

Roger Fenton was 34 years old when he went to the Crimea. His horse-drawn darkroom contained all he needed to coat, sensitize, expose, and develop the 700 photographs he made, including the first-ever images of a battlefield. Action shots were not possible, and his study of the "Valley of Death" at Balaclava was taken weeks after the event, with cannonballs carefully placed. The images were then sent to London, to be reproduced as wood engravings in the *Illustrated London News*.

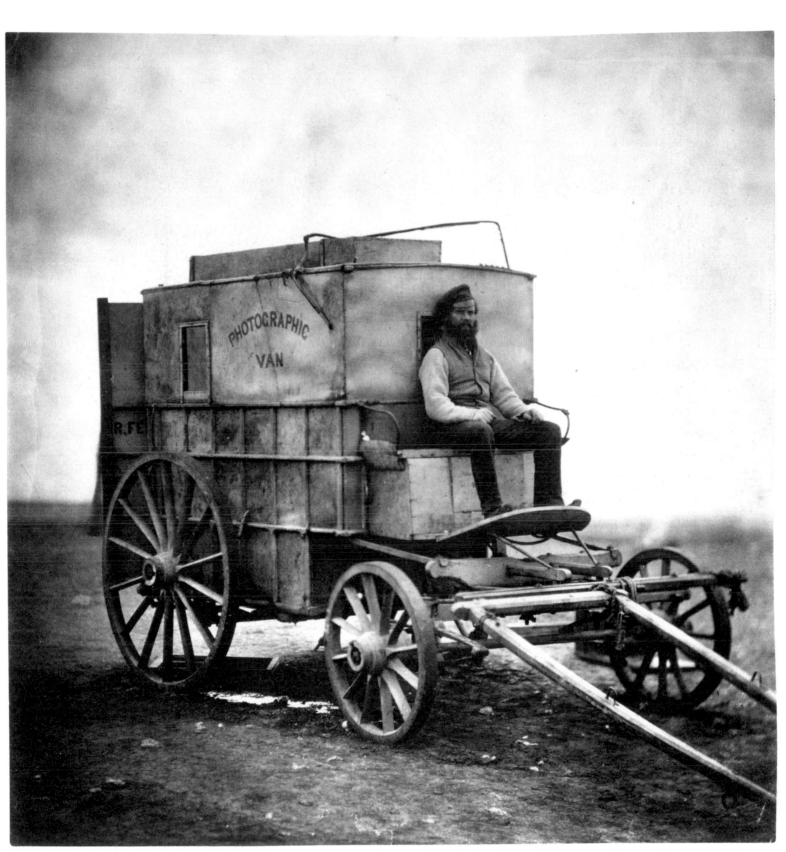

Roger Fenton's partner, Marcus Sparling, seated on the horse-drawn darkroom

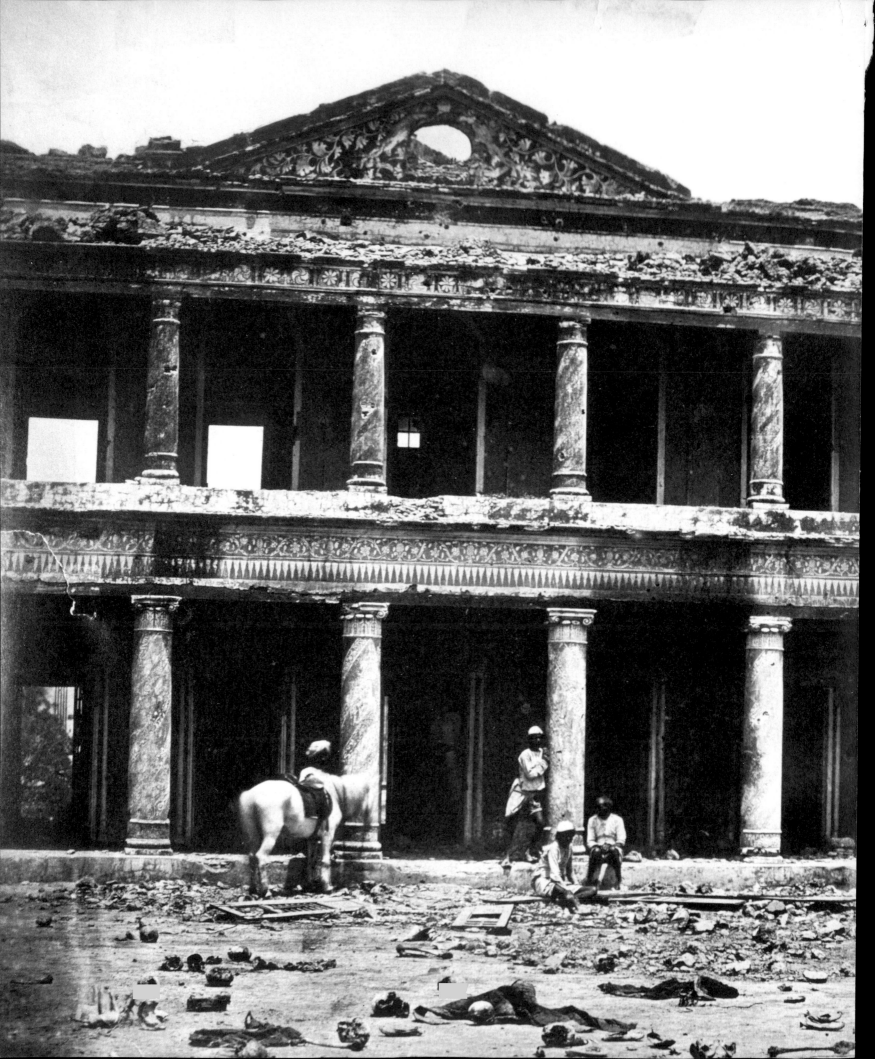

"Sept 23. Oh! Such joyfulness! A letter is come from Sir J. Outram in which he says we shall be relieved in a few days. Everyone is wild with excitement and joy...."

EXTRACT FROM DIARY OF KATHERINE BARTRUM, WIFE OF ARMY SURGEON ROBERT HENRY BARTRUM, 1857

[November 18, 1857]

EXODUS FROM LUCKNOW

The East India Company had a Royal Warrant to develop trade in India for Britain. With extensive powers to expropriate land, raise armies, and appoint governments, the company could be insensitive to natives as it pursued its own commercial interests. In 1857 native troops rose up violently and took Delhi, Cawnpore, and Lucknow, massacring British soldiers and civilians. "The Mutiny," as it was known, was a seminal event that permanently changed the British attitude to India.

By June 1857, Lucknow was the only city in the area that had not fallen to the mutineers. The British garrison there was commanded by Chief Commissioner Henry Lawrence. Aware of their precarious position, Lawrence gathered the entire European population and his 1,700 soldiers (half native Indian sepoys) within the walls of the main Residency. As the siege progressed in the intense heat, the compound began to stink of rotting flesh, urine, and excrement. Escape was impossible. By the middle of August, the garrison had been reduced to 350 soldiers and 300 sepoys, seeking to protect—among others— 200 women and 230 children.

Late in September, reinforcement troops under Henry Havelock burst into the Residency, but the siege continued. Conditions worsened. The starving inhabitants ate sparrows. Surgeons operated without chloroform. Many died of scurvy or dysentery.

In mid-November, a relief column under Sir Colin Campbell stormed the Residency and put down the mutineers; on November 18 an exodus began—women and children leaving first, with the crown jewels of the Kingdom of Oudh, and £250,000 worth of treasure. The British regained control, but the mutiny had caused grave alarm in London. Parliament demanded reform. The East India Company was abolished, and direct rule over India was formalized.

The remains of the Secundra Bagh after the siege of Lucknow

First images of war dead

Felice Beato arrived in Lucknow almost five months after the Indian Mutiny had been crushed. He used a box camera to make some 60 in a series of 10x12-inch photographs from glass plate negatives of the sites of the most memorable events around the Residency. In the case of this famous picture of the Secundra Bagh, a villa where 2,000 mutineers were killed by Sir Colin Campbell, experts generally believe that Beato had the skulls and bones of the rebels exhumed and laid out for dramatic effect.

"Being naturally imbued with artistic taste and perception of a very high order, his critical remarks were made with good humour which softened their occasionally somewhat trying pungency..."

MEMOIRS OF JOHN CALLCOTT HORSLEY, ARTIST AND FRIEND OF BRUNEL

[January 30, 1858]

BRUNEL'S *LEVIATHAN* LAUNCHES

To the people of Victorian Britain, Isambard Kingdom Brunel (1806–1859) was the epitome of British engineering and entrepreneurial genius—imaginative, versatile, and a man who exuded confidence. His obsession was communication—bridges, tunnels, steamships, locomotives, as well as entire railway systems. He saw transportation in international, global terms. The Great Western Railway, from London to Bristol, was his creation—but why stop at Bristol? Why not link London directly with New York? And so Brunel designed and built the *Great Western*, a vast wooden paddle steamer, the first ship to make regular crossings of the Atlantic Ocean. It was a great success, and was followed by the *Great Britain*, the largest vessel afloat, and the first iron steamship to use a screw propeller.

He then turned his attention to designing the largest ship ever built at the time. Work started on the *Leviathan* in 1854, at the Millwall shipyard of John Scott Russell and Company. Brunel's magnificent ship was designed to carry 2,000 passengers—or 10,000 troops, if farflung members of the British Empire were in trouble—around the Cape of Good Hope to India, China, and points east. She was launched on January 30, 1858.

The ship, which was renamed the *Great Eastern,* was ready for trials more than a year later, but she was dogged with ill luck from the beginning. On September 5, 1859, while inspecting the vessel, Brunel suffered a stroke. Four days later, a heater attached to the engines exploded, and six firemen were scalded to death. News of the disaster hastened Brunel's death on September 15.

The *Great Eastern* was simply too big for every other port in the world. Sadly she never worked as a cruise liner, and in 1864 the once-heralded *Great Eastern* was sold for scrap.

Robert Howlett's portrait of Brunel in front of the *Leviathan*, January 1857

Portrait of an era

Isambard Kingdom Brunel's proud pose, captured by Robert Howlett, celebrates the launch of the *Leviathan*. With stovepipe hat, his boots muddy from Millwall Dry Dock, Brunel sits before a roll of launching chains. One of the earliest professional photographers, Howlett worked for the London Stereoscopic Company, a photographic retailer and agency that made a unique record of the second half of the 19th century. Howlett lived only to the age of 27, and is best known for his series of portraits of Brunel and of *Leviathan*'s construction and launch, all captured on wet plate glass negatives and printed on albumen paper. Photography curator Weston Naef noted: "Howlett made what is perhaps the most remarkable environmental portrait in the entire early history of photography."

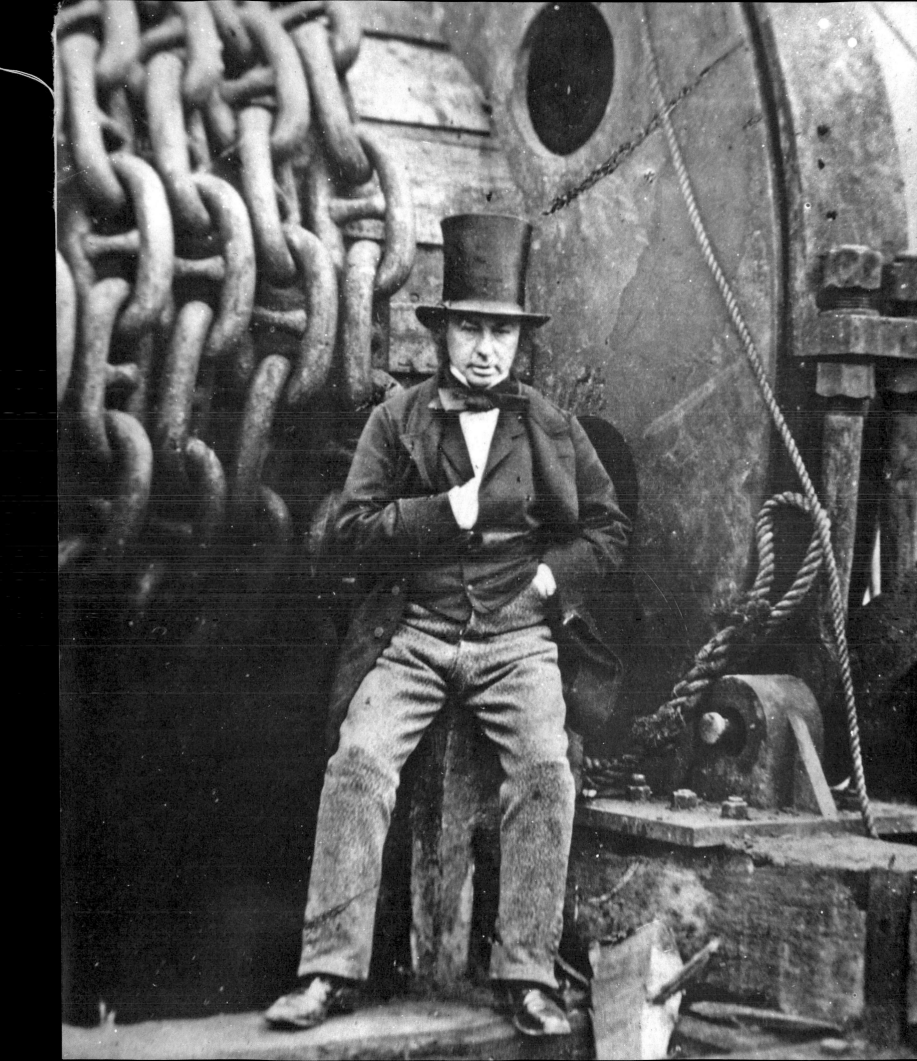

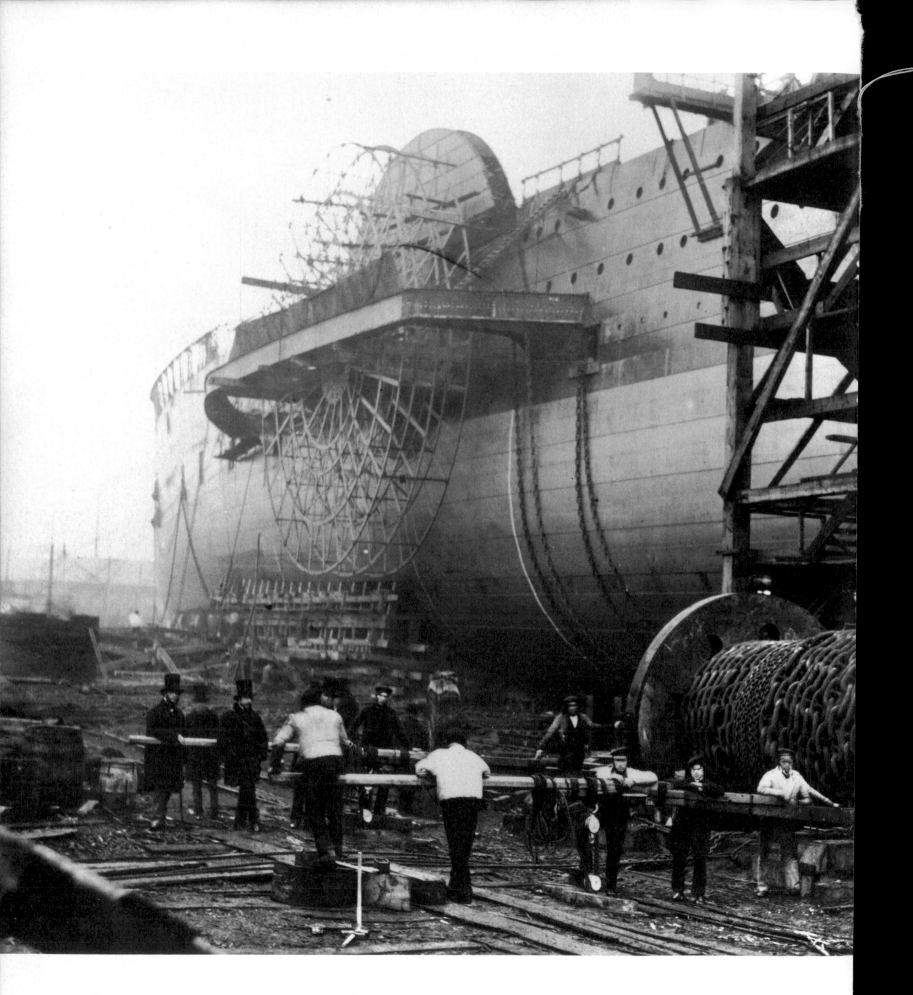

A Contemporary Note

Brunel's account of the construction of the Leviathan *reveals how dedicated he was to this particular "great babe." When work began at the Napier Yard, he wrote to a friend:*

I never embarked on one thing to which I have so entirely devoted myself, and to which I have devoted so much time, thought and labor, on the success of which I have staked my reputation, and to which I have so largely committed myself and those who were disposed to place faith in me; nor was I ever engaged in a work which from its nature required for its conduct and success that it should be entrusted so entirely to my individual management and control....

An early study of men at work. The *Leviathan* takes shape at Scott Russell's Yard in Millwall.

"M. Blondin could be seen dressed in tights and covered in spangles upon which the sun shone, making him appear as if clothed in light. At 5 o'clock precisely he started...."

BUFFALO REPUBLIC, JULY 1, 1859

[June 30, 1859]

BLONDIN CROSSES THE NIAGARA

It was was a hot summer day. Vendors were making good money selling tartaric lemonade at 25 cents a glass, with whiskey for the fainthearted at $1 a shot. Five thousand excited spectators were gathered on the banks of the Niagara River, a little distance upstream from the mighty Falls. It was June 30, 1859, and they had come to see a 35-year-old Frenchman, Jean François Gravelet (1824–1897), who had adopted the show name of Charles Blondin, attempt to cross from the United States to Canada by walking along a rope 1,100 feet long, stretched high over the rushing water. If he succeeded, he was assured a place in the following day's newspaper headlines—and fame as a stuntman. If he failed, he would make the front page only if he died. Among the many reporters there to cover this early, mass-audience, dare-devil event, was William England (1813–1869), chief photographer for the London Stereoscopic Company.

Blondin's tightrope was made of three-inch diameter Manila hemp, and stretched from Prospect Park, New York, to Oakes Garden, Ontario. This was not Blondin's first choice. His original plan had been to string his rope to Goat Island, but the owners refused permission. They were among a great many local people who were against this stunt, claiming that it would demean the Falls, turning one of Nature's greatest spectacles into the backdrop to a mere circus act. So Blondin moved the site for his death-defying attempt a mile downstream.

By late afternoon all was ready. At five o'clock, Blondin stepped confidently onto the sagging rope, moving down from the United States side toward the midpoint, where he would begin the ascent to Canada. To steady himself, he carried a 30-foot-long pole weighing 40 pounds. It was a considerable weight to carry for just under a quarter of a mile, some of it uphill. There were no false steps, but it took Blondin 25 minutes to complete the crossing.

William England

William England was a giant in the development of modern photography. A principal photographer with the London Stereoscopic Company in England, his images were among the first to be licensed for commercial reproduction on a global basis. By using twinned cameras that took closely parallel images of the same subject, he was able to provide stereo portraits and landscapes with a three-dimensional effect when seen through an appropriate viewer. Many of his pictures were taken along the United States eastern seaboard, where he chronicled the growth of the American railroad and Blondin's extraordinary exploits at Niagara.

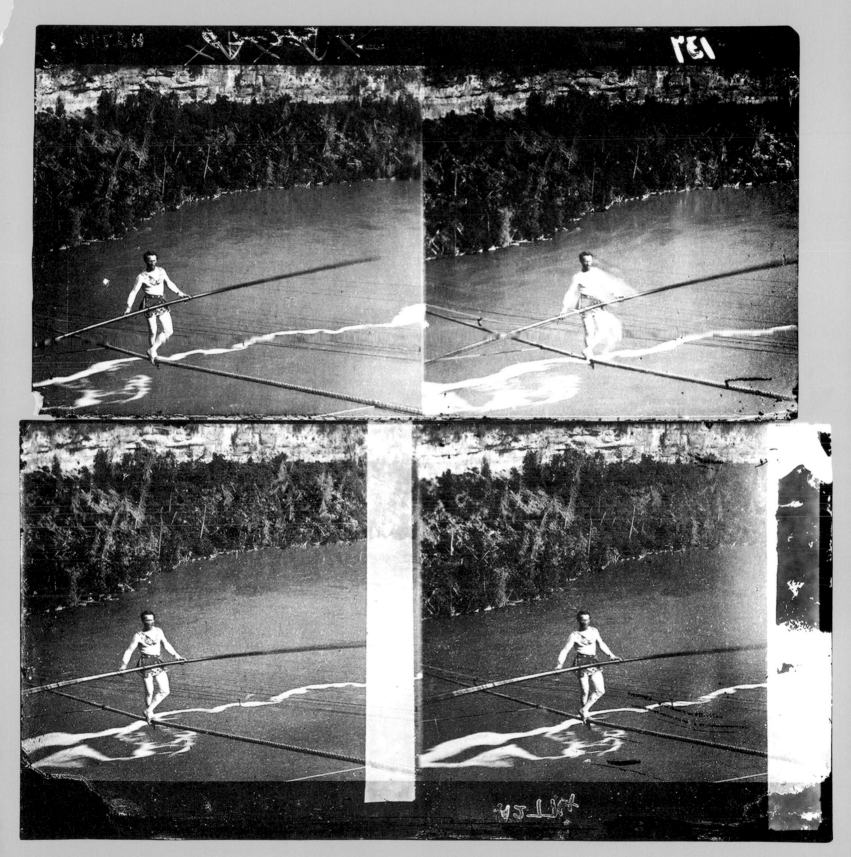

William England's stereoscopic cards showed Blondin crossing the Niagara just after 5 o'clock on June 30, 1859.

Broadway, New York City

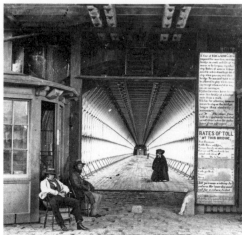

Interior of Niagara Suspension Bridge

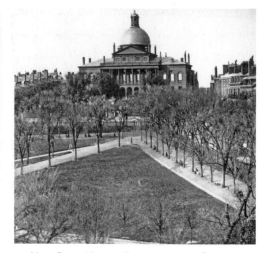

New State House, Boston, Massachusetts

These 12 photographs are part of a series made by William England along the eastern seaboard of the United States, where he recorded views of expanding cities and the growth of the American railroad.

William England faithfully recorded the occasion and sent his three-dimensional pictures back to London. Sales were phenomenal. The images of Blondin on the tightrope became the most popular stereoscope of all time, selling more than 100,000 copies.

England was no stranger to Niagara. He had been there before while on his travels throughout the eastern United States, to record the building of the great suspension bridge over the river. Like other early pioneers of photography, England had his own horse-drawn darkroom in which he prepared his plates and processed his pictures. The vast majority of these were three-dimensional images, taken with closely twinned cameras that took parallel pictures of the same subject. Over the years since the Great Exhibition of 1851, stereoscopic pictures had become popular in both Europe and the United

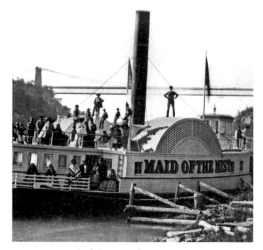

Maid of the Mist ferry at Niagara

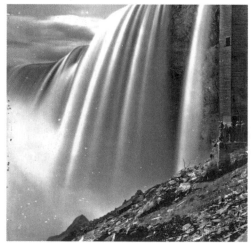

Horseshoe Falls, Niagara

John A. Roebling's Suspension Bridge

Genesee River, near Rochester, New York

Victoria Railway Bridge over the St. Lawrence

New York Harbor from Trinity Church

States. England's later contribution to this success lay not only in the pictures he took, but in his own invention—the "focal plane shutter" camera. The camera revolutionized photography from the early 1860s onward, for it greatly improved the clarity of the photographic image.

The pictures that England sent back to London from America were the first true images that Europeans had seen of the rapidly developing United States, and, as such, they had a huge influence on Old World concepts of the New World. Here were photographs of the streets of New York City, of American and Canadian railroads, of the ports and cities, engineering feats and monuments of what had previously been an unknown land. The United States had entered the world arena.

"One requires a lot of patience, one is often unsuccessful—bad light, absence of the sun at the very moment when the plate is most sensitive, difficulties caused by changes in the silver bath. All this is rather unpleasant..."

WILLIAM ENGLAND IN AN ESSAY ON THE PROBLEMS OF PHOTOGRAPHY, 1862

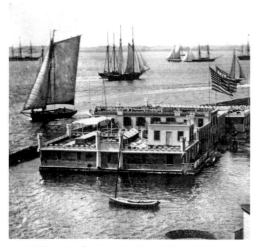

Saltwater floating baths in New York Bay

Victoria Bridge, Montreal, Canada

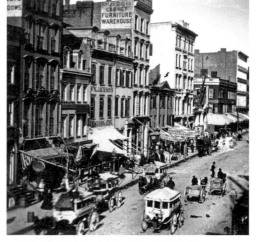

Old Broadway, New York City

[July 3, 1863]

PICKETT'S CHARGE AT GETTYSBURG

By the summer of 1863, it was clear that the South had no chance of winning the American Civil War. If the Confederacy was to survive, its Commander in Chief, Gen. Robert E. Lee, needed to inflict a crushing defeat on the North.

Lee had advanced north to take the battle to Union territory and so relieve pressure on the besieged town of Vicksburg, Mississippi. For the Union, Maj. Gen. George E. Meade was simply following him—at a distance. When a Confederate foraging party, searching for shoes in the little town of Gettysburg, Pennsylvania, ran into Union cavalry, the battle of Gettysburg began almost by accident.

For two steamily hot days, repeated attacks by Lee's infantry served only to push the Union slowly back to strategically stronger positions. By the third day stalemate loomed, and Lee was determined to break it. He resolved to make one last, grand attempt to win the battle that he still hoped might bring an end to the war. It was a desperate measure. Lee's forces had been badly hampered by the absence of Jeb Stuart's Confederate cavalry in the field.

At 2 p.m. on July 3, George E. Pickett's Confederate infantry emerged from woods and advanced on Cemetery Ridge. Their plan was hopeless, but almost majestic in its stubborn heroism. Some 14,000 men advanced on foot over open ground against Union artillery and massed infantry in entrenched positions. When Pickett's men were 700 yards away, Union artillery opened fire. Those who survived were then pounded by musket fire. Barely 7,000 Confederate soldiers managed to stagger back to the relative safety of the woods. Lee watched in horror. "All this has been my fault," he said.

Lack of victory and heavy losses at Gettysburg destroyed any hopes of a victory for the South. That the war dragged on for almost two more years was ultimately a tragedy shared by both sides.

"The Harvest of Death"—a study at Gettysburg by Timothy O'Sullivan

Wartime propaganda

By the early 1860s, the camera had already become a powerful weapon of propaganda, particularly in wartime. Lincoln appreciated the part it had played in bringing him success in his presidential campaign, and both sides exploited the art of photography in the War Between the States. Many photographers followed the armies, among them Timothy O'Sullivan who was in his early twenties when he took his classic studies of the carnage at Gettysburg. The images were published by Philip and Solomons 18 months after the event.

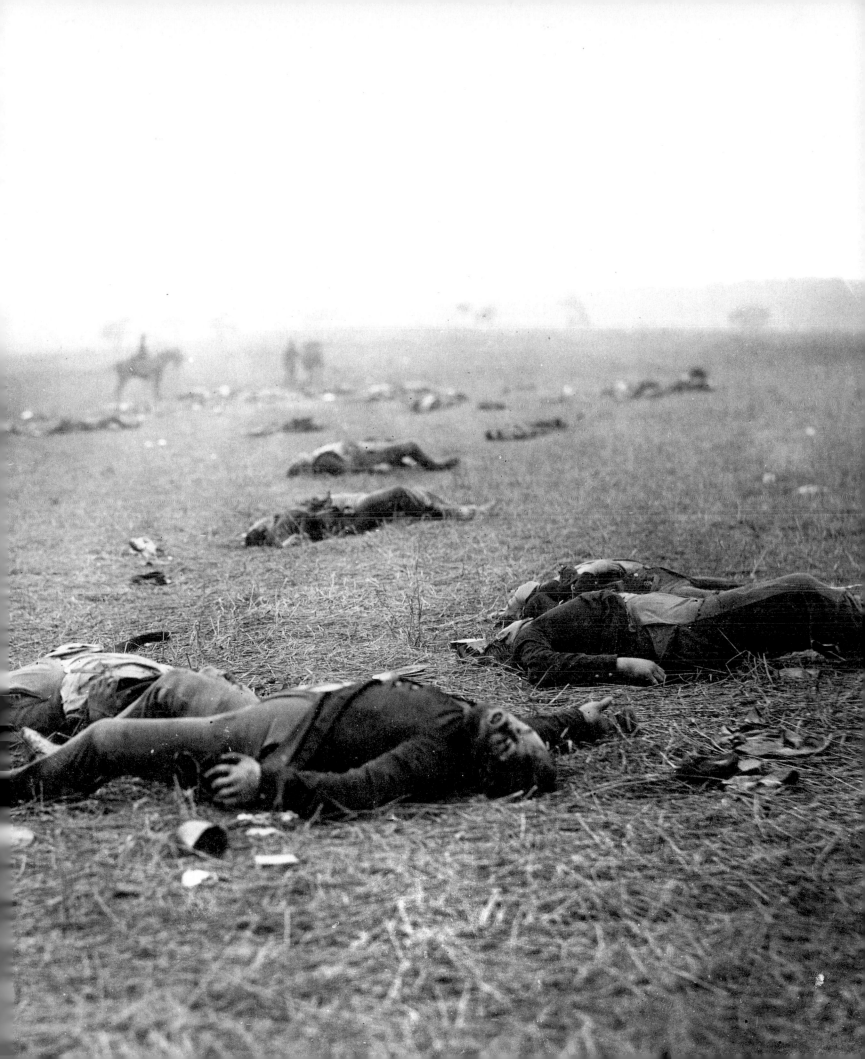

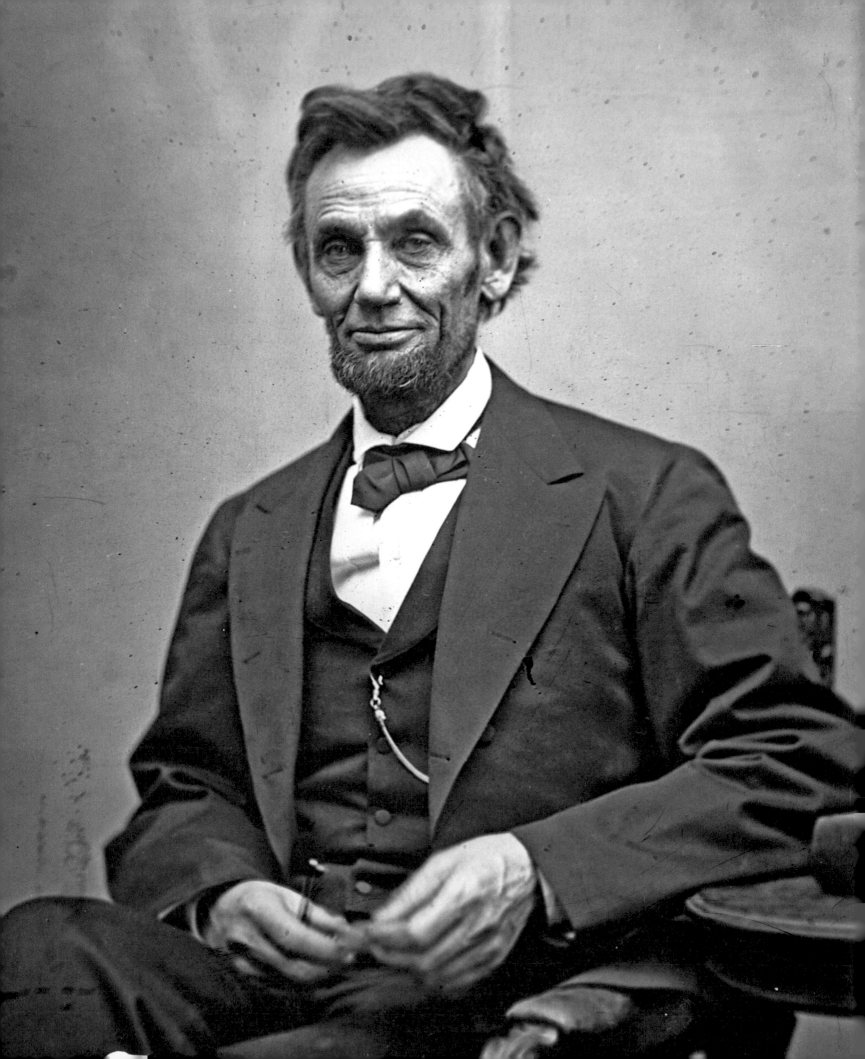

[April 14, 1865]

DEATH OF A PRESIDENT

History has portrayed Abraham Lincoln (1809–1865) as a man of steadfast moderation, insightful leadership, and endurance, who is heralded as one of America's greatest presidents. His contemporaries, both his admirers and detractors, often saw him as a hard man, direct in his approach and stubborn and self-contradictory in some of his beliefs. Three thousand miles away, the London *Times* referred to him as "The Baboon." But the lawyer from Illinois had a gift for words, a legendary insight into human nature, and the courage of his convictions. He took center stage when the greatest drama in America's existence was played.

In spring 1865, President Lincoln had one great task in mind—to bring peace to a divided nation. That had been the aim of his Proclamation of Amnesty and Reconstruction, issued 18 months earlier as a plea for understanding and tolerance between North and South. Some had approved; others, from both ends of the political spectrum, had attacked the idea. The issue had been hotly debated, but no consensus had emerged as to what should be done with those who had seceded from the Union. The matter was now of great urgency, for, on April 9, Confederate Gen. Robert E. Lee, in crisp white uniform, had surrendered to a mud-spattered Gen. Ulysses S. Grant in the parlor of the McLean house at Appomattox, Virginia.

On April 14, Lincoln made his last speech on the subject of Reconstruction. From the balcony of the White House, he said that Confederate states should be returned to "their proper practical relation with the Union as quickly as possible." That evening, he decided to pay a visit to Ford's Theater in Washington, D.C.

For three months now, a 26-year-old actor, racist, and Confederate sympathizer named John Wilkes Booth had been hatching a plot to kidnap Lincoln and hold him in return for the release of

Alexander Gardner

Just four days before his death, Abraham Lincoln sat for the photographer Alexander Gardner in his Washington, D.C., studio. A few weeks later, Gardner was allowed on board the warships *Montauk* and *Saugus*, then used as prison ships, to photograph some of those who had plotted Lincoln's death. On July 7, 1865, Gardner took a series of wet collodion negatives of the execution of four of the conspirators—from the empty scaffold, to the dead bodies hanging from the ropes.

Alexander Gardner's portrait of Abraham Lincoln, April 10, 1865

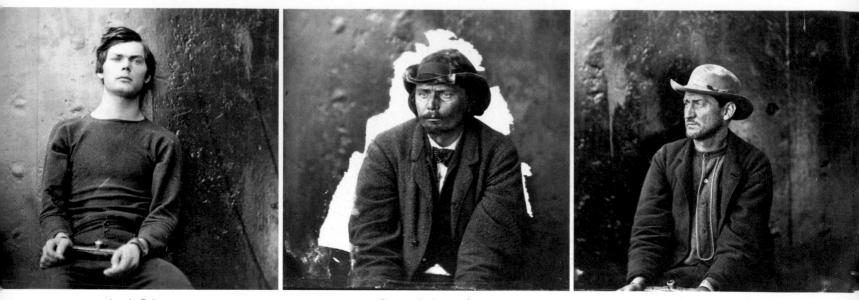

Lewis Paine

George A. Atzerodt

Edman Spangler

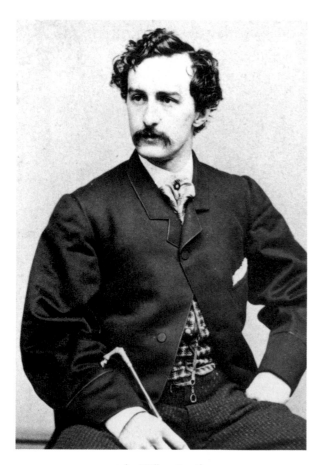

John Wilkes Booth

Confederate prisoners of war. Booth and his co-conspirators held regular meetings at a Washington boarding-house owned by Mary Surratt. There they fixed the date for the kidnapping as March 17, when the President was scheduled to open a hospital on the out-skirts of the city. On the day, however, Lincoln changed his plans, and remained in the capital. On the morning of April 14, Booth visited Ford's Theater, and there learned that Lincoln would be attending the evening performance of *Our American Cousin*.

Booth at once contacted his fellow conspirators. The final prepa-rations were made. Booth was to kill Lincoln, while George Atze-rodt was to kill Vice President Andrew Johnson. Lewis Paine and David Herold would kill Secretary of State William Seward.

Lincoln and his wife, with their friends Clara Harris and Henry Rathbone, arrived at Ford's at 8:30 p.m. Booth arrived an hour later, told William Burroughs, a boy who worked at the theater, to mind his horse in the rear alley, and then went to the next-door saloon to fortify himself with a drink. He entered the theater at 10:07 p.m. He knew Ford's well, and had no difficulty making his way to the State Box. He was in luck. Lincoln's bodyguard, John Parker of the Met-ropolitan Police Force, had temporarily left his post. Drawing his sin-gle-shot Derringer and a hunting knife, Booth entered the box, shot Lincoln in the back of the head at point-blank range, stabbed Rath-bone in the arm, and leapt 11 feet onto the stage below. As he landed, he broke his left fibula. In front of an audience of more than a

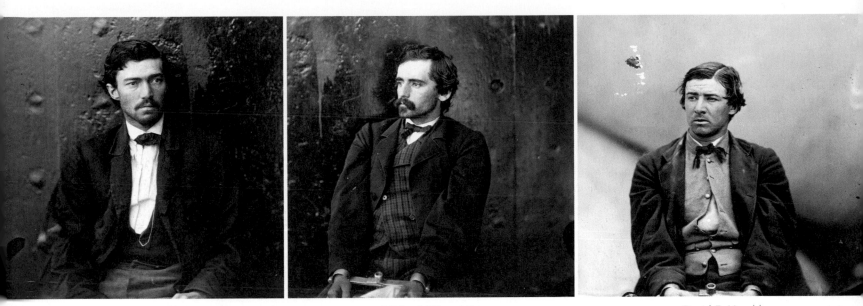

Samuel Arnold Michael O'Laughlin David E. Herold

thousand people, while Mrs. Lincoln screamed, Booth limped to the back door of the theater, and galloped away on his horse.

He rode to Surrattsville, Maryland, where he met Herold, and the two rode on to Dr. Samuel Mudd's house, where the doctor set and put a splint on Booth's broken leg. The following afternoon, Booth and Herold left Mudd's house and headed south. Eleven days later, federal authorities caught up with them at a farm near Port Royal, Virginia. Lincoln never recovered consciousness, and died on the morning of April 15 at the Petersen house, opposite the theater.

Booth's aim had been to plunge the federal government into chaos, and thereby rekindle the South's fighting spirit. But Atzerodt failed to make any attempt on the Vice President's life, and Paine and Herold managed only to wound Secretary Seward. The capital was stunned, but there was no rekindling of the flame of war. Lincoln's aims in the Proclamation of 1864 had been to restore a measure of executive freedom to the defeated southern states, and to put a check on Northern radicals in Congress. That all now fell by the wayside. On March 2, 1867, Congress passed the Reconstruction Act, dividing the South into five military districts in which the authority of the army commander was supreme. Bitterness increased, and over the next decade hopes for a reordering of the basic social and economic structure of the South, beyond the abolition of slavery, died. The death of Lincoln was a set back to progress for Blacks, poor Whites, and Republicans in the South for some 70 years to come.

"I claim not to have controlled events, but confess plainly that events have controlled me."

LINCOLN, IN A LETTER TO A. G. HODGES, 1864

ABOVE Prints taken from Alexander Gardner's wet collodion negatives of some of the conspirators involved in the plot to assassinate Lincoln. Payne, Herold, and Atzerodt were among those executed. The others received long terms of imprisonment.

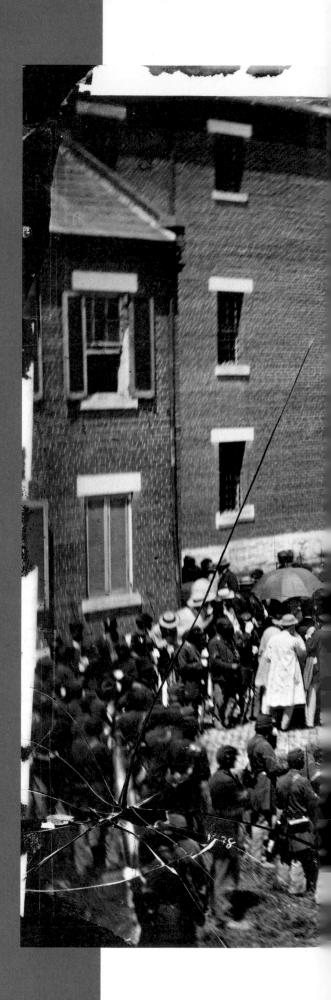

A Contemporary Note

Booth had made no secret of his hatred for Lincoln. Here is an account by Mary Clay, wife of the U.S. Minister to Russia, of an earlier visit to Ford's Theater when she was one of the Presidential party:

In the theater President and Mrs. Lincoln, Miss Sallie Clay and I, Mr. Nicolay and Mr. Hay, occupied the same box which the year after saw Mr. Lincoln slain by Booth. I do not recall the play, but Wilkes Booth played the part of villain. Twice Booth in uttering disagreeable threats in the play came very near and put his finger close to Mr. Lincoln's face; when he came a third time I was impressed by it, and said, "Mr. Lincoln, he looks as if he meant that for you." "Well," he said, "he does look pretty sharp at me, doesn't he?"

The last of Gardner's series of photographs documenting the conspirators' executions

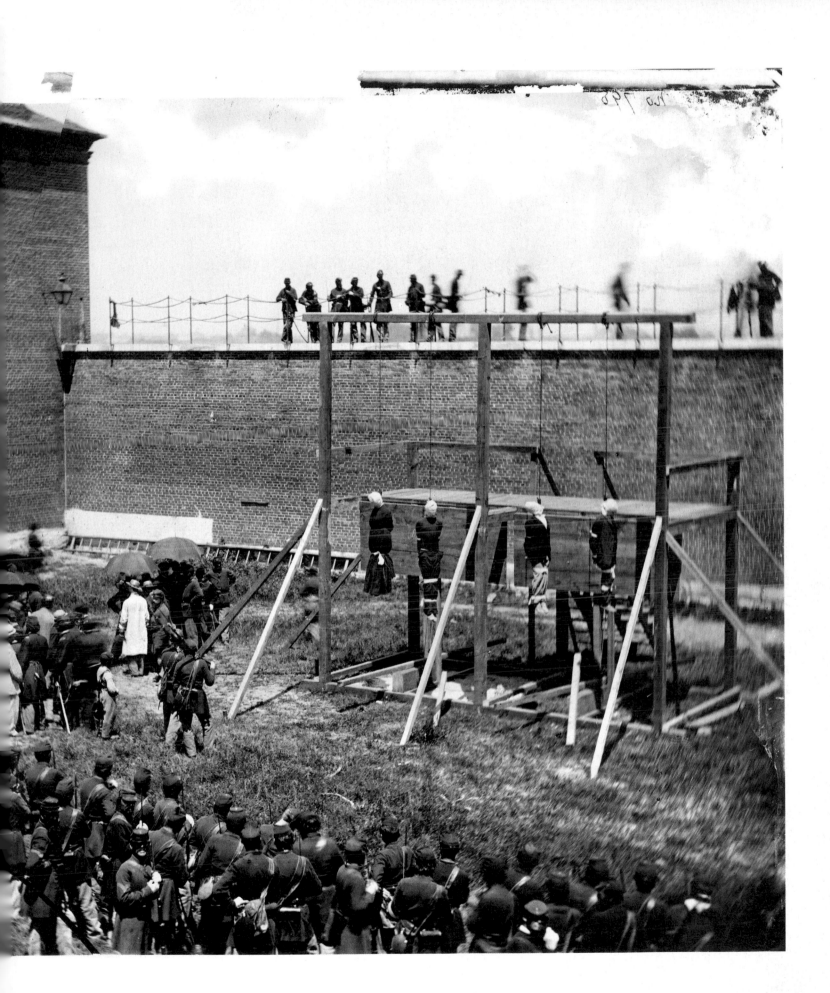

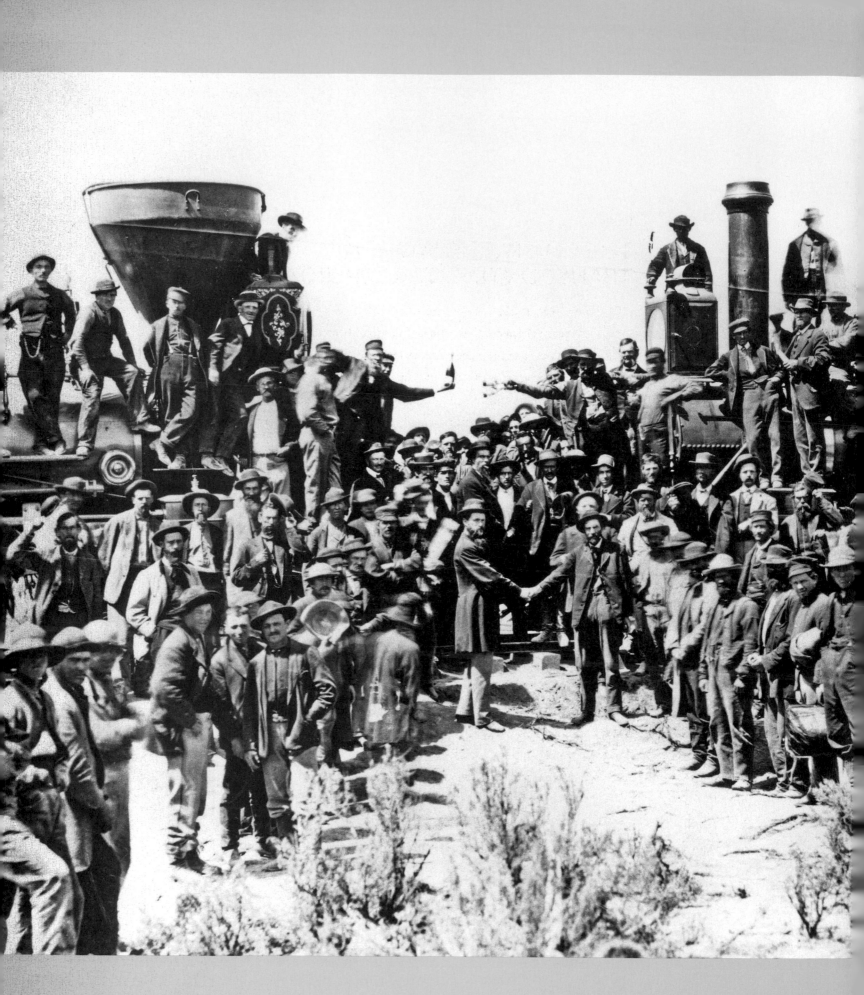

"May God continue the unity of our Country, as the Railroad
unites the two great Oceans of the world."

MESSAGE ENGRAVED ON THE GOLDEN SPIKE DRIVEN IN ON THE DAY OF COMPLETION,
MAY 10, 1869

[May 10, 1869]

THE COMPLETION OF THE TRANSCONTINENTAL RAILROAD

The creation of a truly united United States was achieved at breakneck speed. Once the last shot had been fired in the War Between the States, Americans threw themselves into a frenzy of building bridges—real and metaphorical—so that East and West could meet, and so that news and travelers could cross the continent more rapidly and more reliably than by Pony Express or wagon train.

The key to linking New York to San Francisco, or indeed Kansas City to Albuquerque, was the railroad—the Iron Horse—that raced across plains and through mountains, threatening old ways of life and leaving in its wake the smoky plumes of progress. The First Transcontinental Railroad was authorized by the Railway Act of 1862. From Omaha, Nebraska, in the East came the Union Pacific Railroad crewed by tens of thousands of Irish, German, and Italian laborers, while from Sacramento, California, in the West came the Central Pacific Railroad built by over 10,000 Chinese laborers. The Union Pacific laid 690 miles of track, the Central Pacific 1,087 miles. Both railroads were private enterprises with strong federal backing.

On May 10, 1869, the Pacific and Atlantic coasts were finally connected in the rocky range of Utah, at a place called Promontory Point. Ceremonial spikes of gold and silver linked the tracks of the Union Pacific and Central Pacific, and except for a tedious crossing of the Missouri River by ferry boat at Council Bluffs, Iowa, it was now possible to travel the entire breadth of the vast continent in the comfort and safety of a railroad car.

The men who had planned the railroad breathed sighs of relief. The gangs of men who had built it cheered. Bells rang out across the land. Poems—some good, many bad—were hastily penned. Bands played. The modern United States was born.

A champagne toast celebrates East meeting West at Promontory Point.

Getting to Promontory Point

Painter turned photographer Andrew Joseph Russell was on hand to capture the historic moment of the Central Pacific's *Jupiter* and the Union Pacific's engine *No. 119* meeting head to head at Promontory Point, Utah. Hired by Union Pacific Railroad in 1868 to document the construction of track line as it pushed westward, Russell not only captured heroic feats of engineering, but also the spectacular landscape along the growing tracks. This was no easy feat, since he had to transport his 30-pound view camera, a stereoscopic camera, his glass plates, a tent for quickly developing the plates, and a large supply of chemicals. In documenting the construction and final joining of the rails, Russell made over 200, 10x13-inch glass plate negatives and over 400 stereo negatives. Known as the "Champagne" photograph, this image in time became one of the most noted in American history.

[November 17, 1869]

THE OPENING OF THE SUEZ CANAL

The Suez Canal was a French achievement. Ferdinand de Lesseps (1805–1894), a French engineer, built it. French capital financed it. The French Empress Eugénie was a guest of honor at its official opening, as proud as all the other French citizens present to celebrate French influence in this new Egypt. But the event itself was a truly international affair. The Hapsburg Emperor, Franz Joseph, and the Crown Prince of Prussia were among other royal participants at the magnificent banquet hosted by Ismail, Khedive of Egypt, on a floating platform on the waters of the Suez Canal itself. The band played Viennese waltzes, fireworks exploded spectacularly, and jewelry of the guests glittered in the light of 10,000 lanterns. The British were also there—less proud than the French, though, and most certainly envious.

The site chosen for this feast was Ismailia (named for the Khedive), a new city built halfway between the Mediterranean Sea and the Red Sea, which were linked by the Canal. The Canal itself had taken almost 11 years to build and had cost the lives of tens of thousands of Eygptian laborers. It had an immediate and enormous effect on world trade, opening up Africa for colonization and speeding up circumnavigation of the world. For European tourists heading to the East, and British civil servants bound for India, the Canal was a shortcut that saved them the long voyage around Africa's Cape of Good Hope. For European armies, the Canal became, overnight, a waterway of the greatest strategic importance.

There were those who predicted trouble, that one day wars would be fought over the Canal. On this night, however, the mood in Ismailia was entirely celebratory, despite the Canal being completely blocked by a police launch that had run aground. Voices were raised only to marvel at the outstanding achievement of M. de Lesseps.

Capturing the canal opening

The official inauguration of the Suez Canal was a lavish event, with kings and queens of Europe gathering at Port Said, Egypt, to celebrate this meeting of two large bodies of water: the Mediterranean Sea and the Indian Ocean. On hand to capture this event were several professional photographers, remarkable at a time when photography was so young. Many came from France, but others already resided in Egypt, there to photograph the antiquities, a popular subject of the time. These photographers captured the elaborately decorated official stands, the crowds, and the flotilla of sailing ships, large and small, resplendent in country and semaphore flags.

Preparations for the opening ceremony of the Suez Canal

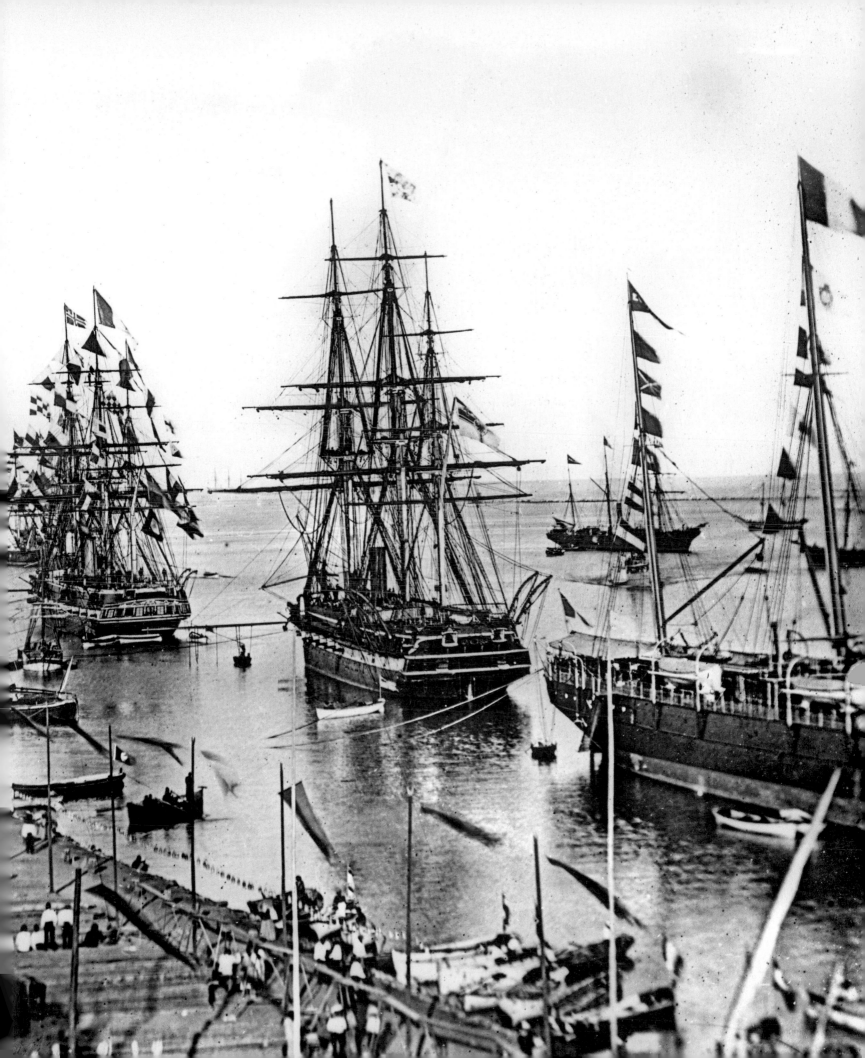

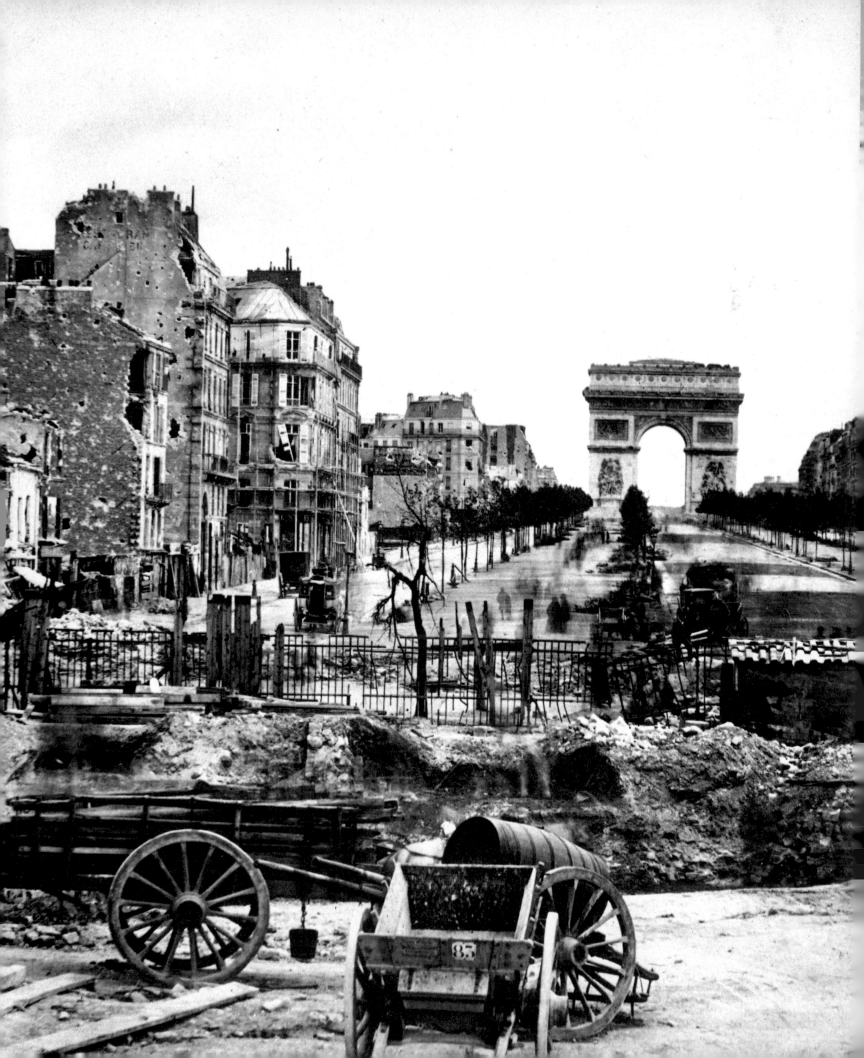

[March 18 , 1871]

RISE OF THE PARIS COMMUNE

After a series of humiliating defeats by the Prussians, the French Second Empire ended on September 4, 1870, and a Government of National Defense was set up in Paris. The Prussians then besieged the city. Inside Paris, revolution broke out against the new government on March 18, 1871, and the red banner was raised by a group calling themselves "Communards." These Marxist-inspired revolutionaries sought a return to the glory days of 1792, when the French monarchy was abolished. Immediately, 80,000 bourgeoisie fled Paris, preferring to live under the Prussians rather than the Communards.

Inside Paris, members and supporters of the Commune argued over how best to promote and protect the revolution so bravely begun, while outside, Adolphe Thiers, the French prime minister, made peace with the Prussians, and established his government at Versailles. The Prussians withdrew, and Thiers' French army now lay siege to Paris, against the Communards. The days of the Commune were numbered.

Over the next two months, Communard supporters and opponents fought on the streets of Paris. The Communards summarily killed priests, petty officials, and the rich, while the French army lined up captured Communards against the walls of parks and cemeteries and shot them by the hundreds. In Bloody Week, toward the end of May 1871, some 35,000 men and women were killed or executed—more than ten times the number that had suffered during the notorious two-year Reign of Terror following the French Revolution of 1789.

Ultimately, the suppression of the Paris Commune broke the last constitutional links with prerevolutionary France. What emerged was a nation bitterly divided between Church and State, Left and Right, rich and poor, the army and politicians. Not until World War I (1914–1918), when the wounds of 1871 were further bathed in blood, was France reunited.

Barricades set up by Communards in Avenue de la Grande Armée, Paris

Photography as weapon

Propaganda became a vital weapon during the Paris Commune. The French government had access to commercial printing and control of the media, and also threatened pro-Communard photographers with imprisonment. Most of the damage to the city was caused by government troops or the Prussians, but photographic captions usually blamed the Communards. Images of atrocities committed by both sides were often doctored or even faked, using actors, but a macabre interest in such happenings led to an increased tourist interest, catered for by travel agent Thomas Cook.

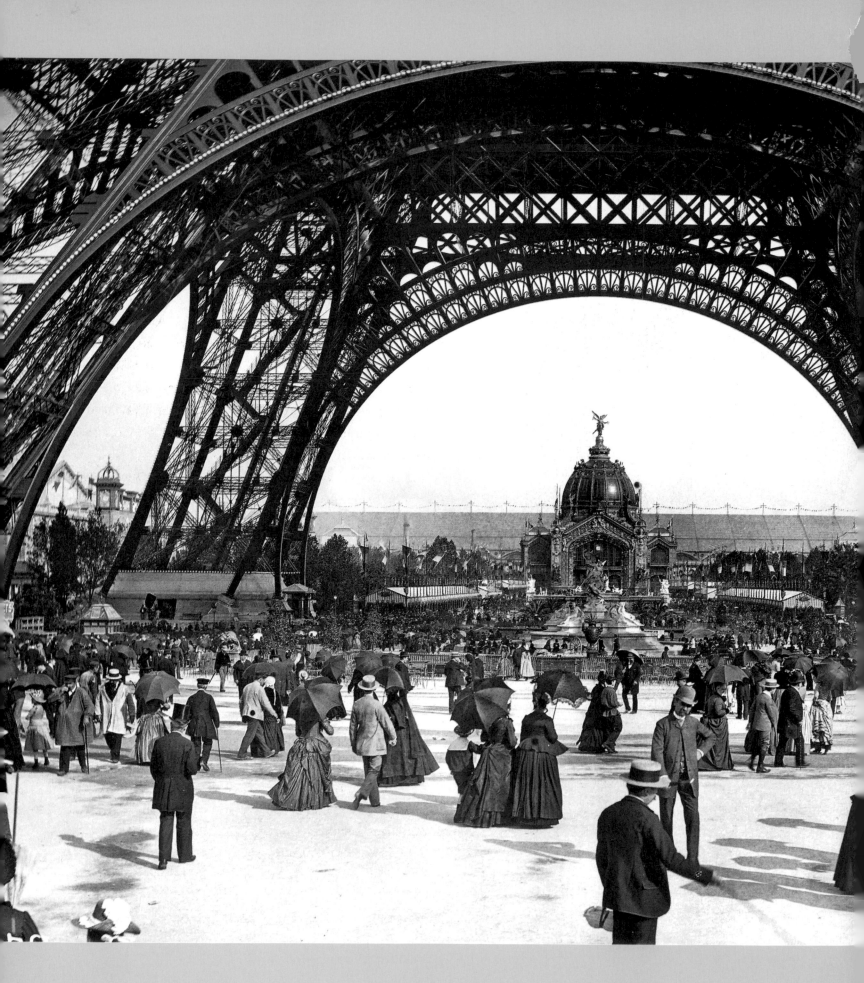

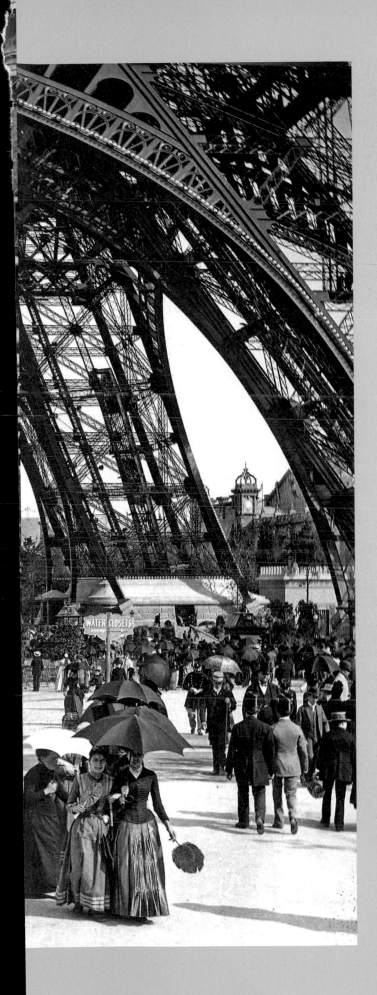

[May 6, 1889]

MONSIEUR EIFFEL'S TOWER INAUGURATED

In 1884, when detailed plans were being drawn up for the Paris Exposition Universelle of 1889, France was in a bad way. Her defeat by Prussia in 1871 had been followed by an economic depression that affected both industry and agriculture, and caused widespread discontent. The mood was not revolutionary, but it was severely critical of the government, and unrest was in the air. By 1888, General Georges Boulanger, a maverick and dangerous populist, threatened a *coup d'état*. A crisis seemed imminent.

The Exposition had been planned, in part, to counter such unrest. Prime Minister Jules Ferry had proposed the Exposition in 1880 with three political goals in mind—"reconciliation, rehabilitation, and imperial supremacy." It was to boost the economy, restore morale, and specifically to bolster the metal industry through the erection of immense iron-framed pavilions.

The site chosen was the Champ de Mars, 235 acres of land stretching from the Seine River to the École Militaire. Among the great metal pavilions were the Palace of Machines, surmounted by a Central Dome, 150 feet high and with a span of 377 feet. Beneath it were housed exhibitions of jewelry, perfumes, furniture, textiles, heating equipment, and much more. The dome was flanked by two palaces —the Palais des Beaux-Arts and the Palais des Arts-Liberaux. The first contained paintings, and the most extensive display of American art ever seen in Europe. The second celebrated public education under France's Third Republic.

But the most amazing structure in the Exposition, and its crowning glory, was the Eiffel Tower—985 feet high, and, until the completion of the Empire State Building in 1931, the tallest building in the world. The Tower had been designed by Gustave Eiffel (1832–1923), a Burgundian engineer, to symbolize the Third

The Dome of the 1889 Paris World's Fair, seen from the Eiffel Tower base

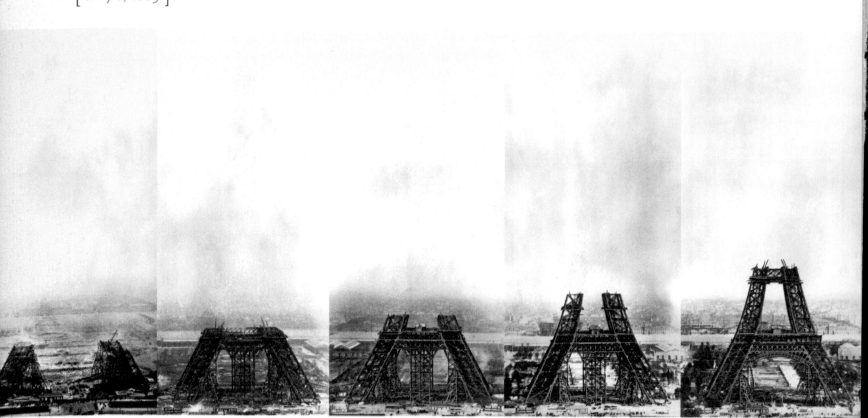

October 8, 1887 March 15, 1888 April 10, 1888 May 10, 1888 July 10, 1888

Capturing the process

During the two years, two months, and five days that it took to build the Eiffel Tower, the French photographer Jules Théophile Féau was given permission to make a detailed photographic history of the process. To do this, Féau set up his cameras in the towers of the Palais de Trocadero, a building originally constructed as part of the Paris Exposition of 1867. Every 15 days, Feau diligently climbed to the top of the Trocadero and captured another stage in the rise of M. Eiffel's novelty. The Trocadero was demolished in 1936.

Republic's "attachment to its revolutionary heritage"—this was, after all, the centenary of the French Revolution of 1789. It was also an architectural riposte to the basilica of Sacré Coeur, erected in Montmartre by ardent Catholics "to atone for the death of the Archbishop of Paris in the 1871 Commune." Tower and church faced each other across the city, symbols of the separation of church and state.

Construction of the Tower began on January 26, 1887. Its foundations were driven 50 feet underground. The First Stage was completed a year later, the Second Stage in June 1888. As it rose from the Champ de Mars, there were those who came to love it, those who instantly detested it. The French writer Edouard Drumont—a man who hated urban life, the Jews, Ferdinand de Lesseps (the Frenchman who constructed the Suez Canal), and all things modern— regarded the Tower as a symbol of all that was wrong with France. Guy de Maupassant lunched regularly at the restaurant on the First Stage so that he would not have to look at the Tower. The public, however, adored it. M.Eiffel's masterpiece was featured on railway posters across all of France, and 32 million visitors came to see the Exposition and the Tower between May and November 1889.

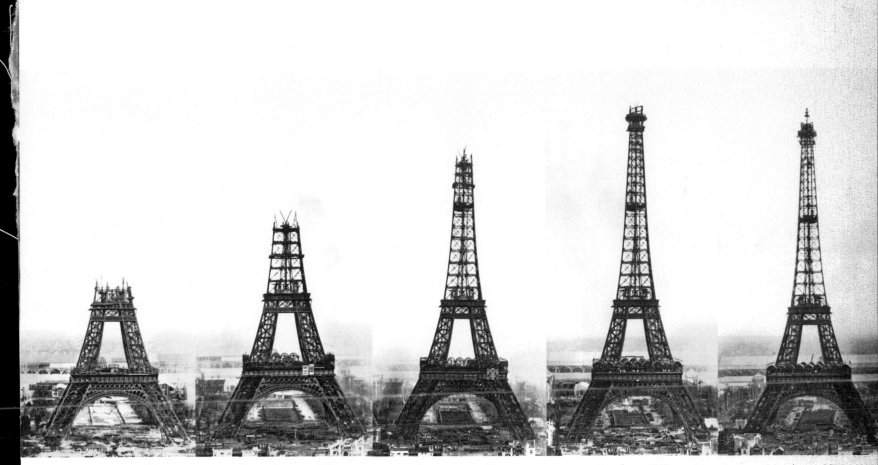

September 10, 1888 November 14, 1888 January 20, 1889 March 12, 1889 March 31, 1889

On May 6, President Sadi Carnot inaugurated the Exposition by leading a procession along the Champs-Élysées, over the Pont d'Iéna, underneath the arches of the Eiffel Tower, and on to the Central Dome, where he made a speech: "Today France glorifies the dawn of a great century which has opened a new era in the history of mankind. Today we contemplate, in its brilliancy and in its splendor, the work born of this century of labor and of progress…. Our dear France is worthy of attracting to her the chosen of the peoples." The Eiffel Tower and the Exposition had done their work.

The Exposition cost 41.5 million francs, but made a profit of 8 million francs. Although most of the buildings were subsequently demolished or dismantled, the Eiffel Tower remained—all 10,000 tons, 1,665 steps and 2.5 million rivets. Eyesore or delight, it is still one of Paris's most popular tourist attractions.

As for M. Eiffel, his fortunes took a tumble four years later when he was fined and condemned to two years' imprisonment for breach of trust in connection with the abortive French Panama Canal scheme. He recovered from adversity, however, and died in 1923 at the age of 91.

Shortly after its completion, Alexandre Gustave Eiffel (in top hat) stands near the top of his beloved Tower, April 1889.

[December 29, 1890]

WOUNDED KNEE MASSACRE

On a bitterly cold winter day, 500 troops of the U.S. 7th Cavalry, under the command of Gen. Nelson A. Miles (1839–1925), surrounded an encampment of 350 Miniconjou and Hunkpapa Sioux, collectively known as Lakota. The cavalrymen were fully armed with rifles and Hotchkiss guns. The Native Americans were mostly unarmed, and almost two-thirds of their number were women and children.

Miles had orders to move the Lakota from their encampment at Wounded Knee Hill, South Dakota, to the railroad, for transportation to a reservation at Omaha, Nebraska. It was one of many such exercises, for the U.S. Government had initiated a policy by which "Indians" were to be made to "conform to the white man's ways, peaceably if they will, forcibly if they must."

There was tension in the freezing air. It was just 14 years since the 7th Cavalry had suffered a catastrophic defeat by the Sioux at the Little Big Horn. Reports of the revival of the Sioux Ghost Dance had misrepresented its significance. The Lakota believed that performing the Dance would accomplish three things: bring about a renewal of the Earth, lead to a return of the buffalo to their former hunting grounds, and make their deceased loved ones live again. The U.S. Army and the Bureau of Indian Affairs had their doubts, and many European Americans mistook the Ghost Dance for a war dance.

The soldiers moved in, disarming those Lakota who had not already handed in their weapons. One deaf warrior resisted. A shot was fired. The tension snapped, and guns blazed. When the shooting stopped, 29 troopers had been killed, and 200 Lakota lay dead. Many of those who fled died of exposure shortly afterward.

Although Miles himself described the event as a "massacre," he was not blamed for what had happened. Twenty Medals of Honor were awarded to U.S. troops who fought at Wounded Knee.

"Wigwam photographers"

George "Gus" Trager and his partner Fred Kuhn advertised themselves as "Wigwam Photographers," specialists in "Indian" studies. Trager was the first photographer on the scene after the massacre at Wounded Knee, capturing the frozen Lakota corpses lying where they fell, with the Army burial party posing by the mass graves. He and Kuhn also took a series of portraits of Red Cloud, the Lakota chief, at their Nebraska studio. Red Cloud was a willing subject; he sat for the camera on more than 50 occasions.

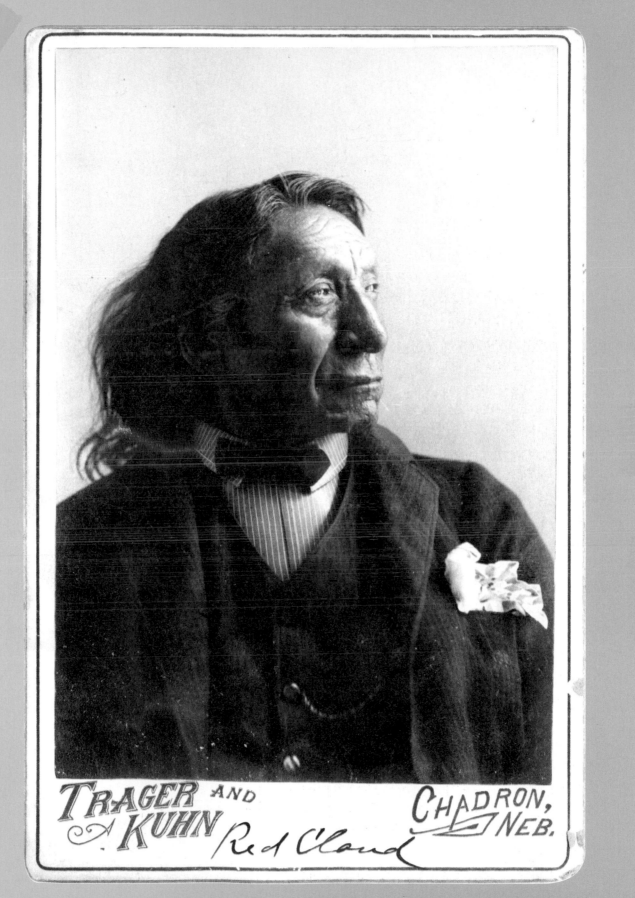

Trager and Kuhn's *carte de visite* of Red Cloud

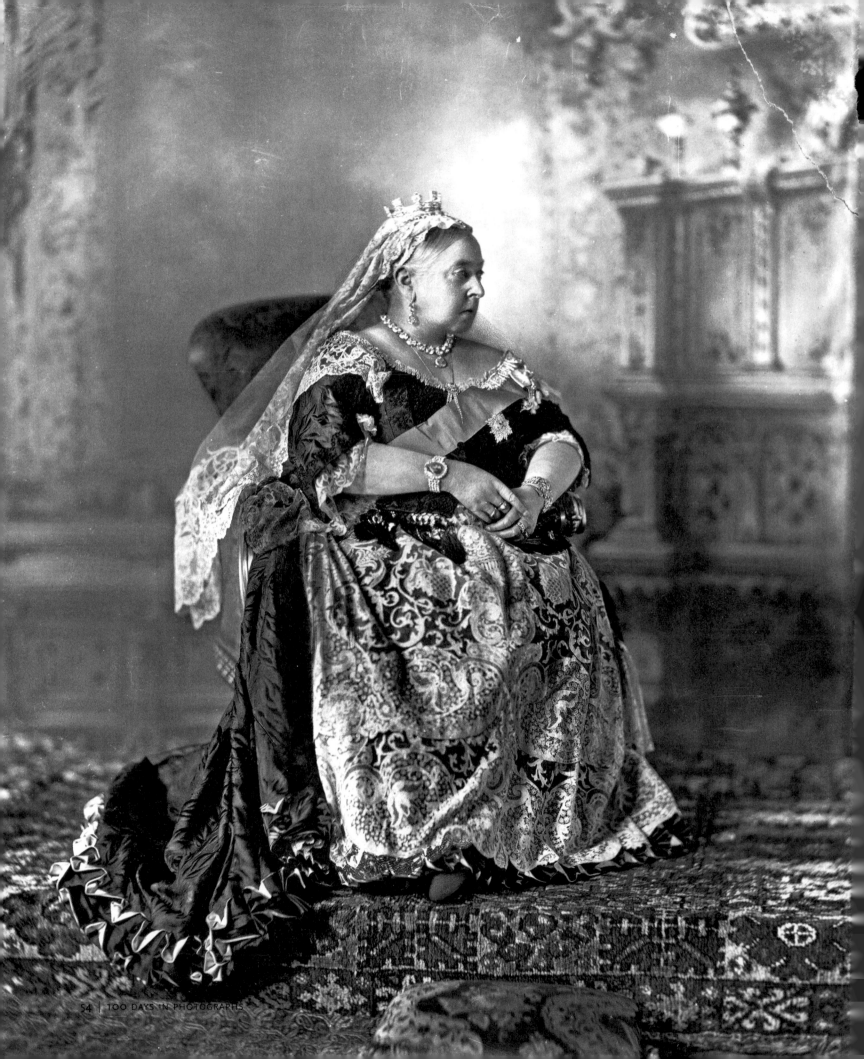

[June 22, 1897]

QUEEN VICTORIA'S DIAMOND JUBILEE

The day dawned fine and dry. Her Majesty—78 years old, plump, and proud of both herself and her people—had no doubt that her entire Empire was as pleased as she was with the wonder of her Jubilee. And what an Empire it was, the greatest the world had ever known. It stretched from the tundra of Canada to the New Zealand Alps; from the impeccably kept island of Bermuda to the steamy jungles of North Borneo; from the slums of London to the slums of Calcutta. It included races and religions by the score, princedoms and kingdoms, kraals and atolls, permanent icefields and burning deserts.

Early on the morning of the great day, Queen Victoria (1819–1901) was helped into a dress of black moiré with dove grey panels, embroidered with silver roses (for England), thistles (for Scotland), and shamrock (for Ireland). She then went to the telegraph room at Buckingham Palace, where she pressed a button. This signaled to the Central Telegraph Office in St. Martin's-le-Grand that her Jubilee message to all the peoples of her far-flung Empire was to be transmitted. The message, in response to the thousands of gifts and loyal greetings that she had received, ran: "From my heart I thank my beloved people. May God bless them."

It was Her Majesty's finest hour. Queen Victoria donned a bonnet of ostrich feathers, picked up her parasol of white silk, and took her carriage into the streets of London. With an escort of 50,000 troops she rode in triumph from the Palace to St. Paul's Cathedral.

The Jubilee service was held outside the Cathedral, for the Queen was too infirm to climb the steps leading to its west doors. Then back to the Palace, in more triumph, through more crowded streets, to record her impressions in her diary.

The Queen's photographer

When the time came for Queen Victoria to have her official portrait taken to commemorate her Diamond Jubilee, she called upon William Downey, a prominent portrait photographer. Known as the "Queen's Photographer," Downey had first photographed the Queen in 1867, and by 1879 he had received this Royal Warrant: the official authorization of a tradesperson to supply goods to a royal household. Along with his brother Daniel, Downey ran studios in both London and Newcastle, although most of the printing was undertaken in the Newcastle office. A truly gifted portrait photographer, his technical and artistic qualities captured the spirit of Victorian England.

W. & D. Downey's official portrait of Queen Victoria on her Diamond Jubilee *Following pages*: The Jubilee procession passes London's National Gallery.

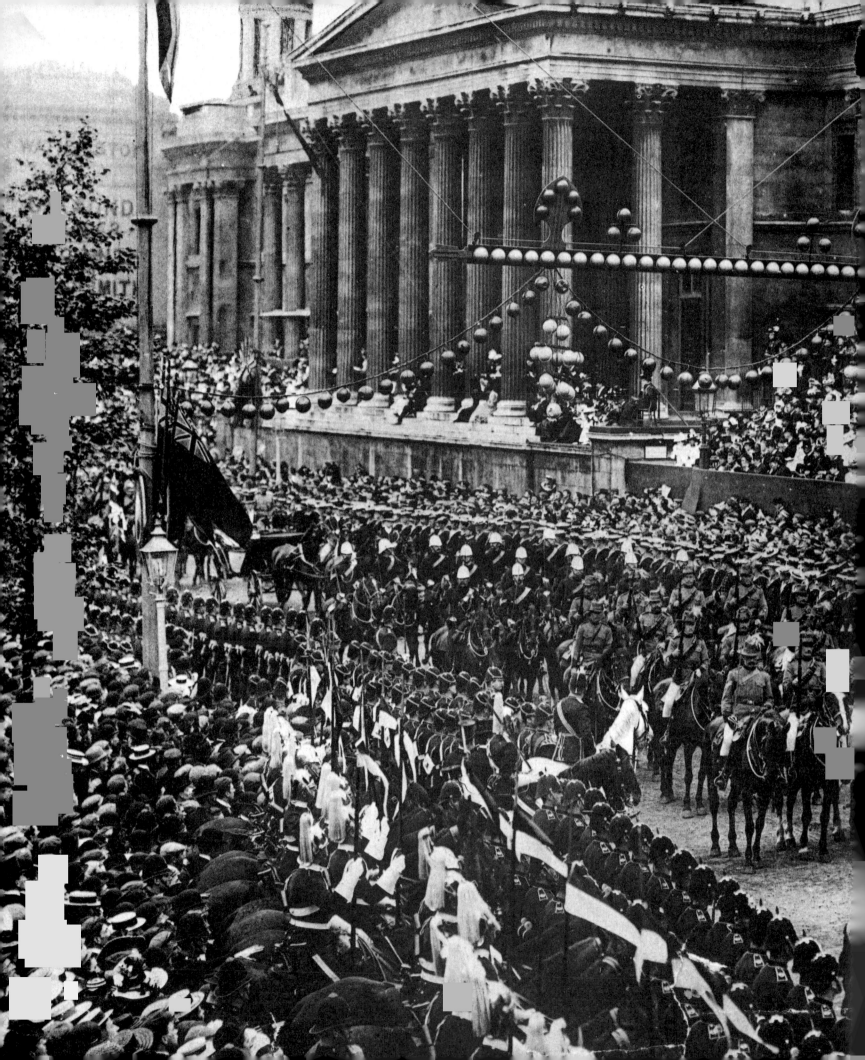

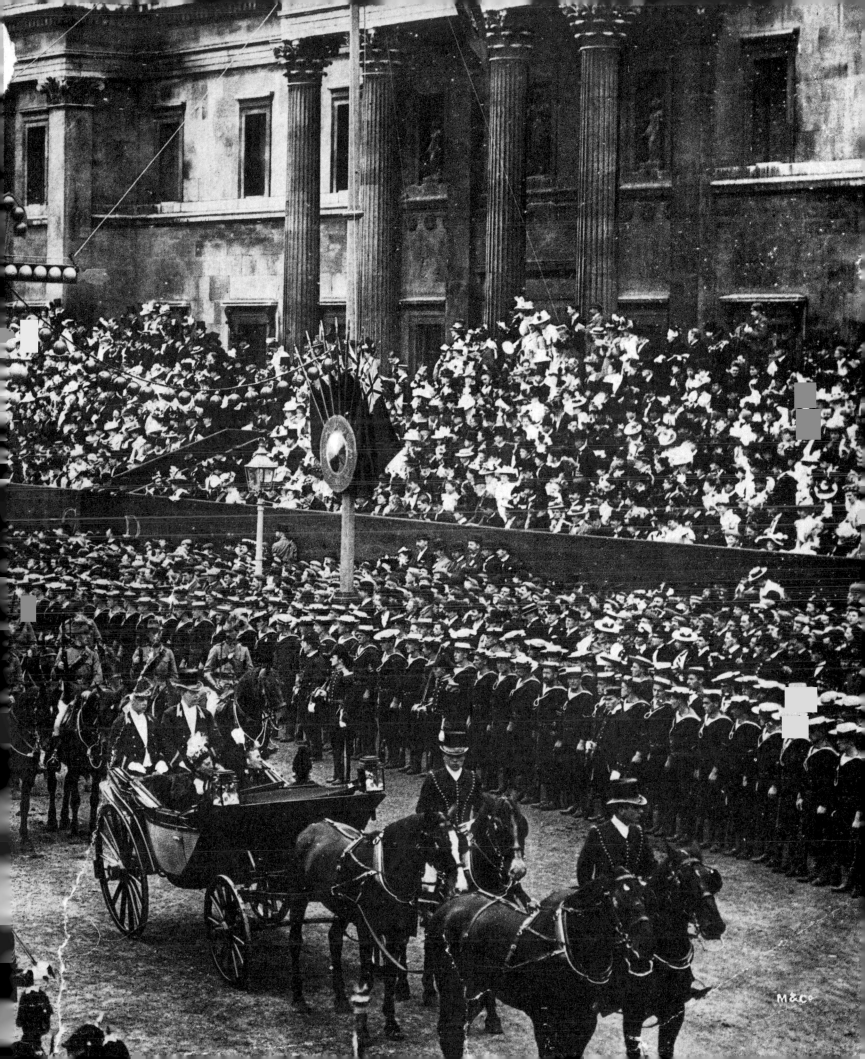

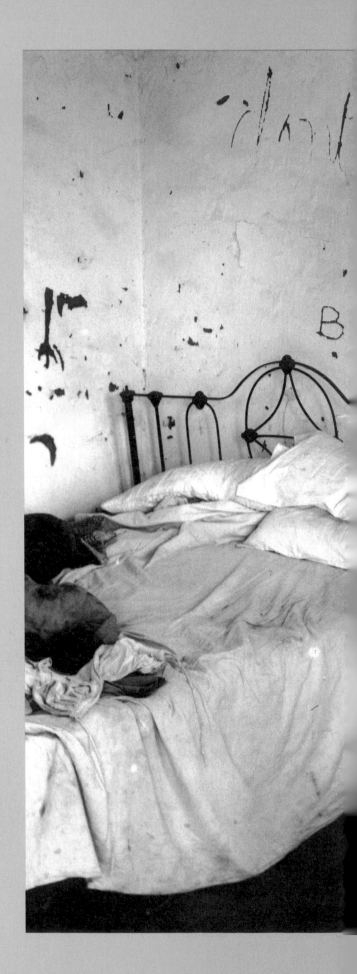

[January 24, 1900]

THE BATTLE OF SPION KOP

In the last year of the 19th century, a second South African War between the British and the Boers, Dutch settlers, became inevitable. To the Boers, the British had always been an invading force, with little respect for Boer culture, religion, or sovereignty. For generations, the Boers had repeatedly moved their families, cattle, and belongings farther and farther into the heart of South Africa to escape British interference. From the British perspective, the Boers constantly resisted British influence and obstructed what was now regarded as inevitable imperial progress. To add to the British-Boer tension, the richest goldfield in the world had recently been discovered in Boer-occupied territory.

On October 11, 1899, the Boers took the first initiative in the pending conflict. They probed deep into Cape Colony and besieged the three important railway towns of Ladysmith, Mafeking, and Kimberley. A British expeditionary force under the command of Gen. Sir Redvers Buller was immediately dispatched to the towns to drive the Boers back. It was confidently believed that this would not pose much of a problem. At most, the Boers could put some 35,000 fighting men in the field. Buller's army numbered about 85,000. Not only that, considerable reinforcements were already on their way from England.

And so, in the last week of January 1900, General Buller came to Spion Kop, a broad, flat-topped hill some 1,500 feet high in northern Natal, frowning down on the Tugela River. Buller had identified Spion Kop as the key to the relief of Ladysmith, 20 miles away. He ordered an assault on the hill, basing his decision largely on ignorance. He was using only scanty intelligence and small-scale maps (5 miles to the inch) that provided little detail. No one was quite sure what lay beyond the immediate horizon of Spion Kop.

Defiant graffiti on the wall of a Boer homestead, 1899

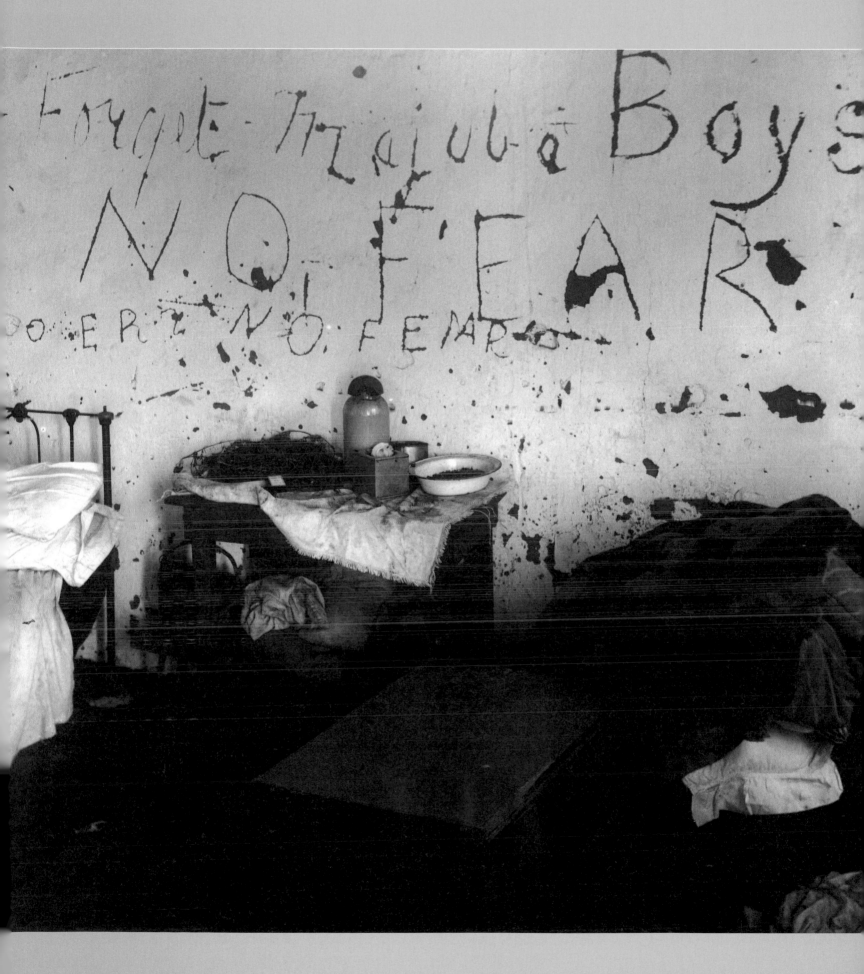

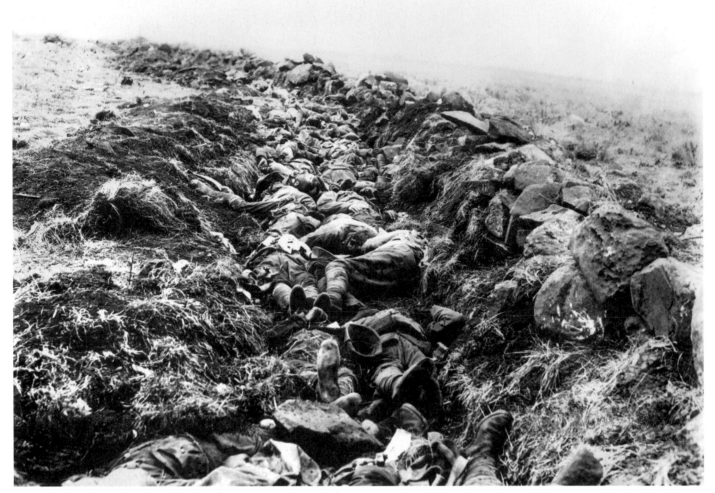

The bodies of British soldiers fill a hastily constructed trench near the summit of Spion Kop, an imperial disaster early in the Boer War.

First salaried photographer

Reinhold Thiele is one of several photographers credited as the founder of photojournalism. He had already covered many major events in Britain (the opening of Tower Bridge, Victoria's Diamond Jubilee, Gladstone's funeral) when in 1899 the London *Daily Graphic* commissioned him to cover the Boer War. For nine months, Thiele crisscrossed the war zone in an ox-drawn wagon. He used a 10x8-inch plate camera with a Dallmeyer telephoto lens to take images that were so starkly real that the *Graphic* suppressed many of them.

Nevertheless, on the night of January 23, a column of British infantry climbed to what they believed to be the summit, put a small Boer picket to flight, gave three cheers in the darkness, and dug themselves in. The next morning the soldiers found to their horror that they occupied not the true summit, but a small triangle of land, about an acre in size, dominated by two high knolls. They were trapped. Their little patch of dry African grassland was within range of Boer artillery, and from both knolls enemy sharpshooters poured down a hail of fire at almost point-blank range. While daylight lasted, there was no chance of advance and no hope of retreat.

Throughout the blisteringly hot day, the Boers fired at any sign of movement. The British had no water, no shade, and no cover, save for a few rocks and hummocks of grass. Time and again, the Boers attacked the British perimeter. Each time they were driven back,

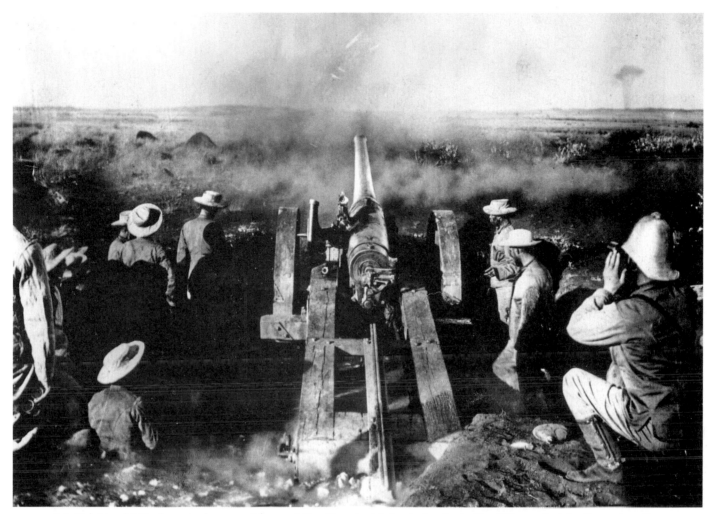

A British Naval Brigade 4.7 inch gun—nicknamed "Joe Chamberlain"—during the battle of Magersfontein, December 1899

but the slaughter continued. Down by the river, Buller panicked. Through the smoke and haze he could see something of what was happening, but had no idea what action to take. For hour after hour, the British suffered and died under the burning sun.

As night fell, the Boers ceased firing. The senior surviving British officer on the hilltop, Col. A. W. Thorneycroft, ordered a retreat. Those of his men who could still walk stumbled down after him, shocked, exhausted, and bewildered.

Spion Kop was more than a turning point in the Boer War. It destroyed Buller's career, and put an end to the imperial idea of glorious adventure. From this point on, Britain poured men and resources into the conflict. Before the war ended, the British army in South Africa numbered almost half a million. Spion Kop marked the beginning of the end of the British Empire itself.

"People walk along speaking in whispers and muttering.... The War Office is besieged—no one goes to the theatres—concert rooms are empty—new books fall flat—nothing is spoken of save the war."

Letter from Miss Bertha Synge to Sir Alfred Milner, High Commissioner for South Africa, January 1900

[December 17, 1903]

TAKEOFF AT KITTY HAWK

When Orville Wright (1871–1948) and his brother Wilbur(1867–1912) dragged their flying machine out onto the remote sands of Kitty Hawk, North Carolina, the wind was gusting at between 25 and 30 miles an hour. That was good. It would assist lift for what they prayed would be the first successful powered flight by a heavier-than-air machine with a pilot on board. Just before they were ready for the attempt, they were joined by a group of local people, among them John T. Daniels and Johnny Moore of the nearby coast guard station. Daniels and his fellow coast guards had earlier watched the two brothers on the beach: "We couldn't help thinkin' they were just a pair of poor nuts. We'd watch them from the windows of our station. They'd stand on the beach for hours at a time just looking at the gulls flying, soaring, dipping.... They would watch the gannets and imitate the movements of their wings with their arms and hands."

The machine was based on a kite that the Wright brothers had designed and flown many times over the previous four years. It was a biplane, mounted on skis, with the two right wings four inches longer than the pair on the left to compensate for the slightly off-center mounting of the engine. Orville took the controls for the first attempted flight.

The first flight lasted 12 seconds, and covered 120 feet. The plane suffered slight damage, and the little crowd waited while repairs were effected. Then it was Wilbur's turn. He flew a little farther—175 feet. Orville then took over, and achieved roughly the same distance. The breakthrough came with the final flight. It lasted 59 seconds, in which time Wilbur flew some 12 to 14 feet above the ground for a distance of 852 feet.

On that windy morning at Kitty Hawk began the most lasting revolution of the 20th century—the age of aviation was born.

Wright Brothers

It speaks volumes for the rapid rise of photography that a camera was present at Kittty Hawk on that historic day in 1903. Orville Wright set up a 5x7-inch plate camera on a tripod before he and his brother Wilbur made the first powered, controlled, and sustained flight. The honor of squeezing the rubber bulb to trip the shutter went to John T. Daniels of the nearby Kill Devil Hills Coast Guard Station, who also captured the starting rail, the wing rest, and other items on the ground needed to start the flying machine.

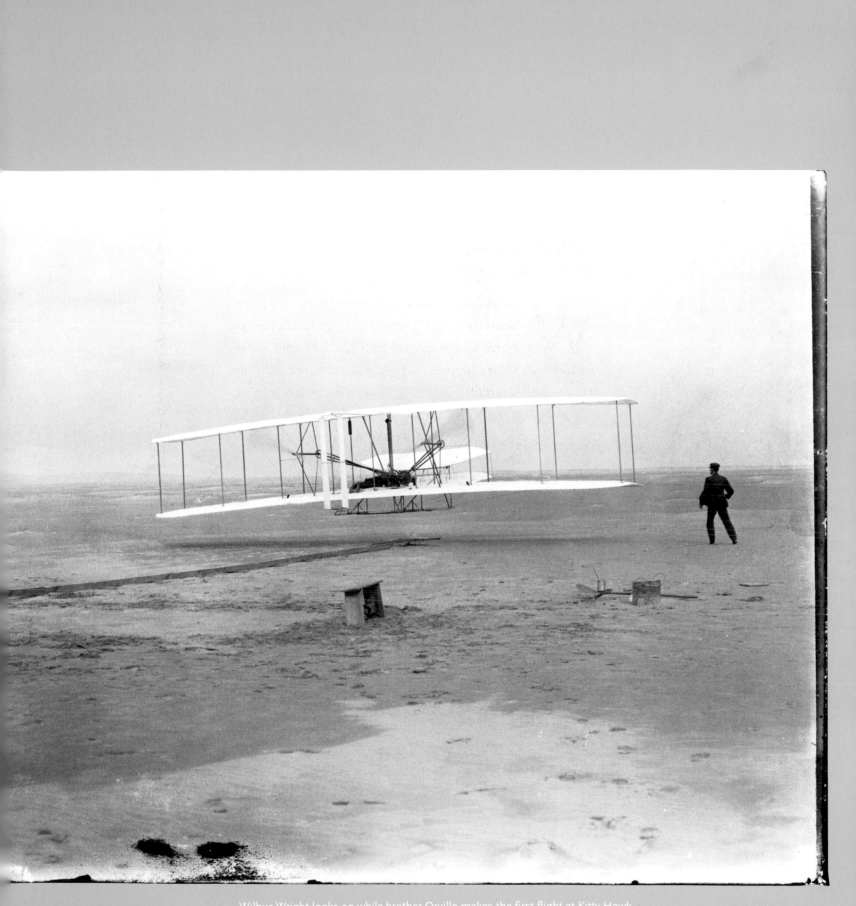

Wilbur Wright looks on while brother Orville makes the first flight at Kitty Hawk.

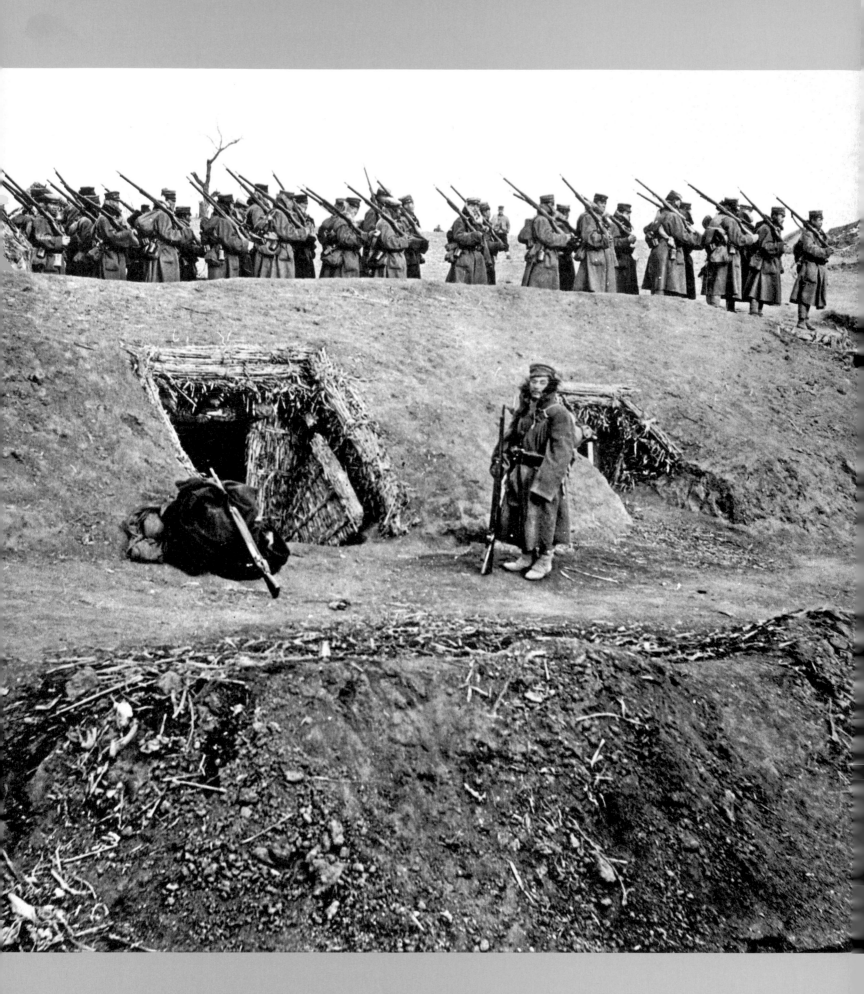

"It may draw the revolutionary sting out of these windbags...."

RUSSIAN PRIME MINISTER PRINCE SVIATOPOLK-MIRSKY'S VIEW OF HOW DEFEAT IN THE
RUSSO-JAPANESE WAR MIGHT AFFECT REVOLUTIONARY TROUBLEMAKERS AT HOME

[May 28, 1905]

THE BATTLE OF TSUSHIMA

On the night of February 8, 1904, Japanese torpedo boats attacked the Russian fleet at anchor in Port Arthur, Manchuria. The surprise attack, with no declaration of war—a tactic that Japan would employ again 37 years later at Pearl Harbor—marked the beginning of the first major conflict between an eastern and a western power, a war that was to have an enormous influence on 20th century history.

At issue were control of Korea and, for Tsarist Russia, the vital question of access to an all-weather port in the Far East. Japanese troops overran Korea early in the war, and the Japanese navy laid a series of mines outside Port Arthur. It was the first time that mines had been used in naval warfare, and they soon proved their effectiveness: When the Russian fleet emerged from the port, the battleship *Petropalovsk* sank instantly after striking one of them. Port Arthur fell to the Japanese on January 2, 1905.

On paper, Russia was the stronger military power, but she was faced with the difficulty of bringing reinforcements to the war zone. Troops had to cross the entire Russian landmass; Russia's Baltic fleet had to sail 18,000 miles. That fleet had set out in October 1904, and took more than seven months to reach the Yellow Sea, where it was immediately engaged in the Battle of Tsushima.

The Japanese had more modern ships, their crews had greater experience than their Russian adversaries, and they were commanded astutely by Admiral Heihachiro Togo. The battle lasted more than five hours, during which the Japanese sank eight Russian battleships. The Russians lost more than 5,000 men. It was virtually the end of the Russo-Japanese War, and a blow for Tsar Nicholas II's autocracy. It was also a signal to the rest of the world that Western control of the East was starting to disintegrate.

Japanese barracks near the Cha-Ho River, Manchuria, 1904

Russo-Japanese War

Southern Manchuria, October, 1904. Winter was setting in. The Japanese had a strong, well-armed foothold, cutting off the main Russian land forces from getting supplies to the besieged Port Arthur. Barracks such as these, photographed by Frenchman Albert Harlingue, were built near the small towns of Sandepu and Heikoutai. They afforded protection to the Japanese army holed in for the winter, thinking that the Russian army would plan no major attacks during the cold and snow. But the Russians made a surprise attack on January 25, 1905, in what would be known as the Battle of Sandepu (or Heikoutai). It was one of the few Russian victories in a war otherwise marked by Japanese triumphs on land and water.

[June 14, 1905]

THE *POTEMKIN* MUTINY

Named after Prince Grigori Alexandrovich Potemkin, the battleship *Potemkin* was the most powerful ship in the Russian Black Sea fleet. The humiliation that the Imperial Navy had suffered in the Russo-Japanese War (1904–1905), however, had left morale at a low ebb, intensifying the ordinary sailors' loathing of their officers. Events in St. Petersburg earlier in 1905 had suggested that the entire Imperial system was beginning to fall apart.

On the evening of June 14, 1905, *Torpedo Boat 267* returned from Odessa with provisions for the *Potemkin*. Early the next morning, June 15, the sailors noticed maggots in the meat to be used for the day's soup. The crew complained to Capt. Giliarovskii Golikov, but then the ship's surgeon sniffed the meat, pronounced it good, and said that all that was needed was to wash the maggots off the carcass. A sentry was posted to guard the meat with orders to take the names of any sailors who came to examine it.

Matters came to a head when the soup was served to the crew. They refused to eat it. Golikov then ordered his men on deck. Accounts of what followed vary. The few officers who survived told of bloodthirsty mutineers butchering the officers who had forced them to eat. The mutineers' account was that the officers threatened death to 30 sailors who had refused the soup. What is certain is that Capt. Golikov, Chief Artillery Officer Neopkoev, Chief Officer Giliarovsky, and torpedo officer Lt. Ton were killed. Other officers managed to escape onto *Torpedo Boat 267*. A red flag was then raised on the *Potemkin*, and the mutineers set sail for Odessa.

A general strike was declared in the city, and workers marched in protest to demonstrate solidarity with the mutineers. The men then sailed to Romania to seek asylum. Like many events in 1905 Russia, the mutiny helped lay the foundation for future revolution in 1917.

The *Potemkin* mutineers arrive at Constantsa, Romania, in June 1905.

News flash

Among many awaiting the arrival of the *Potemkin* mutineers as they sought asylum in Constantsa, Romania, was Ferdinand Bezancon, a scientist and freelance photographer. Bezancon made the photograph of the launch with the *Potemkin* in the background, and quickly sold the picture to the London *Daily Graphic*. It appeared in the newspaper five weeks later, on July 22, 1905. Its appearance was considered a "news flash."

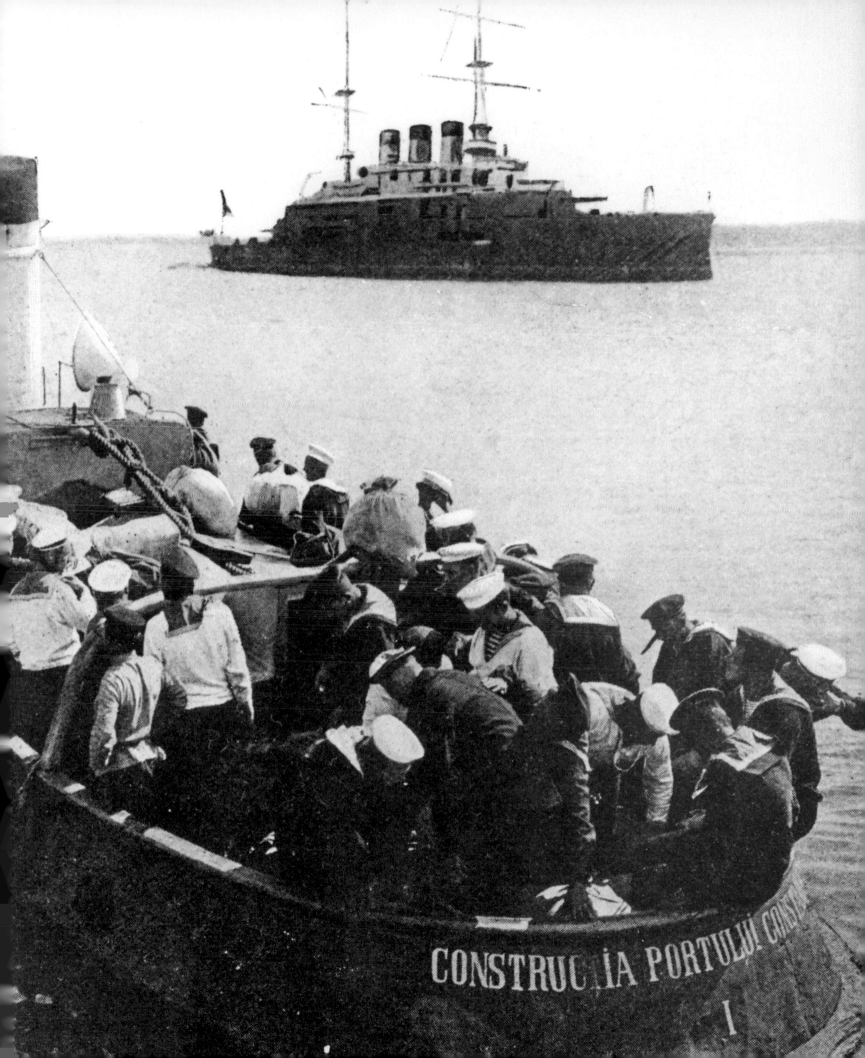

CONSTRUCȚIA PORTULUI CONS

I

> "I will build a motor car for the great multitude. Just like one pin is like another pin when it comes from the pin factory, or one match is like another match when it comes from the match factory...."
>
> HENRY FORD, 1908

[September 27, 1908]

HENRY FORD'S MODEL T ROLLOUT

What Henry Ford (1863–1947) gave the United States was a horse that could carry four people, never had to be unhitched and fed at the end of the day, whose food (originally ethanol, later gasoline) could be stored indefinitely, and that never reared and bolted when confronted by a barking dog— all for just $825.

The horse was the Ford Model T, the car that "put America on wheels," popularly known as the "Tin Lizzie" or "The Flivver." It was designed by Childe Harold Wills and two Hungarian immigrants, Joseph A. Galamb and Eugene Farkas, but the man responsible for the revolutionary assembly-line system was William C. Klann, who developed the idea after a visit to what he called the "disassembly line" at a Chicago slaughterhouse. It was "Pa" Klann who drove the very first Model T off the assembly line at the Piquette Plant in Detroit, Michigan, on the morning of September 27, 1908, in front of a large crowd, reporters and cameramen, and Henry Ford himself.

The Model T was a wonder. It had a 20-horsepower engine, a top speed of 45 mph, and a 10-gallon fuel tank that gave it a range of 150 to 200 miles. Among its many innovations were an enclosed engine and rear-wheel drive. Its price fell steadily as production was streamlined, until by the 1920s it cost only $300, well within the financial means of Ford's own workers, who were paid twice the national average wage. It was easy to drive, cheap to repair, and very durable. Ford himself described the Model T as, "a motor car for the great multitude."

After two years, and 12,000 cars, the Piquette Plant could no longer keep up with demand, so Ford moved production to the new Highland Park plant. There, some 15 million Model Ts were built, the last being completed on August 4, 1941.

The first Model T moving assembly line, Highland Park, Michigan, 1913

Model T corporate image

In one of the first official photographs to promote Ford Motor Company, Model Ts roll along Ford's Highland Park, Michigan, plant in 1913, the first year of the continuously moving assembly line. As each chassis moved by conveyor belt along the 150 feet of factory floor, it passed one of 140 workers, each in his designated spot, trained in one specific task, ready to attach parts to the car, such as the tire-clad wheels at right. Within a year, the plant was turning out one Model T every 93 minutes, reducing the car's price drastically. This car, as Henry Ford put it, was so "low in price that no man making a good salary will be unable to own one."

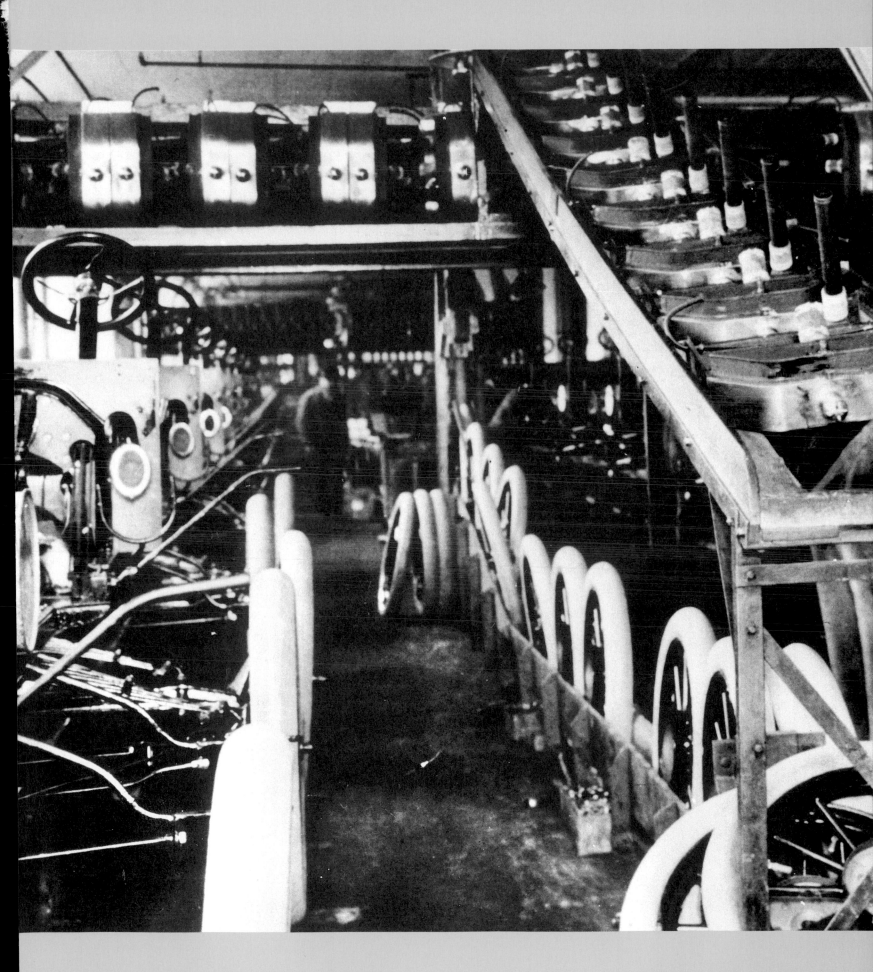

[April 6, 1909]

ROBERT E. PEARY, FIRST TO THE NORTH POLE

At the beginning of the 20th century, while much of the world was still to be explored, only a few of the big topographical landmarks remained untrodden—among them the center of the mass of frozen sea that made up the Arctic, the North Pole.

Robert Edwin Peary (1856-1920) became obsessed by his desire to be the first to the North Pole while still a young lieutenant in the U.S. Navy. Now in his early fifties, he had lost none of his enthusiasm. Several trial journeys, mainly in Greenland, had already cost him eight toes, but he was still not deterred. By the summer of 1908, Peary was ready. He sailed north from New York City on the *USS Roosevelt* on July 6, spent the winter near Cape Sheridan on Ellesmere Island, and began his march to the Pole on March 1, 1909. Exactly one month later, his final support party turned back, and Peary was left with only five companions—a fellow American named Matthew Henson, who was the only Black on the expedition, and four Inuits named Ootah, Egingwah, Seegloo, and Ooqueah. They pushed on for five more days. In his diary, Peary recorded that the ice and snow had given them comparatively little trouble, and, with temperatures of around minus 26°C (minus 15°F), milder than he had anticipated, the going was good. The dogs were in fine spirits. Clouds that threatened bad weather dispersed. On April 6, they established Camp Jesup, in what they believed was the immediate vicinity of the Pole.

Peary then took sextant readings against a background of snow and sun. He later wrote: "The strain of focusing… all in a blinding light of which only those who have taken observations in bright sunlight on an unbroken snow expanse in the Arctic regions can form any conception, left me with eyes that were, for two or three days, useless for anything requiring careful vision…." Nevertheless, he was certain that he had reached his goal. His diary entry for April 7 reads:

Commander Robert E. Peary shortly before his epic expedition

Controversy over claim

Controversy haunted Peary's claim that he and his men had reached the geographic North Pole. Skeptics claimed that none of Peary's team was trained in navigation and could independently confirm his sextant readings. Peary's camera, a No. 4 Folding Pocket Kodak, may have helped to lay some controversy to rest. Although the camera was lost, Peary's photographs taken at the North Pole remain. In 1989, experts at the National Geographic Society examined these photographs. Based on the shadows in photographs and ocean depth measurements taken by Peary, they concluded that he was no more than five miles from the Pole.

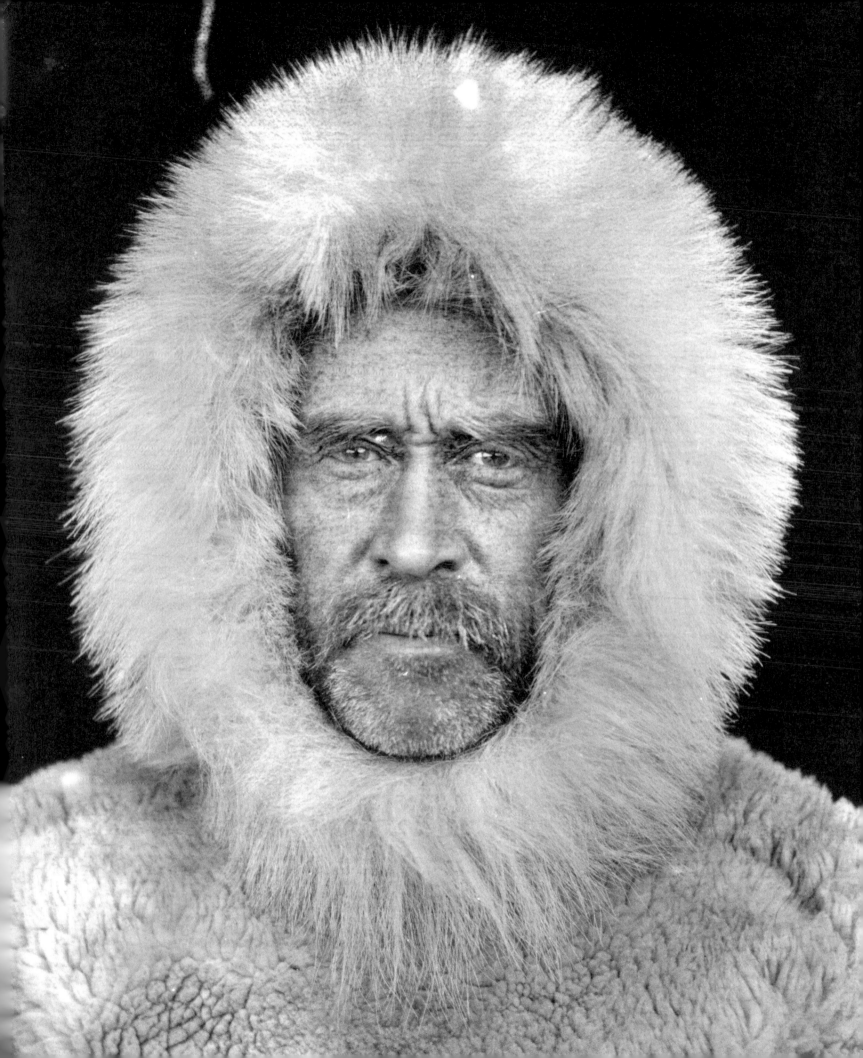

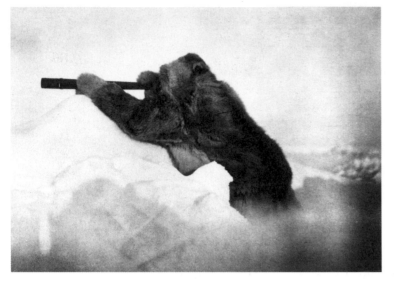

Peary looks through a telescope.

"The Pole at last!!! The prize of three centuries, my dream and ambition for 23 years. *Mine* at last...."

They raced back to base, conscious of the impossibility of survival if the coming of the Arctic spring melted the ice. He returned to the United States to a mixed reception. To many, he was a hero, feted wherever he went. Crowds flocked to attend his lecture tour, and his book was a bestseller. At the same time, controversy broke out. Another American, Frederick Cook, who had served as a physician on one of Peary's earlier Arctic expeditions, claimed that he had reached the North Pole a year earlier than Peary. Some questioned the veracity of Peary's figures concerning the speed of both his outward and inward journey. Counterclaims were made that Cook's photographic evidence of his arrival at the Pole was faked.

A Congressional inquiry took place in 1911, at the end of which Peary was declared to have truly been the first man to the North Pole. Cook's reputation was ruined. Twelve years later his name was linked to an oil-well swindle. Although eventually pardoned, Cook served seven years in prison.

By then, Peary himself was dead, worn out by his Arctic labors. He was buried in Arlington Cemetery, a national hero. Many years later, Henson's body was reburied beside him. What became of the Inuits is not known.

Aboard the *USS Roosevelt* an Inuit child stands with Peary's sled dogs, acquired from Cape York, in Greenland.

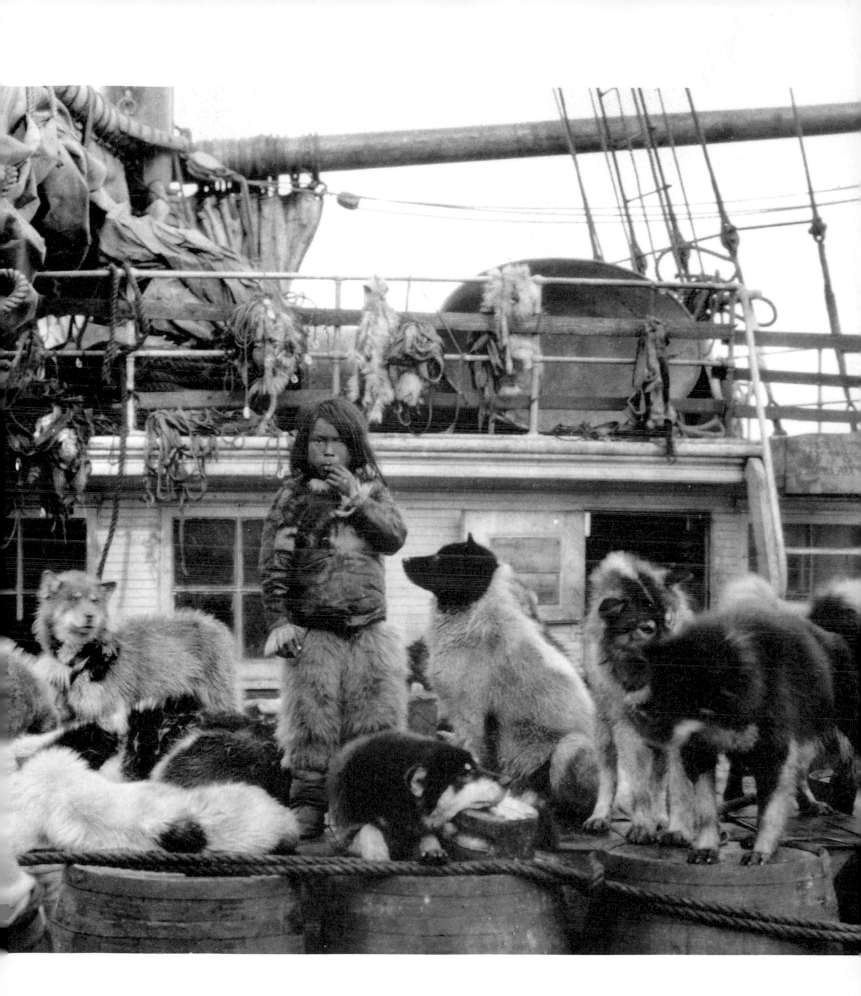

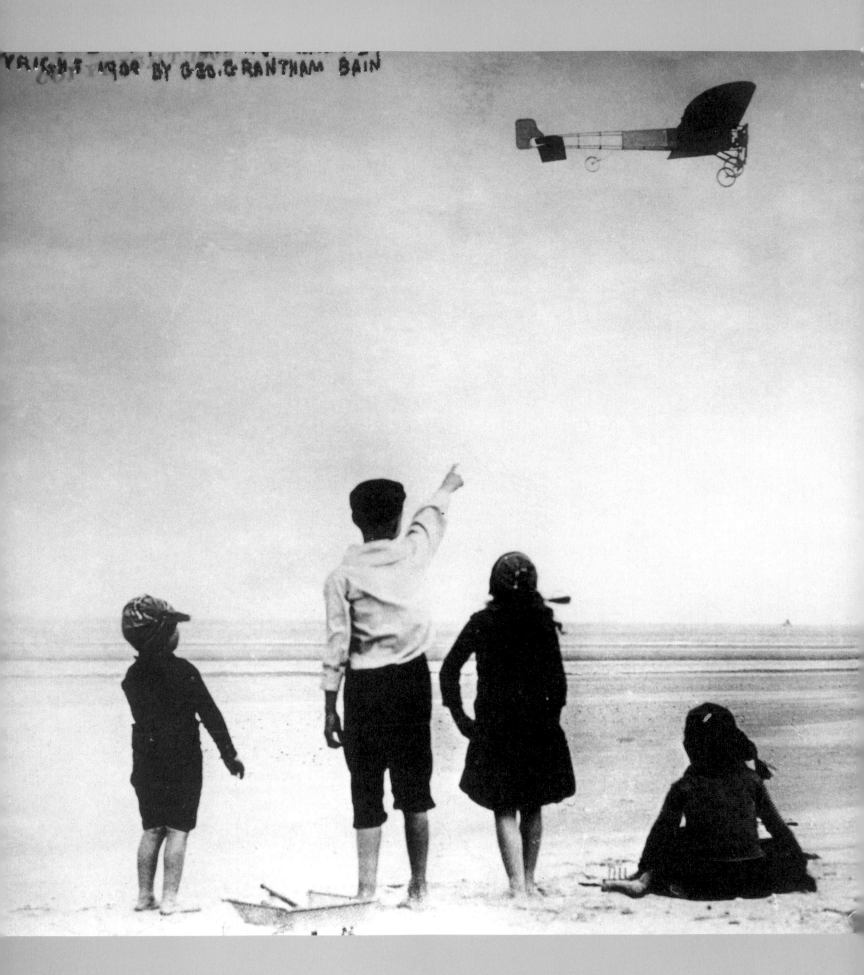

YRIGHT 1908 BY GEO.GRANTHAM BAIN

"Britain's impregnability has passed away....
Airpower will become as vital as seapower...."

BRITISH NEWSPAPER HEADLINE ON THE DAY AFTER
BLÉRIOT'S HISTORIC CROSS-CHANNEL FLIGHT, JULY 26, 1909

[July 25, 1909]

LOUIS BLÉRIOT
FLIES THE CHANNEL

In the years immediately following the Wright Brothers' first successful flight at Kitty Hawk, North Carolina, in 1903, many in Europe and the Americas hurled themselves into the pursuit of flight. For some, it was a hobby, a novelty, an amusement. For others, it was a more serious pastime—an invention that offered the chance to make money. For politicians and soldiers, the airplane was a contraption that might increase their power.

Louis Blériot (1872–1936) was not a rich man, nor a warrior, nor a statesman. He was a young man who had been experimenting with flying machines for several years. In 1900 he had built his Ornithopter, a bizarre contraption that optimistically, and mistakenly, depended on flapping wings to keep it airborne. The Ornithopter was a failure, but Blériot persisted. He built a series of fixed-wing planes, each of which was slightly more successful than its predecessor, although none of them was his dream machine.

In 1903, with a fellow air pioneer named Gabriel Voisin (1880–1973), he formed the Blériot-Voisin Company. It did not prosper, and by the late 1900s, and now in his mid-thirties, Blériot was on the verge of bankruptcy. Hope lay in a competition run by the London *Daily Mail* newspaper, which offered £1,000 to the first person to fly from England to France—or vice versa—across the English Channel. Blériot decided to enter.

Early on the morning of July 25, 1909, he was ready. It was a cold morning, with a thick mist hanging over the Channel, and there were risks to be run that day. Few people had flown successfully for such a distance over water, and Blériot would be flying without a compass. He was taking off from the cliffs of Les Barraques, near Calais. His destination was somewhere on the clifftops near Dover, but he was not sure exactly where. A French newspaper reporter had promised

Louis Blériot in full flight near Calais, August 3, 1909

First news service

George Grantham Bain (who took the picture of children watching Blériot, *opposite*) was a New York photographer who founded Bain News Service, the first news photography service, in 1898. Bain collected images from photographers around the world, then sold them to newspapers, mainly in New York. The agency was at its height between 1900 and the late 1920s, specializing in pictures of sports events, aviation, crime, strikes, disasters, and public celebrations.

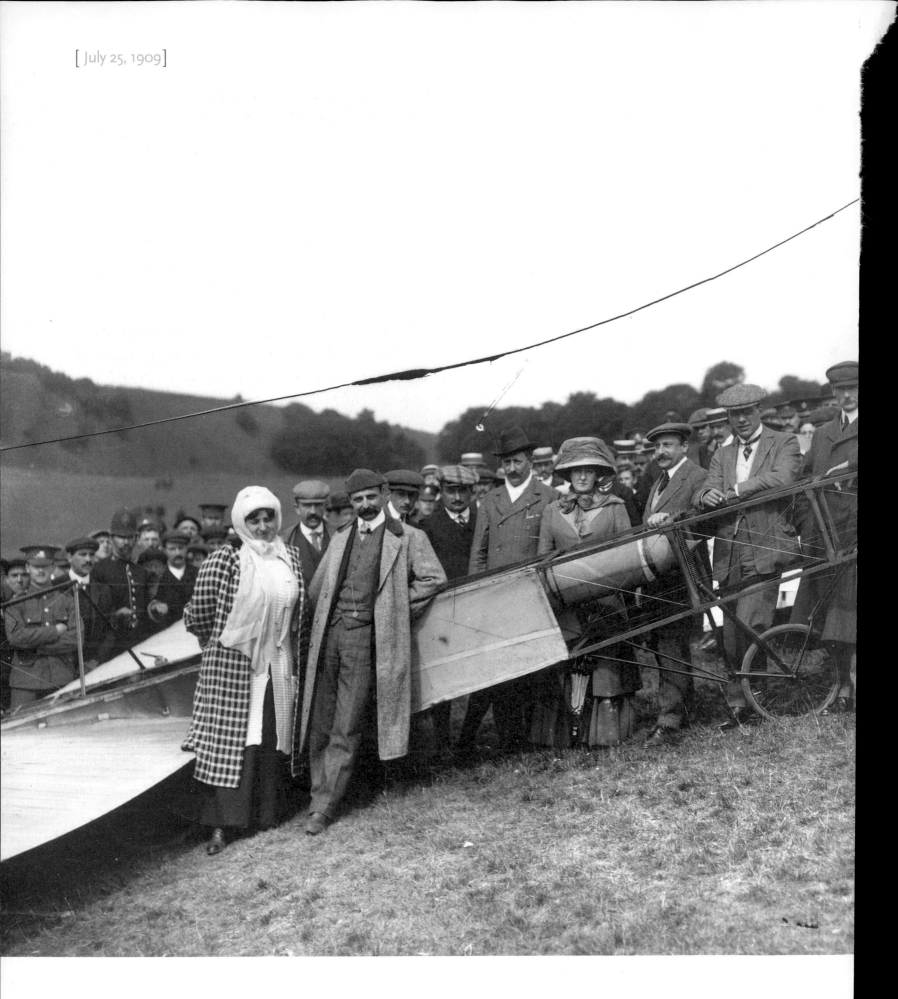

to await his arrival in England, waving a large French flag to indi-
cate a safe place to land.

Blériot taxied across the short grass, then lifted his little Blériot
XI monoplane up into the mist. He pushed the 25 horsepower
Ananzi engine to top speed to clear telegraph wires above the cliffs,
then set the engine speed at about 40 mph for the 21-mile flight. As
he flew into thick clouds he was buffeted by wind and rain, and he
temporarily lost sight of the water below. "I am alone," he wrote. "I
can see nothing at all. For ten minutes I am lost." The plane carried
no compass. After about 20 minutes, he glimpsed the cliffs of Dover
and the ancient Dover Castle. He realized that the wind had blown
him off course, to the west of the landing field, and he had to push
the engine to make up the distance. Fortunately the rain served as a
cooling agent. As he neared the field and spied his friend waving the
flag, gusts of wind sent the plane spinning in circles. Blériot regained
control, cut the engine, and glided to the ground. In just over 38 min-
utes, Louis Blériot had crossed the Channel and landed safely, to his
immense relief and to great public excitement.

The psychological effects of this short flight were enormous. For
France, it was a great triumph. For Britain, it was both a disappoint-
ment and a shock—a shame that a Frenchman should have won the
Daily Mail prize. Beyond that, the event was a cause of great anxi-
ety for Britain: The nation realized that it was now susceptible to
attack by other venues than water; that perhaps a way had been
found to render the mighty Royal Navy impotent. For Blériot, his
successful flight brought financial relief. Now at last he had enough
money to open his own aircraft factory.

Louis and Alicia Blériot pose beside the
monoplane in a field near Dover, on the
day after his historic flight. Blériot's rival,
Count Charles de Lambert, is in dark cap
and overcoat, standing near the tail.

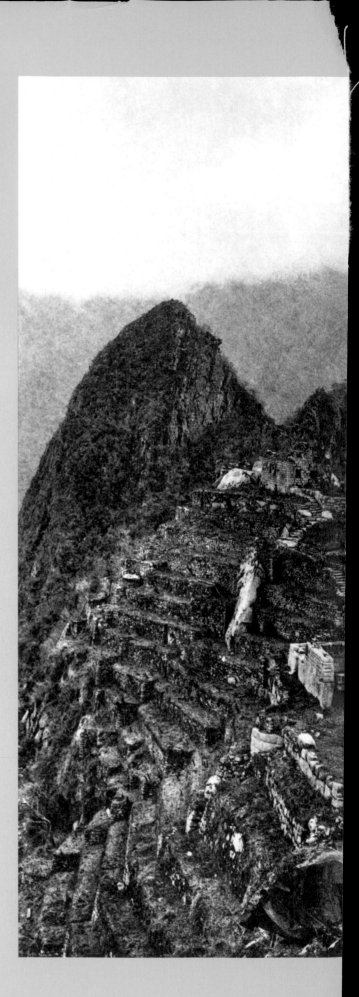

[July 24, 1911]

DISCOVERY OF MACHU PICCHU

On a cold, wet, Monday morning in 1911, a young professor from Yale University peered up through the mountain drizzle at a ridge high in the Andes of southern Peru. His name was Hiram Bingham III (1875–1956), and he had slogged his way some 50 rough miles from Cusco, braving bandits, poisonous snakes, and tropical diseases. He had set out to search for the lost city of Vilcabamba, the final stronghold of the Incas in their 40-year struggle for survival, at first against Francisco Pizarro and his conquistadores, and then against the Spanish adventurers who followed them. The city had finally been abandoned by Manco, a successor to the great Emperor Atahualpa, in 1573. Since then, it was believed that Vilcabamba had been swallowed up by the trees and vines of the South American jungle.

The group of local Quechuans, who were acting as guides to Bingham and his party, had another goal in mind. They had brought him to this ridge after whetting his appetite with fascinating tales of a different city—fabulous, ancient, and beautiful. They were certain of its existence, for they had been living in its ruins. The city was called Machu Picchu, "Old Peak" in the Quechua language, and it had been founded by Sapa Inca Pachacuti in about 1440. Pachacuti was known by the Incas as "the transformer of the world," a leader who united tribes and created one of the world's greatest empires.

At the height of its importance, Machu Picchu covered some five square miles, and its construction was a work of architectural and aesthetic brilliance. It was built of granite blocks, some of which weighed 50 tons. These blocks had been cut from the mountain itself, and were so well crafted that no mortar was used in the creation of the palaces, baths, temples, courtyards, and 150 houses that comprised the city. Access to and within the city was by a series of stone

Huayna Picchu towers above the Lost City of the Incas at Machu Picchu.

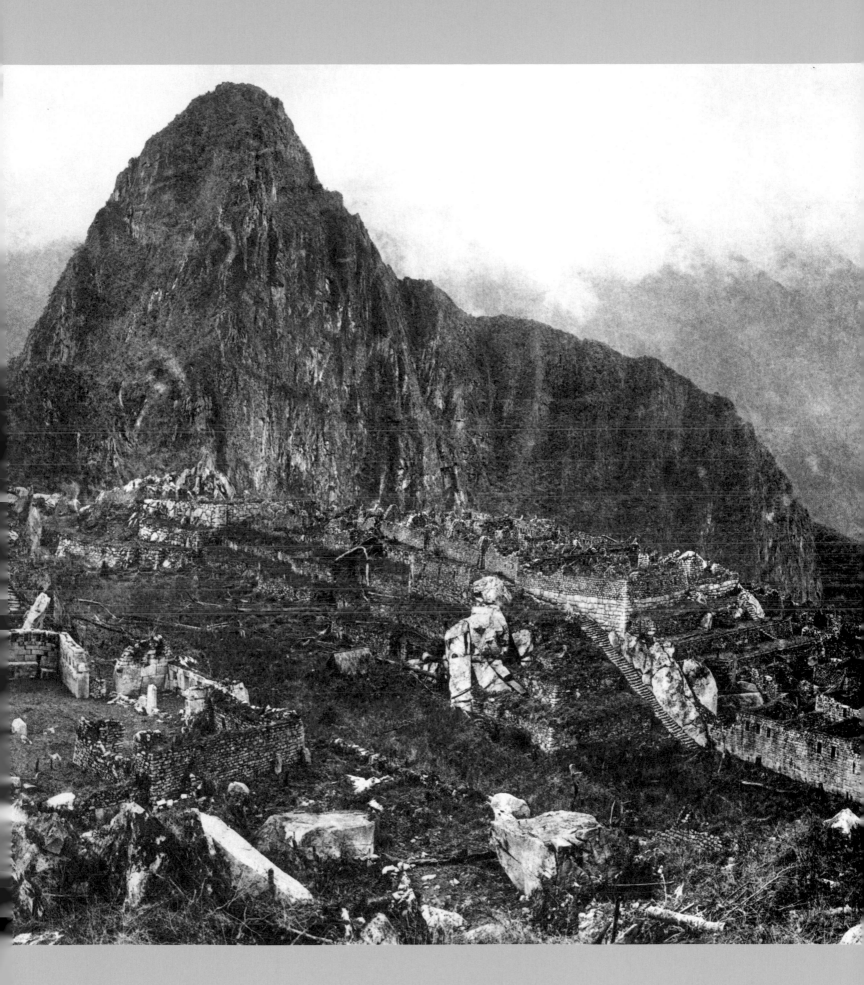

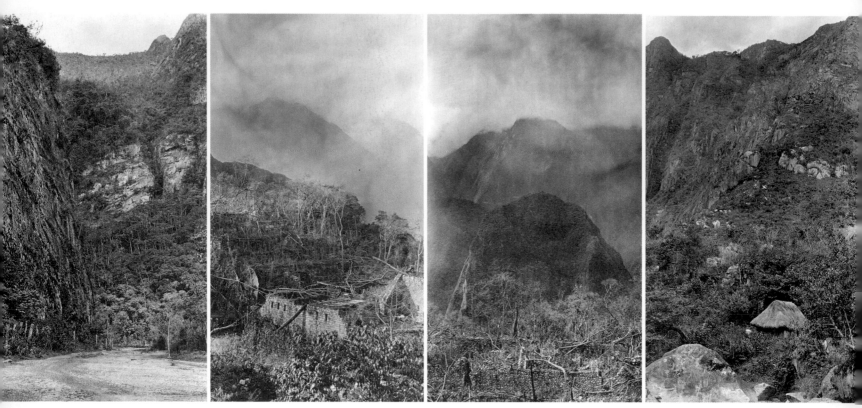

The road to Machu Picchu View west toward Huayna Picchu Mists shroud Machu Picchu Machu Picchu on horizon

Thirty photographs

History professor Hiram Bingham was a meticulous record keeper. On his steep climb up from the Urubamba Valley on his way to the rumored ruins of a "lost" Incan city, he carried not only his regular gear but also a folding camera known as a Kodak No. 3A Authographic Special, and a tripod. When he emerged from the jungle growth, his first view was a broad sweep of ancient terraces, and then stonework buildings made of finely cut white granite, all which were overrun by scrubby vegetation. On July 24, 1911, Bingham documented his new discovery with 30 photographs, each carefully numbered and described. But the ruins were not abandoned. He discovered several local farmers living among the terraces, cultivating corn and other crops and living in the ancient houses.

stairways, many flights of which were carved from a single stone. Fountains and springs, connected by channels, irrigated the city, bringing water to each house. Terraces were cut into the side of the mountain to provide land for agriculture, making Machu Picchu virtually self-sufficient.

Bingham knew that he had stumbled on a rare treasure, although he was never quite sure what its original purpose had been. He described it variously as a "University of Idolatry," a royal palace, an observatory, a temple, a holiday retreat for Inca nobility, and the sacred burial place of the "Chosen Women," the Virgins of the Sun, to whom Machu Picchu was "a refuge from the animosity and lust of the conquistadores."

Machu Picchu may have been many of these things. Certainly, it served as the burial place, and there is little doubt that Machu Picchu served as an astronomical observatory. One of the stones in the city—known as the Intihuatana stone, the "Hitching Post of the Sun" —catches the sun at the two equinoxes. At midday on March 21 and September 21, the sun strikes down on the stone from directly overhead, casting no shadow. It is believed that on these dates, the Incas

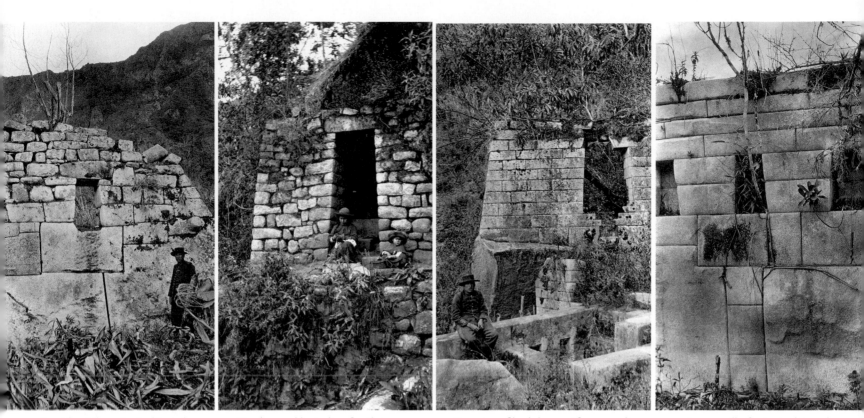

A guide at the principal temple House used by Indian family in 1911 Remains of bath house (*foreground*) Inner wall of principal temple

"tied the sun" to halt its movement in the sky. The most likely explanation is that Machu Picchu was a royal palace, the site of which had been chosen by Pachacuti for its beauty, its highland surroundings, and its remoteness. There, he and his successors were served by potters, stonemasons, silver- and goldsmiths, weavers, and other skilled workers recruited from all over the Inca empire.

In April 1913, the National Geographic Society devoted its entire monthly magazine to Machu Picchu, and the city became famous. Bingham returned to Machu Picchu several times, establishing a good relationship with Peruvian officials, who gave him permission to take artifacts away on loan. Some 5,000 pieces, housed at Yale, have been studied by archaeologists and have revealed much about the ancient world. The Peruvian government has asked for their return.

Bingham served in World War I (1914–1918), then turned to politics: He became Governor of Connecticut, then a U.S. Senator. But it is as an explorer that he is remembered today—some say that he was the model for the character Indiana Jones in the series of movies made in the 1980s. His lasting work is *The Lost City of the Incas*, the book he wrote about his discovery on that wet July day in 1911.

"Above all, there is the fascination of finding the rugged masonry of a bygone race, in a region designed by nature as a sanctuary for the oppressed, a place where they might give expression to their passion for walls of enduring beauty"

HIRAM BINGHAM ON MACHU PICCHU, JULY 24, 1911

A Contemporary Note

Hiram Bingham's own account of the discovery of Machu Picchu on July 24, 1911:

I had entered the marvellous canyon of the Urubamba below the Inca fortress. Here the river escapes from the cold plateau by tearing its way through gigantic mountains of granite. The road runs through a land of matchless charm. It has the majestic grandeur of the Canadian Rockies, as well as the startling beauty of the Nuuanu Pali near Honolulu, and the enchanting vistas of the Koolau Ditch Trail on Maui, in my native land. In the variety of its charms and the power of its spell, I know of no place in the world which can compare with it. Not only had it great snow peaks looming above the clouds more than two miles overhead; gigantic precipices of many-colored granite rising sheer for thousands of feet above the foaming, glistening, roaring rapids, it has also, in striking contrast, orchids and tree ferns, the delectable beauty of luxurious vegetation and the mysterious witchery of the jungle. One is drawn irresistibly onwards by ever-recurring surprises through a deep, winding gorge, turning and twisting past overhanging cliffs of incredible height.

Melchor Arteaga, one of Hiram Bingham's guides, crossing the log bridge over the Urubamba river. A few weeks later, the bridge was washed away.

"Five roughened frost-bitten fists it was that gripped the post,
lifted the fluttering flag on high and planted it together
as the very first at the Geographic South Pole...."

EXTRACT FROM ROALD AMUNDSEN, "THE SOUTH POLE: AN ACCOUNT OF THE NORWEGIAN
ANTARCTIC EXPEDITION" IN THE *FRAM*, 1910–12

[December 14, 1911]

ROALD AMUNDSEN, FIRST TO THE SOUTH POLE

Norwegian Roald Amundsen (1872–1928) was the most professional of explorers, a man whose mind embraced every detail of the voyage he was about to undertake, which in 1911 was probably the most dangerous journey on Earth. He was about to race Britain's explorer Robert Falcon Scott to the South Pole. Amundsen designed the boots and skis for his race, selected the dogs, and fixed the route and siting of each supply depot to avoid every unnecessary step. In addition, he used support teams to put down supplies along the route to and from the Pole—a method that American explorer Robert E. Peary had first pioneered.

His rival, Captain Robert Falcon Scott (1868–1912), was a self-acknowledged amateur, and proud of it. He had considerable Antarctic experience, but drew the wrong conclusions from much of it. He did not ski, had no understanding of dogs, and put much blind faith in the unproven worth of petrol-driven snow tractors. As Amundsen put it, "Victory awaits him who has everything in order—luck, people call it. Defeat is certain for him who has neglected to take the necessary precautions in time; this is called bad luck."

When the two expeditions set out from their respective bases on October 19, 1911, Amundsen was already 100 miles nearer the Pole than Scott. He had picked his team months before. At the last moment, Scott increased his team from four to five, dangerously straining his stores and equipment. From then on, the gods of luck smiled on Amundsen; Scott met bad luck and appalling conditions.

As Amundsen reached the Pole 56 days later, Scott was still 360 miles away, struggling up the Beardmore Glacier. Amundsen returned in modest triumph. Scott and his men died heroically; Scott's belief that amateur pluck made up for professionalism had failed him. Future expeditions made Amundsen-style preparations.

Roald Amundsen and his dog team at the South Pole, December 14, 1911

First photograph at the Pole

Norwegian Roald Amundsen, his team of five men, and 11 Greenland Dogs—a husky relative—reached the South Pole at 3 p.m. on Friday, December 14, 1911. The official expedition camera was damaged en route to the Pole, so all remaining photographs were made with Olav Bjaaland's much simpler camera, which captured Amundsen in this triumphant pose. Originally developed from glass-plate negatives, many of Amundsen's photographs from this and other expeditions were turned into hand-tinted glass lantern slides. By projecting the slides onto a wall or screen, using an early form of slide projector called a Magic Lantern, Amundsen was able to entertain with images of his numerous travels.

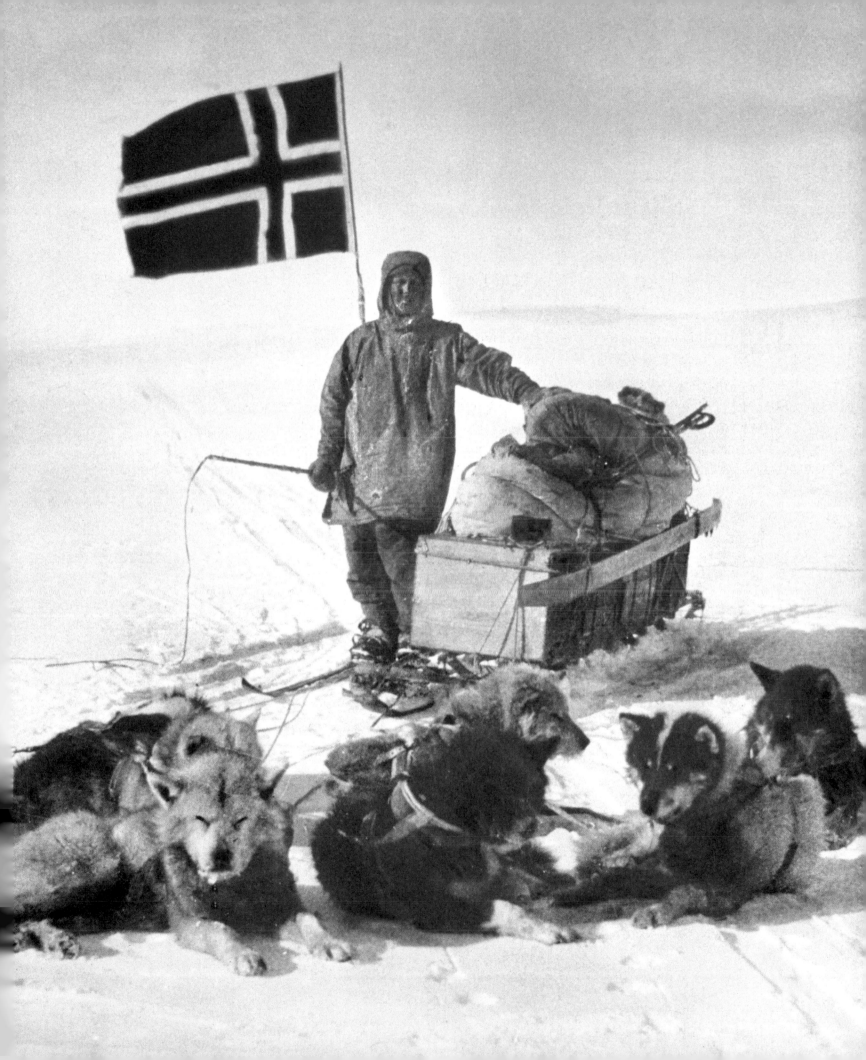

TITANIC
DISASTER
GREAT LOSS
OF LIFE
EVENING NEWS

"Our hopes were buoyed with the interchange of wireless messages with passing ships one of whom was certainly coming to our rescue...."

EXTRACT FROM *THE TRUTH ABOUT THE TITANIC* (1913) BY COLONEL ARCHIBALD GRACIE

[April 14, 1912]

SINKING OF THE *TITANIC*

On a gray spring day, the great new White Star liner, *RMS Titanic*, began her maiden voyage from Southampton, England, to New York. On board were 1,317 passengers, and a crew of 891. In the first-class suites were some of the world's richest and most powerful inhabitants. The steerage accommodation contained the poor and hungry, the "huddled masses" desperate for a fresh start in the United States.

When the *Titanic* entered service she was the largest vessel in the world. She had been designed, like her older sister ship *Olympic*, to compete with the Cunard liners *Lusitania* and *Mauretania*. It had been proudly claimed that she was the first of a new generation of liners—opulent, hedonistically comfortable, and "practically unsinkable." It was a challenge to Captain Edward Smith and his crew to live up to such claims, and for the first three days of the voyage the *Titanic* delivered all that was promised.

At 11:40 p.m. on April 14, the *Titanic* hit an iceberg. The impact ripped open her keel, destroying the system of watertight bulkheads that should have saved her. While passengers danced and dined, and made plans for new lives in the New World, the ship began to list, imperceptibly at first, then with terrible insistence.

Then there was panic. For all the extravagance lavished on the *Titanic*, one thing was missing—an adequate supply of lifeboats. In the terror and confusion that followed, the selfish and the loving fought for their own safety or that of others. A total of 1,496 people died. Children lost their parents; parents lost their children. Wives, husbands, and lovers were parted for eternity. Out of the tragedy did come industry-wide improvements in passenger safety requirements aboard ships, especially an increase in lifeboat capacity.

Plans for the rest of the fleet of *Titanic*-style liners were scrapped.

Three days after its sinking, the *Titanic*'s fate makes headlines in London.

Topical Press Agency

No photographs exist of the *Titanic* disaster. There are images of survivors arriving in New York, of anxious crowds studying lists of those lost and those saved, and famously of newspaper boy Ned Parfett selling copies of the *London Evening News* outside the White Star offices at Oceanic House, Cockspur Street—just off Trafalgar Square. At this time, the Topical Press photographic agency in London claimed it could get six glass negatives developed, printed, captioned, and out to a runner within seven minutes of the plates arriving in Fleet Street.

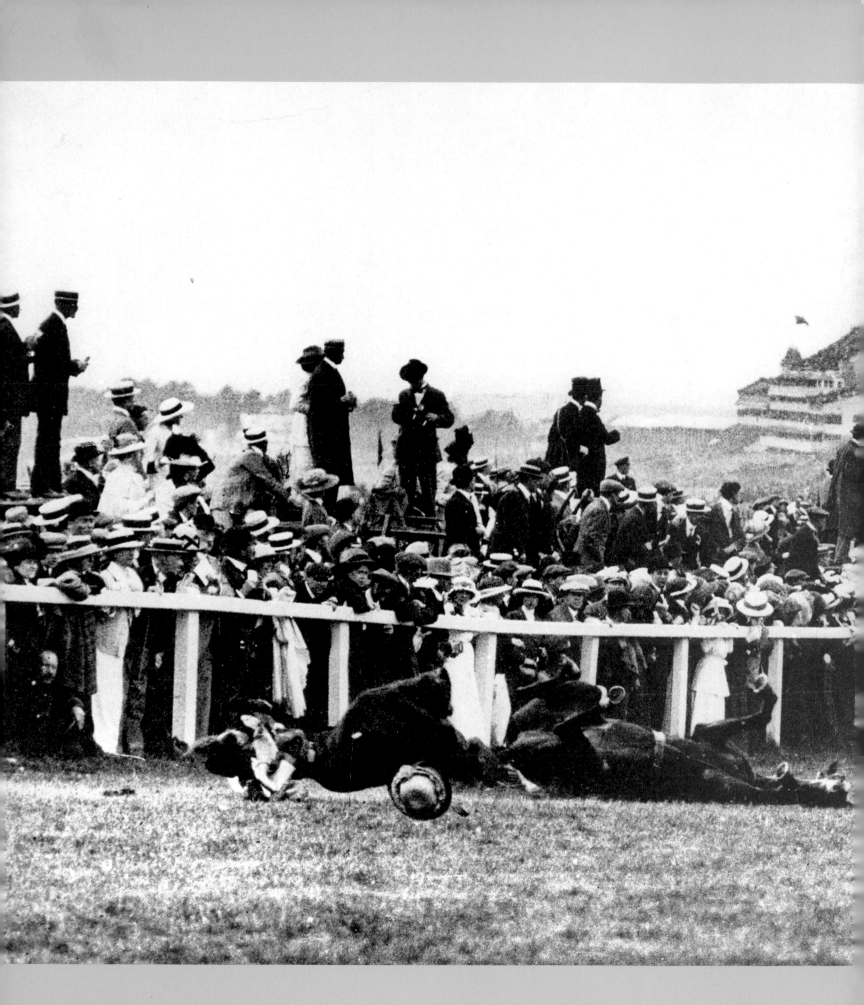

"Even when I heard the pounding of the horses' hoofs moving closer I saw she was still smiling. And suddenly she slipped under the rail and ran out into the middle of the racecourse."

EXTRACT FROM *LAUGH A DEFIANCE* (1953) BY MARIE RICHARDSON

[June 8, 1913]

DEATH OF EMILY DAVISON

Emily Davison was born in 1872, into an English Victorian middle-class family. She gained admission to the University of Oxford, where she qualified for a first-class honors degree in English, although degrees were not awarded to women at the time. This may have politicized Davison; in 1906 she joined the Women's Social and Political Union. She became a suffragette, and through organized protest with other women she sought the right to vote.

Over the next six years, Davison was imprisoned several times for attacks on property, and on those she believed opposed "Votes for Women." Like many of her fellow suffragettes, Davison went on a hunger strike. While held in Holloway Prison, London, she hurled herself from an iron staircase, falling 30 feet before landing on a wire grille. Her spine was permanently damaged.

On a summer day in 1913, Davison bought a round-trip rail ticket to Epsom Downs. It was Derby Day, the greatest event in the horse-racing calendar, a popular and royal occasion. Armed with a suffragette banner, Davison positioned herself at Tattenham Corner, the last curve on the Derby course before the final straight. As the horses rounded the bend, Davison stepped out in front of *Anmer*, a horse owned by King George V. The galloping animal knocked her to the ground. Another horse behind trampled her body.

Davison was taken to Epsom Cottage Hospital, where she died four days later from a fractured skull. Although many tried to brush it aside as the action of an emotionally unbalanced extremist—and voiced greater concern for the horses involved—Davison's sacrifice greatly strengthened the resolve of those already committed to women's rights, and drew many new recruits. Five years later, women in Britain were at last given the right to vote.

Race spectators appear unaware that Emily Davison has been trampled. *Following pages*: Two suffragettes stand guard over Davison's coffin.

Unforeseen image

Arthur Barrett was one of several staff photographers from British newspapers covering the Derby at Epsom Downs in 1913. Derby Day was the biggest event in the British horse-racing calendar, as much a social as a sporting occasion. Barrett stationed himself on the outside of the sharp bend at Tattenham Corner, where the horses would have to slow, and an action shot would be more easily obtained. Most people's eyes were only on the race, but Barrett's camera recorded the tragic drama of Davison's martyrdom.

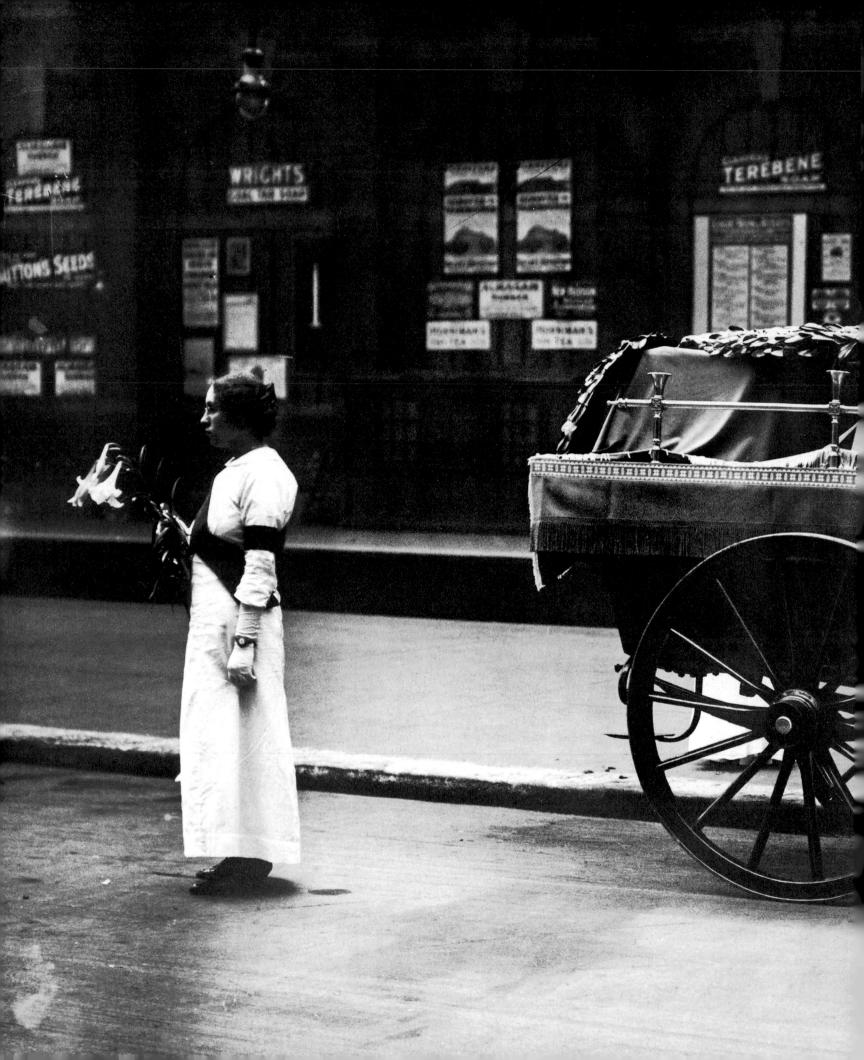

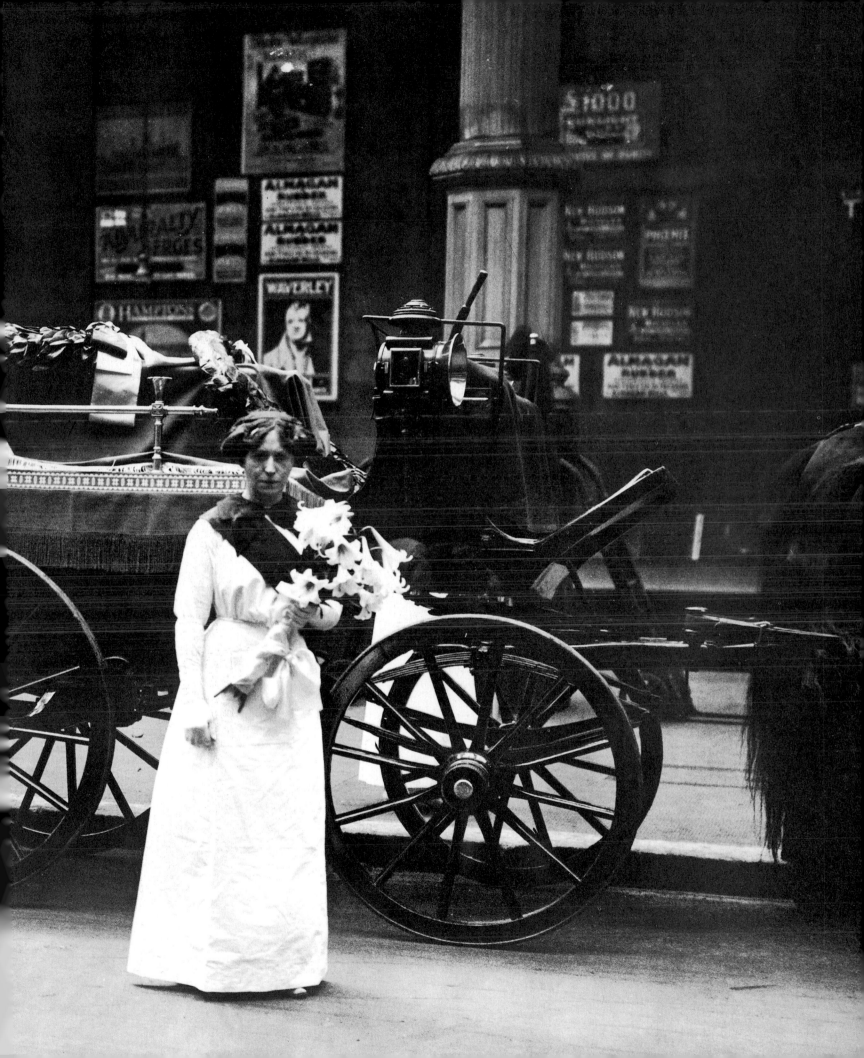

[June 28, 1914]

ASSASSINATION OF ARCHDUKE FRANZ FERDINAND

Just before 10 o'clock on Sunday, June 28, 1914, Archduke Franz Ferdinand (1863–1914), the heir apparent to the Austro-Hungarian Empire, arrived in the city of Sarajevo. Accompanied by his pregnant wife, the Archduchess Sophia, Franz Ferdinand set off in a jovial mood, driving through the city in an open car. Joviality lasted precisely 10 minutes. Nine members of the Narodna Odbrana, a group seeking Bosnian independence, were positioned along the car's route. Before it had traveled a mile, an assassination attempt was made. Nedeljko Cabrinovic, a young nationalist, hurled a grenade. It exploded under the wheels of a following car, seriously wounding two of its occupants.

After attending a reception at the City Hall, Franz Ferdinand asked about the wounded, and insisted on being taken to see them. The Archduchess refused to stay at City Hall, saying: "As long as the Archduke shows himself in public today, I shall not leave him."

No one told the chauffeur of the change in plans. He set off for the railway station, not the hospital, but was ordered to turn the car around. As he made a three-point turn, another conspirator, Gavrilo Princip, was passing. Princip looked up to see the Archduke sitting in a stationary open car. He drew a pistol from his coat, leapt on to the running board of the car, and fired just two shots. The first struck the Archduchess in the abdomen. The second pierced the Archduke's jugular vein. The car drove off at high speed; although both victims were still alive when it reached the Governor's residence, they died soon afterwards. Princip was seized by members of the escort, beaten on the head with the flat of their swords, kicked, and then dragged away to spend the rest of his life in prison.

As a direct result of the killings, exactly one month later, World War I (1914–1918) began.

Citizen photojournalism

A sunny day and a royal visit were twin attractions likely to bring amateur photographers onto the streets of Sarajevo. Among them was Milos Oberajger, a forestry engineer with a love for photography. The image he captured, of the arrest of one of the co-conspirators in the plot to kill Archduke Ferdinand, is perhaps the earliest example of "citizen photojournalism." Doubt remains as to the identity of the man arrested, who may well have been innocent.

An arrest following the first attempt on Archduke Ferdinand's life

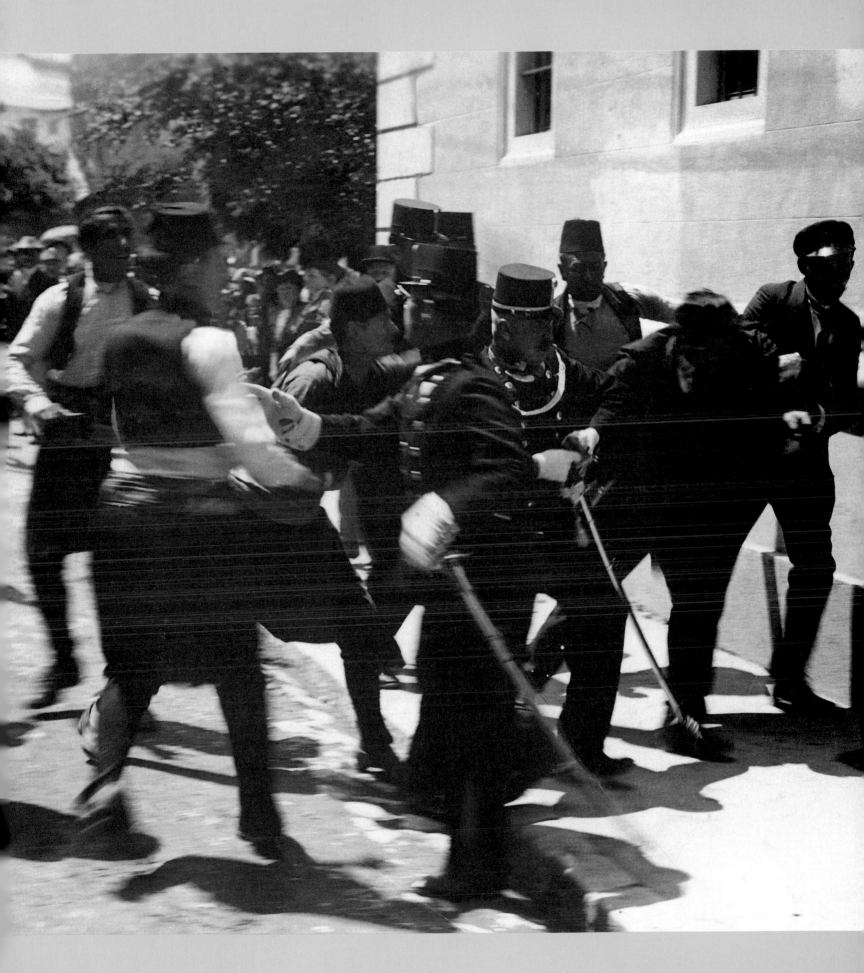

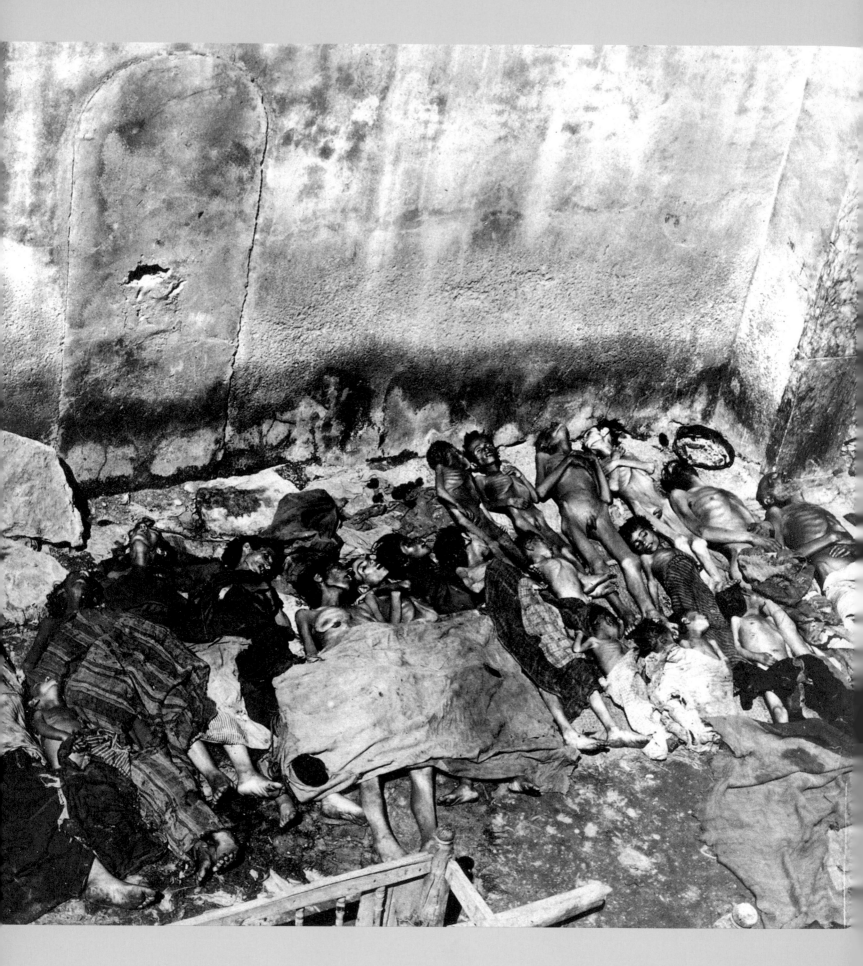

A rare record of ethnic cleansing—Armenians massacred in Turkey

"One of these gendarmes confessed to killing 100 Armenian men himself... the empty desert cisterns and caves were also filled with corpses...."

AN ACCOUNT BY A CAPTURED TURKISH SOLDIER IN *GERTRUDE BELL'S COLLECTED PAPERS* (1982–1988)

[April 24, 1915]

ARMENIAN GENOCIDE

The world's nations still cannot agree as to the cause of the first recorded genocide, with deaths of as many as 1.5 million Armenians in the Ottoman Empire, before and during World War I (1914–1918). Nor is there agreement on the nature of the crime itself. Was it indeed genocide? Was it war between two races and religions? Were the deaths caused primarily by famine and disease?

Until the late 19th century, Armenians in the Ottoman Empire were treated as second-class citizens. Being Christian, they were also infidels in the eyes of strict Muslims. Although they were despised, their lives were not in danger. The situation deteriorated following the accession of Abdul Hamid II in 1876 and the defeat of the Turks by Russia in 1878. The Russian victory led Armenians to hope that they might achieve independence with Russian protection. Such ideas led to a series of massacres between 1894 and 1897. Worse was to come in 1913 when the right-wing Committee of Union and Progress seized power in the Ottoman Empire. One of its key figures was Mehmed Talat Pasha (1874–1921), who became Grand Vizier. He is believed to have instigated the genocide.

On the night of April 24, 1915, more than 250 Armenian academics and intellectuals were arrested and executed. Thousands more were then seized and deported. Tens of thousands were systematically starved to death; lands and belongings were forfeited; Armenians serving in the Turkish army were executed. Concentration camps were set up, controlled by Talat's right-hand man, Sukru Kaya.

With the defeat of the Ottoman Empire at the end of the war, Talat fled Istanbul. He was sentenced to death in absentia, but was never captured. The large-scale ethnic cleansing foreshadowed that of the Nazi Holocaust some two decades later. Although Turkey denies the genocide, the Armenian diaspora has spread its news to the world.

Undercover images

In 1915 Armin Wegner was sent to the Middle East as a member of the German Sanitary Corps. When it was discovered that he had collected documentary evidence of the persecution of the Armenian people, the Turkish authorities sent him to work on cholera wards, hoping that would be the end of him. Wegner survived, and left for Constantinople with a collection of photographic plates hidden in his clothing. His Open Letter to President Wilson, appealing for an independent Armenia, was published in Germany on February 23, 1919.

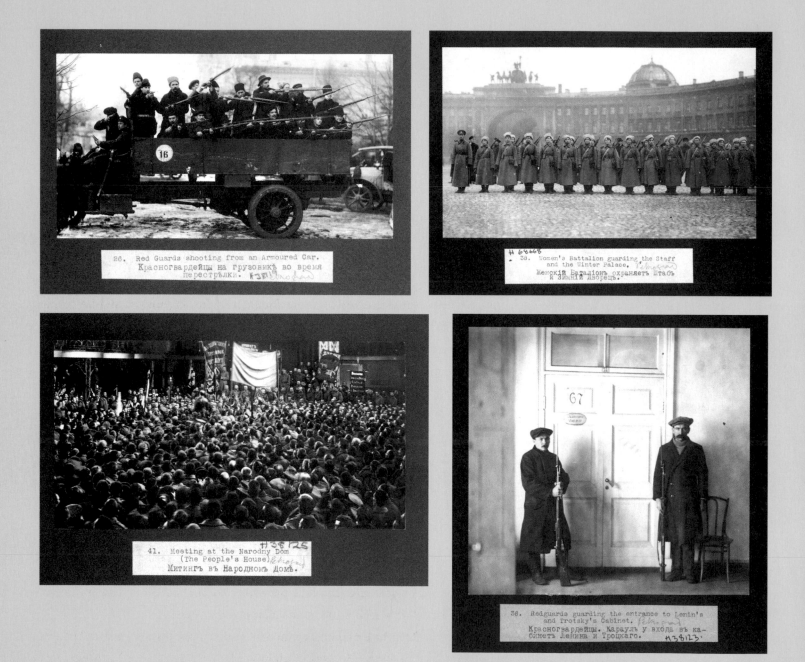

26. Red Guards shooting from an Armoured Car.
Красногвардейцы на грузовикѣ во время
перестрѣлки.

36. Women's Battalion guarding the Staff
and the Winter Palace.
Женскій Батальонъ охраняетъ Штабъ
и Зимній Дворецъ.

41. Meeting at the Narodny Dom
(The People's House)
Митингъ въ Народномъ Домѣ.

36. Redguards guarding the entrance to Lenin's
and Trotsky's Cabinet.
Красногвардейцы. Караулъ у входа въ ка-
бинетъ Ленина и Троцкаго.

Scenes from the 1917 Revolution, including guards at Lenin's office and the Women's Battalion.

[October 25, 1917]

ATTACK ON THE WINTER PALACE

Any account of the Russian Revolution reads like an adventure yarn. There are the set pieces: crowds fighting on the Nevsky Prospect in St. Petersburg; the stirring speech by Vladimir Lenin (1870–1924), in which the future head of state proclaims, "We shall now proceed to construct the socialist order;" the siege of the Duma (parliament) in July 1917. There is the dark and shadowy intrigue behind Lenin's return from exile in Switzerland in a sealed railway car. There are the contradictions of the Revolution itself: the beautiful simplicity of its slogan, "Bread and Peace;" the ugly horror of the slaughter of Tsar Nicholas II and his family at Yekaterinburg.

By fall 1917, it was clear to political activists in St. Petersburg—and the city was crowded with them—that the moderate provisional government set up by Alexander Kerensky in the wake of the Tsar was on the point of collapse. One firm push against Kerensky was all that was needed, and it was provided by the Bolshevik attack on the Winter Palace, Kerensky's headquarters. At 9 p.m. on October 25, the guns of the cruiser *Aurora* and the Peter and Paul Fortress opened fire. Marines and the Red Guard, led by Lenin supporter Vladimir Antonov-Ovseenko, stormed the Palace. Those within—Cossacks, junior army officers, and the First Petrograd Women's Battalion—surrendered. In less than a day, Lenin and his Bolsheviks had taken over the government. Kerensky fled to Moscow (he died in exile in New York in 1970); his cabinet was arrested.

The following day, the All-Russian Congress met and handed over power to the Soviet Council of People's Commissars, with Lenin as Chair and Leon Trotsky (1879–1940) as Minister of Foreign Affairs. The Bolsheviks had now seized control of the future of Russia. "This," proclaimed their leader Lenin, "is only a step toward a similar revolution everywhere."

Scenes of revolution

There were many Westerners in Russia at the time of the Bolshevik Revolution. With the diplomats, military attachés, and journalists (most famously John Reed, author of *Ten Days that Shook the World*, and Arthur Ransome, author of *Swallows and Amazons*) were businessmen and traders, among them Arthur G. Marshall who compiled an album of 100 prints of scenes on the streets of St Petersburg. Forty years later, the Hulton Picture Library (later absorbed into Getty Images) acquired the album from Marshall's son.

"A harum-scarum affair, ill-planned and feebly directed, yet in military history it stands as the most significant battle of the First World War...."

EXTRACT FROM *SOLDIER FROM THE WARS RETURNING* (1929) BY CHARLES CARRINGTON

[November 20, 1917]

THE FIRST TANK BATTLE

By the late fall of 1917, the stalemate on the Western Front had reached epic proportions, with no sign of a break in the reciprocal slaughter. This was the background to what was almost the greatest military surprise of the World War I.

The idea of using massed tanks to mount a major offensive had first been proposed by J. F. C. Fuller and Henry Hugh Tudor in June 1917. The town of Cambrai in the Nord-Pas-de-Calais was selected because the region's chalk subsoil would provide better traction for the tanks than the heavy clay of Flanders. It had been approved by Douglas Haig, the British Commander-in-Chief, although Haig regarded the tank as something of a "novelty," for he was a cavalry-man who knew little of the weapon or its capabilities. Fuller stressed that the object of the attack should be to "destroy, demoralize and disorganize" the enemy, not to seek to capture a huge swathe of ground. Had this advice been taken, Cambrai might have proved a complete success, but, after three years of attrition, British High Command was obsessed with territorial gain.

At 6:20 a.m. on November 20, a barrage of 1,000 guns opened up on the German defenses. When the guns stopped, smoke was dispersed. The Mark IV tanks made their debut lumbering, out of the mist. They were heavy, cumbersome machines, carrying ahead of them massive wooden fascines to aid trench crossing, and "grapnels" to seize and remove coils of barbed wire. They were also stiflingly hot for the crews inside.

The Germans were taken by surprise, and the primitive tanks nearly achieved the breakthrough that could have finished the War. A generation later, in the German defeat of France, in the Desert War, and especially at the battle of Kursk, the Mark IV's descendants showed just how destructive the "novelty" could be.

An official war photograph of the British Mark IV tank

War photography

War photography poses a dilemma for government and the military. The camera can provide images that raise morale or shock the public. In either case, national resolve may be strengthened. But there is always the danger that a photograph may contain visual information useful to the enemy. For this reason, images of British tanks were not made publicly available until after the battle of Cambrai, by which time the German army was already painfully aware of their existence and capabilities.

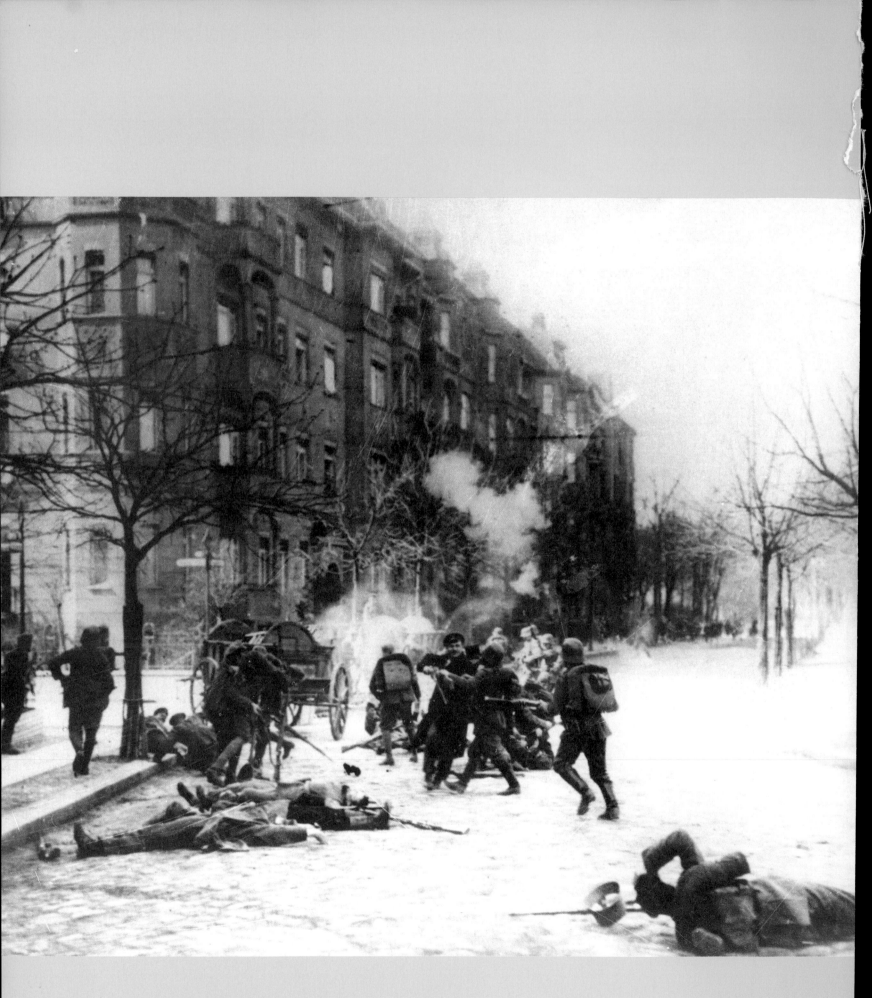

"It's as if Berlin were an elephant, and the revolution were a penknife. It sticks into the elephant, which shakes itself, but then strides on, as if nothing had happened...."

EXTRACT FROM THE DIARY OF HARRY KESSLER, BERLIN, 1919

[January 4, 1919]

SPARTACIST UPRISING

In the fall of 1918, toward the end of World War I, President Woodrow Wilson announced that he would not consider negotiating peace with Kaiser Wilhelm II (ruled 1888–1918). To bring an end to the senseless slaughter, therefore, it was essential that the German head of state be removed from office. On November 6, Prince Max von Baden, the new Chancellor of Germany, set off for the army headquarters at Spa to request the Kaiser's abdication.

The Kaiser's response was uncompromising: "My abdication is out of the question! The army and the people are fully behind me!" That was nonsense. The German army had neither the strength nor the spirit to continue the war or put down the revolution that was threatening at home. On November 9, the Kaiser telephoned his abdication to von Baden, and left by train for Doorn in the neutral Netherlands, never to return.

In Berlin, workers poured into the city, mingling with units of the broken army returning from the front. There was a real threat of a Communist takeover. Karl Liebknecht, co-founder with Rosa Luxemburg of the left-wing Spartacists, proclaimed a Soviet state. Von Baden resigned as Chancellor. The backbone of the German regular army, however, stood firm. By early December 1918, two million troops had come home, many of them forming units of the *Frei korps*, veteran soldiers still acting under their wartime commanders.

Opposing political sides waited for the battle to begin—on the Left, ill-led revolutionary soldiers and sailors; on the Right, the disciplined *Freikorps*. On January 4, 1919, the Spartacist Revolution began. It lasted a week. The revolutionaries were no match for the *Freikorps*. Liebknecht and Luxemburg were murdered. On January 19, the right-wing SPD party won a workable majority in the national elections; the Spartacist threat of Communism was quashed.

Government troops and Spartacist supporters fight on the Berlin streets.

Keystone Agency

The graphic picture of soldiers and Spartacists fighting on the streets of Berlin was credited to the Keystone Agency. Keystone was founded in London in 1900 by the Hungarian Bert Garai, who brought together the Havas Photo Agency and the Keystone View Company at a time when Fleet Street newspapers were crying out for more pictures. Known as "the man who scooped the world", Garai never took a photograph in his life, but had a passion for photojournalism.

"Lloyd George has deceived me. He made me the finest promises, and now he breaks them. Fortunately, I think that at the moment we can count on American support..."

GEORGES CLEMENCEAU AT VERSAILLES, RECORDED IN *GRANDEUR AND MISERY OF VICTORY* (1930)

[June 28, 1919]

SIGNING OF THE TREATY OF VERSAILLES

The guns fell silent and the carnage stopped at 11 a.m. on November 11, 1918. In the trenches, soldiers hugged each other. Many cried. In London, Paris, New York, and Rome crowds danced and sang on the streets. On the Western and Eastern fronts, German armies turned from the enemy and made their way home, broken in spirit. In the corridors of power of the victorious Allies, politicians gathered to wreak a terrible revenge on the nation that they held responsible for the Great War.

The ensuing Peace Conference was held at the Palace of Versailles, on the outskirts of Paris, France. The German delegation, led by Foreign Minister Ulrich Graf von Brockdorff-Rantzau, arrived there on May 7, and saw for the first time the proposed Peace Treaty. Its terms were savage. Germany was to return the regions of Alsace and Lorraine to France. That had been expected. Germany was also to yield territory in the east, predominantly to Poland, and be stripped of her colonies in Africa. In addition, Germany was to destroy all its military weapons and equipment, and pay reparations that amounted to some $25 million. The industrial and economic base of the defeated nation was to be left in ruins. The German delegation was shocked; Germany, which was not allowed to participate in the negotiations, issued a protest, and the delegation withdrew.

On June 1, the Allied triumvirate arrived: British Prime Minister David Lloyd George (1863–1945), his French counterpart Georges Clemenceau (1841–1929), and U.S. President Woodrow Wilson (1856–1924). Lloyd George and Clemenceau were in no mood for negotiation. Germany, in the words of Lloyd George, was to be "squeezed until her pips squeak." Wilson was of a different mind. He had little time for the old European order, regardless of who had won and who had lost. His interest lay in the development of new

Lloyd George, Clemenceau, and Woodrow Wilson at Versailles.

Celebrity statesmen

In the summer of 1919, the three most powerful men in the world gathered at Versailles, near Paris. They were the French Premier, Georges "Tiger" Clemenceau (*center*), the British Prime Minister, David Lloyd-George (*left*), and the United States President, Woodrow Wilson (*right*). Security was tight, by the standards of the age, but the three visitors were happy to walk the streets, and to be photographed wherever they went. The fate of the world was in their hands, and, in photographic terms, they were the first celebrity statesmen.

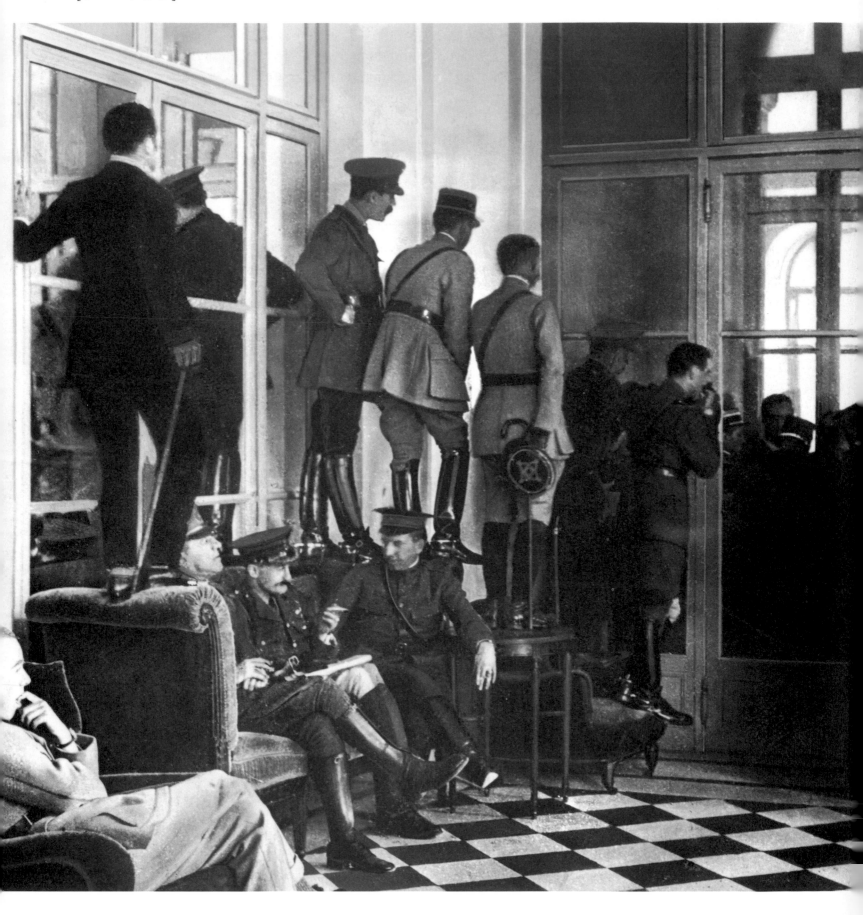

independent nations from the old empires of Prussia, Austria-Hungary, and Turkey.

Wilson offered Fourteen Points, which were less harsh than the terms of the French and British—and gave Germany hope. Among the points, Wilson asked for a new map of Europe, one that created new countries of Czechoslovakia, Hungary, and Yugoslavia, and removed others: Serbia and Bosnia-Herzegovina. He pressed for the establishment of a new international body, the League of Nations, which would be empowered to settle international disputes by negotiation, and thus end the need for war. He preached the doctrine of the "self-determination" of free peoples.

Four weeks later, in the Hall of Mirrors at Versailles, which the victorious Prussians had occupied during the Franco-Prussian War 37 years previously, the Peace Treaty was signed. It was harsher than Wilson's Fourteen Points had led Germany to believe. Among the provisions, including the complete disarmament and massive reparations demanded by the French and British, was the requirement that Germany and its allies accept full responsibility for starting the war. The Germans balked at the terms, but they had no choice. Had they refused to sign the Treaty, Germany would have been invaded.

Wilson's League of Nations did become a reality. But it lacked the strength to safeguard the world from German response to the Treaty's vindictive elements. Historians believe that the Treaty lay fertile ground for Nazi Germany's eventual rise to power. Almost immediately after the signing in 1918, Germany avoided or secretly violated some provisions. By the mid-1930s Adolf Hitler had publicly destroyed the Treaty of Versailles before a cheering crowd, and had begun building a formidable army, navy, and air force.

Soldiers and civilians watch the signing of
the Treaty of Versailles, June 28, 1919.

[October 28, 1922]

MUSSOLINI'S
MARCH ON ROME

Benito Amilcare Andrea Mussolini (1883–1945) was proud to be known as the founding father of Fascism. In 1932 he put his name to "The Doctrine of Fascism," an essay ghost-written by philosopher Giovanni Gentile, which declared: "We are free to believe that this is the century of authority… a Fascist century."

During World War I, Mussolini had fled to Switzerland to avoid national service in the Italian army, and, when eventually conscripted, exaggerated some slight injuries to gain early demobilization. His genius was his political cunning. In spring 1919, Mussolini founded the *Fasci Italiani di Combattimento* ("Italian League of Combat"), an extreme right-wing party that used force and intimidation to spread its message. Two years later, after signing an unlikely and insincere pact with the Italian socialists, Mussolini formed the National Fascist Party—the vehicle by which he came to power.

In the fall of 1922, the poet and military adventurer, Gabriele d'Annunzio, called for a rally in Rome, ostensibly to celebrate Italy's achievements in World War I, but in reality to foment political unrest in the Balkans and North Africa. Mussolini planned a march on Rome to hijack d'Annunzio's demonstration. Luigi Facta, Italy's Prime Minister, was warned of the march, and although he underestimated its threat, tried to declare a state of siege in Rome. However, King Victor Emmanuel III (ruled 1900–1946) was no enemy of Fascism, and refused to sign the necessary military enabling order.

Two days later, the King virtually handed political power to Mussolini. The March on Rome became a victory celebration. Some 25,000 Fascist paramilitary Blackshirts paraded in the city to welcome Mussolini's 30,000 marchers. Eighteen months later, Mussolini declared himself dictator. It took more than 20 years and another world war for democracy to be restored in Italy.

Albert Harlingue

Albert Harlingue was already a portrait photographer of some renown—whose sitters had included Rodin, Einstein, and the French dancer Jeanne Ronsay—when he took this picture of Mussolini entering Rome on October 28, 1922. Mussolini's compatriots in the photograph were three of the main organizers of the March and the Fascist Party in Italy: Emilio de Bono (*extreme left*); Cesare Maria de Vecchi, commandant of the Blackshirts (*second from left*); and Italo Balbo, secretary of the Ferrari Fascist organization (*extreme right*).

Fascist Blackshirts and their leaders enter Rome, October 28, 1922.

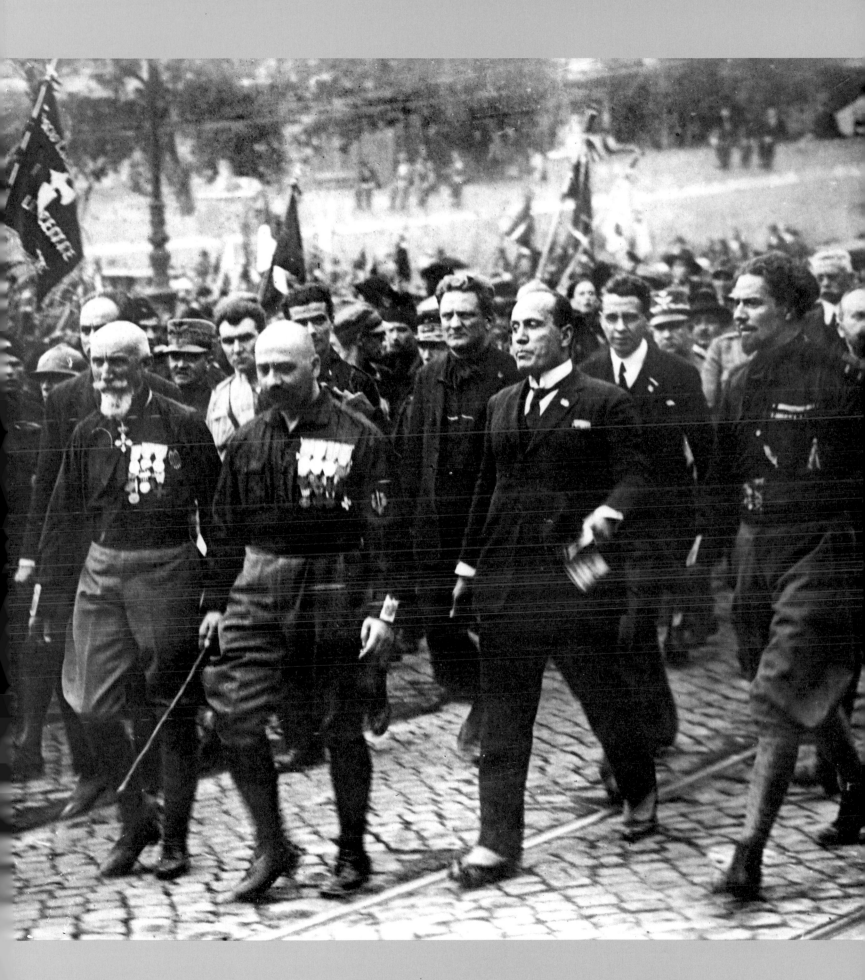

"The interior of the chamber gradually loomed... Lord Carnarvon said to me: 'Can you see anything?'... 'Yes, wonderful things...'."

HOWARD CARTER'S ACCOUNT OF THE OPENING OF THE TOMB, FEBRUARY 17, 1923

[November 26, 1922]

OPENING OF TUTANKHAMUN'S TOMB

In 1922 the amateur Egyptologist George Edward Stanhope Molyneux Herbert, Fifth Earl of Carnarvon (1886–1923), decided to finance one last season of search for the legendary tomb of Tutankhamun. Others in the hunt had given up, notably Theodore Davis, who had come to the conclusion that there was nothing more of any value or interest to be found in the Valley of the Kings.

Carnarvon's protégé, Howard Carter (1874–1939), took a different view. He had carefully mapped the area, marking every pile of earth and rubble from every excavation made since his own work there had begun in 1907. Displayed on his map was a small triangle of land, covered with the spoil from other digs, but itself as yet unexplored. Carter believed—or rather "hoped"—that the tomb of Tutankhamun lay somewhere beneath this triangle of rubbish. He instructed his men to clear the site.

On November 4, 1922, one stone step was uncovered, then another. After three weeks' careful work, an entire flight of 16 steps was revealed, leading down to a door that was not only closed, but sealed. And on this door were carved ancient Egyptian hieroglyphics, denoting the name "Tutankhamun." On the other side of the door was a corridor, filled with rubble. To Carter's consternation, in one corner a small tunnel had been made through the rubble, indicating that the tomb had almost certainly already been entered and robbed. Workmen cleared the corridor, and a second door was revealed.

Carter immediately sent a wire to Lord Carnarvon, urging him to come, and then settled down to wait as patiently as he could for three weeks, strengthened by the knowledge that this "one last season" of searching had been justified. Eventually, Carnarvon arrived, and on November 26, 1922, Carter made the famous "tiny breach in the top left hand corner of the door."

The Egyptian Sultana makes an official visit to the tomb of Tutankhamun.

Archaeologists pack two figures of Hathor, the mountain goddess.

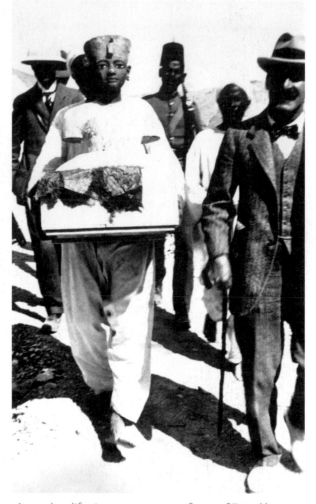

A wooden, life-size, contemporary figure of Tutankhamun

Treasures

Unparalleled treasures reached the light of day from Tutankhamun's subterranean antechamber. One of three funerary beds found in the antechamber depicts Mehetweret, the celestial cow goddess responsible for creation and rebirth. Carved from cedar wood, the bed was covered in gold; colored glass was used for the inlaid eyes and the blue clover-leaf spot. A life-size wooden effigy of Tutankhamun shows the upper torso and head of the pharaoh, but no arms. Covered in plaster and painted and gilded, this life-like mannequin was probably used to display robes, necklaces, and collars.

It was the moment of truth, but at first, by the light of a single candle, it was impossible for Carter to know whether he was looking into the tomb of the young Pharaoh or merely a cache of artifacts. As his eyes grew accustomed to the dim light, Carter saw the outline of another door, with a sentinel statue posted on each side.

The royal seal on the door was intact. Behind it were four chambers, three of them unadorned. The fourth was a treasure house. Its centerpiece was a stone sarcophagus containing three gold coffins, inside one of which lay the mummy of Tutankhamun. It took months to make a detailed exploration of the tomb and to catalog the wealth of material that lay inside. News of the discovery brought archaeologists, cameramen, treasure hunters, and reporters from all over the world, among them Maynard O. Williams of National Geographic, who wrote of "the drama in the very air of the place," and

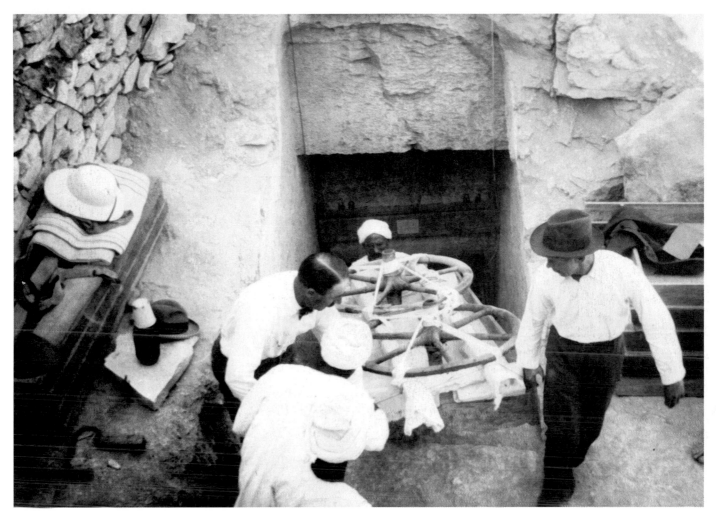

Howard Carter (*left*) and A. C. Mace remove two wheels from a pharoah's chariot.

of "looking for the needle entrance to the royal tomb of Tutankhamun in the limestone haystack of the Valley of the Kings."

Trouble followed. Carter's excavation permit clearly stated that no one was to enter such a place until Egyptian officials had arrived on site, and yet Carter, Carnarvon, and the Earl's daughter, Lady Evelyn Herbert, had all made their way into the tomb the moment it was opened. Carter's relationship with the Egyptians was severely strained, and he adopted a policy of deliberate noncooperation with them. In unwrapping the mummy, Tutankhamun's skull rolled away from the body and fell to the ground, where it was dented.

When Lord Carnarvon died a few months later from an insect bite, it was rumored that the mummy had put a curse on all those who had defiled the tomb. By 1929, 11 people connected with the discovery had died early of unnatural causes.

"At first I could see nothing, the hot air escaping from the chamber causing the candle flames to flicker, but presently, as my eyes became accustomed to the light, details of the room within emerged slowly from the mist, strange animals, statues and gold—everywhere the glint of gold..."

HOWARD CARTER'S ACCOUNT OF THE OPENING OF THE TOMB, FEBRUARY 17, 1923

"Paris, May 21—Lindbergh did it ... tonight suddenly and softly
there slipped out of the darkness a gray-white airplane. ...
At 10:24 *The Spirit of St. Louis* landed."

EDWIN L. JAMES, JOURNALIST, ON LINDBERGH'S ARRIVAL IN PARIS, MAY 21, 1927

[May 21, 1927]

LINDBERGH FLIES THE ATLANTIC

In 1927, a $25,000 prize was offered to the first aviator to fly from New York to Paris, France. Attempts were made and failed, both comically and tragically, until the arrival of Charles E. Lindbergh (1859–1924). Backed by Missouri businessmen, Lindbergh designed and built his own monoplane—the *Spirit of St. Louis*. It was a light machine, severely limited in the load it could carry. Lindbergh was conscious of this, knowing that his problem would be fuel. To fly roughly 3,500 miles, he would need around 450 gallons of gasoline. He loaded 451 gallons, four sandwiches, and two canteens of water.

At 7:40 a.m. on May 20, 1927, Lindbergh switched on the engine. He allowed 12 minutes for it to warm up, and then accelerated down the runway at Roosevelt Field, Long Island. The heavily laden plane climbed agonizingly slowly, and barely cleared the telephone lines. Lindbergh headed for Cape Cod and Nova Scotia.

It took him 33.5 hours to reach his destination. At times, he was flying only ten feet above the waves. He considered turning back, but resisted the temptation. Mid-Atlantic, in the middle of the night, ice began to coat the wings, adding to the weight of the plane and increasing Lindbergh's danger. He flew on.

Eventually, he spotted fishing boats, and prayed that this meant he was nearing land. Sure enough, soon after, he reached the west coast of Ireland. He flew over southwest England, and sighted France near the mouth of the Seine. He followed the waterway all the way to Paris. Late on the evening of May 21, he circled the Eiffel Tower and landed at Le Bourget airfield at 10:22 p.m. local time.

A huge crowd rushed to greet him. The prize was his, together with, on his return to the United States, the largest ever New York ticker-tape parade; the Distinguished Flying Cross—presented to him by President Calvin Coolidge; and worldwide fame.

Crowds engulf the *Spirit of St. Louis* and "Lindy" at Croydon Aerodrome.

Spirit of St. Louis

When Lindbergh landed at Le Bourget it was already dark. Although a huge crowd was on hand to welcome him, the press were unable to photograph because of the darkness. His arrival at London's Croydon Aerodrome on May 29, 1927, was a different matter as witnessed in this aerial photograph. The *Spirit of St. Louis* was literally crushed—the stabilizer was damaged—by a sea of spectators who broke through police lines. On May 31 Lindbergh flew to Gosport on the English Channel where the *Spirit of St. Louis* was dismantled by the Royal Air Force, crated, and loaded onto the U.S.S. *Memphis* to accompany him on his return voyage. Once home, the *Spirit of St. Louis* was reassembled at Bolling Field, in Washington, D.C.

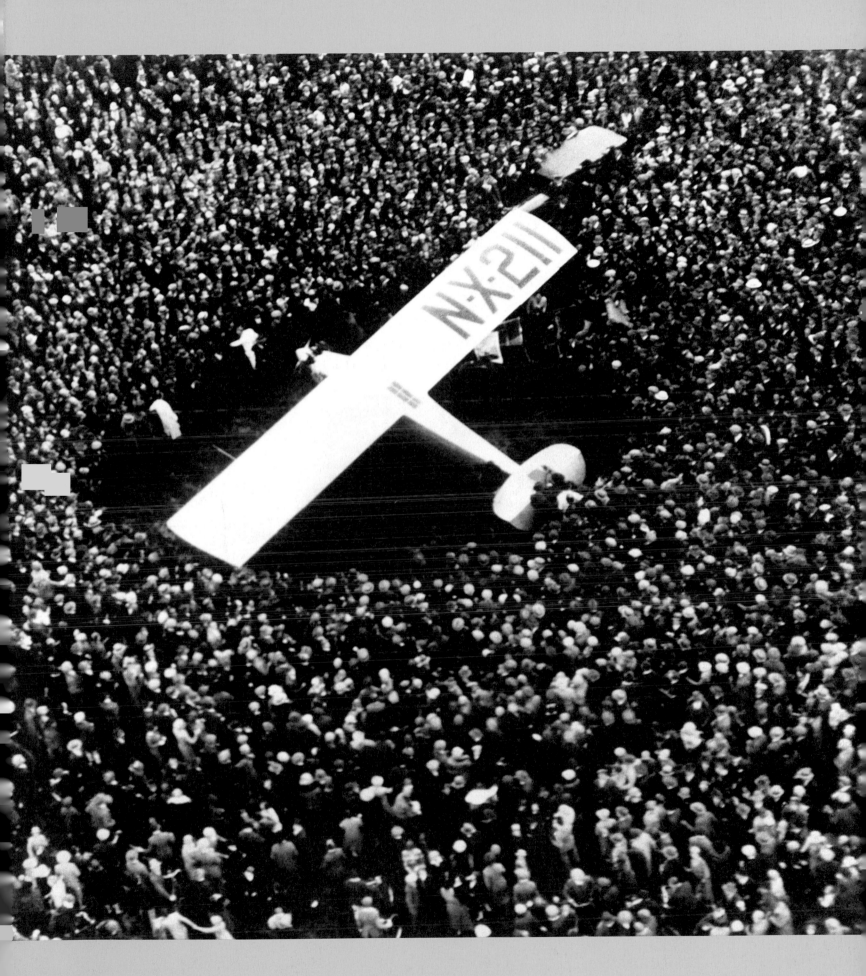

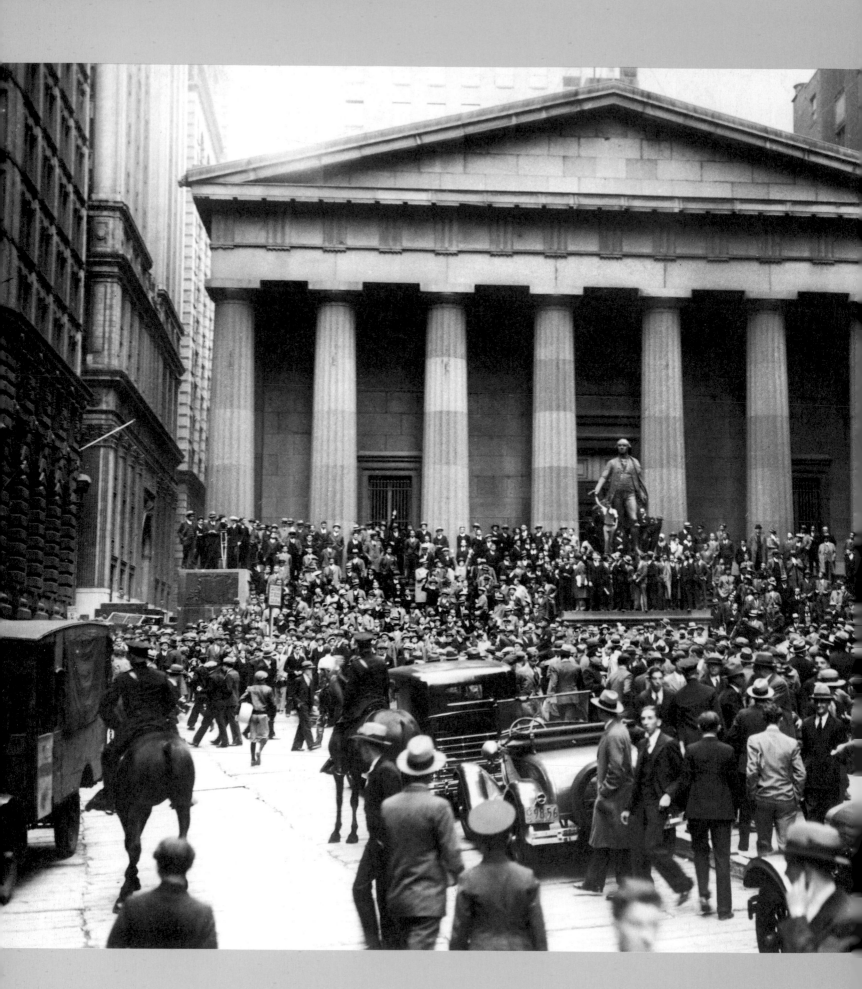

[October 29, 1929]

WALL STREET CRASH: BLACK TUESDAY

Between 1921 and the summer of 1929, the Dow Jones Industrial Average, thermometer of the New York Stock Exchange, recorded a fivefold increase. This was a great period for big-time and small-time investors. Suddenly, between early September and early October 1929, the market lost 17 percent of its value, then staged a short recovery as investors hurried to take advantage of what seemed a mere blip. On Black Thursday, October 24, stock prices tumbled alarmingly, with 12.9 million shares traded in a single day. Something was terribly wrong.

As the crisis worsened, financiers John D. Rockefeller and J. P. Morgan, Jr., stepped in, making massive stock purchases in an effort to prop up the ailing market and reverse the trend. Yet the seemingly impossible had happened, and the bubble burst. On October 29, a day that would come to be known as Black Tuesday, 16.4 million shares were traded in a $14 billion market loss—12 percent of the total value. This time there was no rally, no recovery; it took 25 years for the Dow to regain its pre-1929 level. The United States entered the Great Depression, dragging much of the world with it.

Did the Wall Street crash create the Great Depression, or was the start of the Great Depression responsible for the crash? Some modern economists believe that the crash could have been avoided by juggling the money supply, but others regard that as an anachronism, a little like asserting that 20th-century antibiotics could have been used to prevent the 14th-century Black Death (bubonic plague). Greed, ignorance, and increasingly blind trust in the American dream were all to blame for the ensuing financial nightmare. In the weeks and months that followed, the bodies falling from the towers of commerce, and those who died from shock and strain, were all victims of the most dangerous of financial ailments—overconfidence.

New York's Sub-Treasury Building on Black Thursday, October 24, 1929

The Press

Perhaps the only people to profit from the stock-market collapse were photographers and the journals they worked for. Cameras were everywhere in Wall Street on October 24, 1929: on the top of nearby skyscrapers, focused on the frightened ants below; in and outside the Sub-Treasury Building; even on the floor of the New York Stock Exchange itself. Strangely, it was not all panic. Crowds milled restlessly around, and a great many speculators—grand and modest—simply stood on the sidewalk or the steps, and wondered what on earth was happening.

[November 29, 1929]

RICHARD E. BYRD FLIES OVER THE SOUTH POLE

Richard E. Byrd (1888–1957) had a natural aptitude for aviation, and a remarkable ability to devise ways of calculating the position of a plane when it had been flying for a prolonged time out of sight of land. He developed his techniques and his scientific instruments as a young pilot during World War I.

In 1926, Byrd and his pilot, Floyd Bennett, attempted to fly over the North Pole. Although Byrd claimed success, he may have failed in the bid. Sextant readings of the flight, recorded by Byrd in his diary, suggest that he turned back just before reaching the Pole, rather than just after, but the effort brought him considerable acclaim, the Medal of Honor, and funding for his subsequent attempt to become the first person to fly over the South Pole.

In 1929 Byrd turned his attention to the Antarctic. No American expedition had visited the area since that of Charles Wilkes in 1840, and Byrd's plan to carry out a survey of Antarctica was totally new. He took with him three aircraft—a Ford monoplane (named *Floyd Bennett* after his trusted pilot who had died the previous year after failing to

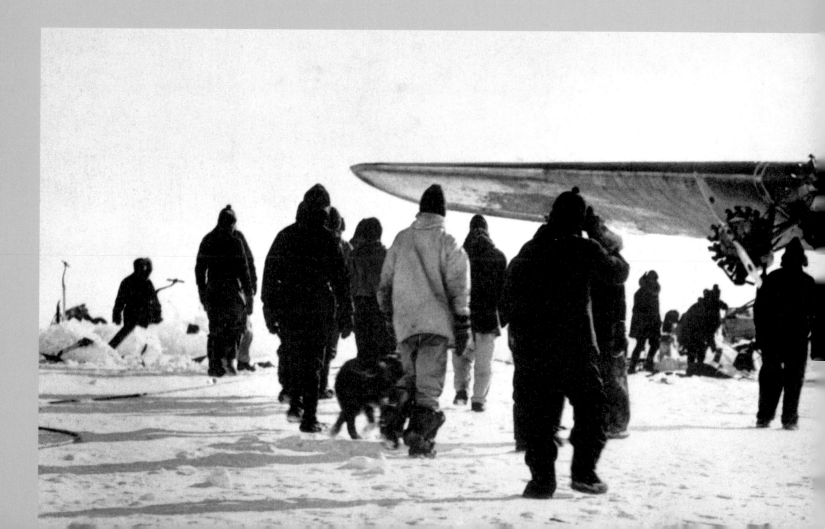

recover from a plane crash), a Fokker Universal, and a Fairchild folding-wing monoplane—and established his base at Little America on the Ross Ice Shelf.

Byrd knew, and had been advised by the great Roald Amundsen, that intricate preparation was needed to fly over the South Pole. Caches of food and fuel had to be established along the flight path chosen by Byrd. Support groups had to be stationed at various points to radio Byrd with details of his position as he approached the Pole. The first exploratory

The monoplane *Floyd Bennett* is prepared for Byrd's historic flight.

Documenting the historic flight

Richard E. Byrd was accompanied by *New York Times* special correspondent Russell D. Owen, who won the 1930 Pulitzer Prize for the most outstanding news reporting for his daily radio dispatches from Little America. Owen was accompanied by a news photographer who captured all facets of the expedition's work and daily life, plus the spectacular environs and wildlife. In addition, Pathé cameramen William Van der Veer and Joseph T. Rucker documented the expedition on 35-mm motion-picture film, resulting in *With Byrd at the South Pole: The Story of Little America*, which won the Oscar for best cinematography in 1930.

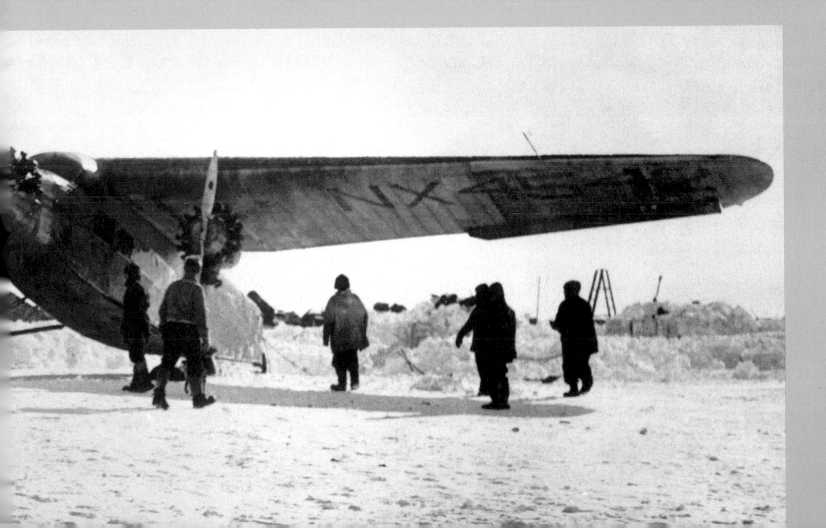

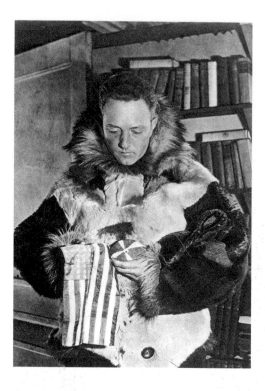

Left: Byrd in the library at Little America, with a stone from the grave of Floyd Bennett, who died in 1928. Bennett had been Byrd's pilot in his attempt to fly over the North Pole in 1926.

Right: The monoplane *Floyd Bennett*, named for Byrd's pilot, emerges from winter quarters in Antarctica.

flight took place in January 1929. Months later, at 1529 hours on November 28, 1929, the *Floyd Bennett* took off from Little America with Balchen as pilot, Byrd as navigator, Harold June as copilot and radio operator, and Ashley McKinley as photographer.

Byrd had to navigate by sun compass, since magnetic compasses were of no use so close to the magnetic South Pole. After flying for five and a half hours, Byrd received a radio message from the ground giving his position. He now knew that the plane was nearing the pass between Mount Nansen and Mount Fisher at the head of the Liv Glacier, some 11,000 feet above sea level, but he did not know if the heavily laden plane was high enough to clear it. By dropping all their empty gasoline containers and dumping 300 pounds of food, they just managed to gain the necessary height.

A little after midnight, early on the morning of November 29, Byrd's observations indicated that the *Floyd Bennett* was only 50 miles from the Pole. He flew on, and at 0030 hours passed over the Pole. To make sure, he continued on the same course for a few more miles, and then traversed the area from side to side. Byrd dropped a small U.S. flag, and at 0125 hours he turned to head back to base. With one stop, at the foot of the Liv Glacier, to take on 200 gallons of fuel and to leave 350 pounds of food for the support party, the *Floyd Bennett* reached Little America at 1010 hours. The historic flight had taken a total of 18 hours and 41 minutes.

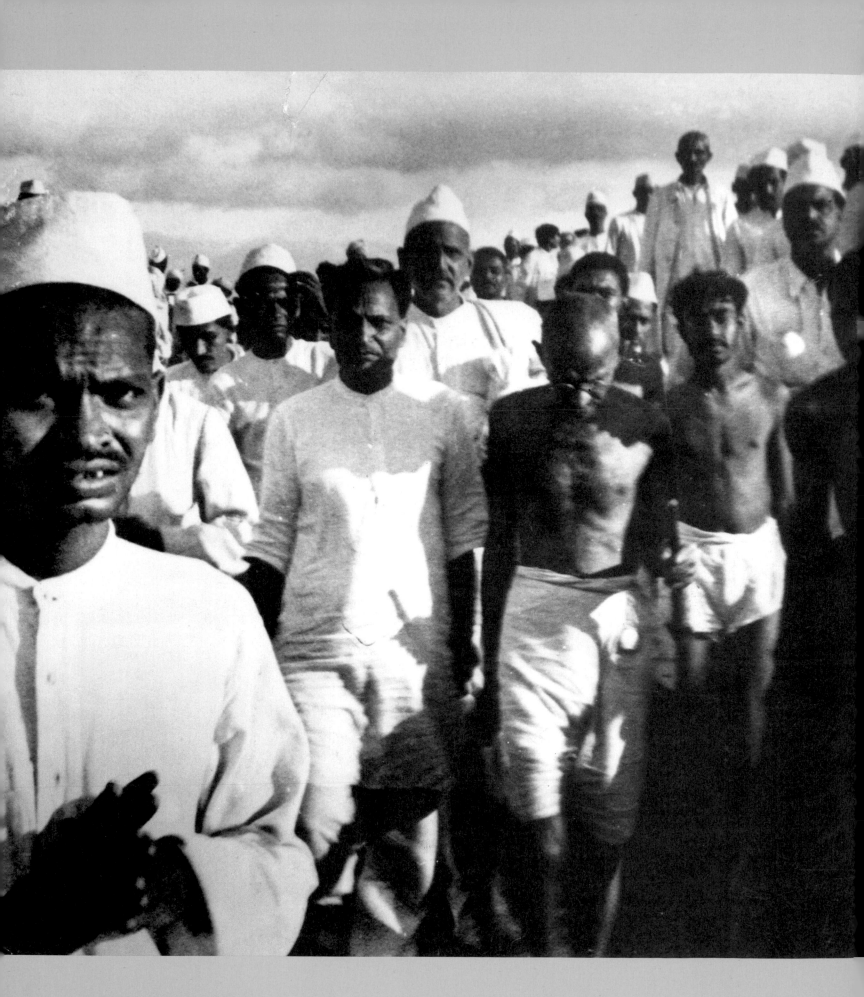

[April 5, 1930]

GANDHI COMPLETES SALT MARCH

The march itself lasted 24 days and covered 250 miles. It was almost a leisurely progress, as Mohandas Karamchand "Mahatma" Gandhi (1869–1948) and his rapidly increasing number of followers made their way from Ahmedabad to the coast. Their destination was the little village of Dandi, where a few houses clustered around a mosque and a Hindu temple, and, beyond the salt flats, fishing boats bobbed on the bright blue Arabian Sea. It was a peaceful place; there was not even one radio. Gandhi arrived there on April 5, 1930. The next day he took a lump of salty mud from the seashore and declared, "With this, I am shaking the foundations of the British Empire."

The purpose and the outcome of the march were shattering. Gandhi, barefoot and wearing only a *dhoti*, had come to awaken the political conscience of his fellow Indians, and to challenge the British rulers of his country. He wished to take a spoonful of salt from the mud of his native land, thereby symbolically challenging the government monopoly of that mineral. He believed that many would follow his example.

They did. People took salt from the sea, from the land, from government salt depots. There were salt riots. University classes marched behind their professors demanding salt. Soldiers mutinied. Pro-Gandhi newspapers were banned. Gandhi was once again arrested and put in jail.

British India was never the same again. Gandhi was invited to New Delhi to discuss the nation's future with the Viceroy, Lord Irwin. The next year, Gandhi visited London and had an audience with King George V. While conservative Britons—among them Winston Churchill—disapproved, others began preparations for the almost unthinkable—an independent India.

Gandhi (*center*, with head down) leads the Salt March in 1930.

A life exposed

Walter Bosshard was born in Switzerland in 1892. He was one of the great pioneers of modern photojournalism, much in demand in Germany in the 1930s by such new illustrated magazines as the *Berliner Illustrierte Zeitung* and the *Münchner Illustrierte Presse*. The latter journal sent Bosshard to India specifically to cover the Salt March. During the March, Bosshard gradually gained the Mahatma's trust, to the extent that Gandhi— who normally shunned all publicity of his private life— allowed Bosshard to make a photographic record of his daily life at home.

[October 16, 1934]

MAO'S LONG MARCH BEGINS

The Long March of units of the Red Army of China is widely regarded as one of the most remarkable mass migrations in history. It began on October 16, 1934, and lasted 370 days. In that time, the march covered some 8,000 miles, according to official Chinese histories, and more than half that distance according to modern Western research. Of the 100,000 men, women, and children who set off, only 7,000 completed the journey.

The Long March was inspired by Mao Zedong (1893–1976), leader of the Chinese Communist Party. At the time, a war was raging between the Communist Red Army and the Kuomintang (Nationalist) troops under Gen. Chiang Kai-shek (1887–1975). Chiang Kai-shek sought control of the entire country, and he knew that the Red Army had to be crushed in order to achieve his goal. At first his Kuomintang troops were successful, pushing the Communists farther and farther back until they were virtually imprisoned in the Jinggang Mountains in the southeastern province of Jiangxi.

The Communists tried to fight their way out, losing 45,000 troops in a single battle. Mao then switched tactics, devising a plan whereby four units of the Red Army would march independently to the far northwest of China. Mao's aims were twofold: To escape the Kuomintang and to return to what he regarded as the Communist Party's natural base among rural Chinese peasants.

And so the Long March began in Jiangxi. The route was long, twisting, and arduous, crossing the Ta-hsueh Shan mountains and treacherous marshy terrain. A few of the marchers deserted, while thousands died of fatigue, hunger, cold, or sickness. However, the marchers pushed on, and Mao's Long March reached its destination at Yan'an in northern Shensi Province on October 19, 1935. A year later all four units of the Red Army had reassembled.

Mao Zedong (*left*) and Zhou Enlai on the Long March

Marching toward victory

Few photographs have survived of the Long March. It is unlikely that many of the marchers would ever have seen a camera, let alone owned one, and the identity of the photographer of Mao Zedong and Zhou Enlai remains unknown. The Swiss photographer Walter Bosshard was in China from 1933 to 1939, during which time he photographed both Mao and Chiang Kai-shek. A visual record of the Long March was supplied by artists, whose simple, but dramatic black-and-white pictures captured such events as the crossing of the Xiangjiang River in July 1934 and the great victory at Zunyi in January 1935.

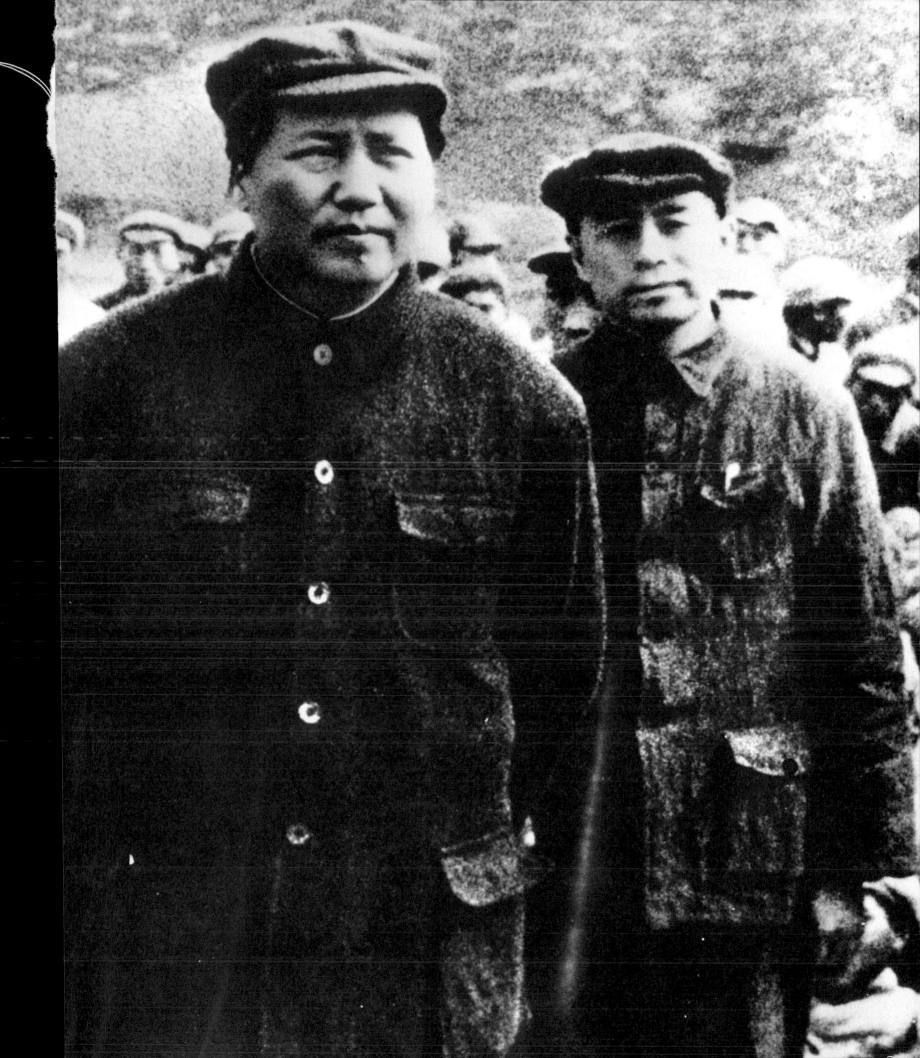

[August 3, 1936]

JESSE OWENS WINS
THE 100-METERS FINAL

The Berlin Olympic Games of 1936 was to be a Nazi showcase. Adolf Hitler (1889–1945) had used his considerable powers of persuasion to convince everyone involved that the Games must be perfect—in transport and accommodation for the athletes, in facilities for the world's press, in the purpose-built Olympic Village, and above all in the image of Germany to foreign visitors.

Orders were later given that, for the duration of the Summer Games, any evidence of anti-Semitism was to be removed—temporarily—from the city. All visitors were to be greeted with well-drilled charm. The streets, always impeccably clean, were to be even cleaner. Above all, the Aryan race was to dominate the games themselves.

The arena in which this triumph was to unfold was the Olympischer Platz Stadium. In order to seat 110,000 people, the old Deutsches Stadion had been buried underground, and the new arena erected on top. This entailed lowering the level of the original sports track by some 40 feet. The crowning glory of the stadium was the Marathon Arch, beneath which stood the receptacle for the Olympic Flame.

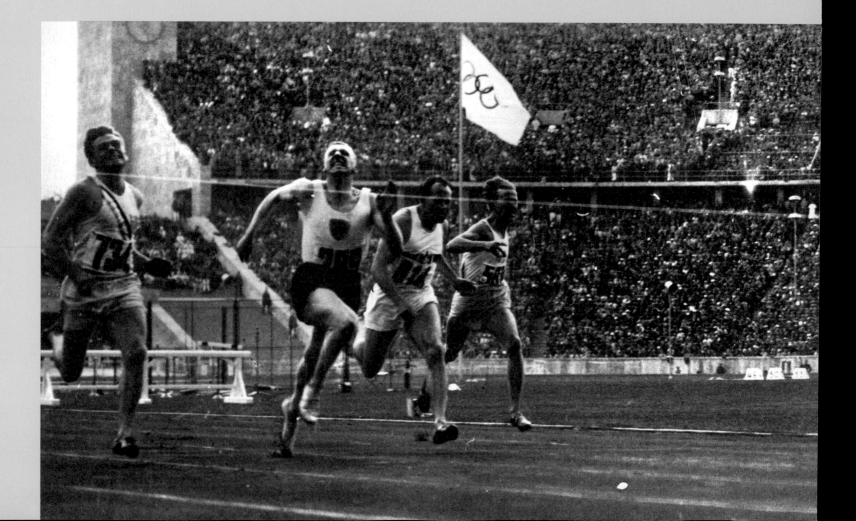

The man who shattered Hitler's dream of using the games as a showcase for white Aryan racial supremacy was a 22-year-old black athlete from Oakville, Alabama. His name was James Cleveland Owens (1913–1980), the seventh of ten children, grandson of a slave, son of a sharecropper. He was known as Jesse, simply because a teacher had misheard him when he had said that his name was J.C. Three years before the Berlin Olympics, Owens had equaled the world record of 9.4 seconds in the 100-yard dash at an athletics meeting in

Jesse Owens takes the gold in the 100-meters final, August 1936.

Capturing the gold

Foreign photographers were given every opportunity to shoot whatever the Nazis wished them to see at the Berlin Olympics. This particular picture of Jesse Owens winning the gold medal in the men's 100-meters final was taken by an unknown German photographer from the German bureau of the American Pacific & Atlantic Agency. The photo agency was founded in 1928 by New York's *Daily Mail* and the *Chicago Tribune*.

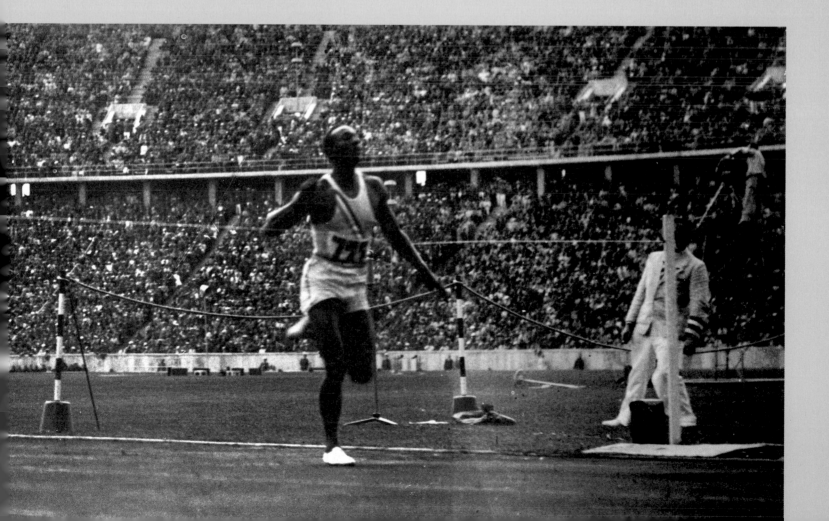

"The Americans should be ashamed of themselves, letting Negroes win their medals for them. ... Do you really think that I will allow myself to be photographed shaking hands with a Negro?"

BALDER VON SHIRACH QUOTING ADOLF HITLER,
AFTER JOHNSON WON GOLD IN THE HIGH JUMP,
JULY 12, 1936

Chicago, Illinois. On May 25, 1935, at the Big Ten meet in Ann Arbor, Michigan, Owens had set four world records in 45 minutes: the 100-yard dash, the long jump (a record that stood until 1960), the 220-yard dash, and the 220-yard low hurdles.

The men's 100-meters final was held on August 3, 1936. Owens took the lead with his first stride and hit the halfway mark almost two meters ahead of his nearest rival, Ralph Metcalfe, also of the United States, and also black. Owens hit the tape in 10.3 seconds; Metcalfe was one-tenth of a second behind.

Contrary to popular opinion, it was not Owens who was snubbed by Hitler. That dubious honor fell to Cornelius Johnson, another African American, who won the gold medal in the high jump on the opening day. When Hitler refused to shake hands with Johnson, the Olympic Committee insisted that Hitler must either shake hands with all the medalists or none of them. He opted for none, and so was "not available" when Owens won all four of his gold medals: the 100 meters, the 200 meters, the long jump, and the 4x100 meters relay.

Owens bore Hitler no ill will. "When I passed the Chancellor," he said later, "he rose and waved his hand at me, and I waved back at him. I think the writers showed bad taste in criticizing the man of the hour in Germany."

Germany emerged as the most successful nation at the games, winning 89 medals in all, 33 of them gold. But Hitler had wanted his Aryan athletes to produce total dominance. Owens returned to the United States a hero; he later worked at such jobs as sports promoter and radio disc jockey.

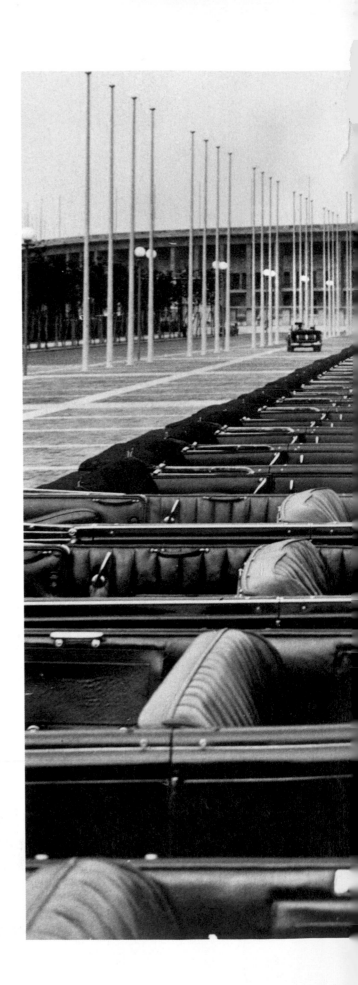

German chauffeurs with their Mercedes on parade before the opening of the 1936 games. It was their job to ferry guests of honor to and from the stadium.

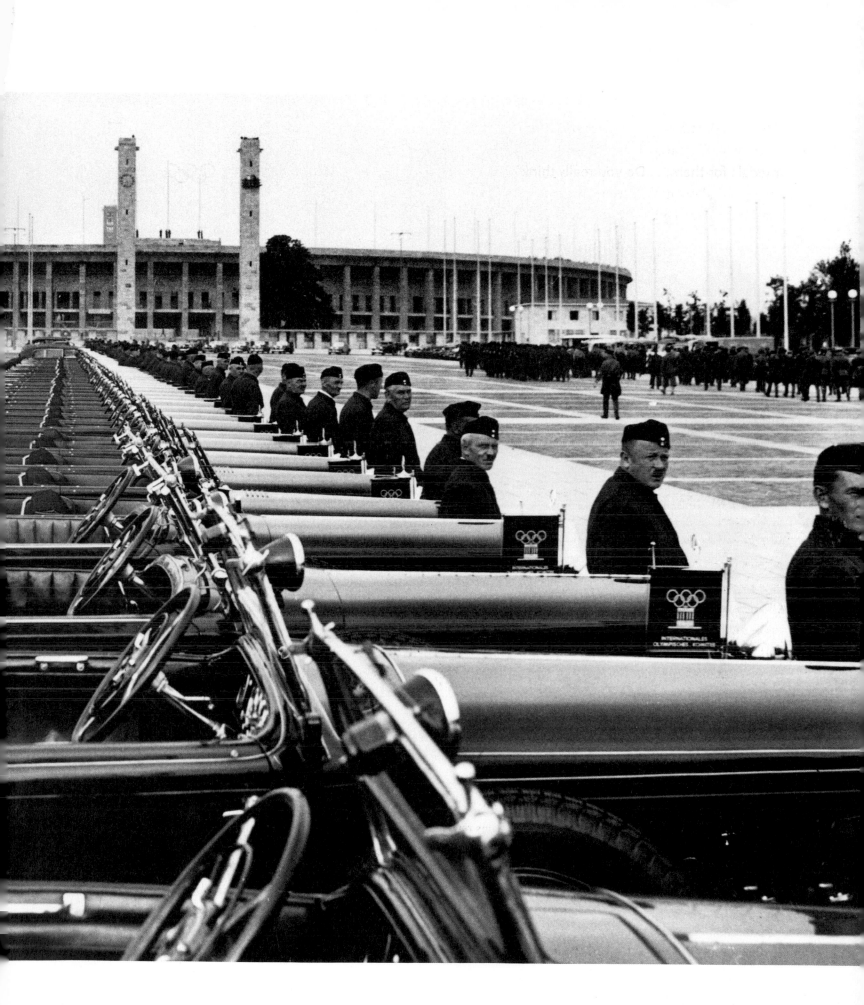

"At long last, I am able to say a few words of my own.
I have never wanted to withhold anything, but until now,
it has not been constitutionally possible for me to speak."

EXTRACT FROM EDWARD VIII'S ABDICATION BROADCAST, DECEMBER 11, 1936

[December 10, 1936]

ABDICATION OF EDWARD VIII

Edward, Prince of Wales, eldest son of Great Britain's King George V, was a handsome, charming, and problematic man. Wherever he went, crowds cheered, reporters eagerly recorded what he saw and what he said, and young women competed for his attention. On January 10, 1931, he was introduced to a young American woman named Wallis Simpson, who was by nature a flirt, and by ill luck married. Within a short time there were obvious signs of the dangerous attraction between them. In the mid-1930s, most British people regarded divorce as a shocking thing, and even an innocent party in such an affair was seen as "tainted." Then in 1936, most inconveniently, George V died, and Edward succeeded to the throne.

The Simpsons separated, and commenced divorce proceedings. Edward installed Wallis in a flat in London's Regent's Park—too close for decorum. On November 16, 1936, Edward told Stanley Baldwin, the British prime minister, that he wished to marry Wallis Simpson. Baldwin advised that such a union could not be a true marriage but only a morganatic one, hoping this would dissuade Edward. It did not. On December 2, Baldwin delivered an ultimatum. Either Edward must give up Wallis Simpson or he must abdicate. If he married her, a constitutional crisis of epic proportions would ensue. The empire, the church, and the press were all against Edward.

When news of the affair broke in the press, Edward told Baldwin that he would abdicate. The Bill of Abdication was hurriedly composed, and on December 10 Edward signed it. The following day, he broadcast to the nation, renouncing the throne and protesting his love. It was perhaps the most impressive act of his life. Within 24 hours his brother had been proclaimed King George VI, and Edward left the country. Edward and Wallis duly married, and lived a long life together.

Edward VIII's first broadcast as King, from Studio 38, Broadcasting House

Photo ops

Edward knew that he was handsome, and welcomed the attentions of professional photographers. He was not, however, at ease for the Central Press photographer sent to cover Edward's first broadcast as King. When he left England for Austria, immediately after his abdication, Edward held an impromptu photosession at Vienna Station, saying to his companions: "The photographers have had a very tough journey and they deserve some pictures. Let's turn back." Shutters clicked for five minutes, then Edward said: "Well, I guess, gentlemen, this is enough."

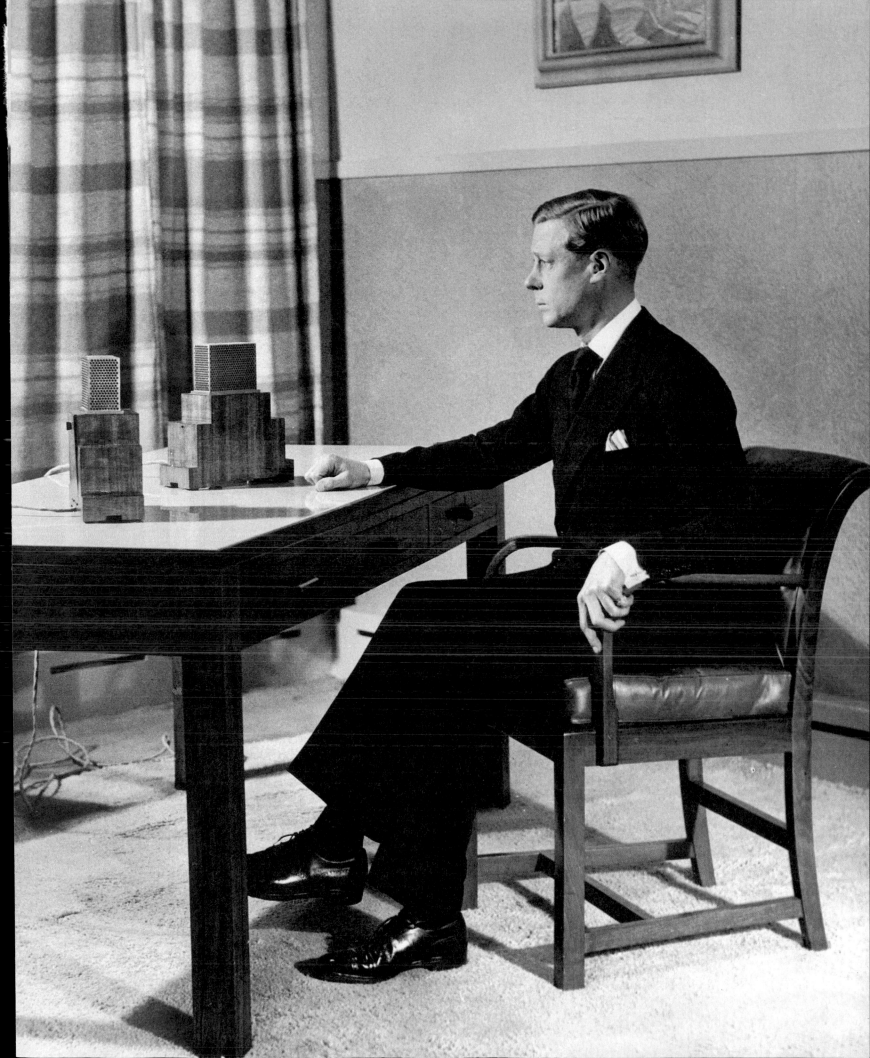

A Contemporary Note

Extract from Edward VIII's abdication broadcast, December 11, 1936:

A few hours ago I discharged my last duty as King and Emperor, and now that I have been succeeded by my brother, the Duke of York, my first words must be to declare my allegiance to him. This I do with all my heart.

You all know the reasons which have impelled me to renounce the throne. But I want you to understand that in making up my mind I did not forget the country or the empire, which, as Prince of Wales and lately as King, I have for twenty-five years tried to serve. But you must believe me when I tell you that I have found it impossible to carry the heavy burden of responsibility and to discharge my duties as King as I would wish to do without the help and support of the woman I love.

And I want you to know that the decision I have made has been mine and mine alone. This was a thing I had to judge entirely for myself. The other person most nearly concerned has tried up to the last to persuade me to take a different course.

I have made this, the most serious decision of my life, only upon the single thought of what would, in the end, be best for all.

Edward and Wallis, now Duke and Duchess of Windsor, at a photoshoot in their temporary Sussex home, September 13, 1939. The war forced them to leave France, their prior home. Edward was later appointed governor of the Bahamas.

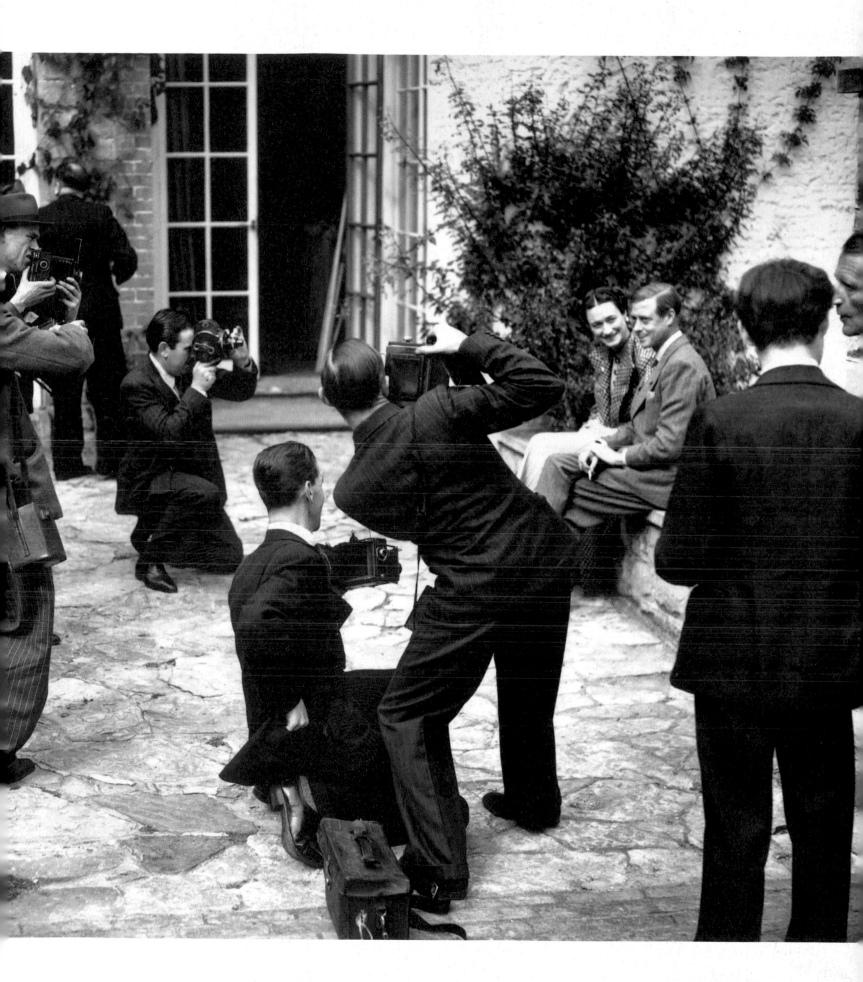

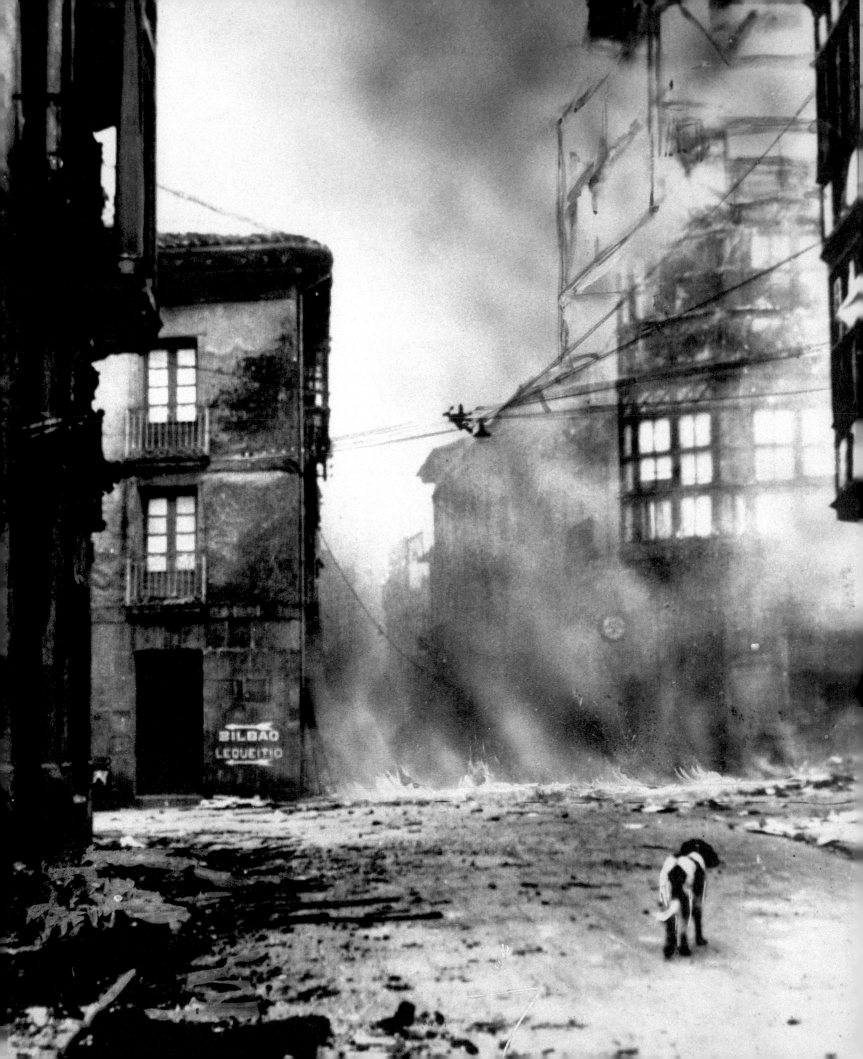

[April 26, 1937]

THE BOMBING OF GUERNICA

G uernica (Basque: Guernika) lies on the Ria de Gernika in the north of Spain, some nine miles from the Bay of Biscay. Little distinguishes it from dozens of other small towns along the Costa Vasca other than its ancient history, its importance to the Basque nation, whose cultural capital it is, and the terrible events of April 26, 1937.

At the height of the Spanish Civil War (1936–1939), Guernica was selected as the target for a bombing raid by 24 planes of the Condor Legion, a wing of Gen. Francisco Franco's Nationalist air force composed of elements of the German Luftwaffe and the Italian Aviazione Legionaria. The little town was chosen for a variety of reasons. The Nationalists claimed it stood in the way of their army's advance on the major port of Bilbao; it also had an important bridge and railroad station and a small arms factory. More relevant, perhaps, was the historical importance the town had for the fiercely independent Basques, a people whose spirit Franco was determined to break.

It was Monday afternoon. The weekly market was beginning to close down, but the square was still crowded with people. The planes appeared without warning. For three hours, bombs rained down. More than 100,000 pounds of high explosives and incendiary devices created a firestorm. Some 1,600 people—one-third of Guernica's population—were killed or wounded.

Days later, when the fires had been extinguished, the people of Guernica looked about them. The railroad station, the bridge, and the small arms factory had not been hit. Nor, miraculously, had the ancient oak tree beneath which the Basque Parliament traditionally met. It seemed that there had been no strategic reason for bombing Guernica. It was merely a practice raid for young pilots in a terrible new form of warfare.

The aftermath of the concentrated bombing attack on Guernica

Documenting the civilian toll

The images of the bombing of Guernica shocked all those who were not supporters of Franco or other Fascist leaders of the time. A wave of terror followed their publication. Many took Guernica to be a portent of the likely destruction of civilization in the next few years, with bombs raining down on every city in Europe. Those who authorized the raid, or approved it, like the German Baron von Richthofen, saw the photographs as evidence of the efficiency and destructive power of bombing civilian targets.

"The whole future of warfare lies in the employment of mobile armies ... rendered more effective by the addition of aircraft, and in the simultaneous mobilization of the whole force."

GEN. HANS VON SEECKT, CHIEF OF GERMAN ARMY COMMAND, 1928

[May 10, 1940]

NAZI BLITZKRIEG ON THE WESTERN FRONT

After the Nazi invasion of Poland in September 1939, World War II entered the phase that has become known as the Phony War. Those nations on mainland Europe that were not already under Nazi rule waited to see what would happen next. Was Adolf Hitler satisfied? Had he enough conquests? Always in the past, after swallowing another country, he had said that he had no further territorial ambitions. Was this at last true?

The answer came in spring 1940. In April, Norway and Denmark were invaded, and then, on May 10, Hitler launched his blitzkrieg against Belgium, Luxembourg, and the Netherlands, his ultimate objectives being the defeat of France and a negotiated peace with Britain. Literally meaning "lightning war," the blitzkrieg was a fearsome new military tactic, a rapid cross-country advance by massed tanks, with air support by fighters and dive-bombers. At the same time, major enemy cities were to be taken care of by concentrated bombing raids. The idea was to strike hard and quickly, cutting opposing forces into isolated pockets of limited resistance, and then to move on, giving the enemy no time to recover or plan an effective counterattack. The blitzkrieg was developed partly to avoid further trench warfare, the attritional strategy that had turned the Western Front into a mass graveyard in World War I. It could not, however, have been called a humanitarian idea.

Ironically, the tactic was the brainchild of a British soldier, Col. John Fuller, chief of staff of the British Tank Corps in 1917 and 1918. Disappointed with the way tanks had been used at that time, Fuller wrote two books, *Reformation of War* (1923) and *Foundation of the Science of War* (1926), in which he outlined a method of attack that used tanks with strong air and motorized artillery support. The books were largely ignored in Britain, but were closely studied in

German soldiers destroy the Polish border checkpoint of Sopot in 1939.

Nazi photographers produce propaganda

As serving soldiers, many official army photographers were in the advance units in the Wehrmacht's rapid progress as it invaded Poland in September 1939 and smashed its way through the Low Countries and France in the spring of 1940. As well as having ample supplies of the best quality film (including Agfacolor), they were equipped with the finest cameras in the world (including Leicas). The pictures they sent back enabled Nazi leaders to convince people at home, and much of the uncommitted world, of the invincibility of German arms.

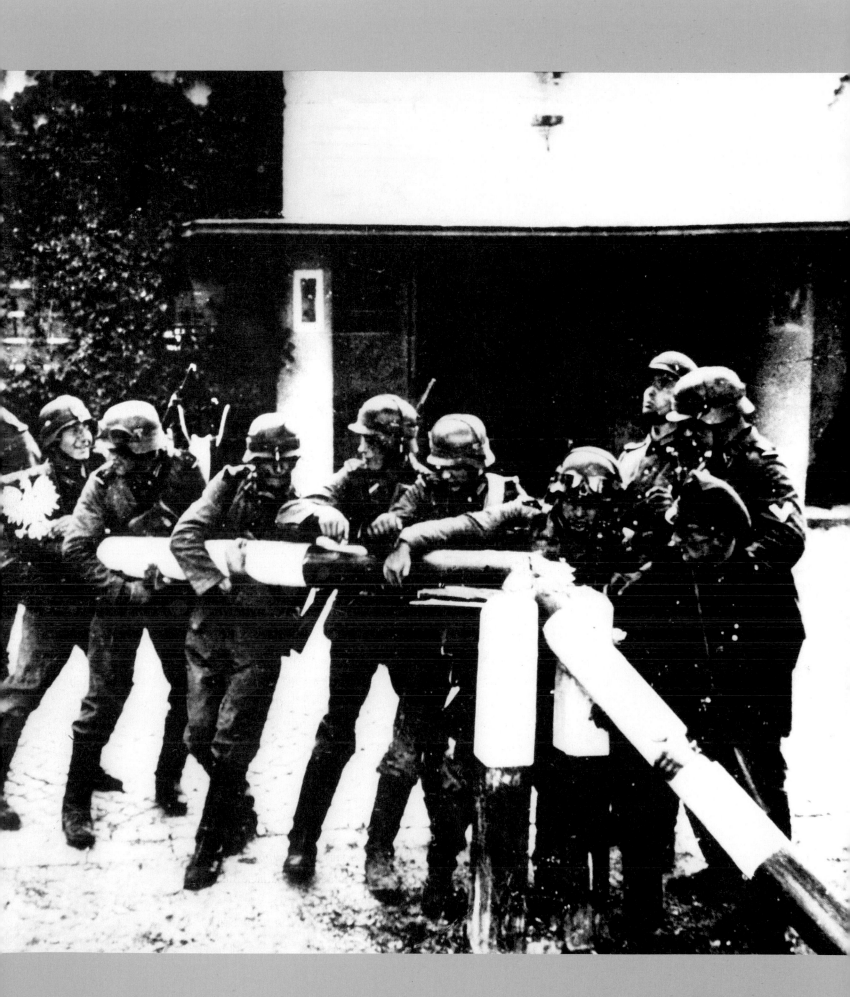

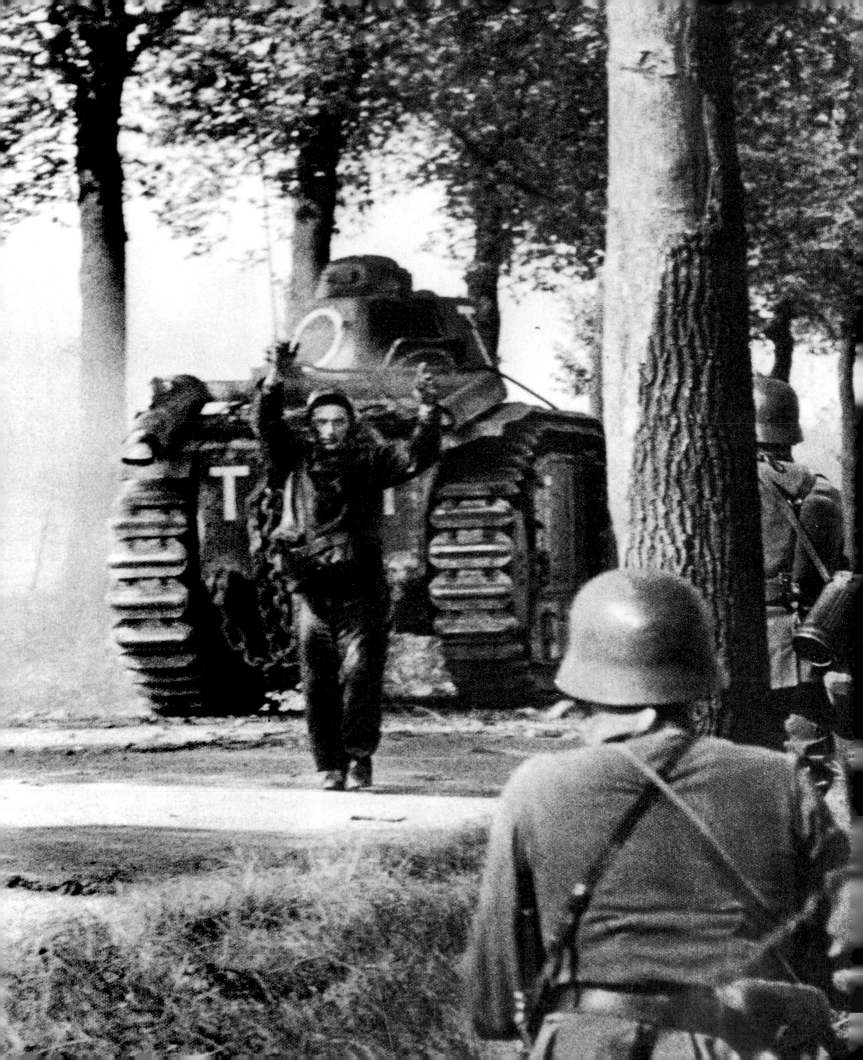

Germany. In 1928, Gen. Hans von Seeckt, the then chief of army command in Germany, wrote: "In brief, the whole future of warfare appears to me to lie in the employment of mobile armies, relatively small but of high quality, and rendered distinctly more effective by the addition of aircraft, and in the simultaneous mobilization of the whole forces." It was a concept that appealed particularly strongly at the time, for it was compatible with the terms of the Treaty of Versailles, which had severely limited the size of the German army.

The invasion of Poland, although highly successful, revealed that only the Panzer Mark IV tank had the right combination of speed, maneuverability, firepower, and reliability to carry out successful attacks. Similar to the Panzer Mark III, it was heavier, larger, and more powerful. It henceforth became the spearhead of the Nazi blitzkrieg across Europe.

On the morning of Friday, May 10, the Western Front, across which German and Allied forces had been quietly eyeing each other for six months or more, erupted in an explosion of artillery and tank fire. Units of the Wehrmacht smashed their way into the Netherlands. Others were dropped by parachute behind enemy lines. By the evening, while in London Britain's Prime Minister Winston Churchill was racing to Buckingham Palace to ask the King for permission to form a new government, the Panzer tanks had already advanced deep into Dutch territory.

However, *Fall Gelb* (Operation Yellow), as it was called, was a feint attack. The main target was France, and three days later *Fall Rot* (Operation Red) was launched—an attack through the Ardennes that broke through the French defenses at Sedan and then raced north to the English Channel, cutting off the British Expeditionary Force (BEF), the Belgian Army, and divisions of the French Army.

It was almost too successful. Some armored units of Panzers Mark I and II advanced much farther than had been intended. The BEF counterattacked near Arras with tanks that outgunned the Panzers. Only astute defensive work by German artillery under the command of Field Marshal Erwin Rommel saved the day. The British retreated to the port of Dunkirk.

Four years of bitter fighting in World War I had failed to bring about the fall of France. Now, in less than seven weeks, the German army had destroyed its old enemy. The blitzkrieg had achieved its purpose. On June 25, 1940, France surrendered.

"Gradually the speed increased. We were 500 ... 1,000 ... 3,000 yards into the fortified zone. Engines roared, tank tracks clanked and clattered. Whether or not the enemy was firing was impossible to tell in the ear-splitting noise. We crossed the railway line, and swung north.... Now we had broken through the Maginot Line and were driving deep into enemy territory ... "

GEN. ERWIN ROMMEL, LEADER OF THE 7TH PANZER DIVISION, MAY 16, 1940

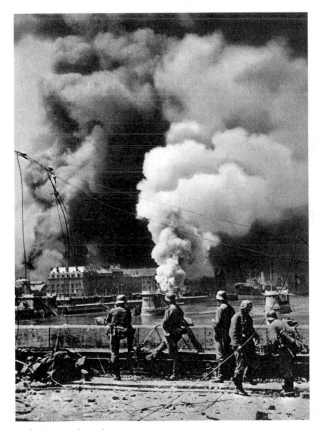

Left: A French tank crew surrenders to German troops in 1940.

Above: German troops in Rotterdam, May 1940

[September 7, 1940]

START OF THE LONDON BLITZ

The Battle of Britain began in July 1940 with the Luftwaffe, the German air force, ineffectually dropping bombs on merchant shipping in the English Channel, and ended with the last heavy bombing raid on London four months later. Some doubt that it can truly be called a battle at all, but to those people who fought in it, and to those many more who suffered and died in it, it was undeniably a battle, perhaps the pivotal engagement in the European war.

For Adolf Hitler and his air force chief Hermann Göring, it was a battle intended to destroy the British Royal Air Force (RAF), and thus open the way for a seaborne invasion of England by the Wehrmacht, Germany's army. The first stage was a series of attacks on airfields in southeast England, particularly Kent. But destroying the RAF posed problems. The RAF was equipped with better planes than the Luftwaffe (with the exception of the Me109). The battle area was covered by radar, which gave the RAF early warning of approaching raids. And the British were fighting a defensive action, which enabled them to keep their planes longer in the air in combat. Day after day, Spitfire and Messerschmitt, Fokker and Hurricane blazed away at each other in cloudless blue skies.

By early September, it was clear to Göring that the RAF would not be destroyed, and that other methods would have to be used to knock Britain out of the war. His favored role for the Luftwaffe was now the systematic destruction of London by nightly saturation bombing raids. The first of these took place on Saturday, September 7. Starting at five o'clock in the afternoon and lasting all night, the London docks were set ablaze by incendiaries. By 4:30 the following morning, the entire eastern side of the city was lit by towering flames. The Battle of London had begun.

Symbolism in photography

On the night of one of the heaviest raids of the Blitz on December 29, 1940, staff photographers from several newspapers gathered on the roof of the *Daily Mirror* building to record the destruction. The resulting photographs of St. Paul's Cathedral standing proud amid the smoke and ruins of the City of London became iconic images of the war. The British government knew the value of such images, and, although many pictures of the Blitz were censored, those of St. Paul's were hurried into publication.

St. Paul's Cathedral survives German bombing on December 29, 1940.

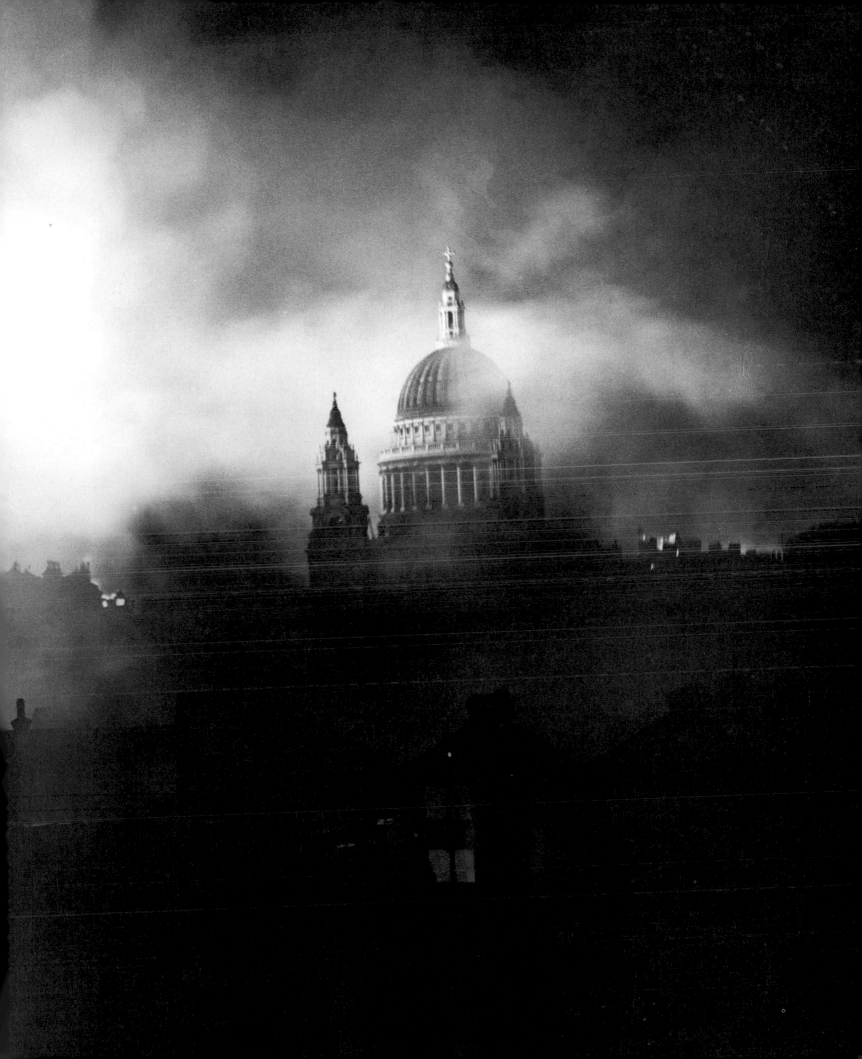

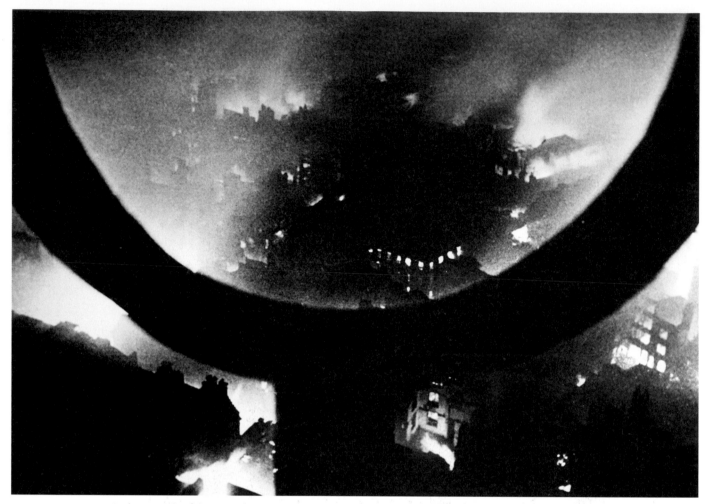

A photograph of the City of London ablaze, taken from the dome of St Paul's, December 29, 1940

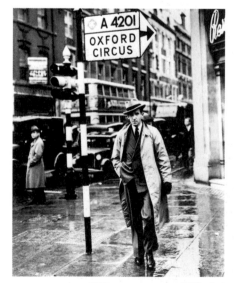

CBS correspondent Edward R. Murrow in London, 1940

It was the beginning of a long series of attacks that did not cease until May 1941. From time to time, other cities were targeted—Coventry, Plymouth, and Liverpool among them—but London bore the brunt of what became known as "the Blitz." Much of the fabric of London and other cities was destroyed. People spent night after night in primitive air-raid shelters in their back gardens or in the stations of the London Underground system—at first unofficially, later with permission. Gas and water mains were regularly cut, roads blocked by rubble, houses wrecked. Normality ceased. For a while there were fears that the inhabitants of the East End of London—where the bombing was at its worst—might rise in protest, if not revolution. But the spirit of London survived.

On May 11, there was one last raid, and then the Blitz ended as suddenly as it had started. In all, some 43,000 civilians were killed.

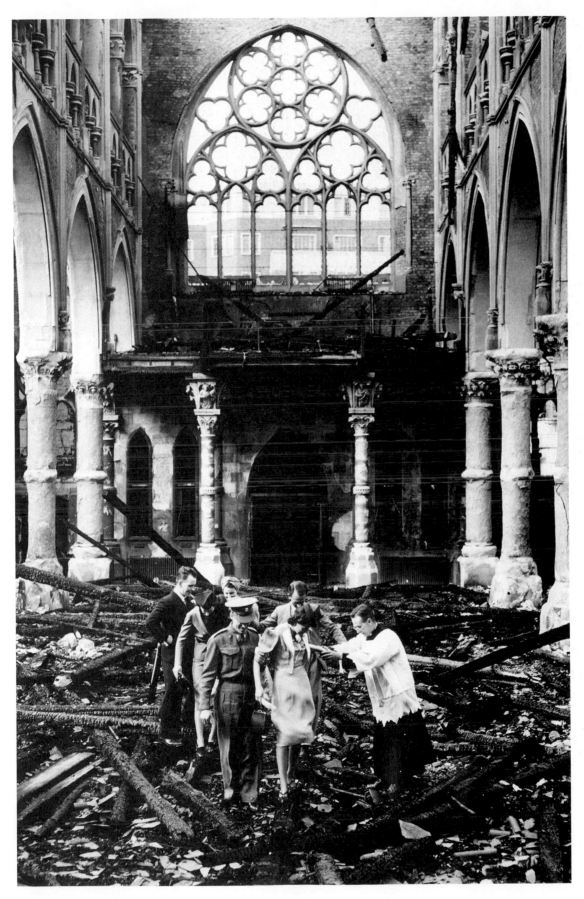

Left: A wartime wedding takes place in a ruined church during the London Blitz.

Following pages: To protect against the bombings, some 150,000 Londoners slept each night in the underground railway system.

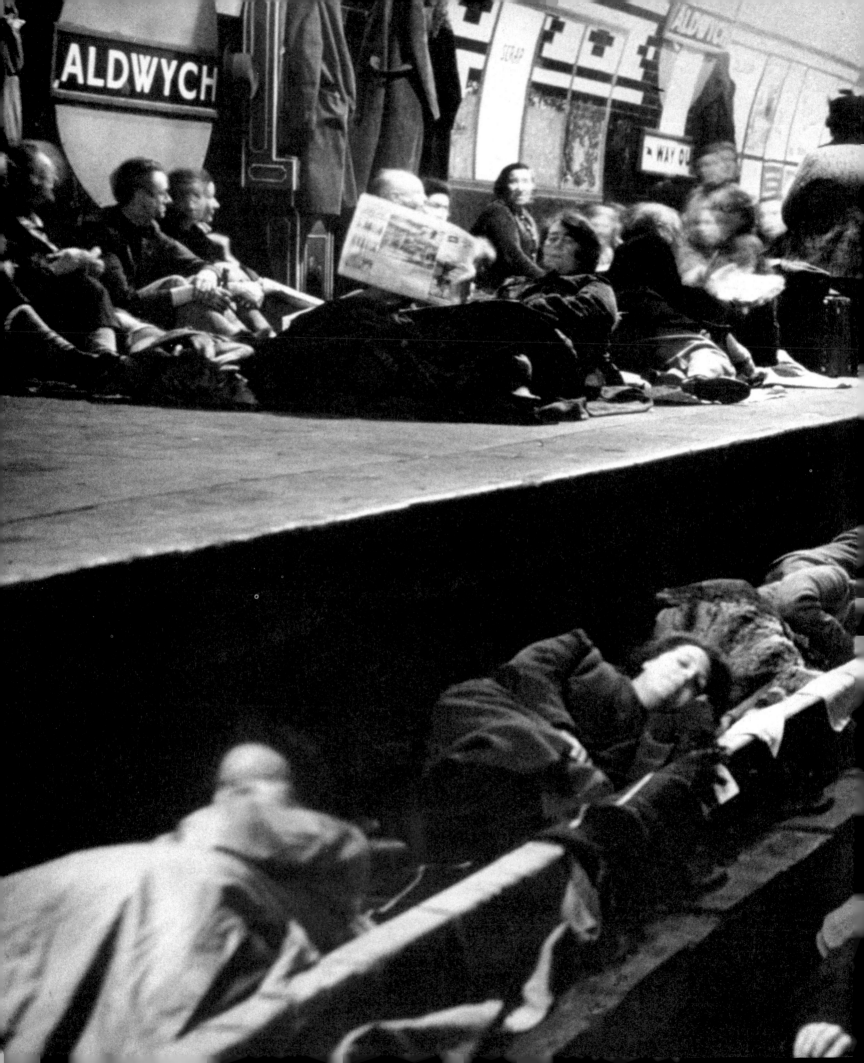

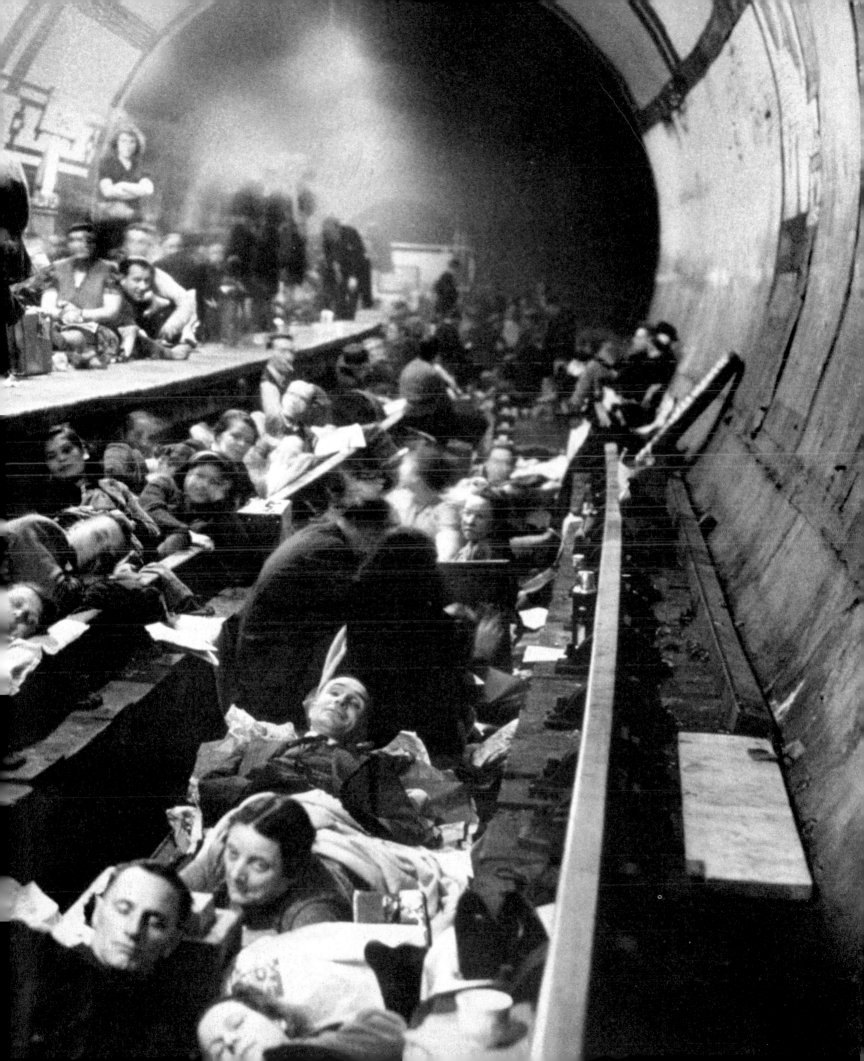

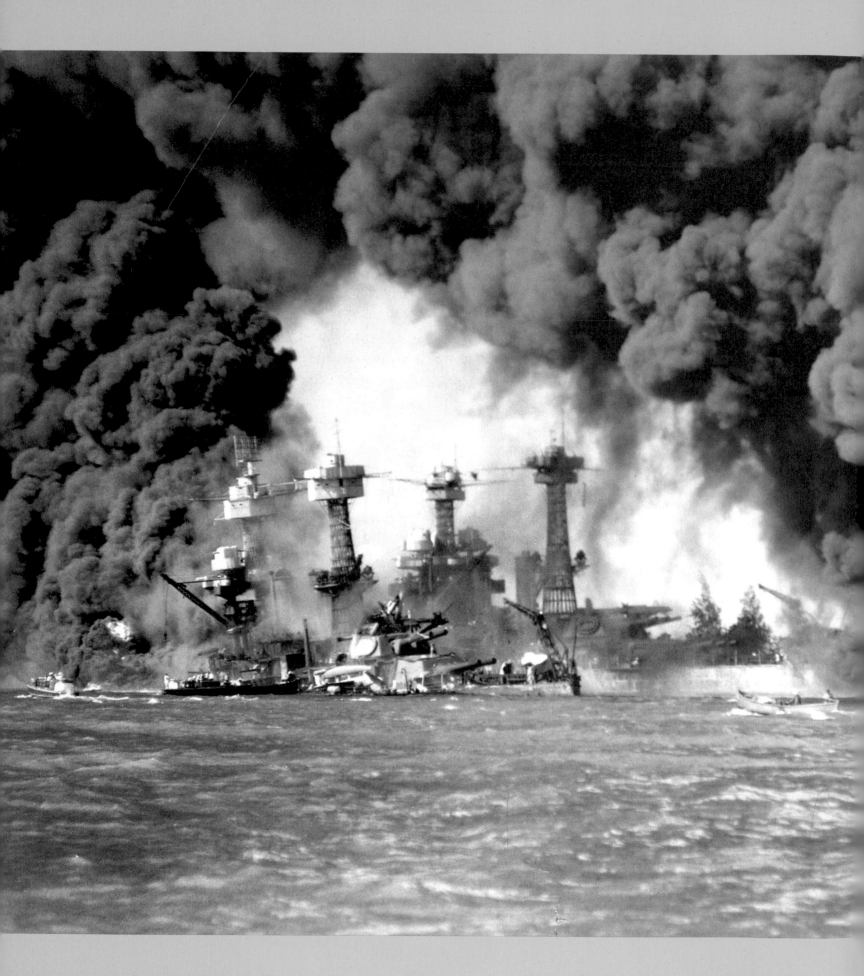

"The bodies of the dead were thick, and badly burned men were heading for the quarterdeck, only to fall apparently dead or badly wounded. Charred bodies were everywhere ... "

MARINE CORP. E. C. NIGHTINGALE,
A SURVIVOR FROM THE U.S.S. *ARIZONA*, DECEMBER 7, 1941

[December 7, 1941]

JAPANESE FORCES ATTACK PEARL HARBOR

In September 1941, the Japanese military drew up detailed plans for an attack on U.S. bases in Hawaii, and gave the Premier of Japan, Fumimaro Konoye, six weeks to reach agreement with President Franklin D. Roosevelt on their plans for imperial expansion in the Pacific. On October 15, after no deal had been made with the United States, Konoye resigned. Hideki Tojo, Japan's bellicose war minister, replaced him as premier.

At dawn on December 7, some 360 planes took off from the decks of six aircraft carriers, and headed for Pearl Harbor. At 7:53 a.m. local time, the first wave of planes reached the target and began the attack, flying low over Ford Island and the U.S. fleet at anchor on Battleship Row. Taken by surprise, the United States lost 8 battleships, 3 destroyers, and 11 smaller warships. In addition, 200 U.S. military aircraft were destroyed, most of them on the ground. More than 2,400 U.S. service personnel and civilians were killed, 1,177 of them dying aboard the U.S.S. *Arizona* when the battleship blew up and sank in the harbor ten minutes after the attack began. The losses would have been higher except for the fact that it was a Sunday—many people were at church or off duty. The mayhem and horror lasted just two hours before the raiders returned to their carriers. Japanese losses were light—38 planes and 5 midget submarines. There is some evidence that Roosevelt had been given 24 hours' warning of the impending attack, and that an attempt to alert the garrison at Pearl Harbor had failed to get through due to technical difficulties. A few hours later, the Japanese launched attacks on the Philippines, Guam, Midway, Hong Kong, and the Malay Peninsula.

Back home, on the afternoon of that first Sunday in December, radio listeners across America were settling down in readiness for the

U.S.S. *West Virginia* and *Tennessee* ablaze in Pearl Harbor, December 7, 1941

Mustering support

The Roosevelt Administration was happy to give the U.S. press access to images of Japanese infamy at Pearl Harbor. For months, Roosevelt had been seeking to sway American opinion into supporting the war. Now, within hours of publication, the policy of American isolationism had virtually died. Since Japanese pictures of the same raid were published simultaneously in Tokyo, Pearl Harbor remains one of the few actions in World War II where almost identical images were used in support of the war effort by both America and Japan.

"The Captain doubled up with a groan...
Just then the U.S.S. *Arizona*'s
forward magazines blew up with
a tremendous explosion. ... "

Lt. Comm. T. T. Beattie, U.S. Navy Navigator,
U.S.S. *West Virginia*, December 7, 1941

regular concert by the New York Philharmonic Orchestra, broadcast coast-to-coast. Seconds before it was due to begin, as the orchestra was tuning up, a tense voice announced: "The Japanese have attacked Pearl Harbor, the United States naval base on Oahu Island in the Hawaiian Islands."

The President's public reaction to Pearl Harbor left no doubt as to his outrage. He famously described December 7, 1941, as "a day which will live in infamy," but promised, "We will gain the inevitable triumph, so help us God." The United States immediately declared war on Japan. The attack on Pearl Harbor was devastating, but the U.S. was lucky in two respects: First, the oil storage tanks at Oahu survived, allowing what was left of the U.S. fleet in the harbor to put out to sea. Second, the U.S. aircraft carriers had left Pearl Harbor a few days earlier and were thus untouched; these ships would form the backbone of U.S. recovery in the Pacific.

The historical significance of the attack on Pearl Harbor is immense. It was perhaps the most influential day in the 20th century. The entry of the United States into World War II gave the enemies of Fascism an "inevitable" victory, and that meant victory for the Soviet Union and Western democracy. Without Pearl Harbor, it is possible that Britain would have made peace with Hitler, and that the Soviet Union would also have been forced to come to terms. The Cold War might never have happened. The development of the A-bomb would have been delayed. The states of Eastern Europe would have become satellites of the Nazis, rather than the Communists. The story of the last 70 years certainly would have had a different beginning, and maybe a very different ending.

A Japanese plane takes off from the deck of an aircraft carrier, heading for Pearl Harbor, December 7, 1941.

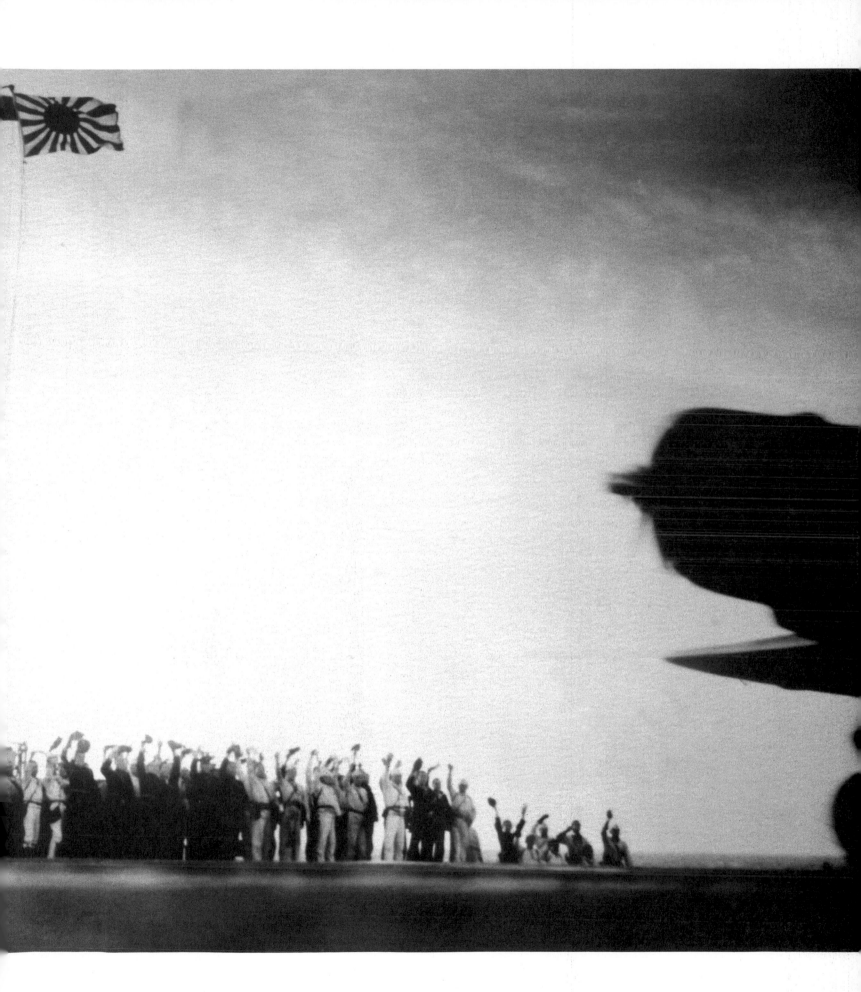

"A rocket rising into the air signalled the attack.
The cries of 'Forward!' and 'For the Fatherland!' resounded.
A fierce bloody battle began which lasted all day. ... "
SOLDIER WITH RUSSIAN 5TH TANK CORPS AT STALINGRAD, 1943

[January 31, 1943]

SURRENDER AT STALINGRAD

In June 1941, during World War II, Adolf Hitler launched Operation Barbarossa to smash the Soviet Union and give the Nazis mastery of virtually all Europe. The Germans thought that Russia would capitulate as easily as France and Poland had done. At first, all went well for the Germans. By September 1942, the Russian city of Stalingrad was besieged by the German Sixth Army under Gen. Friedrich von Paulus. To Joseph Stalin, leader of the Soviet Union, this was the critical moment in the Great Patriotic War, a test of the resolve of the Bolshevik Revolution, and of the very loyalty of the Soviet people. In reality, it became a living hell for the millions of soldiers and civilians involved.

The Russian winter bit hard, and the besiegers became the besieged. Von Paulus requested permission to withdraw and save his men. Hitler refused the request. Starving, freezing, dying in their thousands, the Wehrmacht fought on. In Stalingrad, a civilian army joined Soviet troops, as men, women, and children battled through the rubble to save what was left of their city. The battle was perhaps the bloodiest in history with as many as 1.5 million casualties.

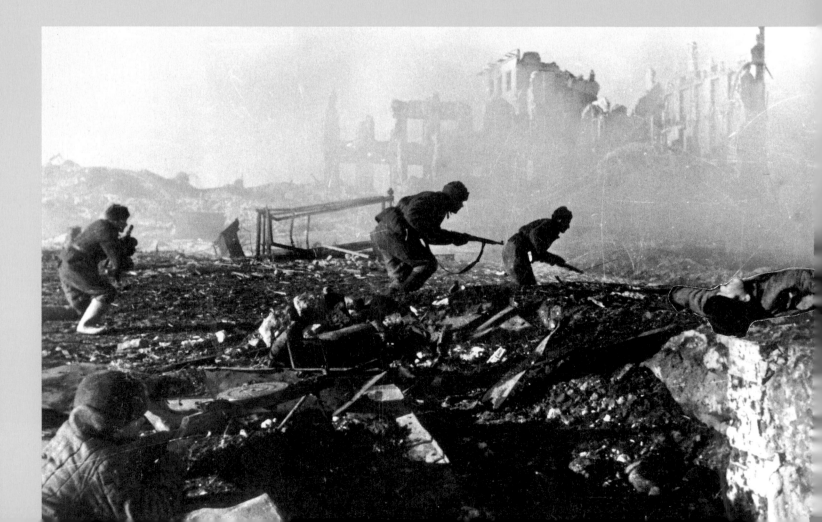

By 1943 von Paulus had had enough. More than 90,000 of his men had died from cold and hunger. In the last three weeks of the fighting, another 100,000 had been killed. On January 31, he surrendered. The siege was over.

Germany's failed siege of Stalingrad was a turning point in World War II. Hitler's generals never trusted him again, and the Soviet Army began its inexorable advance on Berlin. Germany never recovered and its weakened defences failed to cope with the Allied invasion of 1944.

A photo composite by Georgi Zelma of Soviet troops at Stalingrad

Soviet propaganda

Georgi Zelma began work as a professional photographer in 1924, for the Russfoto Agency. Over the next 20 years he traveled throughout the Soviet Union, chronicling the rapid development of Soviet industry and agriculture. During World War II, he was a frontline correspondent for *Izvestia*, and became well known for his images of the Battle of Stalingrad—several of which were doctored to provide powerful propaganda material. Here, three images have been combined—the ruined buildings in the background, the attacking Soviet soldiers, and the civilian corpse in the foreground.

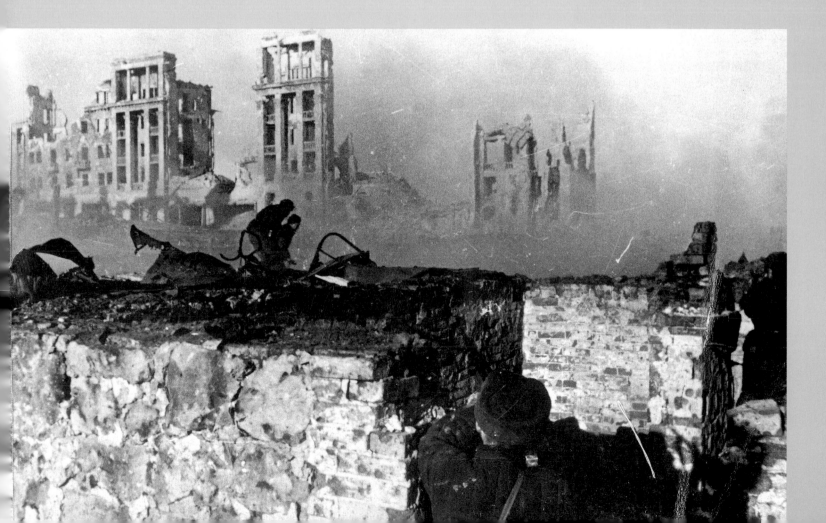

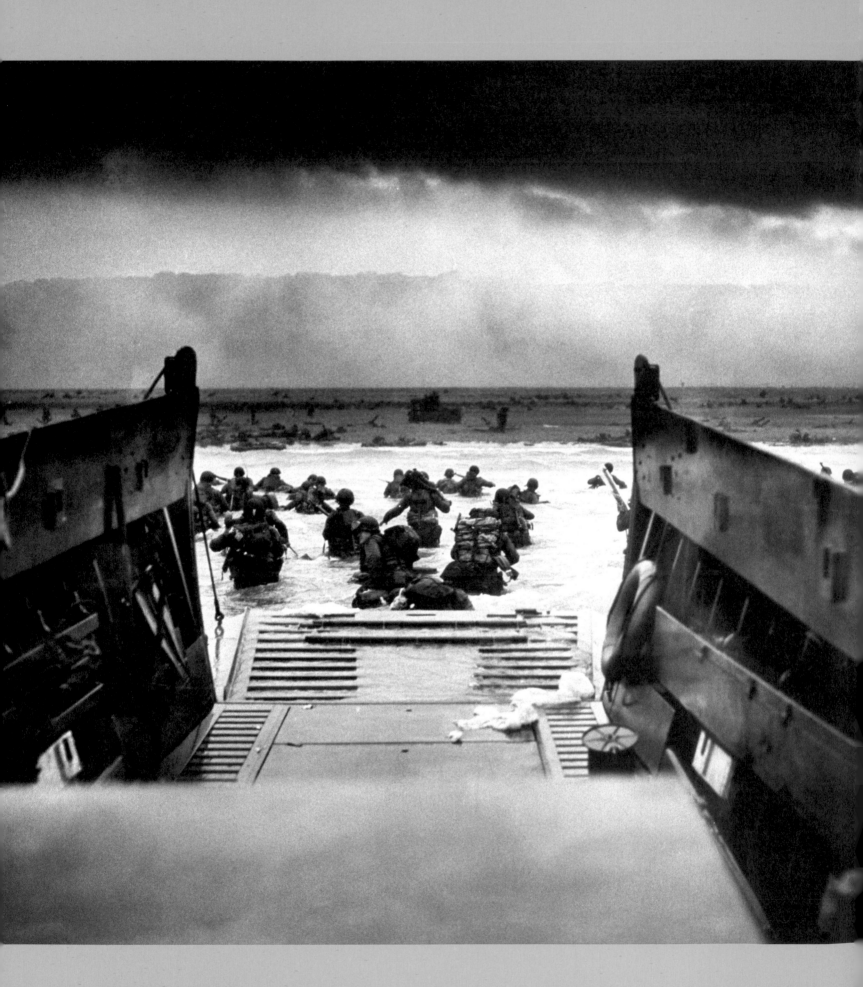

"You are about to embark upon the Great Crusade. ...
The eyes of the world are upon you. The hopes and progress of
liberty-loving people everywhere march with you."

EISENHOWER'S MESSAGE TO ALLIED TROOPS ON THE EVE OF D-DAY, JUNE 5, 1944

[June 6, 1944]
D-DAY NORMANDY LANDINGS

German High Command knew that a massive Allied invasion of France was imminent, but very few knew precisely where it would take place. Estimates varied from the Pays Basque in the southwest of France to the Pas de Calais in the northeast. To the defending Germans, the latter seemed the most likely place—where the English Channel was at its narrowest and where the least warning would be given. General Eisenhower, however, chose Normandy, where the beaches were wider and where the large port of Cherbourg could accommodate the warships escorting the assault craft.

The invasion, code-named Operation Overlord, was set for June 5, 1944, when tide, weather, and moonlight would be at their most favorable. Success was by no means a foregone conclusion. The invading troops would be wading through heavy seas in the face of strong defenses manned by crack German divisions, and it was expected that the Luftwaffe would be making sweeping strikes. All was in place when a fierce storm blew up, delaying Overlord for 24 hours.

By 0400 hours on June 6, the storm had abated. Airborne troops were dropped behind the beaches, and at 0600 hours the first U.S. seaborne troops hit the beach. The British followed one hour later. Resistance was fierce. At Omaha Beach, the Americans suffered 2,000 casualties on the first day, mainly from machine-gun and mortar fire. Landing craft, pierced by shells, sank fully manned. Fierce tides carried other craft more than two miles from their destination. All day long the slaughter and the confusion continued. When night came, some 156,000 troops had been landed.

That night, the BBC broadcast: "Under the command of General Eisenhower, Allied naval forces, supported by strong air forces, began landing Allied armies on the northern coast of France."

Robert F. Sargent's iconic picture of dawn on Omaha Beach, D-Day

Operation Overlord

It was the most photographed military operation of all time—from loading the transport ships in southern England to the assault on the Normandy beaches, from the scramble to establish a foothold to the return of the wounded back to the ships. Photographers such as Sargent, Steck, Bacon, Weintraub, Wall, Moore, Capa, Nehez, McCombe, and many more captured every aspect of Operation Overlord—giving the censors back home a hard time deciding what images to release and what to withhold.

"So I was hiding out in the heaps of dead bodies
because in the last week when the crematoria didn't function,
the bodies were just building up higher and higher."

BART STERN, A SURVIVOR OF AUSCHWITZ, JANUARY 27, 1945

[April 11, 1945]

U.S. TROOPS LIBERATE BUCHENWALD

There was nothing new about concentration camps. The British had herded Afrikaaner families into dozens of camps in the Second Boer War (1899–1902). In the Soviet Union in the 1930s, Joseph Stalin had established many such camps to detain "reactionaries." What made the Nazi camps so infamous was the combination of efficiency and sadism with which they were run.

In the beginning, the Nazis used them as rural prisons for those who did not fit into the system—trade unionists, gypsies, homosexuals, communists, liberals, Jews, and others considered racially "unfit." Within a short time, however, they became places of death and experimentation, and, finally, many of them became the settings for the "Final Solution," the attempt to exterminate every Jew in the Nazi empire.

There had long been rumors about what took place in Belsen and Treblinka, Dachau and Ravensbruck. Early in 1945, as the Soviet Red Army advanced westward, the stories were substantiated by discoveries made upon the liberation of three extermination camps in Poland—at Majdanek, Sobibor, and especially Auschwitz. It was not until April that the Western Allies had any firsthand experience of the horrors of the concentration camps, where starving and disease-ridden people had been systematically gassed.

On April 4, a unit of the Fourth Armored Division of the U.S. Third Army reached a concentration camp at Ohrdruf, in Thuringia, central Germany. It had been abandoned. A week later, on April 11, troops of the U.S. Fourth Army 12th and 22nd Infantry Regiments came to Buchenwald, near Weimar. It was not empty. For months, prisoners had been dying at the rate of 150 a day. Truckloads of corpses awaited burial. The Nazi SS guards had fled. There was no food, no medicine, and little water. All that remained were walking skeletons, the collective evidence of man's inhumanity to man.

Medical stations

When the extermination and concentration camps were liberated toward the end of the war, units from the Allied and Soviet armies set up medical stations to process and care for the former occupants. Almost all the prisoners were desperately malnourished, and a majority were also suffering from TB, pneumonia, or other diseases—many of which subsequently proved fatal. The system of medical records introduced included photographic cards of the victims, such as this young boy in Auschwitz.

Блейер Стефан 14 лет из Венгрии
(N В.14615) Алиментарная дистрофия II степ.

Russian medical card: Blayer Stephan, 14 years from Hungary, No. B14615, Alimentary dystrophy 2nd degree.

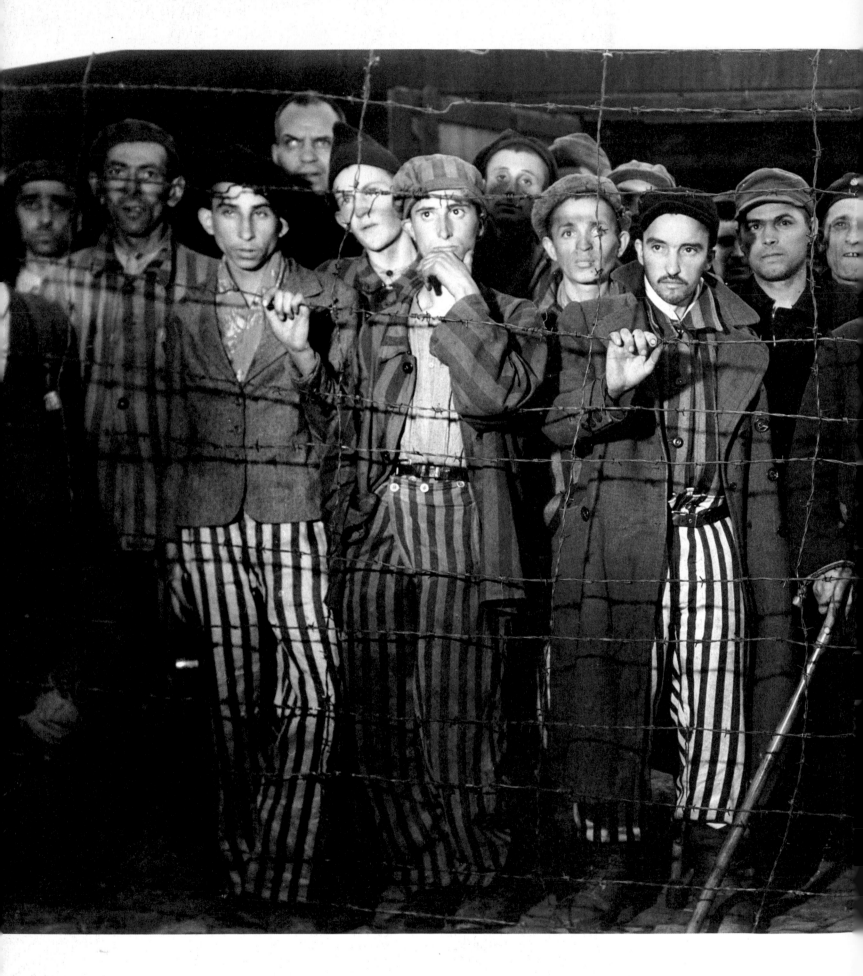

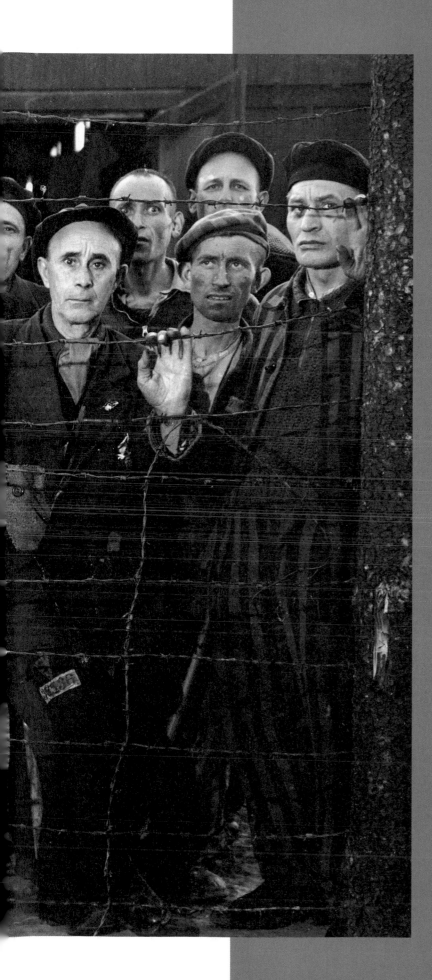

A Contemporary Note

Extract from broadcast report by CBS reporter Edward R. Murrow, April 16, 1945:

There surged around me an evil-smelling stink, men and boys reached out to touch me. They were in rags and the remnants of uniforms. Death already had marked many of them, but they were smiling with their eyes. I looked out over the mass of men to the green fields beyond, where well-fed Germans were ploughing. ...

As we walked out into the courtyard, a man fell dead. Two others, they must have been over 60, were crawling toward the latrine. I saw it, but will not describe it.

In another part of the camp they showed me the children, hundreds of them. Some were only six years old. One rolled up his sleeves, showed me his number. It was tattooed on his arm. B-6030, it was. The others showed me their numbers. They will carry them till they die. An elderly man standing beside me said: "The children—enemies of the state!" I could see their ribs through their thin shirts. ...

Murder had been done at Buchenwald. God alone knows how many men and boys have died there during the last 12 years. Thursday, I was told that there were more than 20,000 in the camp. There had been as many as 60,000. Where are they now?

If I have offended you by this rather mild account of Buchenwald, I'm not in the least sorry.

Margaret Bourke-White's study of bewildered prisoners in Buchenwald facing the U.S. troops who had come to liberate them in April 1945

"At Los Alamos there was no moral issue with respect to working on the atomic bomb. Everyone was agreed on the necessity of stopping Hitler and the Japanese from destroying the free world."

JOSEPH O. HIRSCHFELDER, CHEMIST AT LOS ALAMOS, *REMINISCENCES OF LOS ALAMOS, 1943–45* (1980)

[August 6, 1945]

ATOMIC BOMB DROPPED ON HIROSHIMA

Even before the outbreak of World War II, there were those who believed that the Nazis were developing an atomic bomb. It was decided that any Allied response should be sited in the United States, out of reach of German bombers.

The bulk of the research, named the Manhattan Project, took place in Los Alamos, New Mexico. There, under the direction of Dr. Robert Oppenheimer (1904–1967), an international team of scientists and engineers worked around the clock developing two bombs. It was very secret work. Everyone involved carried false driving licenses, and went under assumed names. They were allowed no personal contact with their families.

By summer 1943, two things were clear: The tide of war had turned in Europe, with the Allies heading for victory; and the Nazis had fallen behind in the race to produce the first atomic bomb. The Manhattan Project proceeded apace, and on July 16, 1945, the first test explosion of an implosion-type bomb was carried out in the New Mexico Desert and proved a success. Two bombs were then prepared: the gun-type, uranium-based Little Boy, named for President Franklin D. Roosevelt, and the implosion-type, plutonium-cored Fat Man, named for British Prime Minister Winston Churchill.

The war in Europe had already been won by the Allies. The war in the East was entering its final phase. During the grueling fightback in the Pacific, however, U.S. losses had been horrific, and there was no doubt that the Japanese would defend their homeland to the very last. Military advisers suggested that using the atomic bomb would bring the war to a swift end, and thus save many lives. Politicians believed that the bomb had to be used, if only to convince Congress that it had received value for the $2 billion it had spent on the Manhattan Project.

An Eisenstaedt photo of a mother and child in the wreckage of Hiroshima

Alfred Eisenstaedt: A master portraitist

Alfred Eisenstaedt was 14 when he took his first photographs with a folding Eastman Kodak camera, and 29 when he sold his first picture. From then on, he rapidly developed into a recognized master of the camera. For 30 years, from 1936, he was a staff photographer for *Life* magazine, where he worked alongside Margaret Bourke-White. Although he often used a Leica or other 35mm camera, he took many of his famous spur-of-the-moment portraits with a Rolleiflex, as it did not have to be raised to the eyes. This photograph of mother and child was taken four months after the bomb landed on the city of Hiroshima.

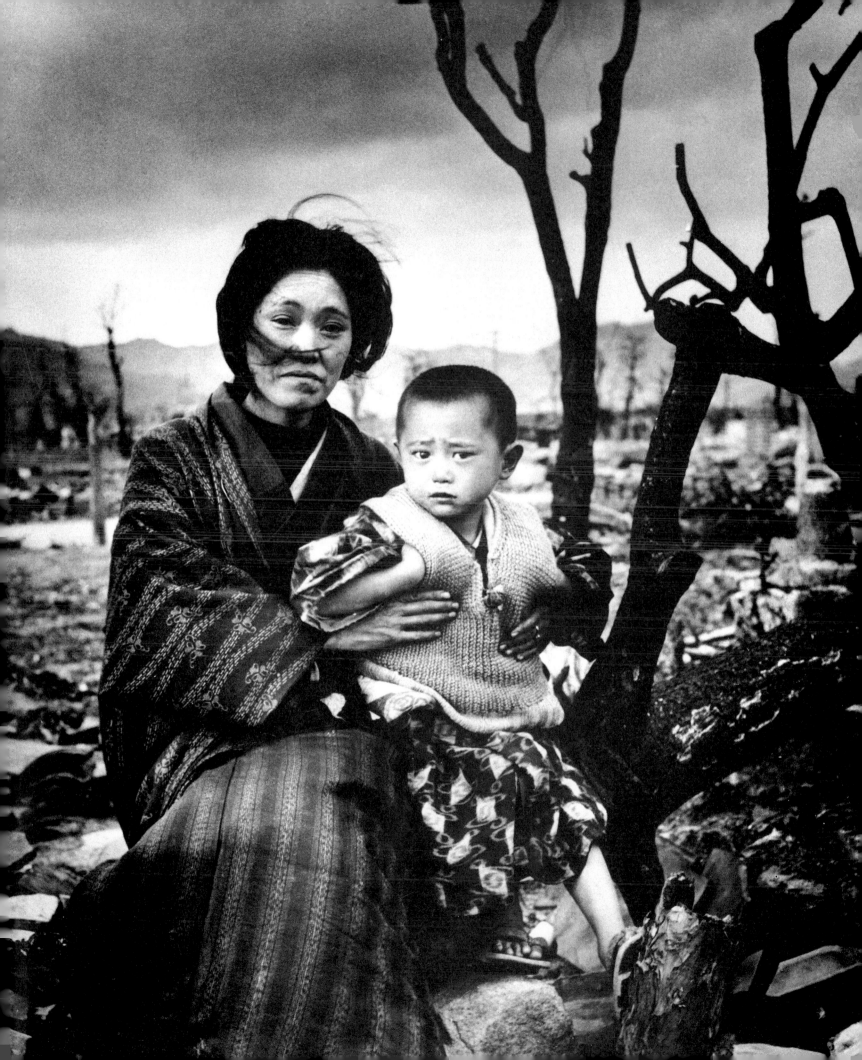

And so, on August 6, 1945, the B-29 Superfortress *Enola Gay*, named after the mother of its commanding officer, Col. Paul W. Tibbets, Jr., took off from the Marianas and headed for Hiroshima. The bomb on board was the Little Boy, the equivalent in explosive power to 12,000 to 15,000 tons of TNT. At 0815 hours local time, the bomb was released. The crew reported that they saw a column of smoke rising, and intense fires springing up all over the city below. The tail gunner described it as "like bubbling molasses down there … the mushroom is spreading out … it's like a peep into hell."

The resulting shockwave and firestorm killed some 80,000 people instantly, including 23 U.S. prisoners of war. Cyclonic winds and radioactive rain killed more. The final death toll for citizens of Hiroshima is reckoned to be 140,000 out of a population of 350,000. An area of five square miles was devastated.

Three days later, the Fat Man bomb was dropped on Nagasaki. Japan surrendered to the Allies on August 14, 1945.

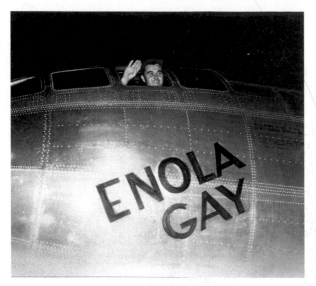

Radar operator Richard Cannon's photo of Col. Paul W. Tibbets before takeoff in the *Enola Gay*

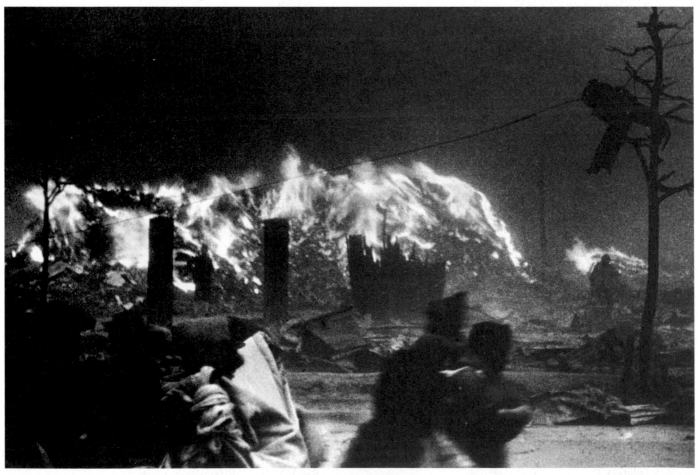

Japanese refugees flee the fires that followed the nuclear bombing of Hiroshima.

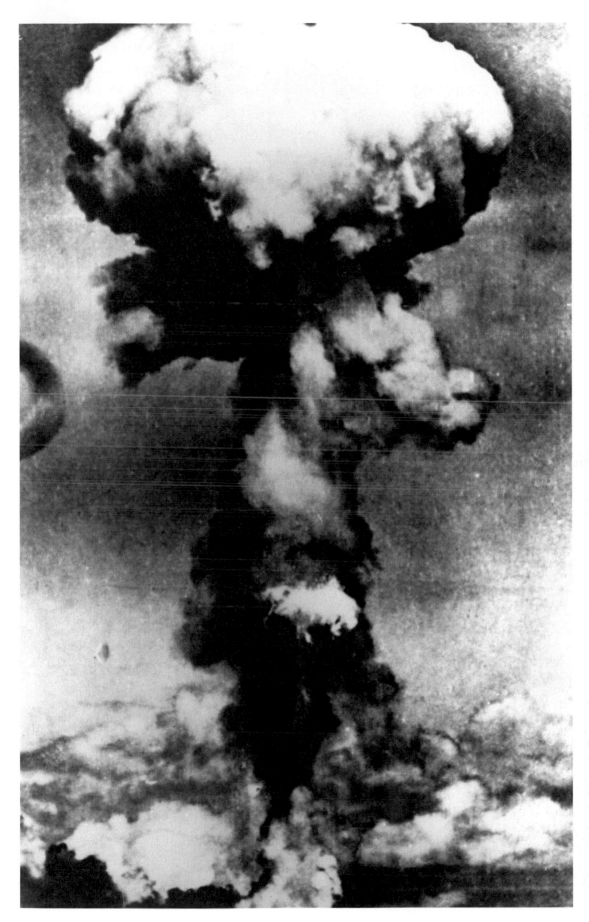

An aerial photograph of the mushroom cloud rising from Hiroshima, August 6, 1945. Tibbetts knew the weapon he carried on his plane that day was special. No one, however, knew the level of destruction that would result from a nuclear explosion on a crowded city.

[August 15, 1947]

THE PARTITION OF INDIA

Since the 1920s, successive British governments had been promising Indian independence, but not delivering it. The defeat of the British by the Japanese in the early 1940s had irreparably damaged British prestige in the eyes of India's 400 million people, and their demands for independence had intensified.

By the 1940s there were strikes, riots, acts of terrorism, and displays of active and passive resistance. Everyone, it seemed, wanted independence: Sikhs, Kashmiris, even the ancient princedoms that had made their separate treaties with the British. But despite growing opposition, still the British delayed the inevitable.

Two events changed all this. The first was Prime Minister Winston Churchill's defeat in the general election of 1945, and his replacement by Clement Attlee. The second was the arrival in New Delhi of a new viceroy in the spring of 1947. He was Lord Louis Mountbatten—young, eager, self-confident, and determined. Mountbatten was well aware of the problems he faced. Sweeping caution aside, on June 3, Mountbatten announced that the British would withdraw from India on August 15, come what may. The operation was code-named "Plan Balkan." It was a brave and brilliant decision, although it ensured that, for a while at least, India would be plunged into chaos as Mahatma Gandhi had predicted. The Muslim leader Mohammed Ali Jinnah, too, feared that the country would be destroyed.

It almost came to that. In the first of the world's modern religious wars, hundreds of thousands of innocent people were slaughtered in Hindu–Muslim conflict. In the midst of this bloodshed, however, the British at last kept their word. At 8:30 a.m. on August 15, the Union Jack was hauled down. The British Raj (rule) in India was over. India was now separated into two new countries: one predominantly Hindu—India—the other Muslim—Pakistan.

Chitpur Road, Calcutta, 1946. Vultures feed on Muslim and Hindu corpses.

India's division

This period in India was a golden age of black-and-white photography, if such a thing is possible. Many of the images of the mass migration of Hindus and Muslims in the period immediately before and after the partition of India have an almost rhapsodic grandeur. Others are dark, images of hate and death. "The way to the promised land was lined with graves," wrote the photographer Margaret Bourke-White, seen by many as the greatest chronicler of this frenzied time in history.

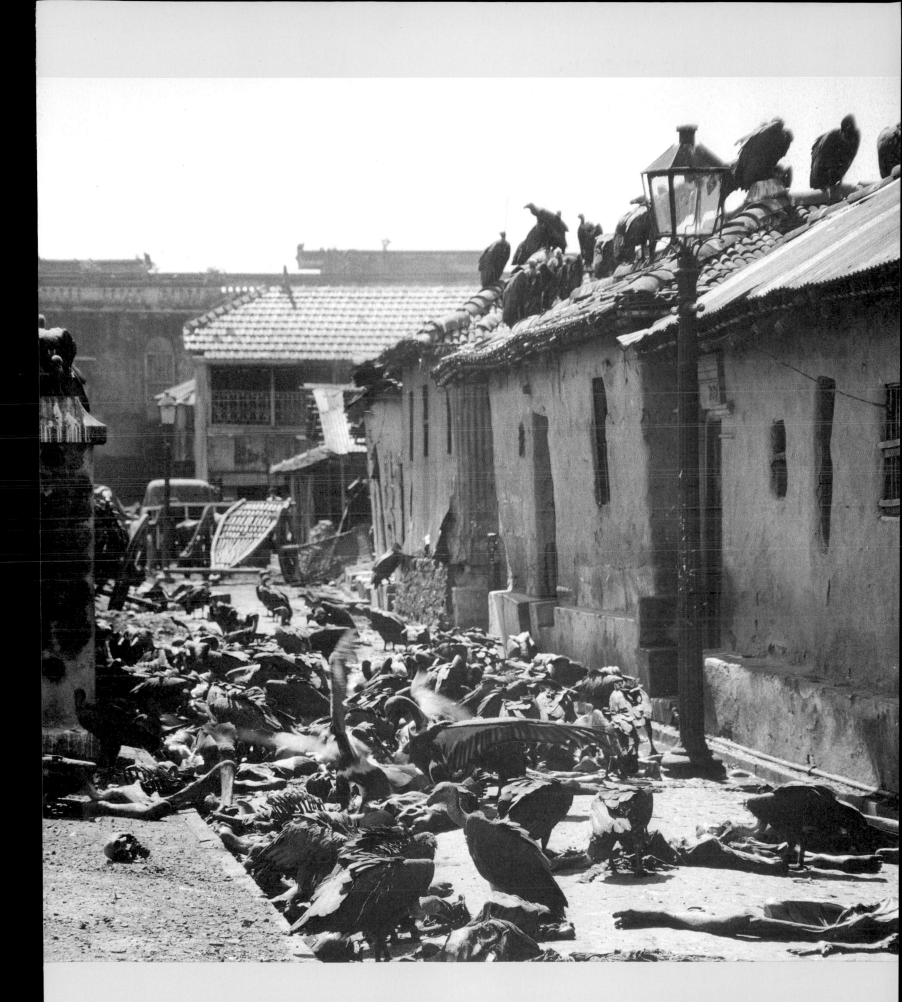

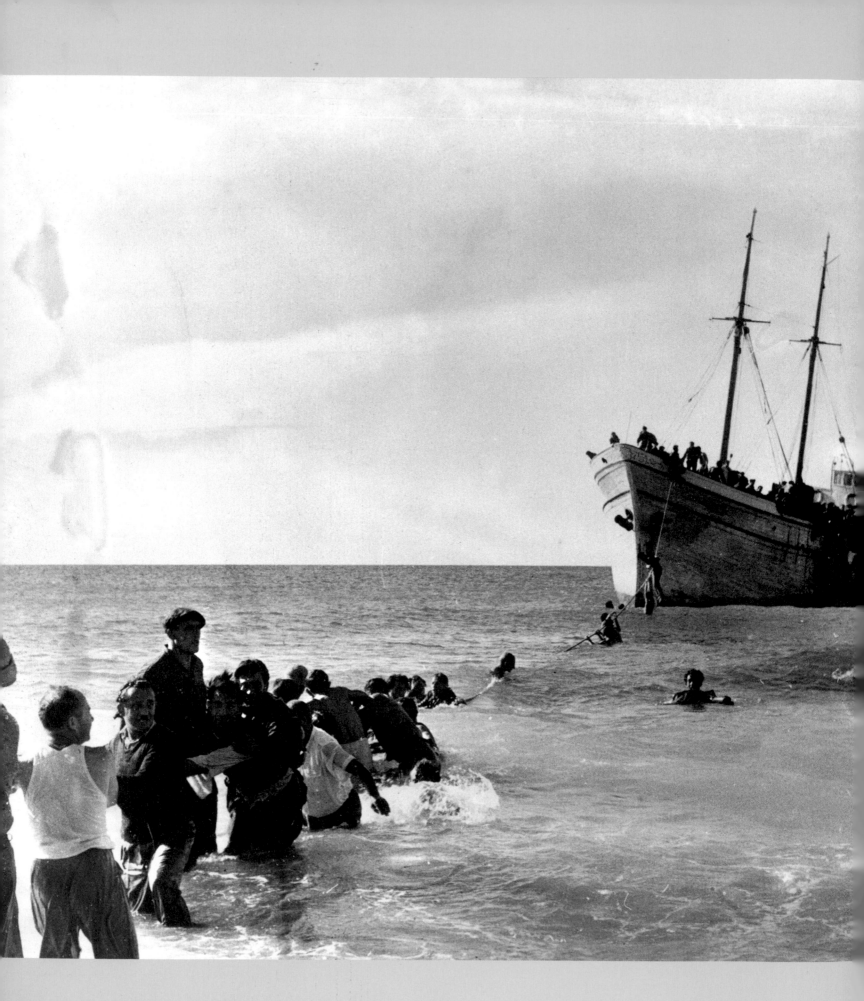

[May 14, 1948]

STATE OF ISRAEL PROCLAIMED

I n 1897, the First Zionist Conference had declared its aim "to establish a home for the Jewish people in Eretz-Israel ['The Land of Israel,' then known as Palestine], secured under public law." It was always likely to be a struggle.

Twenty years later, British Foreign Secretary and former Prime Minister Arthur Balfour issued what became known as the Balfour Declaration: "His Majesty's Government views with favor the establishment in Palestine of a national home for the Jewish people." As a consequence of this statement, Britain was granted a mandate over Palestine by the League of Nations, which was possibly what Balfour wanted—the establishment of a British buffer zone between the French in Syria and the Suez Canal.

The British Mandate persevered unhappily for 25 years, but the appalling persecution and slaughter of the Holocaust raised the profile of the need for a Jewish homeland. In November 1947, the General Assembly of the United Nations resolved that Palestine should be partitioned into Jewish and Arab sectors. It was a well-meaning attempt to create a Jewish homeland, but it misread the situation and angered the Arabs, who saw it as "a sort of declaration of war." In Jerusalem, however, Jews took to the streets to celebrate "Liberation Day" and the fulfillment of a 2,000-year-old dream.

The British now found themselves policing an area where both sides of the population regarded them as oppressors. On July 22, 1946, Irgun—a Zionist guerrilla group led by Menachem Begin—had planted a bomb in Jerusalem's King David Hotel, the headquarters of the British government in Palestine. The explosion killed more than a hundred people, and, although U.S. President Harry S. Truman warned that such actions might harm the Zionist cause, Begin was unrepentant, saying: "The force of the blast surpassed all our hopes."

Jewish immigrants swim ashore at Nahariya, near Haifa, February 2, 1948.

S.S. *United Nations*

On February 2, 1948, the S.S. *United Nations* evaded the British naval blockade and made it to Nahariya, near Haifa, where it deliberately ran aground, allowing its 700 central European Jewish passengers to reach the shores of their new homeland. Between this date and 1951 a combined total of 700,000 Jews from Muslim and European countries alone immigrated to Israel, more than doubling the country's population. This image was made by a photographer working for the New York bureau of the Keystone Agency.

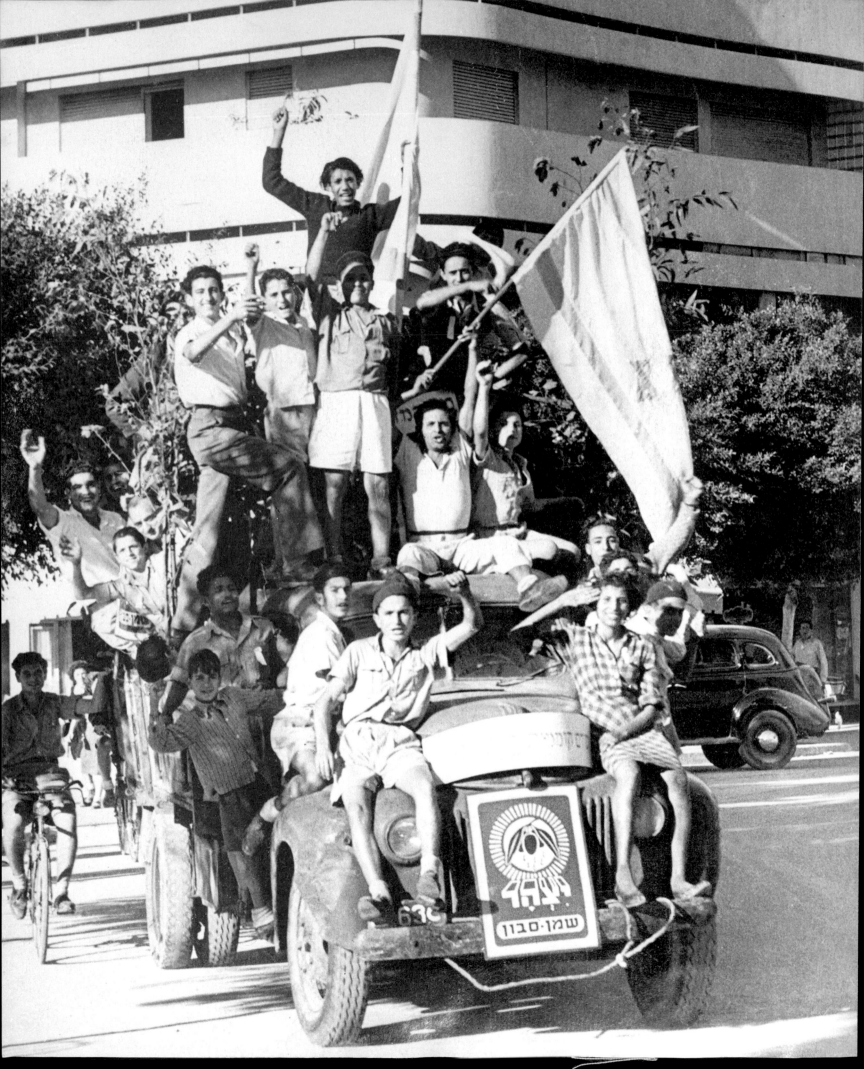

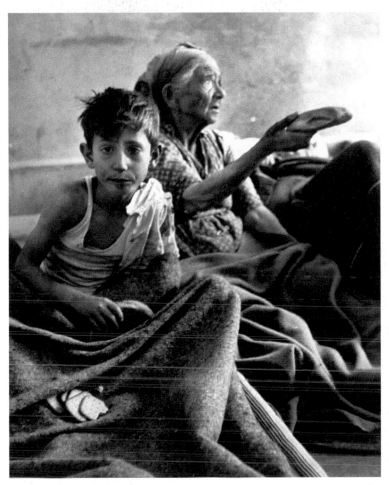

A Jewish family in a hospital receives bread supplied by Arabs, June 1948.

Arab refugees from Haifa arrive at Port Said, May 3, 1948.

In fact, there was little the British could do to win the propaganda war. When the British attempted to prevent boatloads of Jewish refugees from Europe from reaching Palestine, taking them off to camps on the island of Cyprus instead, international opinion sided with the refugees. In June 1946, the *Haviva Reik*, a passenger ship carrying 450 refugees, broke down in the Mediterranean Sea 120 miles from Palestine. The vessel was towed to Haifa, flying a banner bearing the brave and determined message: "Keep the Gates Open—We Are Not the Last." Those on board endured appalling conditions, and were regarded as heroes: the British image was further tarnished.

On May 14, 1948, the British Mandate formally ended, and the new state of Israel came into being. That night, the United States officially recognized the new nation, but, as the British left, Arab armies from Egypt, Syria, Transjordan, Lebanon, and Iraq massed on the old Palestine borders.

"It will ensure complete equality of social and political rights to all its inhabitants, irrespective of religion, race, or sex; it will guarantee freedom of religion, conscience, language, education and culture. ... "

EXTRACT FROM SPEECH BY PRIME MINISTER DAVID BEN-GURION, PROCLAIMING THE NEW STATE OF ISRAEL, MAY 14, 1948

Celebrating the new state of Israel, Tel Aviv, May 14, 1948

[June 24, 1948]

BERLIN BLOCKADE BEGINS

With the division of Germany into two separate countries at the end of World War II, the city of Berlin posed a particular problem for the victorious Allies. It lay in the newly created German Democratic Republic, under Soviet control. Like Germany itself, the city had been divided, presenting the West with a problem of access. To reach West Berlin by road or rail from West Germany meant having to rely on Soviet permission to pass through some hundred miles of East German territory.

Early in 1948, it was apparent that this permission could not be relied on. The economic stagnation of East Germany compared unfavorably with the rapid recovery of West Germany, thanks largely to the Marshall Plan, and nowhere was the contrast more striking than in Berlin itself. On June 24, 1948, the Soviet Union cut all surface traffic to West Berlin, seeking to bring business to a halt and the population to its knees.

The Soviet plan failed thanks to the Berlin Airlift, a daily round-the-clock air delivery system. Two days after the blockade began, 32 C-47 cargo planes flew in 80 tons of supplies, including milk, flour, and medicines. Three air corridors were created, and aircraft took off from West Germany at three-minute intervals, each flying 500 feet higher than the one before it, until a ceiling of 5,000 feet was reached. Then the process started again.

The planes were small, the airfields tiny by modern standards. For 462 days, the U.S. Air Force and the British RAF maintained this extraordinary service, during which 70 pilots lost their lives. French military engineers built a new airport in 90 days—today Berlin-Tegel International Airport. By the time the airlift came to an end in September 1949, the Allies had made 278,228 flights and landed 2,326,406 tons of supplies, including 1.5 million tons of coal.

A plane flies into Berlin during the Soviet blockade in 1948.

Cold War images

Stalin's attempt to deny West Germans and their allies access to West Berlin presented the West with the opportunity for a massive propaganda coup that was immediately exploited. Photographer Henry (Heinz) Ries's classic image of a group of children waving to a U.S. supply plane coming in to land at Tempelhof Airport (similar to the one shown here) played its part. Published in the *New York Times* and later used as the design for a U.S. postage stamp, it became one of the classic images of the early Cold War.

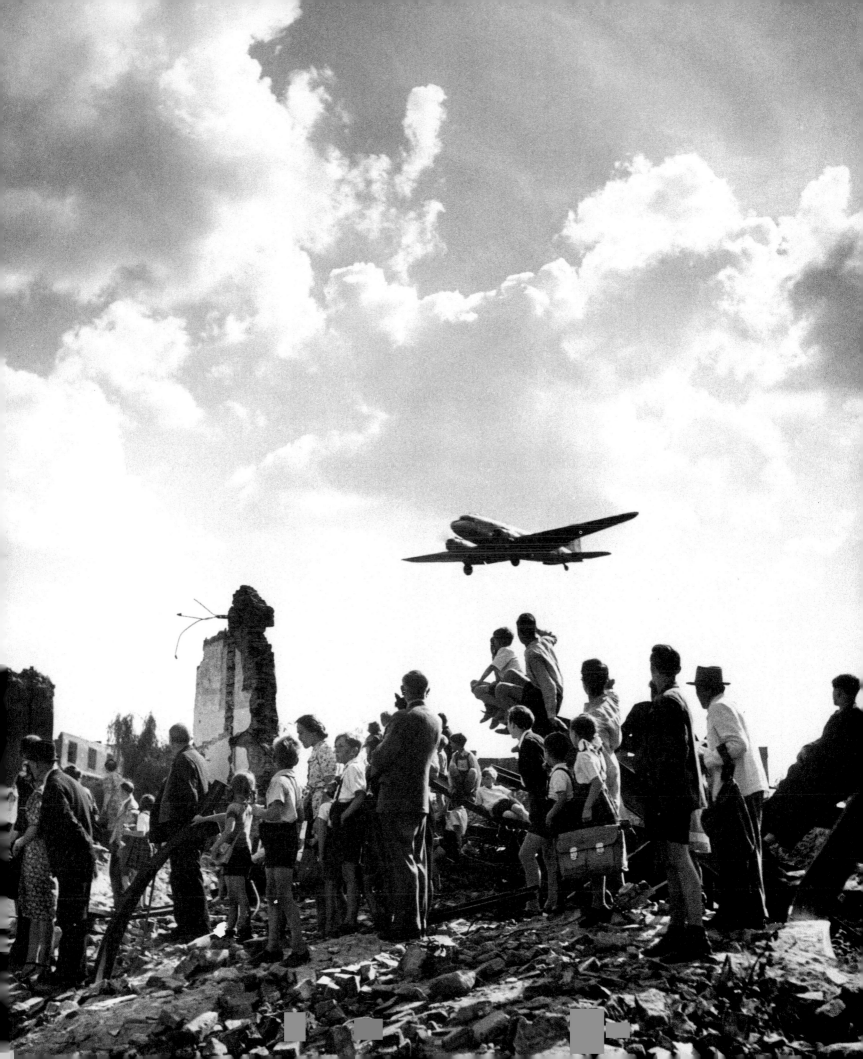

"We reached one billion light years into space—twice as far as man had ever looked before. The tests confirm our previous conclusion that the Hale telescope is an unqualified success."

EDWIN HUBBLE AT MOUNT PALOMAR ON THE NIGHT OF FEBRUARY 1, 1949

[February 1, 1949]

HUBBLE FIRST USES THE HALE TELESCOPE

E dwin Hubble (1889–1953) first began to indulge his passion for astronomy when he was 25, in 1914, and within 10 years he had made one of the greatest scientific discoveries of the 20th century, overturning perceived wisdom and revolutionizing the world of science.

Hubble began his major research at the Mount Wilson Observatory in Pasadena, California, in 1917, leaving just a few months later to enlist in the infantry and serve in France in World War I. Only a great sense of patriotic duty could take him from his beloved work.

He returned to Mount Wilson in 1919, by which time the observatory had recently installed the most powerful telescope on Earth, the 100-inch Hooker Telescope, and Hubble spent night after night, in bitter cold, examining the universe. In October 1923, he made his great discovery. He observed a young, bright, massive, pulsating star —a cepheid. By examining photographs of the same area taken years earlier, Hubble showed that the cepheid was now one million light years away, beyond the Milky Way, and farther away from it than when previously observed. It meant that the universe was not finite, but constantly expanding. Albert Einstein, who had himself briefly postulated a theory that the universe was expanding, but later retracted his view, now realized his mistake. He called his earlier climbdown "the greatest blunder of my life."

After World War II, Hubble returned to civilian life and devoted all his time to the design and construction of the Hale 200-inch Telescope. When completed, the instrument was four times more powerful than the Hooker; it remained the most powerful telescope on Earth until the 1980s. With his constant "hope to find something we had not expected," on February 1, 1949, Hubble had the immense joy of being the first person to use the Hale Telescope.

Hale Telescope

Photographer J. R. Eyerman posed Edwin Hubble in the focal point cage of the huge 200-inch Hale Telescope for this photograph for a *Life* article about the universe in the October 9, 1950 issue. To reach the focal point cage, located 55 feet above the reflecting mirror, Hubble would ride the ramp-like prime focus elevator which tracked along the inside of the observatory dome. When the telescope was in use, Hubble would phone his orders from this point down to an assistant who would aim the telescope from a control panel on the floor behind the mirror.

Edwin Hubble and the 200-inch Hale Telescope, February 2, 1950.

"This was the top secret business for which we had been lurking furtively in Pusan, of which everyone in Korea appeared to know almost everything, even us. ... "

JAMES CAMERON, WAR CORRESPONDENT, *PICTURE POST*, OCTOBER 7,1950

[September 15, 1950]

THE BATTLE OF INCHON

On June 25, 1950, North Korean forces crossed the 38th parallel and invaded South Korea. The Cold War had suddenly burst into flames. A series of resolutions calling for the United Nation's intervention and counter-calling for a cancellation of such a move ended with Resolution 85, which supported an armed response by the United States, later to be backed by troops under U.N. command. On July 19, the first U.S. Marines landed in Korea. Their presence provided much needed help for the South Koreans. Nevertheless, at first the North Koreans carried all before them, forcing the U.N.–U.S. troops back to Pusan in the southeast.

The counterpunch came in September. Codenamed Operation Chromite, it was delivered by Gen. Douglas MacArthur (1880–1964). The idea was to land a substantial force some hundred miles behind North Korean lines, at Inchon, the city port for the South Korean capital, Seoul. It was a bold move—other military experts believed the days of large-scale amphibious operations were over.

Operation Chromite involved 320 warships, 6,500 vehicles, 25,000 tons of supplies, and some 54,000 marines and soldiers. It was the largest seaborne attack since D-Day, June 6, 1944. The first landings were made at 0630 hours on September 15 on an island just off the Inchon coast. The defenses were inadequate and poorly maintained, and American casualties were few. Throughout the cold winter that followed, however, the U.N. and the U.S. forces suffered appalling losses. The Korean War was a bitter contest. China sent hundreds of thousands of troops to support North Korea.

By the time the war ended on July 27, 1953, the United States had lost some 25,000 men, the South Koreans more than a million, and the Chinese and North Koreans considerably more. Korea itself remained partitioned, as before.

Gen. Douglas MacArthur at Inchon, September 15, 1950

Life photographers

American Carl Mydans was one of the "Big Four" photographers employed by *Life* when the magazine began publication in 1936 (the others were Alfred Eisenstaedt, Margaret Bourke-White, and Thomas D. McAvoy). He was captured by the Japanese in 1941, but released 18 months later as part of a prisoner exchange. In 1944 he was back in the Pacific, and was at hand to record Gen. Douglas MacArthur's reactions, from the bridge of the U.S.S. *Mount McKinley*, as he watched the U.S. First Marine Division hit the beach at Inchon on September 15, 1950.

[July 2, 1952]

SALK BEGINS POLIO VACCINE TESTS

Poliomyelitis, or polio, is a viral disease that afflicts mainly children; it leaves them paralyzed, unable to breathe without an iron lung, or dead. For centuries it was one of the most prevalent and horrific diseases in the world, one for which there was no cure, and no protection. From the very beginning of the 20th century, there had been frequent cycles of terrible polio epidemics.

Attempts had been made in the 1930s to develop a vaccine that would provide immunity to polio. They failed largely because of the difficulty in obtaining sufficient polio virus on which to experiment. That problem was solved in 1948, when a research group at the Children's Hospital in Boston, Massachusetts, cultivated the virus on human tissue in the laboratory. That gave American physician Jonas Salk (1914–1995) his chance.

Salk used formaldehyde to kill the polio virus but preserve it to a degree where it was still strong enough to trigger the human body's response—the classic use of any vaccine. He then sought subjects for experiment from families whose children had already contracted polio but had recovered. On July 2, 1952, Salk began his tests, using his newly developed vaccine for the first time. The results were encouraging. After vaccination, the children's antibodies to the disease increased. Salk then switched to volunteers who had not had polio—including himself, his wife, and their children. Every volunteer produced antibodies. No volunteer became sick.

Two years later, the vaccine was tested throughout the United States, with incredible results. Between 60 and 70 percent of those vaccinated obtained immunity from the disease. Over the next few years, the figures spoke for themselves. In 1952, there had been 58,000 cases of polio in the United States; in 1959, there were fewer than 6,000. It was a staggering victory over an insidious enemy.

The Protection campaign

The little town of Protection in Comanche County, Kansas, was selected by the National Polio Foundation as the subject of a national advertising campaign to encourage people to sign up for inoculation against polio by the new Salk vaccine. Every citizen of Protection under 40 years of age received the injection, and *The Protection Beacon* published photos of the session, proudly recording that 311 sore arms proved that the town was the first in the U.S. to be 100 percent protected against the disease.

Young residents of Protection, Kansas, line up for polio shots.

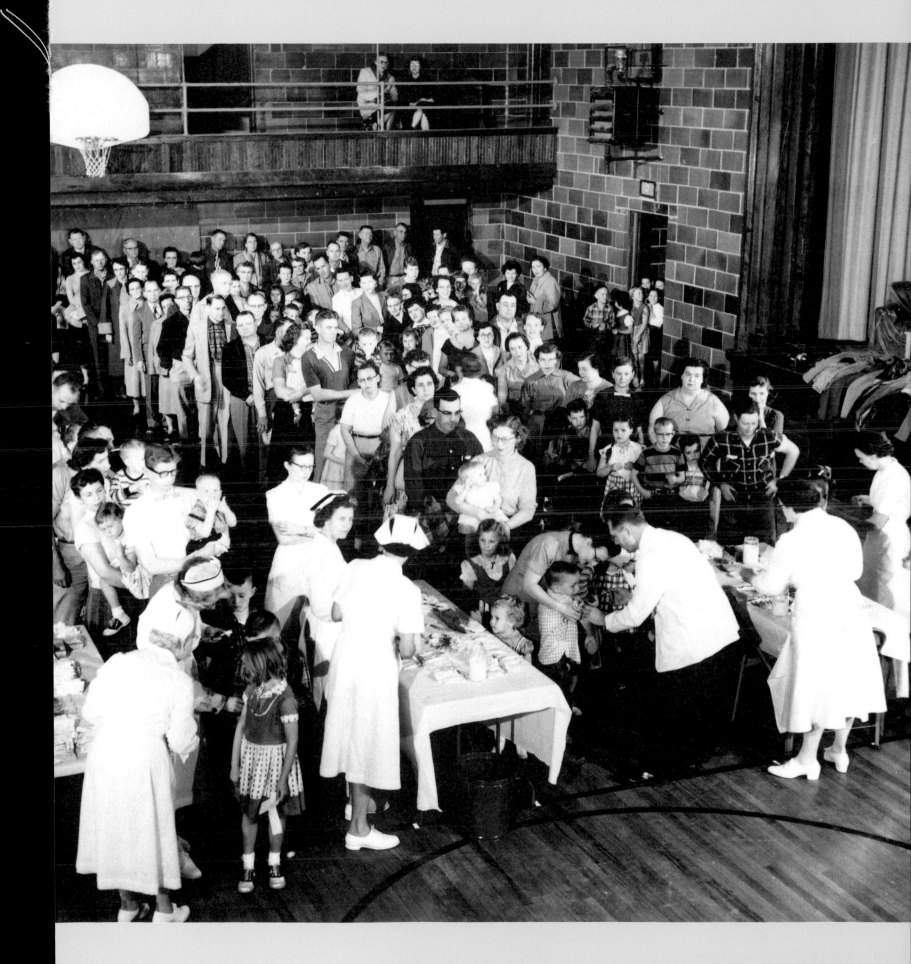

"A potential key to the secret of life was impossible to push out of my mind
...the stuff that genes are made of."

EXTRACT FROM *THE DOUBLE HELIX* (2001) BY JAMES WATSON

[February 28, 1953]

DISCOVERY OF
THE DOUBLE HELIX

In the early 1950s, scientists James Watson (1928–), Francis Crick (1916–2004), Rosalind Franklin (1920–1958), and Maurice Wilkins (1916–2004) were all investigating deoxyribonucleic acid (DNA), the basic building block of life, trying to determine its structure. Their research proved highly successful and led to a scientific revolution.

The heroes of the quest were young. Britons Crick and Franklin were 35 and 32 respectively; Watson, an American, was aged 24. They were from contrasting scientific backgrounds. Crick was as much a chemist and biologist as a physicist. Watson was, by inclination, an ornithologist. Franklin was intensely interested in the use of x-ray photography for research purposes. They did not work together. Watson and Crick were based at the University of Cambridge, England. Franklin was working at King's College, London, where her strong feminist views were coldly received by New Zealander Wilkins, a fellow colleague.

By early 1953, Watson and Crick had long been building and dismantling large, three-dimensional models of the possible molecular structure of the four basic components of DNA—adenine, thymine, guanine, and cytosine. The permutations were endless. Then, on February 28, Watson had his famous "Aha!" moment, prompted by an idea from Crick.

When they broke the news of their discovery of the double-helix molecular structure, they flipped a coin to see who was to get top billing—would they be Watson and Crick, or Crick and Watson? Their dependence on Wilkins' research was later acknowledged, but few in the scientific world thought to include Franklin, whose x-ray diffraction photographs had played such an important part in the quest. She died in 1958, four years before the Nobel Prize was awarded to Watson, Crick, and Wilkins.

Cambridge scientists

This portrait of Watson and Crick was taken by Cambridge photographer A. Barrington Brown. An undergraduate friend at the University of Cambiridge had told Brown about an important piece of research taking place at the Cavendish Laboratory. The friend needed a photograph to accompany an article he was writing for *Time* magazine. Brown cycled to the laboratory, met Watson and Crick, and told them "you'd better stand by the model and look portentous." *Time* turned the picture down, but paid Brown $1 for his trouble.

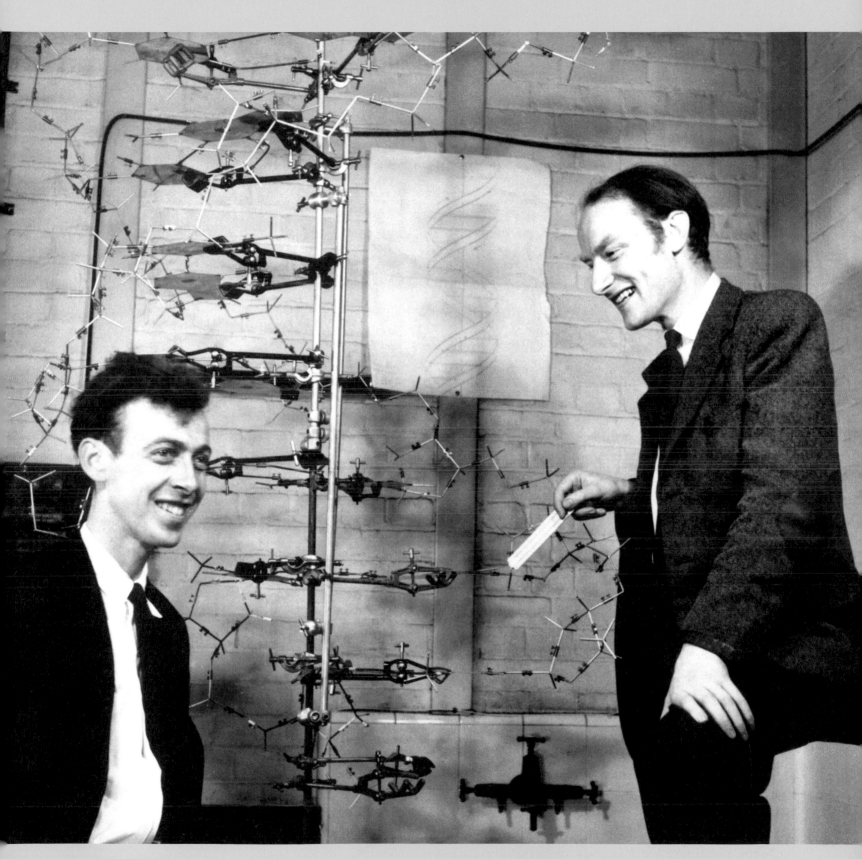

James Watson *(left)* and Francis Crick with their model of the double helix.

"With all our oxygen masks on it was hard to speak, but we certainly shook hands and gave each other the odd thump on the back."

EDMUND HILLARY ON REACHING THE SUMMIT OF EVEREST, 1953

[May 29, 1953]

FIRST CONQUEST OF MOUNT EVEREST

British climber George Mallory was once asked why he was so determined to climb Mount Everest. "Because it is there," he replied. In the end, Mallory's determination cost him his life. In June 1924, both Mallory and his climbing partner, Andrew Irvine, died only a few hundred yards short of Everest's summit, climbing with poor clothing and equipment.

The Ninth British Everest Expedition was better equipped when it set out from Khatmandu, Nepal, in March 1953. Its leader was John Hunt, an experienced mountaineer. Its team of climbers included a schoolteacher, a nuclear physicist, a physician, a beekeeper from New Zealand named Edmund Hillary (1919–)—and 350 porters.

It took them 45 days to cross the great ice fall and reach the Western Cwm: struggling through ice corridors where the air was foul; avoiding towers of ice that were impossible to climb; building bridges with ropes and a portable ladder across the worst of the crevasses that opened beneath them. Although Hunt's team was well prepared, conditions were tough. At such a height, the human body undergoes alarming changes. The heart dilates and the lungs weaken, while the eyes have to be protected against snow blindness and the feet from temperatures that hover around minus 58°F (minus 50°C).

They climbed on, mounted the South Col, and reached the threshold of Everest. They made camp at 25,850 feet. That left just 3,000 feet to go. Hunt had planned for this moment. He knew that the last section of the climb would be the toughest and the most debilitating, and had "nursed" four members of the expedition so that they would have most in reserve for this last assault. He divided the four men into two teams, and sent the first pair forward. Their task was to establish one last camp at around 27,500 feet. Once that was done, the second pair would make the last climb to the summit.

Edmund Hillary celebrates the conquest of Everest at Camp IV.

High-altitude photography

A jubilant Edmund Hillary relaxes with a cup of tea at Camp IV after his recent descent from the top of the world. The cup belonged to Tom Stobart, the expedition's cameraman. Stobart, along with fellow expedition climber and cameraman George Lowe, created the color footage for the 80-minute 1953 documentary film *The Conquest of Everest*, which was nominated for two Oscars in 1954. This photograph itself was taken by Alfred "Greg" Gregory, the expedition's official "stills" photographer. Although he took three cameras on the expedition, at this altitude he only carried a compact Kodak Retina, one of the early roll-film cameras. Shooting only in Kodachrome, black-and-white negatives were made later from this color slide film.

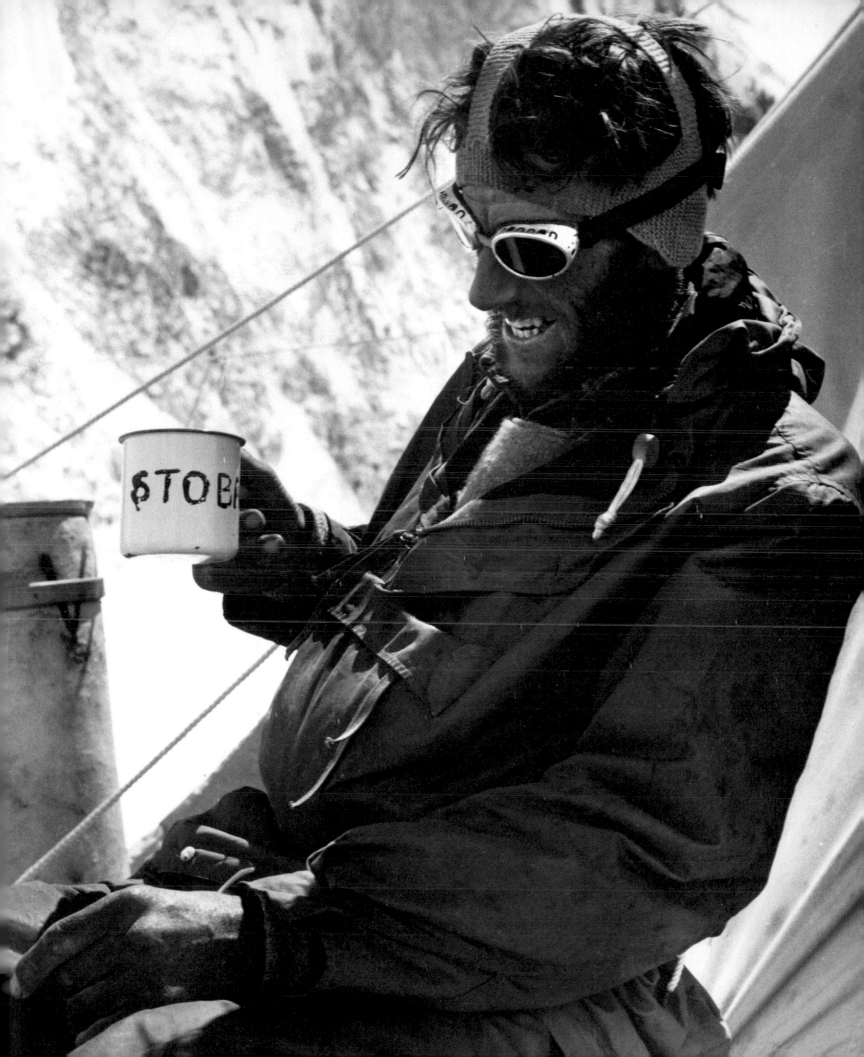

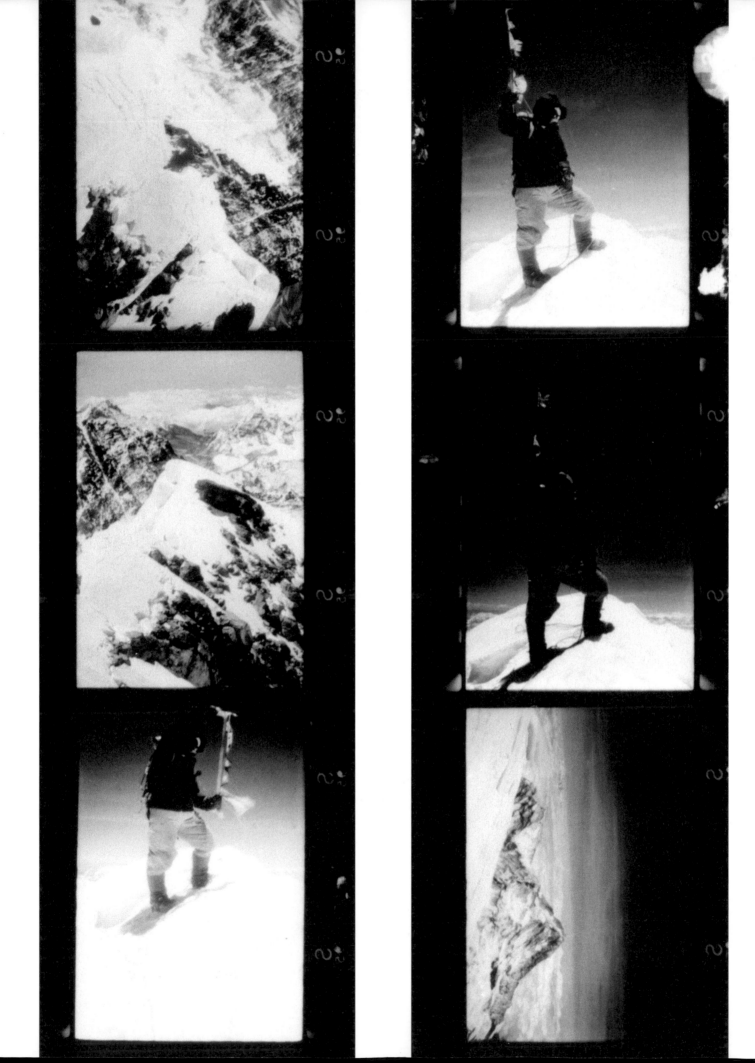

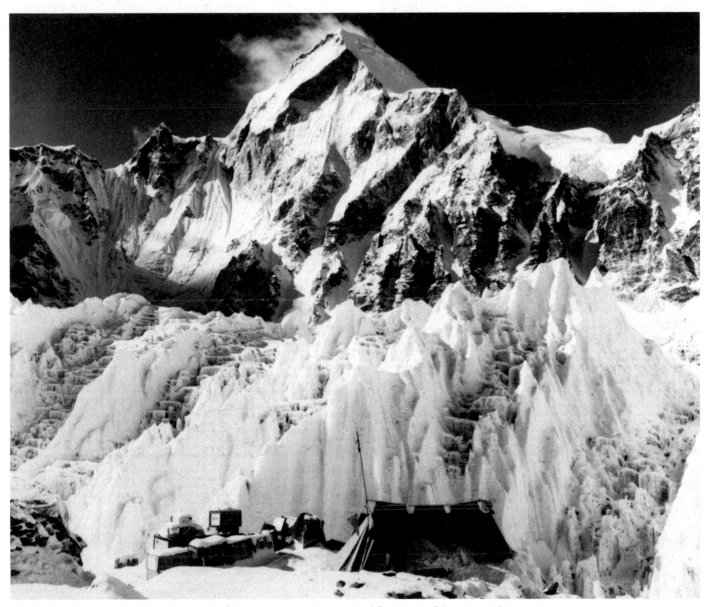

The peak of Mount Everest photographed from one of the approach camps

Hillary and Sherpa Tenzing Norgay (1914–1986), the second pair, set off on May 28. They climbed to 27,900 feet, where they pitched their tiny tent and spent the night in a howling gale. When dawn broke, cloud covered the summit of Everest. They began to climb, only to find their way blocked by an uncharted ice ridge. They found a chimney, wriggled their way up and through it, out on to the snow.

At 1130 hours, they stood on the roof of the world, roped together and hugging each other. Hillary later said that standing there made him feel "Damn good." Tenzing said: "I thought of God and his work." They stayed for only 15 minutes before descending.

Left: A sequence of images taken from the summit of Everest: *(clockwise from top left)* A view looking down at the route the climbers took; two shots of Tenzing Norgay on the summit; one of the ridges leading to the summit; Norgay; another Everest ridge.

"Let us not assassinate this lad further, Senator. ...
You've done enough. Have you no sense of decency, sir,
at long last? Have you left no sense of decency?"

JOSEPH WELCH, U.S. ARMY ATTORNEY, ARMY–MCCARTHY HEARINGS, JUNE 9, 1954

[March 9, 1954]

EDWARD R. MURROW ATTACKS SENATOR JOSEPH MCCARTHY

From the beginning of his political career, Joseph McCarthy (1908–1957) showed that he was a man of terrifying determination. His rise was meteoric, as he lied about his war record and smeared his opponents. In 1946, he was elected as a Republican U.S. Senator from Wisconsin; on taking office in 1947, he set about attacking members of the Democratic administration.

The idea of inciting anticommunist hysteria was given to him in 1950 by a Roman Catholic priest named Edmund Walsh, and McCarthy successfully used the tactic when he stood for reelection to the Senate in that year. He also took advantage of national concerns about the ongoing Korean War to create a Red Scare, with investigations into communists quickly turning into witch hunts. At McCarthy's insistence, 30,000 books allegedly written by communists were purged from U.S. libraries. Academics and lawyers, politicians and commentators were threatened by him, and few of his targets had the courage to fight back.

McCarthy's success went to his head. In 1954, he turned on the U.S. Army, denouncing senior officers as traitors and Soviet agents. President Dwight D. Eisenhower, who had received some support from McCarthy during his own election campaign, was furious at this step. Opponents toughened their resistance to McCarthyism, and counterattacked. In the famous March 9, 1954, edition of TV's *See It Now*, Edward R. Murrow said: "The line between investigating and persecuting is a very fine one, and the junior Senator from Wisconsin has stepped over it repeatedly." It was the beginning of the end. Six months later, on December 2, 1954, a censure motion on McCarthy's conduct was passed in the U.S. Senate by 67 votes to 22. His career was finished; his demise was near. He died of hepatitis in Bethesda Naval Hospital, Maryland, on May 2, 1957, at age 48.

Senator Joseph McCarthy *(left)* with his lawyer, Roy M. Cohn

Iconic *Life* images

Known as "The Photographer of the Impossible," Yale Joel joined the staff of *Life* magazine in 1947, having been a combat photographer with the Army Pictorial Service from 1942 to 1946. Later in his career Joel experimented with 3-D and infrared photography, but is best known for his working portraits of the great, the famous, and the infamous, including a 1952 picture of a young John F. Kennedy campaigning for Congress, and this shot of McCarthy and his lawyer, Roy Cohn, at the Army–McCarthy hearings in 1954.

"I'd like to tell you that we're going to do a sad song for you. This here song is one of the saddest songs you ever heard."

ELVIS PRESLEY'S INTRODUCTION TO "HOUND DOG"
ON *THE ED SULLIVAN SHOW*, SEPTEMBER 9, 1956

[September 9, 1956]

ELVIS PRESLEY APPEARS ON THE *ED SULLIVAN SHOW*

Elvis Presley (1935–1977) had to finance the start of his professional career in 1953. He paid $6.50 to record two double-sided disks at Sun Studios on Union Avenue, Memphis. The owner of Sun Records, Sam Phillips, had been looking for "a white man with a Negro sound and the Negro feel," and when Presley began singing "That's Alright Mama" during a rehearsal break, Phillips decided to take a risk and release it as a 78-rpm single, backed with "Blue Moon of Kentucky." The bandwagon slowly started to rock and roll.

In August 1955, Presley signed with Colonel Tom Parker, a bustling entrepreneur with a natural talent for product placement. Parker negotiated a deal with RCA, who bought Presley's contract with Sam Phillips for $35,000. On January 10, 1956, two days after his 21st birthday, Presley had his first recording session with RCA. One of the tracks laid down was a moody, stark, almost despairing ballad entitled "Heartbreak Hotel." It was different, and the public liked the difference. It sold more than 300,000 copies in the three weeks following its release on January 27, 1956, and later the same year it was number one on the U.S. charts.

On January 28, 1956, Presley made his first TV appearance, on Jackie Gleason's *Stage Show*. The studio audience was not sure what to make of Presley's gyrations, but he was booked to come back for a further five shows. In July, Presley's "I Want You, I Need You, I Love You" was briefly at number one, but then came the most commercially successful double-sided single in pop history: "Hound Dog" and "Don't Be Cruel." It stayed at number one for 11 weeks.

The speed with which Presley's career developed seems staggering, even today. By April 1, 1956, Presley was in Hollywood, taking a screen test for Paramount Studios, where Hal Wallis persuaded him

Elvis Presley at CBS studios in Los Angeles, 1956, for the *Ed Sullivan Show*

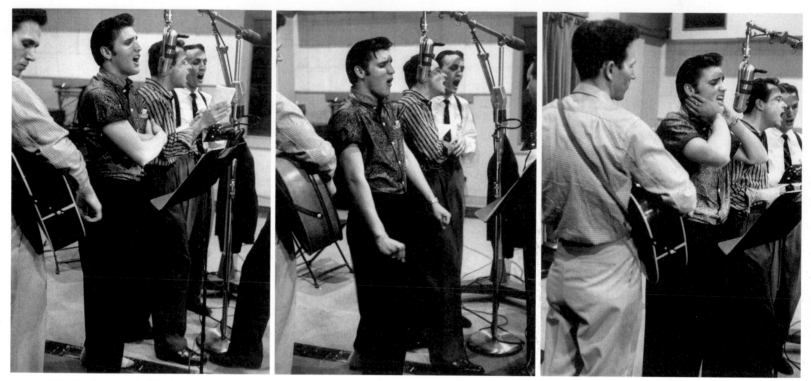

RCA Studios, Nashville, April 14, 1956 | Presley and The Jordanaires | Chet Atkins, Presley, and The Jordanaires

RCA Studio

Dan Cravens was a working photographer who just happened to be present in the Nashville RCA Studio on April 14, 1956, when Presley arrived for a recording session produced by the guitarist Chet Atkins. The King was riding high at the time—"Heartbreak Hotel" was at number one on the U.S. charts. With him were the singers Gordon Stoker, Neal Matthews, Jr., Hugh Jarrett, and Hoyt Hawkins—better known as The Jordanaires—and it was at this session that Presley told them he wanted to use them at all future recording sessions.

to sign a seven-year contract. Before the year was out, Presley's first film, *Love Me Tender,* had premiered at the Paramount Theater in New York City and become a smash hit. Two days later, on April 3, Presley appeared on the *Milton Berle Show* on ABC-TV, the show originating from the deck of the aircraft carrier U.S.S. *Hancock.* A couple of weeks later, Presley made his debut at the New Frontier Hotel in Las Vegas, Nevada. It was the one comparative failure of his year, for the audience of hard-boiled gamblers was not enthusiastic. Elsewhere, however, the crowds got bigger and bigger, the hysteria mounted, and the record sales soared.

On June 5, Presley was back on the *Milton Berle Show*, this time coming live from the studio. He went to town on "Hound Dog," shaking his pelvis and letting rip with his gyrations. The studio audience went wild, but some home viewers and some members of the press were horrified, slamming Presley's performance for its "appalling lack of musicality," "vulgarity," and "animalism." The Roman Catholic Church warned the faithful to "beware Elvis Presley." Sociologists and psychologists rushed into print, holding Presley responsible for much juvenile delinquency. Ed Sullivan declared that he would never have the likes of Presley on his show.

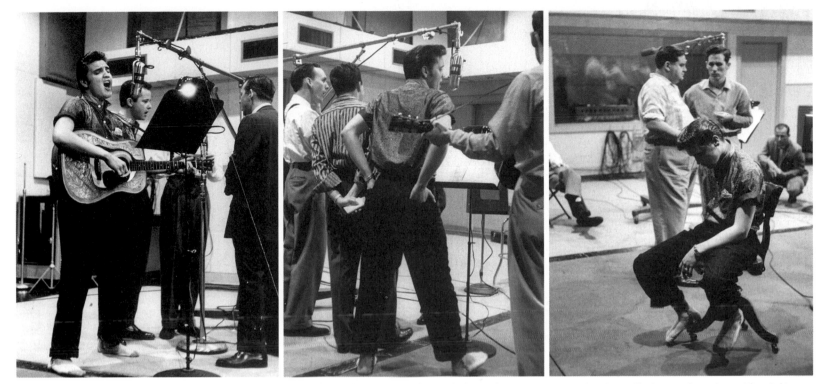

Presley and The Jordanaires The Jordanaires, Presley, and Chet Atkins Presley, Steve Sholes, and producer Chet Atkins

But the huge audiences that Presley attracted were too much for Sullivan to ignore. Three months later, on September 9, 1956, Presley made the first of three appearances—after signing a $50,000 contract—on the *Ed Sullivan Show*. Neither was actually present in the studio: Presley was in Los Angeles; Sullivan was in the hospital, recovering from an automobile accident. It was Charles Laughton who introduced Presley, waving his arm and saying: "Away to Hollywood to meet Elvin [Elvis] Presley." Presley responded by saying that "being on the show is probably the greatest honor that I have ever had in my life." The show pulled an audience of 60 million, an incredible rating of 82.6 percent.

Throughout all three shows, the camerawork was discreet, pulling back occasionally to reveal some of Presley's bodywork, but concentrating on the upper half of the young star. In the final show, the cameras showed Presley only from the waist up, even during a staid performance of a gospel tune. At the end of the last show, Sullivan walked across to Presley, placed his arm around the young man, and praised him for being "a real decent, fine boy."

Many people believe that the camera directions were the work of the ever astute Colonel Tom Parker.

"We've never had a pleasanter experience on our show with a big name than we've had with you. ... You're thoroughly all right."

ED SULLIVAN TO PRESLEY, THE *ED SULLIVAN SHOW*, JANUARY 5, 1957

Following pages: Hysteria greets Presley at the Florida Theater, Jacksonville, in August 1956.

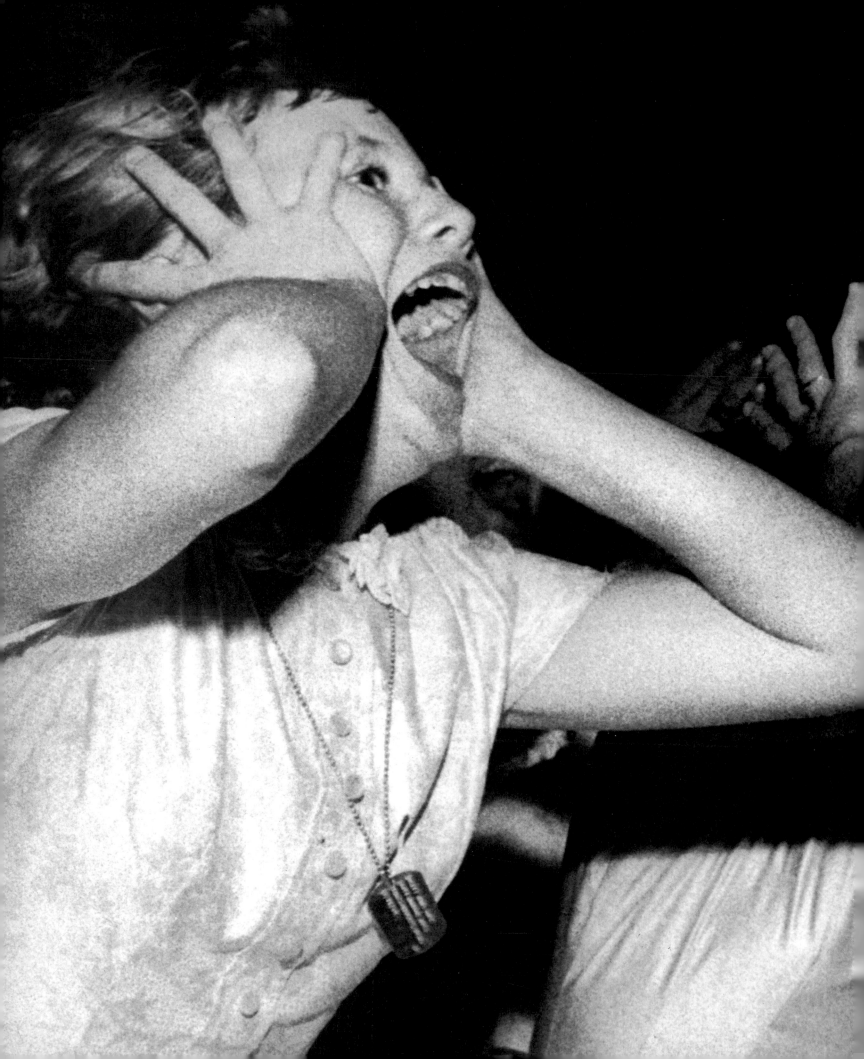

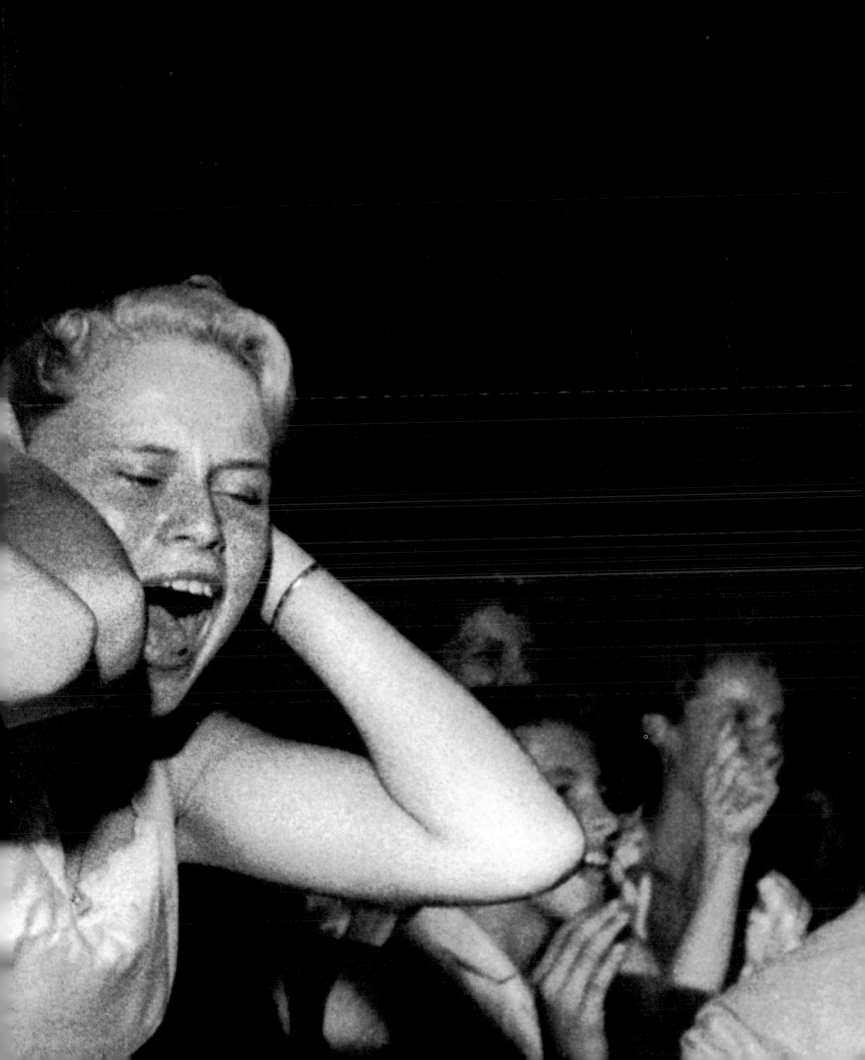

"The secret police lie twisted in the gutter, their faces dark masks
of dust and blood, blank eyes staring at the day ...
the Hungarians will not touch the corpse of an AVH man."

EYEWITNESS REPORT ON SLAUGHTER ON THE STREETS OF BUDAPEST, OCTOBER 23, 1956

[October 23, 1956]

HUNGARIAN REVOLUTION BEGINS

In February 1956, Nikita Khrushchev, General Secretary of the Soviet Communist Party, told the Party Congress that his predecessor, Joseph Stalin, had been a monster, a murderer, and a coward. The announcement had a great impact on the Soviet satellite states in Europe, fanning the flames of revolution. On October 23, thousands of students and protestors in Budapest demonstrated against their Stalinist First Secretary, Matyas Rakosi, tearing down a statue of Stalin and ripping the Communist emblem from the Hungarian Flag.

Imre Nagy, a former prime minister and reformer who had been ousted a year earlier by the Kremlin, was reinstated by popular demand. But the change of leadership did not end the violence. Many Hungarians had old scores to settle with the AVH (secret police). Members of this hated agency were dragged from their posts to await justice by trial. Others were killed by the crowds.

The violence of Hungarian against Hungarian might have run its course, but, on November 4, Soviet tanks entered Budapest and took control of key areas. The Russian Army removed Nagy from his post, and replaced him with a puppet ruler, János Kádár. The people rose in armed resistance. It was a heroic struggle—thousands were killed, parts of the city were reduced to rubble, and 200,000 Hungarians fled across the border into Austria. Back in charge, the hardline communist regime executed 350, the vast majority being young men.

It was all over in a few days. The West, preoccupied with the Suez Crisis, failed to respond to calls for help from the embattled freedom fighters. The Kremlin called the uprising a procapitalist escapade planned by the West. The West claimed it had been an attempt to establish a "free society." The desire for democratic freedoms was a chief motivating factor, as was hatred of a system that imposed deplorable work conditions.

Hungarians burn a portrait of Joseph Stalin.

Jack Esten: staff photographer

Jack Esten was for many years a staff photographer with *Picture Post*, a job that demanded all the usual talents and attributes of a working photographer, plus considerable versatility. On one assignment Esten might be taking a portrait of Marilyn Monroe, while on the next, he was in Budapest, recording horror and slaughter on the streets as freedom fighters wreaked savage revenge on members of the hated AVH secret police.

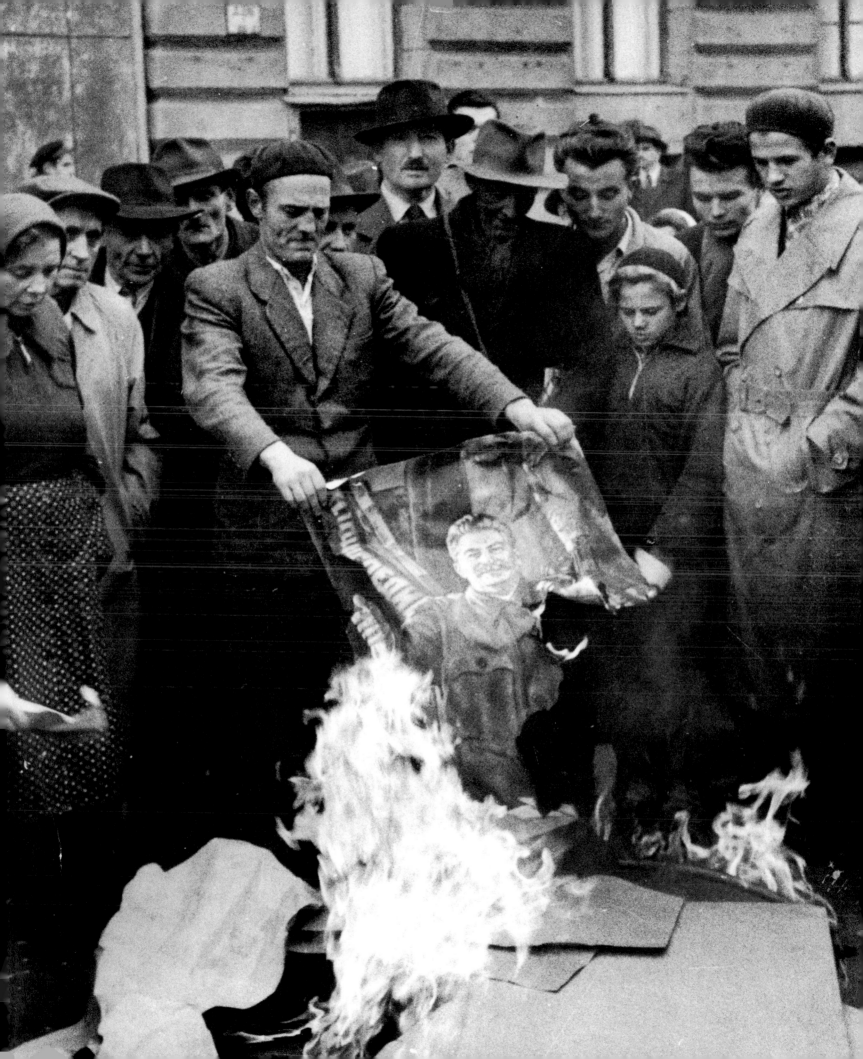

"I never expected it to be life threatening.
I didn't even have any sense of how dangerous it was
until we got home and saw it on television."

EARNEST GREEN, ONE OF THE LITTLE ROCK NINE, NBC, OCTOBER 1957

[September 4, 1957]

ELIZABETH ECKFORD AT LITTLE ROCK

On May 31, 1955, in the case of *Brown* v. *Board of Education of Topeka*, the U.S. Supreme Court ruled that segregation in public schools was unconstitutional.

The decision was more easily made than put into practice. Many white people opposed it, and one of the main centers of resistance was Little Rock, Arkansas. There, in May 1957, nine black students were assigned by the local school board to enter in the fall the Central High School, which had previously accepted whites only. On the final day of the summer vacation, 250 Arkansas National Guard troops surrounded the school, ordered there by Orval Faubus, Governor of Arkansas, who that night addressed the state on radio. He announced that, on the following day, the Central High School would be "off limits to Negroes," and warned that "blood will run in the streets" if black students attempted to enter the school.

On September 3, the first day of term, only white students filed into school past the National Guardsmen; the Little Rock Nine—as the nine black students came to be called—were stopped at the door. Members of the black community then suggested that the students be escorted to school the next morning by ministers of religion, but this idea was rejected for fear of what might happen: A white mob now surrounded the school building. It was decided that it would be safer to delay any further attempt by the black students to enter the school.

But one of the nine students, 15-year-old Elizabeth Eckford, did not get the message; there was no telephone at her home. Alone, at 8:15 on the morning of September 4, she presented herself at the Central High School. The heckling that followed as white students blocked her way was filmed by television crews and reported in newspapers around the world. By the end of the day, Elizabeth had failed to enter the school, but segregation had been dealt a massive blow.

Daisy Bates watches a National Guardsman approach the black students.

A drama unfolds on film

This picture of Daisy Bates, peering anxiously from her front room at the height of the Little Rock crisis, was taken by Thomas D. McAvoy—one of *Life*'s Big Four photographers. Bates was a journalist and the president of the Arkansas State Conference of the NAACP. In that latter capacity, she was acting as adviser to the nine African-American Little Rock students, some of whom can be seen by the station wagon. The presence of the National Guardsman with fixed bayonet heightens the drama of a tense week in U.S. history.

"What is a 184-pound object in orbit?"
"Are they looking down at us?"

U.S. REACTIONS TO NEWS OF THE
LAUNCH OF THE SOVIET SPUTNIK I, OCTOBER 4, 1957

[October 4, 1957]

LAUNCH OF SPUTNIK I

In the depths of the Cold War, the concept of an International Geophysical Year, dedicated to the peaceful exploration of the Earth and its atmosphere, offered hope to those who preferred cooperation to confrontation. Rivalry between the Soviet Union and the United States remained intense, however. In 1955, President Eisenhower had announced that the United States would put a satellite into space during the International Geophysical Year, fixed for 1957. Then came an extraordinary coup by the Communist superpower.

On October 4, 1957, the Soviet Union launched Elementary Satellite-1, or Sputnik 1. The highly polished, aluminum-alloy satellite was a sphere, some 22 inches in diameter, packed with pressurized nitrogen, and weighing 184 pounds. It was propelled into outer space by rocket from the Baikonur Cosmodrome in Kazakhstan, reached its minimum orbiting distance from Earth at 150 miles, and proceeded to orbit the planet once every 95 minutes, passing over Moscow twice a day. It traveled at 18,000 mph (5 miles per second) until the transmitter batteries were exhausted early in January 1958. It had by then covered approximately 38 million miles.

Those working on the U.S. space program were stunned. Sputnik 1 was eight times heavier than the satellite they were planning to send into space in February 1958. By that time, however, the Soviet Union had already launched Sputnik 2, weighing a thousand pounds and carrying the first ever space cosmonaut—a stray dog named Laika. For a short while, Laika was the most famous animal in the universe, although most people preferred not to think what would happen to her when Sputnik 2 reentered the Earth's atmosphere.

The good news was that the Soviet Union, the United States, and 22 other nations agreed that the exploration of space should be for peaceful purposes only.

Smithsonian scientists plot the course of Sputnik 1, October 4, 1957.

Dmitri Kessel

As a child in Russia, Dmitri Kessel's prize possession was a Box Brownie camera. When he emigrated with his family to the United States in 1923, Kessel set about becoming a serious photographer. He worked on the staff of *Life* magazine during and after World War II, and was sent to cover the Greek Civil War. His picture of Fred Whipple *(left)*, J. Allen Hynek *(behind globe)*, and Don Lautman *(right)* became the color cover of *Life* for the October 21 issue in 1957.

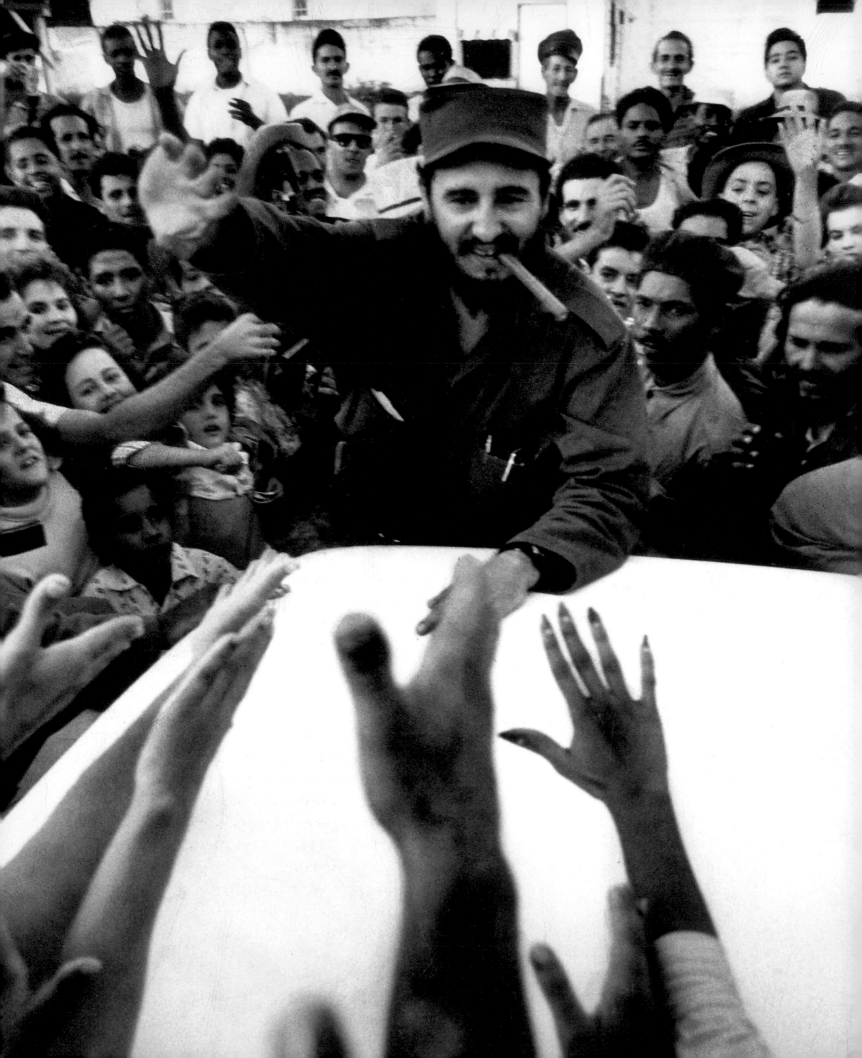

"The people of Cuba know the truth very well. We do not have to convince the people of Cuba of anything, because the people of Cuba are more than convinced. It is necessary to convince the world public."

EXTRACT FROM SPEECH BY FIDEL CASTRO, JANUARY 21, 1959

[January 2, 1959]

VICTORY FOR CUBAN REVOLUTIONARIES

It took Cuban rebels five years of military struggle to overthrow the corrupt regime of Fulgencio Batista, but when the end came, it was swift. In December 1958, Marxist guerrillas led by Fidel Castro (1926–) and his brother Raúl, the Argentinian revolutionary Che Guevara, Camilo Cienfuegos, and Jaime Vega came down from their hideouts in the Sierra Maestra mountains and attacked all the major cities in Cuba, apart from the capital, Havana.

On New Year's Day 1959, Batista fled to the Dominican Republic, leaving Havana and Cuba to the rebels. The next day, unopposed and acclaimed by delighted crowds, Guevara and Cienfuegos entered the city at the head of an army of peasants and farmers, lawyers and doctors, writers and shopkeepers, ordinary men and women. Photographers and film cameramen were there to record the triumph. Members of the world's press were there to describe the retribution that followed: the confiscation of church property, and the public trials of Batista's hated henchmen for war crimes and abuses of human rights.

Once the playground of the rich, the property of the Mafia, and a hotbed of exploitation, Cuba became, overnight, an outpost of communism in the Caribbean, a region that was otherwise almost entirely American-influenced. And Cuba remained communist, embarrassing some, infuriating many, but inspiring those who believed in a code of strictly enforced socialism.

Eighteen months later, Cuban exiles unsuccessfully challenged Cuba's new leader, Fidel Castro, in what became known as the Bay of Pigs disaster, when an ill-prepared armed force of 1,500 Cuban exiles invaded Cuba and were either killed or captured. Six months after that, the Cuban Missile Crisis brought the world to the brink of a nuclear holocaust.

Fidel Castro celebrates on the streets of Havana, January 1959.

Grey Villet:
Award-winning photographer

Grey Villet was an American photographer attached to *Life* magazine. In his long career he covered a wide variety of subjects, from the war in the Pacific to the arrival of the "teenage" phenomenon in the 1950s, from Rocky Marciano's fight with Archie Moore to the lives of nuns. This photograph of Fidel Castro and his victorious fellow revolutionaries appeared in the January 19, 1959, issue of *Life*. In 1956, the National Press Photographers Association had voted Villet Magazine Photographer of the Year.

"Then, very gingerly, we began the work of uncovering the find with delicate camel's hair brushes and dental picks. In the end it took us 19 days..."

LOUIS LEAKEY, *NATIONAL GEOGRAPHIC MAGAZINE*, SEPTEMBER 1960

[July 17, 1959]

DISCOVERY OF
ZINJANTHROPUS

The true scientist has always needed a generous spirit and a sense of proportion. Poised on the brink of some great discovery, then beaten to it by a rival, he or she has to hold tight to the concept that it is what is discovered that matters, not who has discovered it.

In the case of Louis Leakey (1903–1972), this was perhaps made easier by the fact that it was his wife, Mary, who unearthed the fossil *Australopithecus boisei*—better known as *Zinjanthropus*, or just "Zinj"—on a hot Friday morning in July 1959, while he lay sick with flu in his tent in the Olduvai Gorge, Tanzania. With financial backing from British businessman Charles Boise, Louis Leakey had been interested in the gorge since 1931, believing that it was potentially one of the world's richest sources of archaeological material.

The discovery itself is best described in Mary Leakey's own words. "I went with two Dalmatians, Sally and Victoria … to a site where we knew that bones and stone artifacts were fairly common. … There was plenty of material lying on the eroded surface, but one scrap of bone that held my eye was not lying loose on the surface but projecting from beneath. It seemed to be part of a skull, but the bones seemed enormously thick. … I carefully brushed away a little of the deposit, and then I could see parts of two large teeth in place in the upper jaw. It was a hominid skull, and there was a lot of it there. I rushed back to camp to tell Louis, who leapt out of bed."

What Mary had found was the 1.8-million-year-old skull of a small-brained, flat-faced early hominid with a large jaw (Louis Leakey's nickname for *Zinjanthropus* was "Nutcracker Man"). It was not a direct ancestor of mankind, but a species that had evolved from an earlier common ancestor. The fossil was published in *Nature* in September 1959, and its discovery radically changed the concept of the time line of human evolution.

Des Bartlett

Award-winning wildlife photographer, documentary filmmaker, and author Des Bartlett grew up in Queensland, Australia. In 1954, Bartlett was asked to travel to Africa for a six-month filming assignment that ended up lasting ten years and culminating in, among other works, his book *Nature's Paradise*. During this time, he filmed and photographed the excavation of *Zinjanthropus*. Mary Leakey later wrote: "the reason why 'Zinj' was so important to us was that he captured the public imagination. … If we had not had Des Bartlett and his film camera on the spot to record the discovery and excavation of the skull, this might have been much harder to achieve. Zinj made good television and so a very wide public had the vicarious excitement of being there when he was dug up."

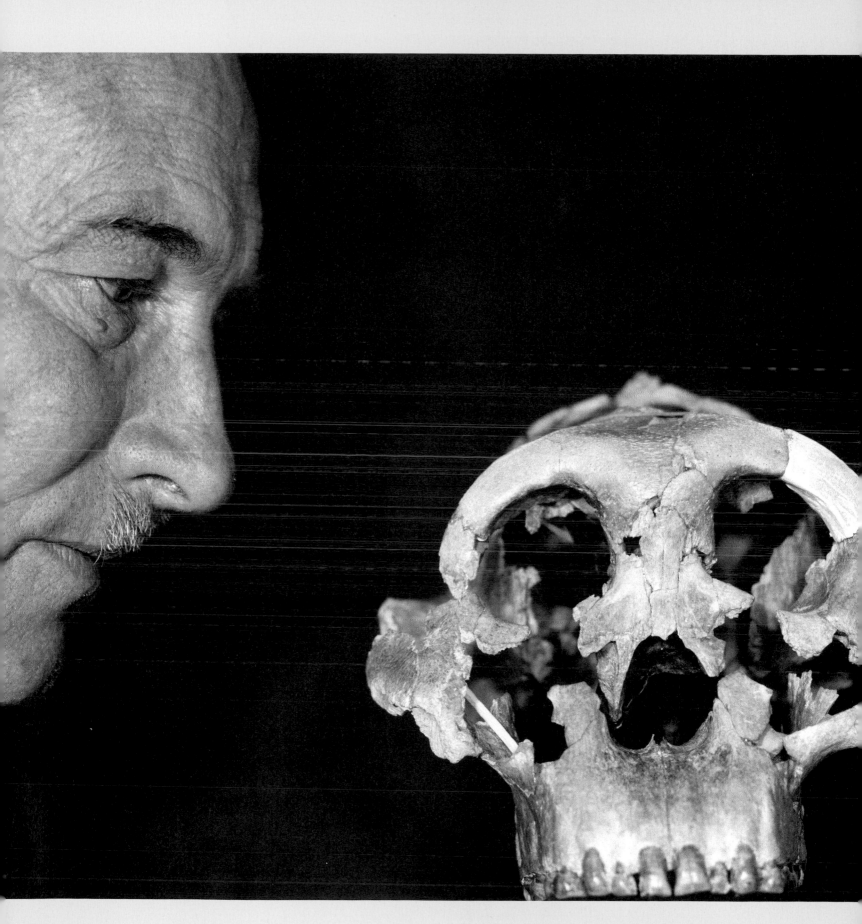

Louis Leakey with the skull of *Zinjanthropus*

A Contemporary Note

Extract from Louis Leakey's account of the discovery of Zinjanthropus:

As we bounced down the trail in the car, Mary described the dramatic moment of discovery ... her eye caught a piece of bone lodged in a rock slide. Instantly she recognized it as part of a skull ... Her glance wandered higher, and there in the rock were two immense teeth ... They were undeniably human ... She marked the spot with a cairn of stones, rushed to the Land-Rover, and sped back to camp with the news.

The gorge trail ended half a mile from the site, and we left the car at a dead run. Mary led the way to the cairn, and we knelt to examine the treasure. I saw at once that she was right. The teeth were premolars, and they had belonged to a human. I was sure they were larger than anything similar ever found, nearly twice the width of modern man's. I turned to look at Mary, and we almost cried with sheer joy, each seized by that terrific emotion that comes rarely in life. After all our hoping and hardship and sacrifice, at last we had reached our goal—we had discovered the world's earliest known human. Somehow we waited until the next day before doing anything further

The Leakey family, with their son Peter and dogs, examine the site of their find.

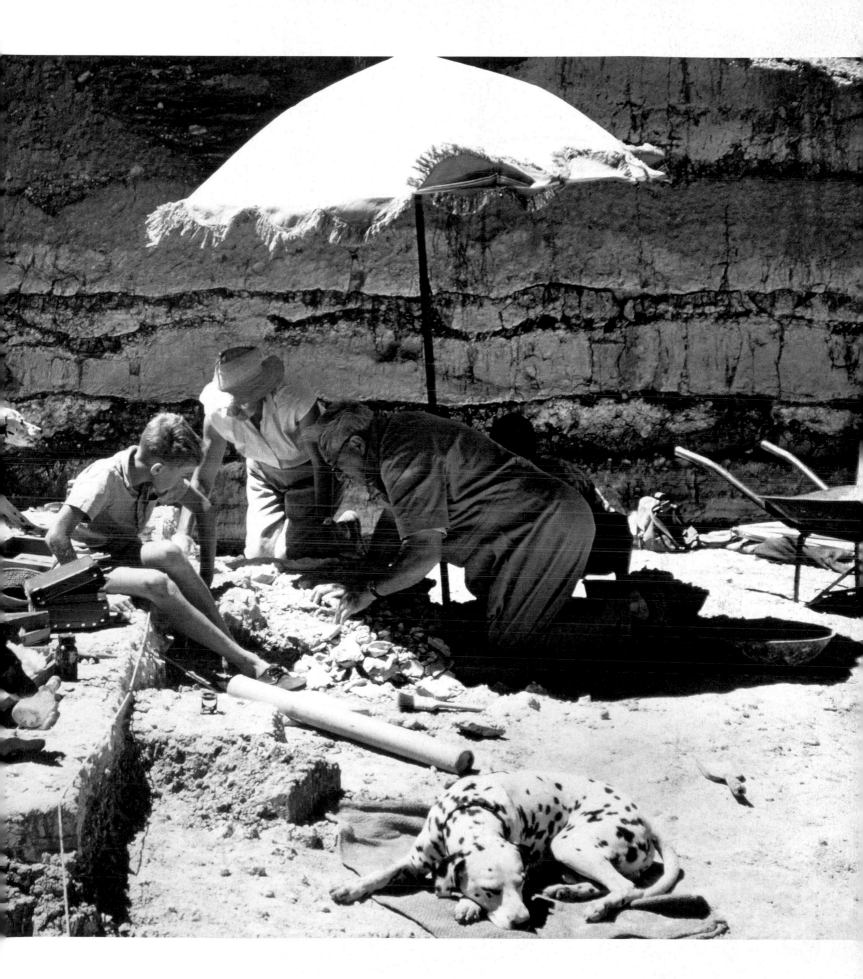

[January 23, 1960]

TRIESTE EXPLORES THE MARIANA TRENCH

The Challenger Deep lies at the very bottom of the Mariana Trench, on the floor of the western North Pacific Ocean, 210 miles southwest of Guam. It is the deepest location in the Earth's crust, and, although still almost 4,000 miles above the center of the Earth, it is farther below sea level than the summit of Mount Everest is above it.

The deep was named for the H.M.S. *Challenger*, the British Royal Navy vessel that first surveyed the area in 1951. In 1957, a Soviet expedition measured the depth of the deep as 36,200 feet. Three years later, an American expedition transported the U.S. Navy bathyscaphe *Trieste* to the Mariana as part of Project Nexton. The *Trieste* had been built by the Swiss engineer Jacques Piccard and his father, Auguste Piccard, and sold to the U.S. Navy in 1957.

Jacques Piccard rejoined the *Trieste* for this new expedition to the Mariana. At 1306 hours on January 23, 1960, in very rough seas, Piccard and Lt. Don Walsh of the U.S. Navy reached the floor of the Challenger Deep. The *Trieste* carried iron shot as ballast for the descent—which took five hours—and gasoline for the ascent. When the bathyscaphe reached the bottom, the two men recorded a depth of 37,799 feet, later revised to 35,813 feet. The pressure on the *Trieste* at this point was more than eight tons per square inch.

Piccard and Walsh were surprised to find flounder and a new type of shrimp at this depth, where the bottom appeared to Piccard "light and clear, a waste of firm diatomaceous [fossil-impacted] ooze." To Walsh, the experience was "like being in a big bowl of milk." Having spent barely 20 minutes on the ocean floor, the divers became alarmed by cracks appearing in the viewing windows, and so began their ascent, a process that took three and a quarter hours to complete.

A legend in the making

Globetrotting, award-winning photographer Thomas J. Abercrombie was a legend among the staff at *National Geographic*. Abercrombie did it all, from diving with Jacques Cousteau to witnessing civil war in North Yemen to being the first reporter to visit the South Pole. Also legendary were his expense accounts, which not only included the purchase of a small airplane with pontoons for a trip to Alaska, but also his justifying two AK-47s as "auto insurance."

Jacques Piccard (*right*) and Lawrence Shumaker (*center*) repair the *Trieste*

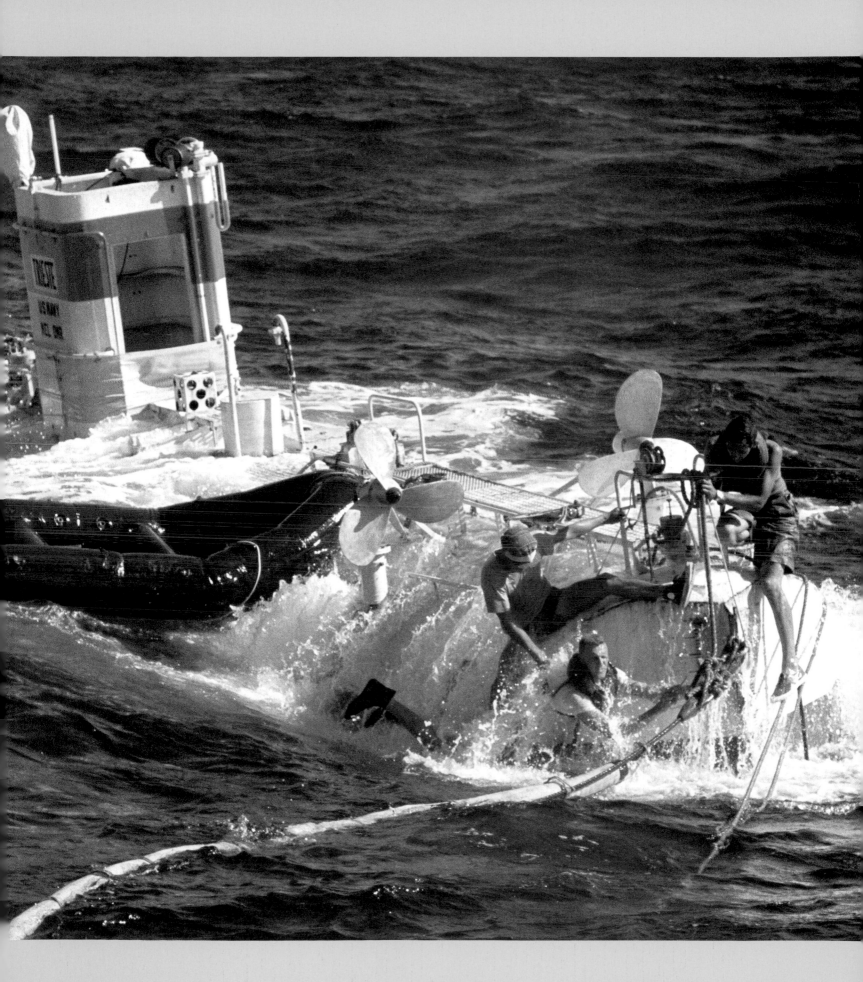

"I think we're ready to move. And it is to that great task,
if we are successful, that we will address ourselves."

CLOSING REMARK OF JACK KENNEDY IN FIRST TV DEBATE, SEPTEMBER 26, 1960

[September 26, 1960]

FIRST PRESIDENTIAL DEBATE ON TELEVISION

The 1960 U.S. President election was the first in which television was used as part of the electoral process. The Republican candidate was the astute and experienced incumbent Vice President, Richard M. Nixon (1913–1994). For the Democrats, John F. Kennedy (1917–1963) was relatively raw, but he was charismatic and he had his own vision of a new United States.

Television had now come of age as a means of communication. Aware of its potential influence over voters, the two candidates agreed to take part in a series of four televised debates, which would also be broadcast on radio. The prime mover was CBS News. "The Great Debate," as it became known, was seen by political parties as a chance to make the equivalent of a whistle-stop tour of the whole country in just one hour.

The first head-to-head clash of the candidates took place in a studio in Chicago, Illinois, on September 26, 1960. The debate was chaired by CBS anchorman Howard Smith. The panel of questioners included Walter Cronkite of CBS, John Edwards of ABC, John Chancellor of NBC, and Frank Singiser of Mutual News. The debate centered on domestic issues. Kennedy and Nixon were given eight minutes each to make their opening addresses, which were followed by a series of questions, with the candidates making short summaries of their points at the end. Kennedy opened on welfare and the economy, saying, "I think it's time America started moving again." Nixon went on the defensive, justifying the record of the Republicans.

Most of the 60 million who watched the debate on television thought that it had been won by the tanned and confident Kennedy. Meanwhile, most of those who heard it on radio thought that the candidates were equally matched, and called it a draw. The contrast between the reactions of the two audiences was a significant early demonstration of the power of television as an image-builder.

Photographing TV

In the comparatively early days of mass TV, and long before video recorders, many people took photographs of what was on screen, to capture a permanent image of their own of some great happening. The picture of Nixon and Kennedy debating on television was taken by Paul Schutzer, a *Life* magazine photographer who was present in the CBS Studio in Chicago on September 26, 1960. Schutzer covered many of the seminal events of the 1950s and 1960s.

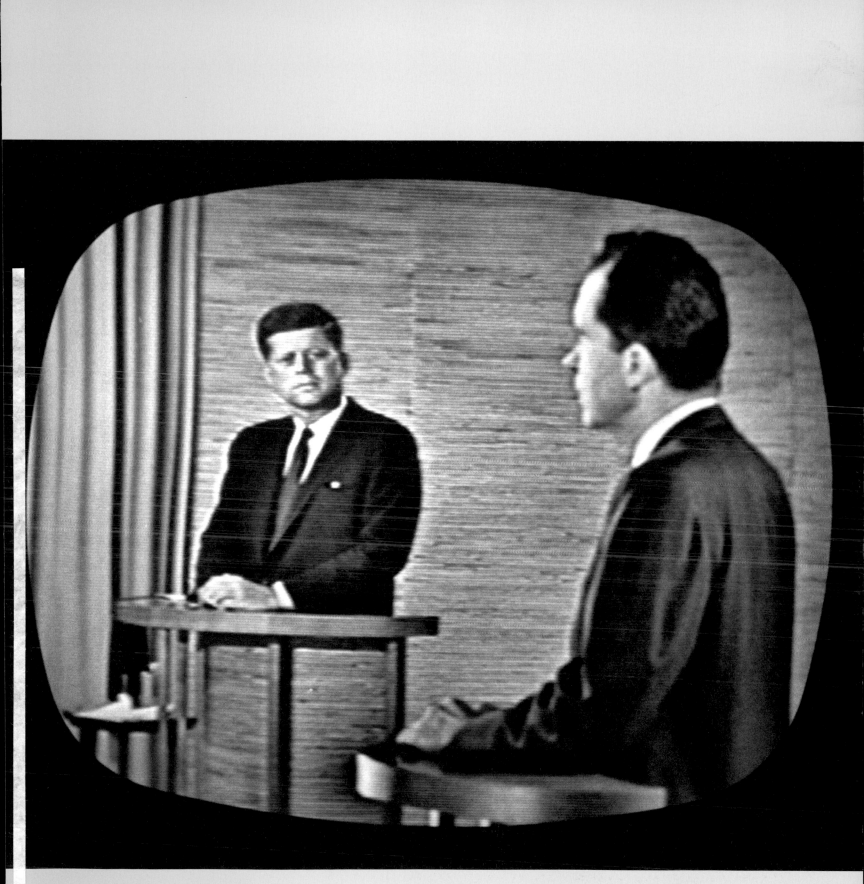

John F. Kennedy shone on camera in the candidates' first television debate.

[October 24, 1962]

MISSILE CRISIS IN CUBA AVERTED

On October 14, 1962, U.S. intelligence flights over Cuba discovered the existence of missile sites, then under construction. The National Security Council debated two possible courses of action: a strategic air strike to take out the bases, or a naval blockade of the island to force both Cuba and the Soviet Union to negotiate. The United States eventually chose the latter option, although they called it a "quarantine," because "blockade" technically represented an act of war.

Kennedy announced the imposition of the quarantine on Monday, October 16. He demanded that the Soviet Union dismantle the sites and withdraw all nuclear weapons from Cuba. The Cuban premier, Fidel Castro, then announced the mobilization of Cuban forces. Krushchev followed this with the declaration that the Soviet Union would take no notice of the "quarantine." The fleet of five supply ships, already well on their way to Cuba, would sail on. The threat of war loomed.

The climax occurred on Wednesday, October 24: Khrushchev changed course. The five supply ships stopped short of sailing into the U.S. Navy ships that had been sent to oppose them, and turned for home. On October 26, a member of the Soviet Embassy staff in Washington, D.C., used a journalist to deliver a message to Secretary of State Dean Rusk. The Cuban missiles would indeed be withdrawn if the United States made a public pledge not to attack Cuba.

The crisis was not over quite yet. The Pentagon announced the disappearance of a U-2 spy plane, and reported that other U.S. aircraft had been fired on. Over 14,000 reservists with the U.S. Air Force were called up. Not until October 28 did Khrushchev finally and officially agree to remove the missiles, and, on November 8, U.S. intelligence confirmed that all missile sites on Cuba had been dismantled.

A Californian family at home in their nuclear shelter, July 29, 1961

Julian Wasser

Julian Wasser began his photographic career as a copy boy in the Washington, D.C., bureau of Associated Press. He later worked as a staff photographer for *Time* magazine, based in Los Angeles; his work appeared in numerous journals all around the world—covering life on the street, the arts, rock music, landscape, politicians, and celebrities. His picture of the Benson family in their home nuclear bunker was published when the Cold War was at its most frigid.

"It was a circus, a performance that beat anything Hollywood could ever do, the performance of the year."

EXTRACT FROM SPEECH BY MALCOLM X, *MESSAGE TO THE GRASS ROOTS*, NOVEMBER 10, 1963

[August 28, 1963]

MARCH ON WASHINGTON, D.C.

In the summer of 1963, the administration of U.S. President John F. Kennedy was deeply concerned about plans for a massive civil rights march on the national capital, believing that it might provoke violence. The President also feared that the march might cause the U.S. Congress to turn down proposed civil rights legislation.

The idea for the March on Washington, D.C., came from the Reverend Dr. Martin Luther King, Jr. (1929–1968), who, at a March 1963 meeting of the Southern Christian Leadership Conference, declared: "We are going to Washington to call attention to the great problem of poverty." Rioting and police brutality in Birmingham, Alabama, had convinced him that the way forward was through nonviolent direct action. The alternative was more violence.

The march was organized by a coalition that included the Congress of Racial Equality, the National Association for the Advancement of Colored People, and the National Urban League. It was supported by many celebrities, including Bob Dylan, Mahalia Jackson, Harry Belafonte, and Sidney Poitier. It was opposed by white supremacist groups and by Malcolm X and the Nation of Islam.

It was a resounding success. On a hot summer day, more than 250,000 people, a quarter of whom were white, marched peacefully from the Washington Monument to the Lincoln Memorial, protesting poverty and discrimination, but also celebrating the strength of their cause and their following. Media coverage was extensive, and the march began and ended with two of the most famous speeches in the history of the United States: The "Wake up, America" speech at the start by John Lewis and Martin Luther King, Jr.'s "I Have a Dream" speech at the end. It also led to the passage of two key pieces of legislation—the Civil Rights Act of 1964, and the Voting Rights Act of 1965.

Martin Luther King, Jr., waves at the crowd as he turns to the cameras.

Washington speeches

A lot of thought had gone into the rally that marked the end and high point of the March on Washington. Civil rights activist John Lewis toned down his speech at the Lincoln Memorial. The actor Burt Lancaster was called in to read James Baldwin's speech, as it was feared that Baldwin might not stick to the approved text. Martin Luther King, Jr.'s speech went ahead as planned, with press photographers given unrivalled vantage points on the platform from which to take their pictures.

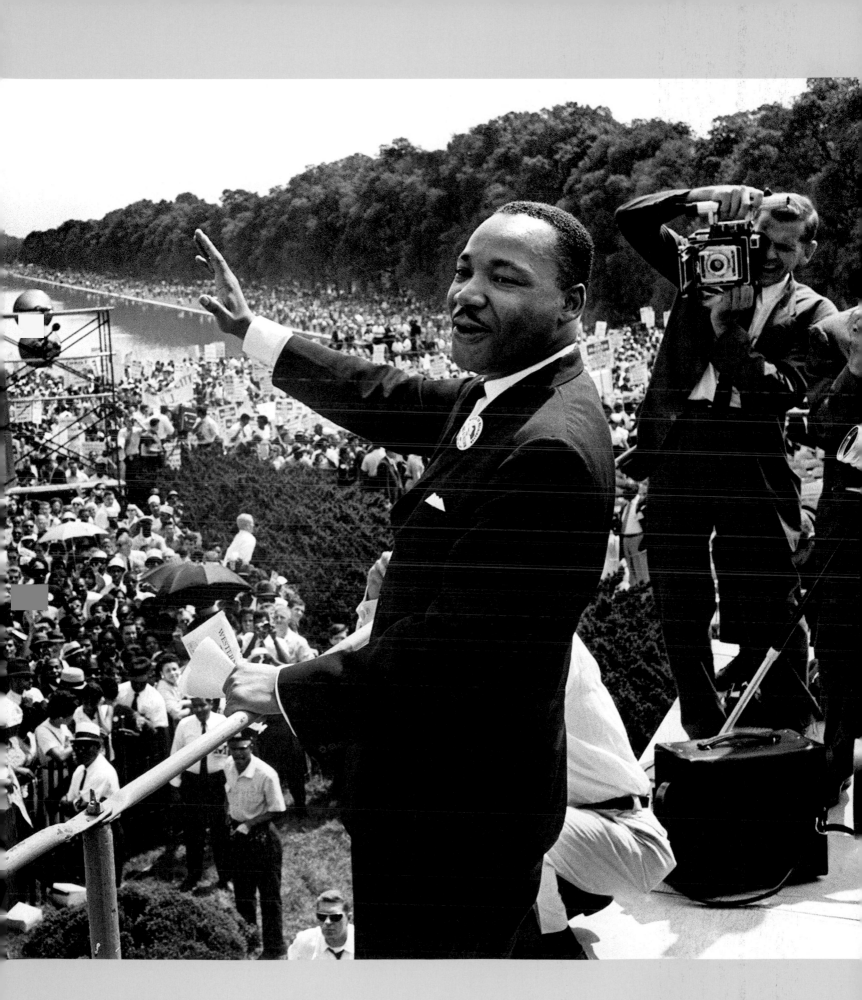

"Here is a bulletin from CBS News. In Dallas, Texas, three shots were
fired at President Kennedy's motorcade in downtown Dallas. The first
reports say that President Kennedy has been seriously wounded."

WALTER CRONKITE, CBS ANCHORMAN, NOVEMBER 22, 1963

[November 22, 1963]

ASSASSINATION OF JOHN F. KENNEDY

President John F. Kennedy (1917–1963) was shot and killed while traveling in a motorcade along Elm Street in Dallas, Texas, on the afternoon of November 22, 1963. Three-quarters of an hour after the attack, an ex-U.S. Marine named Lee Harvey Oswald was arrested for the murder of police officer J. D. Tippit. During police interrogation, Oswald was further charged with the assassination of the President. Two days later, while in police custody, in front of dozens of reporters and millions watching on live television, Oswald was shot by a club owner named Jack Ruby. And that is as much as the world knows for certain about the most famous assassination of the 20th century.

A week after the killing, the Warren Commission began its investigation into the killing. Ten months later, the commission reported that there had been no conspiracy. Oswald had acted alone, firing three shots from his Mannlicher-Carcano rifle from the sixth floor of the Schoolbook Depository Building. One of the shots missed the President's limousine. Another struck Kennedy in the back, passed through his throat, and went on to hit Texas Governor John Connally in the back, ending up embedded in the governor's thigh. This shot was later to be dubbed, by those skeptical of the official account, the "magic bullet." The third shot hit Kennedy in the head. The limousine had then been driven at high speed to the Parkland Hospital, where the President was dead virtually on arrival.

There were other versions: that Kennedy had been killed on the orders of Mafia boss Carlos Marcello; that Lyndon B. Johnson was implicated; that disgruntled Cuban ex-pats angry at Kennedy's soft-handed approach to Castro were to blame; or the CIA; or agents of the Soviet Union. There were also many doubts. Many questioned Ruby's statement that he had killed Oswald simply to spare Jackie

Three-year-old John F. Kennedy, Jr., salutes his father's coffin.

Kennedy's funeral

As a young photojournalist, David S. Boyer covered the early days of the Republic of Israel. He spent 37 years working for *National Geographic*, winning an Antarctic Service Medal for his work there in 1961. Boyer also worked for the *New York World-Telegram* and the *Sun* newspaper. His picture of the Kennedy family standing on the steps of St. Matthew's Cathedral in Washington, D.C., following the Requiem Mass for President Kennedy, is one of the most poignant images of the 20th century.

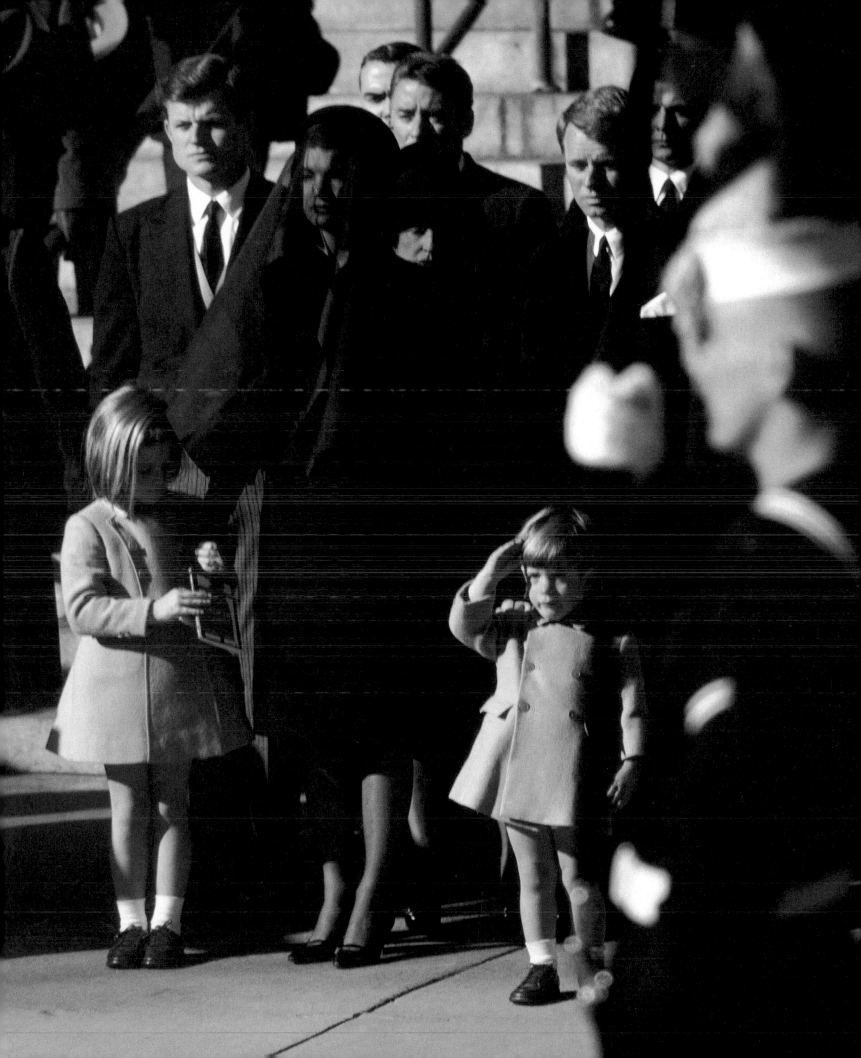

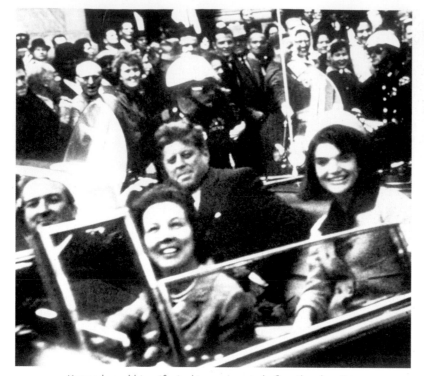

Kennedy and his wife, Jackie, moments before the shooting

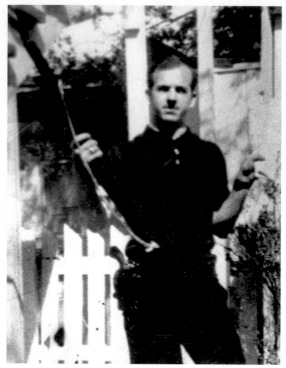

The photo of Lee Harvey Oswald used by *Life*

Kennedy, the President's widow, the pain of the trial of his assassin. Ballistics experts doubted that Oswald was a good enough marksman to score two hits in three shots fired in six to nine seconds from an elevation of some 60 feet at a moving target. The profusion of such doubts prompted in 1976 a second enquiry—the House Select Committee on Assassinations (HSCA). This report stated that four shots had been fired (including one from the famous "grassy knoll"). It further suggested that Ruby had an accomplice in the police who helped him gain access to Oswald, and it questioned whether the security arrangements for Kennedy had been adequate. The HSCA also noted that in the three years directly following the slaying, 18 material witnesses had died—six by gunfire, three in motor accidents, two by their own hand, one from a cut throat, one from a blow to the neck, three from heart attacks, and two from other natural causes.

More than 40 years later, the world will never know what really happened. Had Kennedy served out his term in office, and possibly been reelected, the dreams he wove for the American people and the Western world might well have come true. In this, he was never put to the test. The West lost a leader who many believed in, and dreams of peace and justice were shattered.

"Get a man on top of that triple underpass and see what happened up there… Looks like the President has been hit. Have Parkland stand by."

POLICE RADIO TRANSMISSION BY DALLAS POLICE CHIEF JESSE E. CURRY, NOVEMBER 22, 1963

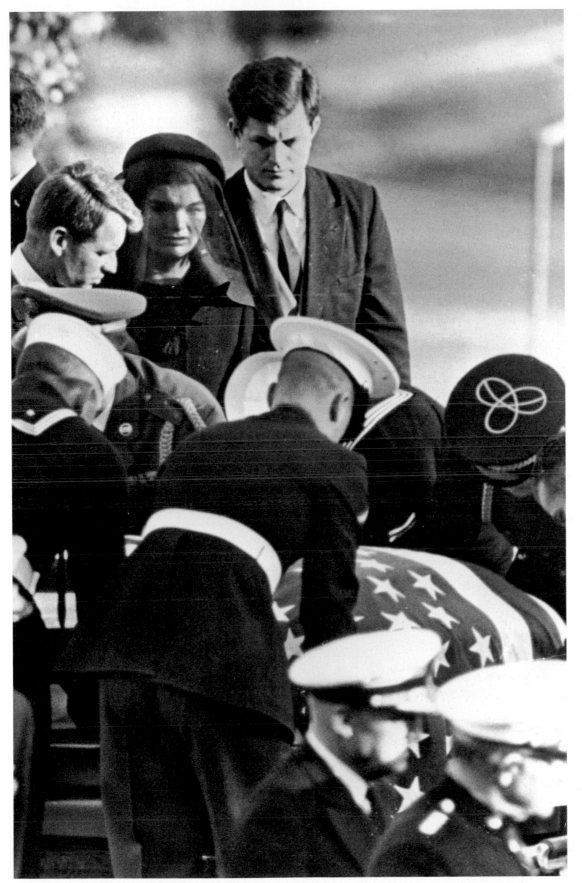

The President's widow, Jackie, and his two brothers, Robert and Edward, at the funeral in Washington, D.C., November 25, 1963

A Contemporary Note

Extract from the diary of Lady Bird Johnson, wife of the Vice President, November 22, 1963:

We were rounding a curve, going down a hill and suddenly there was a sharp loud report—a shot. It seemed to me to come from the right above my shoulder from a building. Then a moment and then two more shots in rapid succession. There had been such a gala air that I thought it must be firecrackers or some sort of celebration. Then in the lead car, the Secret Servicemen were suddenly down. I heard over the radio system, "Let's get out of here," and our Secret Serviceman who was with us, Ruf Youngblood, vaulted over the front seat on top of Lyndon, threw him to the floor, and said, "Get down." Senator Yarborough and I ducked our heads. The car excellerated [accelerated] terrifically fast—faster and faster. Then suddenly they put on the brakes so hard that I wondered if we were going to make it as we wheeled left and went round a corner. We pulled up to a building. I looked up and saw it said "Hospital." Only then did I believe this might be what it was

New York commuters read the
only news there was on
November 23, 1963.

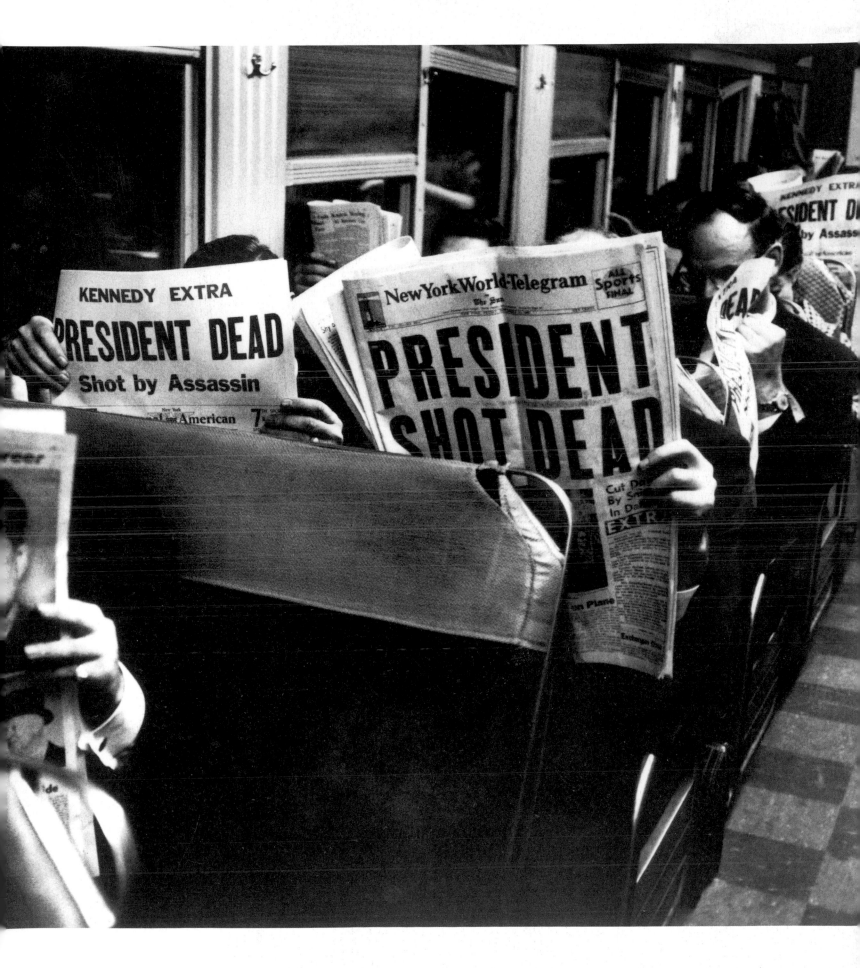

[May 16, 1966]

CHINESE CULTURAL REVOLUTION BEGINS

It was perhaps the most astounding purge in history, a movement initiated to maintain and accelerate revolutionary momentum and to rid China of those in the Communist Party who had fallen into the error of adopting Soviet economic policies. At a grassroots level, Mao Zedong's Cultural Revolution was aimed at schoolteachers, factory managers, and petty officials. At a domestic level, it was aimed at encouraging children to denounce their parents.

The Cultural Revolution began officially on May 16, 1966, with a call by Mao to investigate the bureaucratic and feudal tendencies that he believed still existed in Chinese culture and in the Communist Party. The agents of the revolution were the Red Guards, who were mobilized personally by Mao. The movement grew rapidly, and members adopted a uniform of cap and jacket, with the bright red armband. Across China these young fanatics attacked schools, factories, and officials in rural communities. Victims were publicly humiliated, beaten, imprisoned, and in some cases killed.

Red Guard rallies took place regularly in Tiananmen Square, Beijing, with many conspicuously waving their copies of the so-called "Little Red Book" of Mao's quotations. At such events, the Guards had no fear of denouncing those who stood near the very top of the Party organization, including Liu Shaoqi, Chairman of the People's Republic, and Deng Xiaoping, General Secretary of the Communist Party for more than 20 years. The charge against them was that they had taken "the capitalist road" and become Soviet-style revisionists.

By spring 1967, however, much of China was in chaos, with schools and offices closed, railways shut down, and factory production almost at a standstill. Two years later Mao called a halt to the Cultural Revolution, declaring its victory complete. It did, in fact, continue until 1976.

Mao Zedong and supporters swim in the Yangtze River on July 16, 1966.

Press in China

This picture was released by the Chinese official news agency in July 1966. It shows some 5,000 Chinese following Chairman Mao Zedong's example of swimming in the Yangtze River, near Wuhan. Floating portraits of the Great Helmsman and slogans calling for a "10,000 year" life for him are displayed in the water. Immediately after swimming in the Yangtze, Mao went back to Beijing to head the Cultural Revolution against his former comrades, such as Liu Shaoqi and Deng Xiaoping, bringing Red China close to civil war.

A Contemporary Note

An account of an episode in the Cultural Revolution:

Early on the morning of 25 July 1968, they [Red Guards] gathered about 100 children of high ranking officials and stormed into our school from the back ... Using home-made spears they wounded two of our girl students—one of them needed to be sent to emergency care ...

With adrenalin rushing into my head, straight away I went to the school factory with a dagger attached to a steel pole ... I remember vividly, I was at the front with a spear in my hand. We managed to hold them in a small school building for two or three days. They didn't have food and the water had been cut off as well. Then the Party officials in Shanghai broke us up. During the fight, I had my revenge, I beat up the students in the hostile faction; I slapped the face of the classmate who sold me out.

What made us behave in this way? Firstly it was the system, secondly it was because we were young, childish and fanatical. As Professor Ding Xue Liang said, from a certain aspect, the Cultural Revolution was an act of revenge between human beings. I agree, but it wasn't just that.

Students wave their copies of the "Little Red Book" during a street rally in Beijing, September 1966.

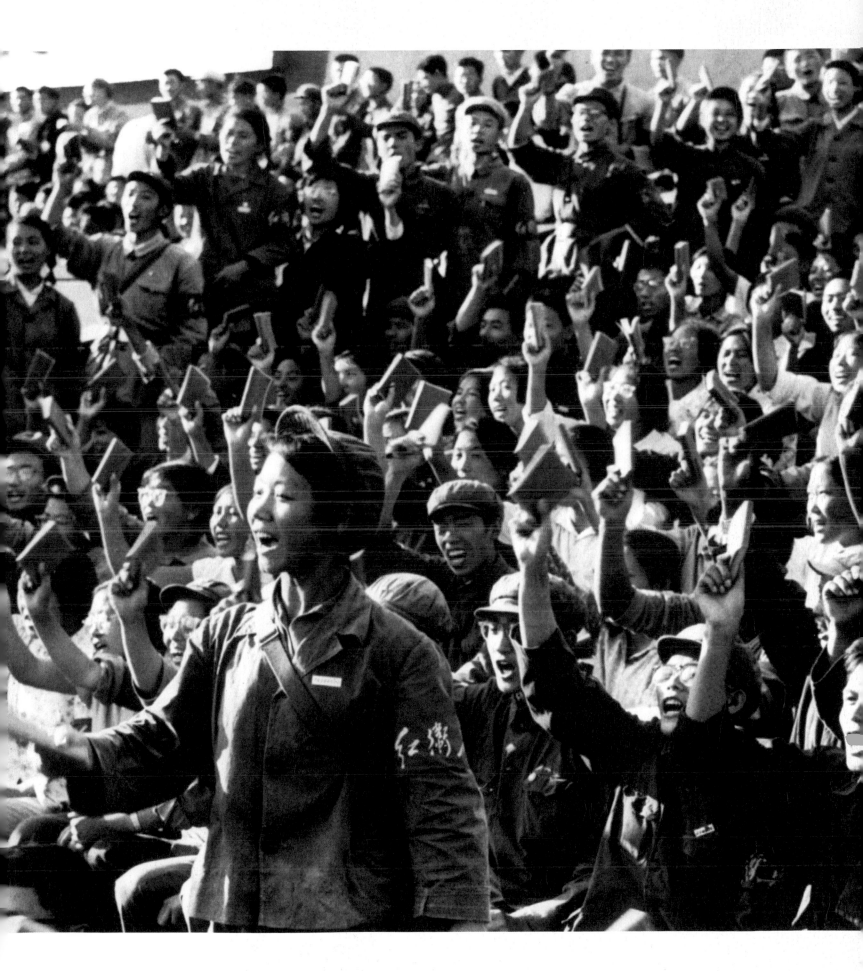

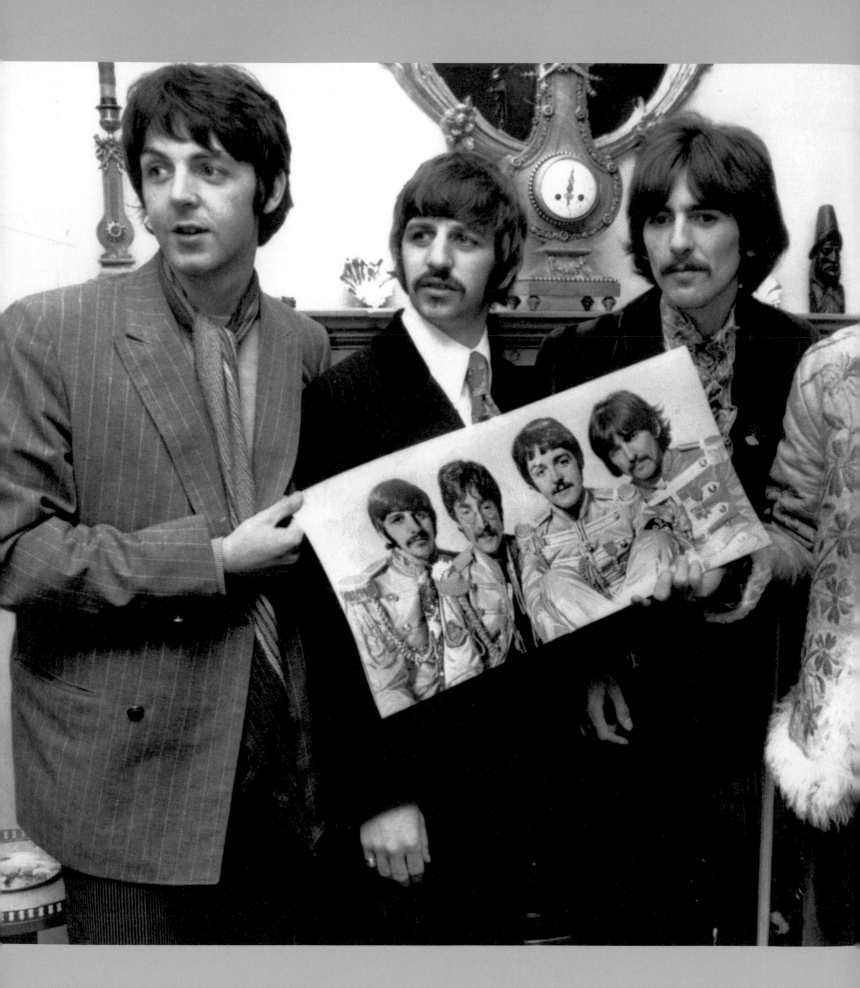

[June 1, 1967]

SGT. PEPPER'S LONELY HEARTS CLUB BAND RELEASED

In 1967 The Beatles had the eccentric idea that it might be possible for them to assume other identities and make future live appearances incognito, in the guise of Sergeant Pepper's Lonely Hearts Club Band. The idea fell by the wayside, but Sergeant Pepper came to life in the form of the first ever "concept album," one of the most innovative and successful recordings in music history.

Within a year of its completion on March 30, 1967, *Sgt. Pepper* won four Grammy Awards from the National Academy of Recording Arts and Sciences: Album of the Year, Best Contemporary Album, Best Recorded Engineering, and Best Album Cover Graphic Art. The industry loved it, the critics praised it, the fans adored it, and the art world recognized the cover's importance.

During the five months that it took to record the album, the artists and designers Peter Blake and Jann Harrison had the job of putting the cover together. From what little he knew of the contents of the album, Blake worked on the notion of a German marching band. Then came the idea of illustrating the tracks with a group photo that would include the four Beatles themselves and characters from the album. Eventually, it was decided that this theme should include The Beatles' waxwork effigies from Madame Tussaud's Museum, and life-size, cutout figures of friends and famous people.

The living greats had to consent to their inclusion. Only one resisted. Mae West responded: "What would I be doing in a Lonely Hearts Club?" The Beatles wrote to her, and she gave in. Paul McCartney, Ringo Starr, and George Harrison persuaded John Lennon to drop the idea of including Adolf Hitler. The figures were assembled, the Fab Four donned their psychedelic costumes, and photographer Martin Cooper took the shot that was to become the most famous album cover of all time.

Paul, Ringo, George, and John—The Lonely Hearts Club Band

John Downing

In 1967 John Downing was a staff photographer with the London *Daily Express*. He was invited to the studio of artist/designer Peter Blake for a photoshoot with The Beatles as part of the material Blake was collecting for the album's cover. Downing went on to become chief photographer for the *Express* from 1985 to 2001, and seven times British Press Photographer of the Year.

[June 5, 1967]

START OF THE SIX DAY WAR

In the years that followed the 1956 Suez Crisis, Arab states, led by Egyptian President Gamal Abdel Nasser, regularly denounced Israel, declaring their intention of destroying the young nation. Almost every day, Israeli settlers encroached on the land of their northern neighbor, Syria. In retaliation, Syria attempted to divert and cut off Israel's water supply. In November 1966, several members of an Israeli border patrol were killed when their armored vehicle hit a land mine near the Jordanian border.

Despite attempts by King Hussein of Jordan and Israeli premier Golda Meir to maintain a diplomatic dialogue, armed conflict was always the preferred option of many on both Arab and Israeli sides. The rapid deterioration of relations between Israel and the combined Arab nations of Egypt, Syria, and Jordan was, therefore, almost inevitable. On May 22, the Straits of Tiran—the narrow passage at the Red Sea entrance to the Gulf of Aqaba—were "closed to all ships flying the Israeli flag." Two weeks later, the Six Day War began.

For Israel, the war was a complete triumph, a lightning victory over three enemies on three fronts. On June 5, a preemptive strike virtually destroyed the entire Egyptian air force in a single day, with 300 planes put out of action and a hundred Egyptian pilots killed. It took Israeli forces two days (June 6–7) to deliver a knockout blow to the Jordanian army and capture Jerusalem; and three days (June 6–8) to rout the Egyptian army at the battle of Abu-Ageila and then race on to the banks of the Suez Canal. In the north, the seemingly rash plan to attack the Golan Heights resulted in an easy victory. When the ceasefire came on June 11, the Israelis occupied the West Bank, the Gaza Strip, the Sinai Peninsula, and the Golan Heights. It was perhaps the most successful war in modern history. And when it was over, provocation and accusation remained.

Egyptian planes destroyed on the ground, June 6, 1967

Aerial photography

Photo reconnaissance from the air had been pioneered in World War I, at first using cameramen stationed in balloons. The big change came in 1916 when Fred Zinn from Battle Creek, Michigan, an ex-member of the Foreign Legion, joined the French Aeronautique Militaire and began taking photos of enemy positions from an early fighter plane. Some 50 years later, the Israeli Air Force used aerial photography to great effect, not only to identify enemy targets and troop movements, but also to provide evidence of the speed and extent of their victory in the Six Day War.

"...600,000 or so refugees have fled to the safety of the Eastern Region—
hacked, slashed, mangled, stripped naked and robbed of all their
possessions; the orphans, the widowed, the traumatized"

COLIN LEGUM, REPORTING IN THE OBSERVER, OCTOBER 16, 1966

[July 7, 1967]

NIGERIAN TROOPS MOVE INTO BIAFRA

The mass famine that afflicted Biafra, a province of Nigeria, in the late 1960s was a product of war. On July 7, 1967, Nigerian federal army troops moved into Biafra, the homeland of the Igbo people who, under their leader Col. Emeka Ojukwu, were attempting to establish an independent state. In the fighting that followed over the next three years, some 30,000 Igbos were killed.

During that time, Nigeria imposed a blockade on Biafra, cutting off supplies of salt, meat, and fish to the rebels. The effect was devastating. More than a million civilians died, mainly through hunger, but also, in the case of many children, from *kwashiorkor,* a disease caused by lack of protein that leads to a wasting of the muscles and a swelling of the belly. Early in 1968, a fact-finding mission of the International Committee of the Red Cross (ICRC) counted more than 300,000 children suffering from kwashiorkor.

A few months later, the ICRC reported that three million children were near death, and that 2,500 people were being admitted to emergency hospitals in the region each week. Conditions in the temporary camps set up to accommodate refugees were worsening. The hundreds of people who died each day were unceremoniously buried in undergrowth surrounding the camps.

Photography and film brought some of the most painful images ever seen to the attention of the world, and the world responded. By April 1969, the ICRC, with the help of UNICEF and the World Council of Churches, was operating the biggest relief program of all time, establishing—with difficulty—an air corridor over Nigeria that enabled them to fly 40 planeloads of essential supplies into affected regions each night.

The war ended in 1970. Slowly, Biafra was reabsorbed into the Federal Republic of Nigeria.

Some of the Biafran children suffering the *kwashiorkor* scourge

Photographing famine

Photographer Gerard Klijn took this 1967 picture of starving Biafran children—one of many that brought this horrific side effect of the Nigerian civil war to the world's attention. The Biafran experience changed the entire outlook of many photographers. "I was devastated by the sight of 900 children living in one camp in utter squalor at the point of death," wrote the acclaimed war photographer Don McCullin. "I lost all interest in photographing soldiers in action." This war became a turning point in the way famines were reported—from now on journalists would try to shape events as well as record them.

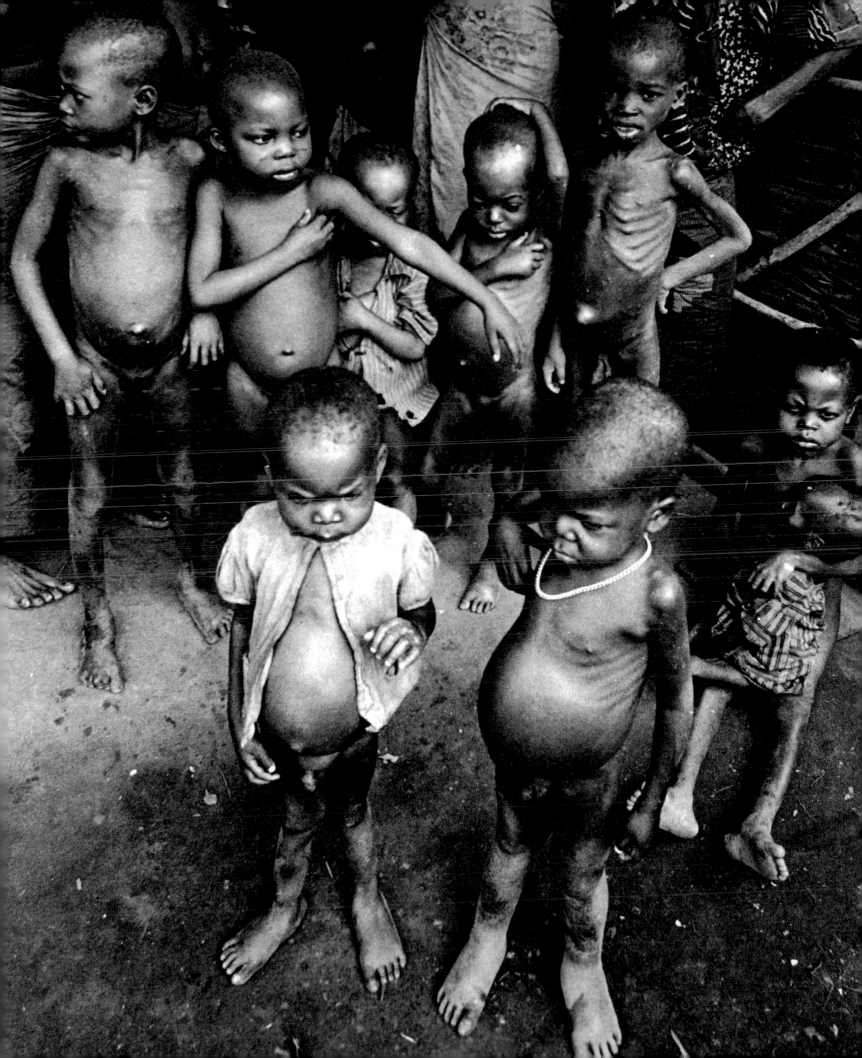

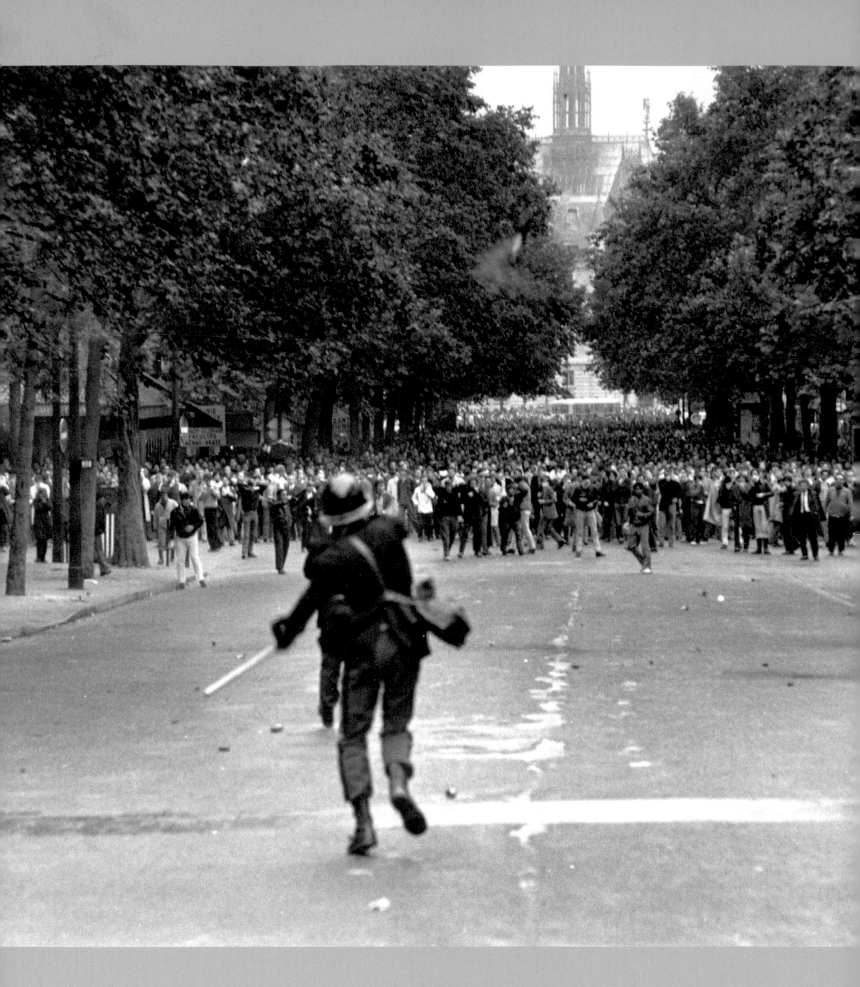

[May 14, 1968]

PARIS ON STRIKE: THE BRINK OF REVOLUTION

Some blamed rock-and-roll. Others blamed the new generation of teachers and philosophers. Many blamed youth itself. Whoever was to blame, there was an air of fury in the air in the late sixties. Crowds took to the streets in London, Prague, Berlin, Washington, D.C., Johannesburg, and hundreds of other cities, in many cases seeking the overthrow of the government of the day.

In Paris, France, the trouble began on May 2, 1968, when administrators shut down the Sorbonne, the university at the heart of the city, locking out the students. Meetings were convened on the streets, in public buildings, and in factories as students and workers joined together in protest. On May 6, more than 20,000 students, teachers, and their supporters marched on the Sorbonne, and declared it an "Autonomous People's University." A leader emerged in a young Marxist named Daniel Cohn-Bendit (1945–), known as "Danny the Red," who believed that the Day of the People had finally arrived, and that the proletariat would now create a progressive state, as the Russian Bolsheviks had sought to do 50 years earlier.

Labor unions called for a general strike to take place on May 14. Trains stopped running. Airports were shut down. Mail and telephone communications were cut. Barricades were erected. A million people took to the streets, many looking for conflict. The French police—especially the CRS riot police—did not hesitate to use force. Running battles were fought on the streets of Paris between the police and students.

The violence continued for more than a month, with the President of the French Republic, Charles de Gaulle, watching and biding his time. In June, he made a television broadcast to the nation in which he promised limited concessions and reforms. His performance was enough to pacify the discontent. Order was restored.

Demonstrators confront the Paris riot police on June 17, 1968.

Reg Lancaster

By June 1968 photographers from all over the world were covering the riots in Paris. Among them was Reg Lancaster, a staff photographer with the London *Daily Express*. Lancaster was with the paper for 40 years, turning his hand to every variety of occasion. Four months after taking the picture opposite, Lancaster was back in Paris, taking pictures of Maria Callas and Richard Burton at the Longchamp racecourse.

[August 20, 1968]

INVASION OF CZECHOSLOVAKIA

In April 1968, there was a reawakening of democratic ideals in the Soviet satellite country of Czechoslovakia. The Communist Party chief there, Alexander Dubcek, spoke of introducing a system of "socialism with a human face." Such sentiments alarmed Soviet leaders. The rising in Hungary of 1956 was still in their minds, and alarm bells always rang when reactionary or liberal forces appeared in any of their satellite countries.

What became known as the Prague Spring continued. By May 9, Moscow's line had hardened, and Soviet tanks were massing on the Polish and East German borders with Czechoslovakia. Dubcek was summoned to Moscow, where sharp exchanges took place between him and leading members of the Kremlin Politburo. Leaders of other communist countries in Europe met to discuss Czechoslovakia's future. There was talk of a counterrevolution being engineered in Prague. Dubcek was not intimidated. He now openly questioned the structure of the Warsaw Pact, and its control by the Soviet Union. More Russian troops moved to the Czechoslovakian border.

The near anarchic events in Paris, France, in mid-May that year did not reassure Soviet leaders. On August 20, troops from Poland, Bulgaria, Hungary, and East Germany entered Czechoslovakia. By August 22, Soviet tanks were rolling into Prague, to be greeted with outrage by the citizens. As Soviet troops stormed the national radio station, one last broadcast urged loyalty to Dubcek and President Ludvik Svoboda, before the transmitter went dead. Communist Party headquarters were then surrounded, and Dubcek was whisked away in an armored car.

The counterrevolution, if it was such, was snuffed out. Some 30 Czechoslovakians were killed, and 300 injured. Order was restored, but resentment for the Soviet stranglehold on the country remained.

Bricks and flames greet a Soviet tank, Prague, August 25, 1968

Czech photographers

The rapid train of events that followed the Prague Spring of 1968 presented problems for most Western press and photographic agencies. Access to Czechoslovakia became extremely difficult, and the Soviet authorities were not eager to have the rest of the world witness what was going on. Czechoslovakian photographers—among them the award-winning Josef Koudelka—risked a great deal as they smuggled pictures out of the country and on to the front pages of international newspapers.

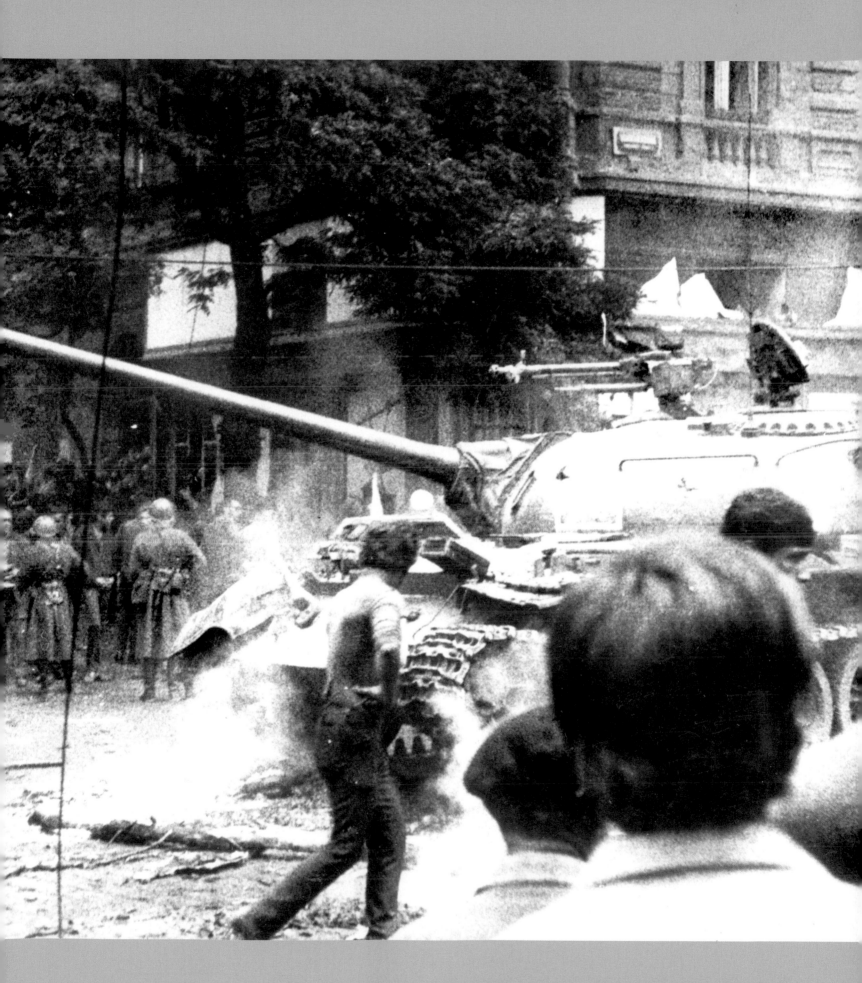

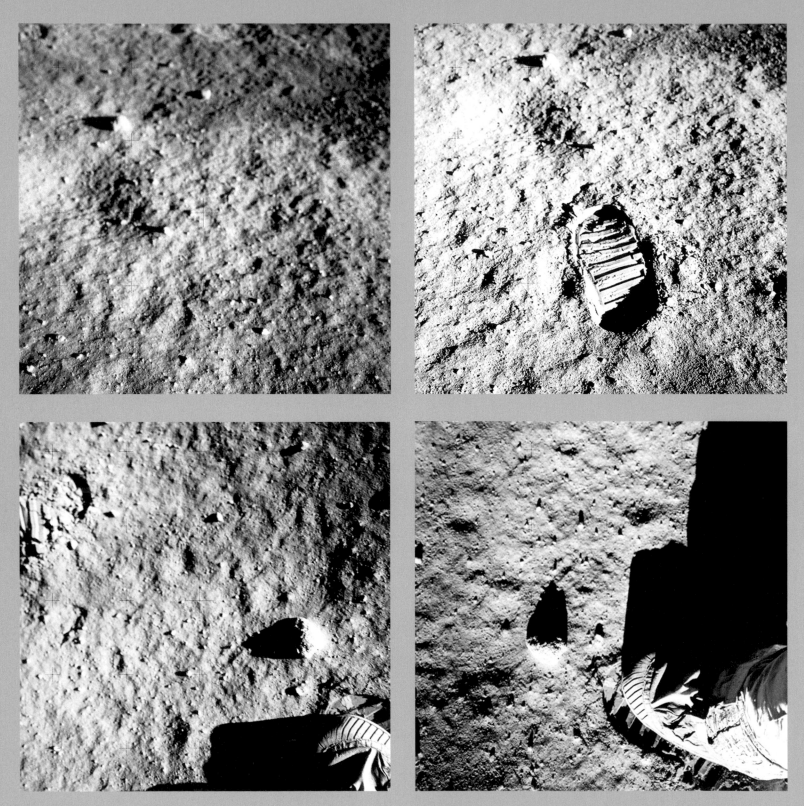

Buzz Aldrin's foot and the footmarks on the surface of the moon

[July 20, 1969]

MAN LANDS ON THE MOON

It was a concept that had filled the daydreams of countless scientists and children—that a human being should one day walk on the surface of the moon. By the 1950s, it became clear that there were only two contestants in the space race—the United States and the Soviet Union. In April 1961, the Soviet Union appeared to have inched ahead: Yuri Gargarin beat Cmdr. Alan B. Shepard, Jr., by just one month to become the first man in space.

Others followed—John Glenn, Valentina Tereshkova, and a whole band of astronauts and cosmonauts—rocketing through space as pioneers of a new age of discovery.

Finally, the great day came. On July 16, 1969, Apollo 11 lifted off from Cape Kennedy, Florida. On board were Neil Armstrong (1930–), Edwin "Buzz" Aldrin (1930–), and Michael Collins (1930–). Four days, six hours, and 45 minutes later, at 4:17:42 p.m. eastern standard time, one-fifth of the world's population watched on TV as Armstrong took his "giant leap for mankind" from the *Eagle* lunar module onto the moon's Sea of Tranquility. Armstrong and Aldrin explored the surface of the moon, while Collins orbited overhead in the *Columbia* command module, waiting for the *Eagle* to return. While on the surface, the two astronauts collected rocks, talked to President Nixon by phone, and raised the American flag—although the United States did not lay claim to the moon. The spaceship stayed for 21 hours before returning to Earth. From liftoff to splashdown, the entire voyage had been a triumph of planning, technology, and human determination.

It was a hammer blow to the Soviets. The space race continued, but the United States now had an unassailable lead. Space itself had somehow become the final battleground between East and West, and the Cold War was never the same again.

Following pages: President Nixon congratulates the astronauts on July 24.

Shooting on the moon

When Buzz Aldrin and Neil Armstrong took those first faltering steps on the surface of the moon, it was Armstrong who carried the camera. Consequently, although the two astronauts remained on the moon for two and a half hours, the only images of Armstrong on the moon are those in which he is reflected in Aldrin's helmet. The footprints left in the lunar soil by Armstrong and Aldrin on the Sea of Tranquility, barring a chance meteorite impact, may well last for a million years.

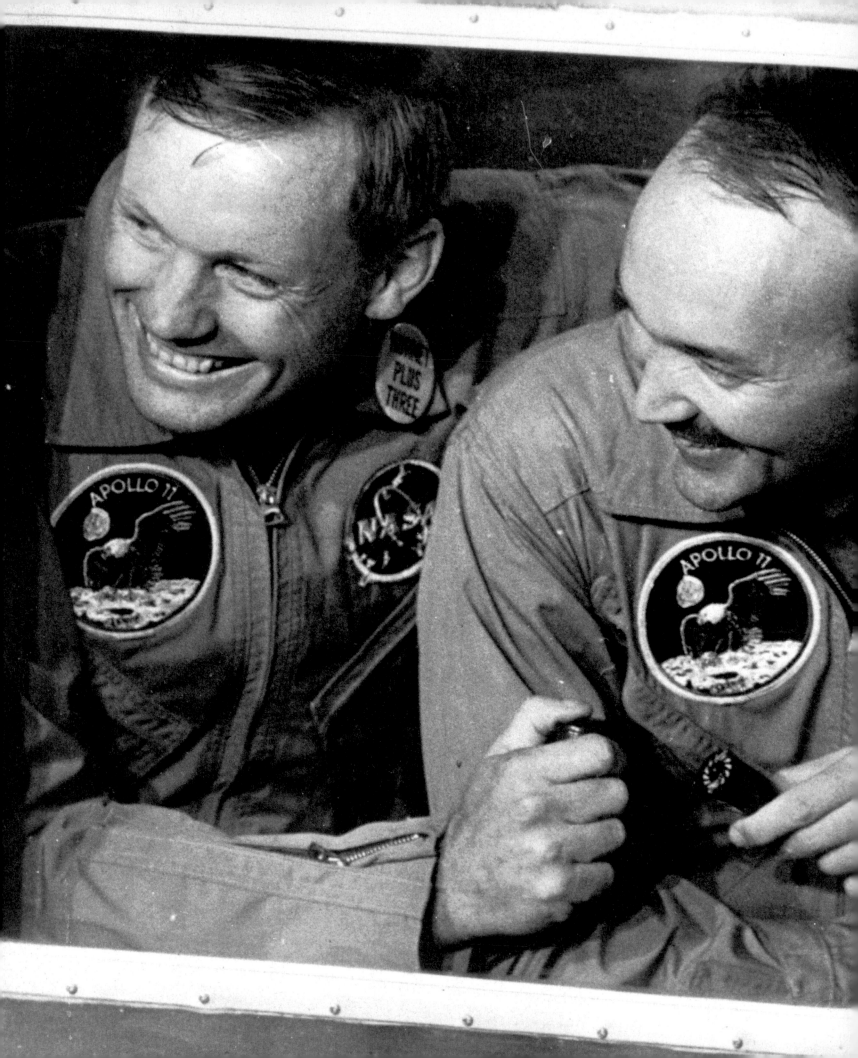

"Just love everybody around ya,
an' clean up a little garbage on the way out. ..."

JOHN SEBASTIAN, FORMER LEAD SINGER OF THE LOVIN' SPOONFUL,
WOODSTOCK, AUGUST 15, 1969

[August 15, 1969]

WOODSTOCK OPENS

To upmarket commentators on pop music, it was "Rock's Coming of Age." To those with a less cerebral outlook, it was a "Krazee Kwagmire." To its young promoters, it was "Three Days of Peace and Music," or simply "A Weekend in the Country." To local police and residents, it was one long nightmare. In the opinion of Arnold Skolnick, the artist who designed Woodstock's dove-and-guitar emblem: "Something was tapped ... a nerve, in this country. And just everybody came."

Not quite everybody, but at least twice as many as were expected. Between August 15 and 18, 1969, Woodstock attracted 450,000 fans to a pasture on Max Yasgur's 600-acre dairy farm near the town of Bethel (population: 3,900) in Sullivan County, New York. Billed to appear was the richest line-up in pop history: Joan Baez; Arlo Guthrie; Sly and the Family Stone; Sweetwater; Santana; Jimi Hendrix; Janis Joplin; Joe Cocker; Creedence Clearwater Revival; Jefferson Airplane; The Who; The Grateful Dead; Richie Havens; The Band (without Bob Dylan, who, the promoters thought, was bound to turn up, but didn't); and Blood, Sweat and Tears. The fees paid to the performers were wildly over the top. The Who came for $12,500, Jefferson Airplane for $12,000—at least twice their normal appearance fees. Hendrix, who was to close the festival on Monday morning, was paid $32,000. Max Yasgur, the farmer, did better than any of them: he collected $75,000.

The promoters, who called themselves "Woodstock Ventures," were absurdly young. John Roberts—who supplied most of the money behind the festival—had only ever seen one pop concert. Artie Kornfeld was a vice president at Capitol Records. Joel Rosenman was a law graduate from Yale. Twenty-six-year-old Michael Lang, the oldest of the four, was described as a "cosmic pixie."

Festival goers dance in the sunshine at Woodstock.

Bill Eppridge

There were plenty of photographers at Woodstock, among them Bill Eppridge from *Life* magazine. Eppridge began his career as a student, when he won a competition offering a week's internship with *Life* as the prize. Eppridge made his reputation with his coverage of the Beatles' U.S. tour, the war in Vietnam, and Robert Kennedy's 1966 and 1968 election campaigns. Woodstock was a natural assignment for Eppridge—the immense and upbeat occasion was fueled by all the passion, energy, and madness of youth.

"In two hours we were all soaring, and everything was just fine. In fact, it couldn't have been better—after all, the dirty little secret of the late '60s was that psychedelic drugs taken in a pleasant setting could be completely exhilarating"

GLENN WEISER, TEENAGE MEMBER OF THE CROWD AT WOODSTOCK, AUGUST 1969

A week before the festival, a group of Bethel residents filed a lawsuit seeking to have the event banned. Woodstock Ventures settled the claim within a couple of days, simply by promising to increase the number of onsite portable toilets. Other locals were more supportive. When the Monticello Jewish Community center heard that the young fans were running out of food, they collected 200 loaves of bread, 40 pounds of cold cuts, and two gallons of pickles. Unfortunately, Woodstock Ventures reckoned at that stage that they needed at least 750,000 sandwiches. Drugs, however, were never in short supply. Although there were two deaths and two births during the festival, most of the medical dramas that occurred came as a result of bad acid trips. And local shopkeeper Art Vassmer raised the price of his six-packs of beer from $1.95 to $2, not so much for profiteering reasons, but rather because he could never find enough change.

The concert was scheduled to start at 4 p.m. on Friday, August 15. The crowds began to arrive on Tuesday, and by Thursday there was already a ten-mile traffic jam stretching back to the freeway. Performers had to be flown in from nearby hotels by helicopter. Richie Havens rushed onstage just in time for the music to start an hour late. What Havens didn't know was that he'd have to keep going until 8 p.m., as no other act arrived till then. That first night, five inches of rain fell in three hours. Acts failed to arrive, and musicians who had rolled up just to watch were persuaded to play.

When it was all over, it took five days for the Woodstock Ventures' crews to clear away all the trash left behind, and considerably longer for the promoters to pay all the money they owed—it had cost them $2.4 million. But it was such a success that a whole raft of new state laws were passed to ensure it would never happen again.

Carlos Santana *(far left)* on stage at Woodstock, August 16, 1969

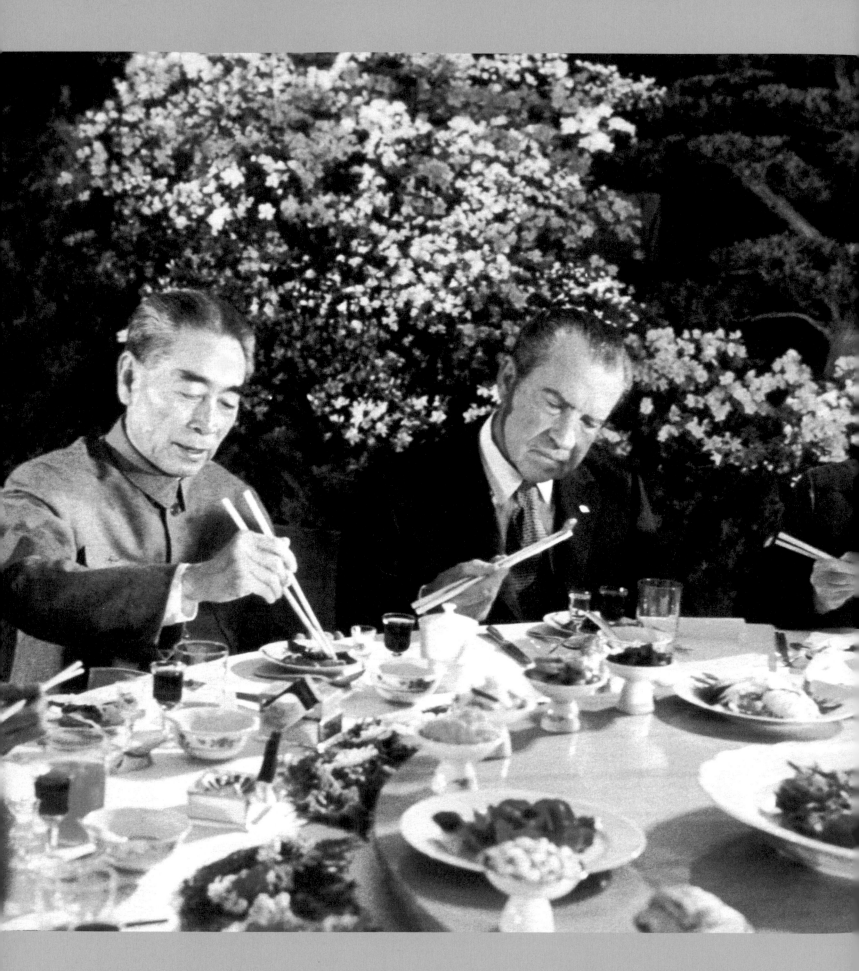

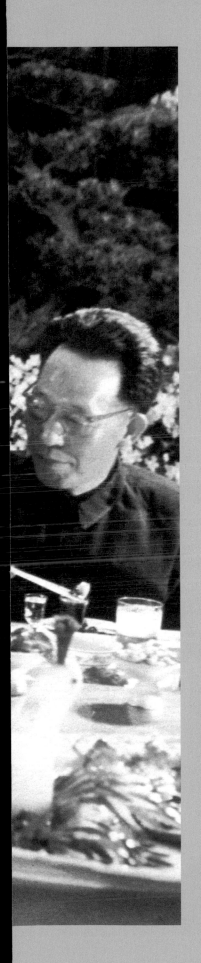

[February 21, 1972]

PRESIDENT NIXON VISITS CHINA

The first visit by a U.S. President to the People's Republic of China was remarkable in many ways. Few minds could seem more incompatible than those of Richard M. Nixon and Mao Zedong, then leader of China, but, for both, there was a chance that the enemy's enemy could become a friend. In 1969 China was in need of a new friend, or at the very least, a new international partner.

Nixon would hardly go that far in his thinking, but the Cold War was still extremely chilly, and both he and his national security adviser, Henry Kissinger, believed that closer ties with China would strengthen the U.S. hand in its dealing with the Soviet Union. After a covert trip to China by Kissinger a few months earlier, Nixon's visit was arranged, and on February 21, 1972, Air Force One landed at Beijing Airport. Within hours, the leaders of the capitalist and Communist worlds were talking. That evening, the Nixons dined with Zhou Enlai, Mao's second in command, and toasts were exchanged while a Chinese band struck up with "Home on the Range" and "America the Beautiful."

Every day of the following week Nixon and Zhou Enlai met for talks. Television coverage was huge for the benefit of those watching in the United States. Nixon was determined that his role as a statesman on the world stage should not go unnoticed.

Interspersed with the talks were visits for Nixon and his wife, Pat, to the tombs of the ancient Ming emperors and the Forbidden City, to Hangzhou, Shanghai, and the Great Wall. It was a tiring and tiresome process, and, by the time the Nixons got to the Great Wall, at Badaling, the President could barely manage: "As we look at this Wall, we do not want walls of any kind between peoples."

Two weeks later, China agreed to establish full diplomatic relations: Nixon's foreign policy triumph was complete.

President Nixon dines with Zhou Enlai *(far left)* on February 21, 1972.

Ollie Atkins: presidential photographer

Ollie Atkins began his professional life as a photographer in 1938. In 1940 he joined the *Washington Daily News,* later serving as a correspondent and photographer for the American Red Cross during World War II. After the war he joined the *Saturday Evening Post* as a Washington, D.C., correspondent. As personal photographer of Richard Nixon and chief White House photographer, Atkins accompanied the Nixons on their visit to China in 1972.

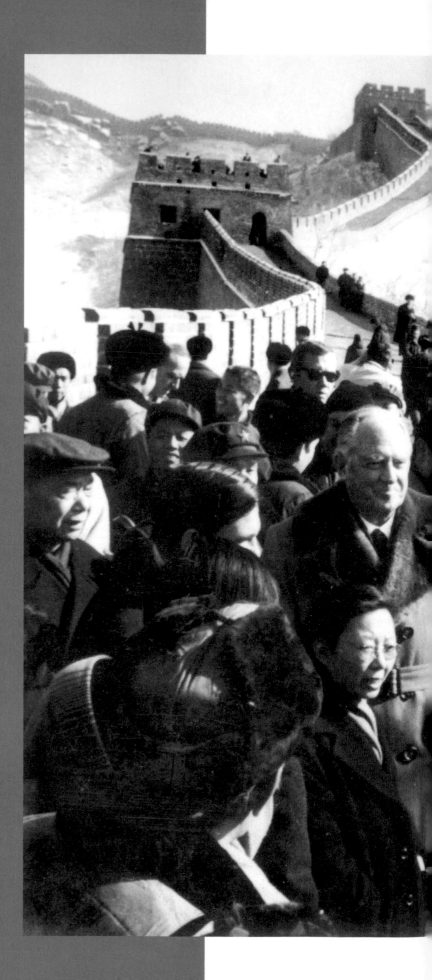

A Contemporary Note

Henry Kissinger, National Security Adviser in 1972, on the President's visit to China:

I don't think he originally intended to send me. The irony is that ... we went over a number of names jointly, and every time he considered one it was obvious that whoever went would become a major public figure and would therefore get some of the credit for the China opening, which Nixon was absolutely determined not to share. So he thought sending his adviser ... was the safest way for him not to have to compete on this. And also the easiest way for him to keep control of it.

We received this communication and I think I brought [it] to him in the Lincoln sitting room if I remember correctly. And I did tell him that I thought this was a diplomatic revolution and maybe I used the phrase "It's the most important communication since World War Two." And he opened a bottle of Courvoisier and we had a drink on that. But we realized that this might break the back of the Vietnam War and certainly would change the nature of our relationship with the Soviet Union. Assuming they weren't playing games, but we never thought that it was likely or even conceivable that they would drag the President's top aide to Beijing to humiliate me.

The President and First Lady visit the Great Wall of China with U.S. Secretary of State William Rogers *(fourth from right)*, February 24,1972.

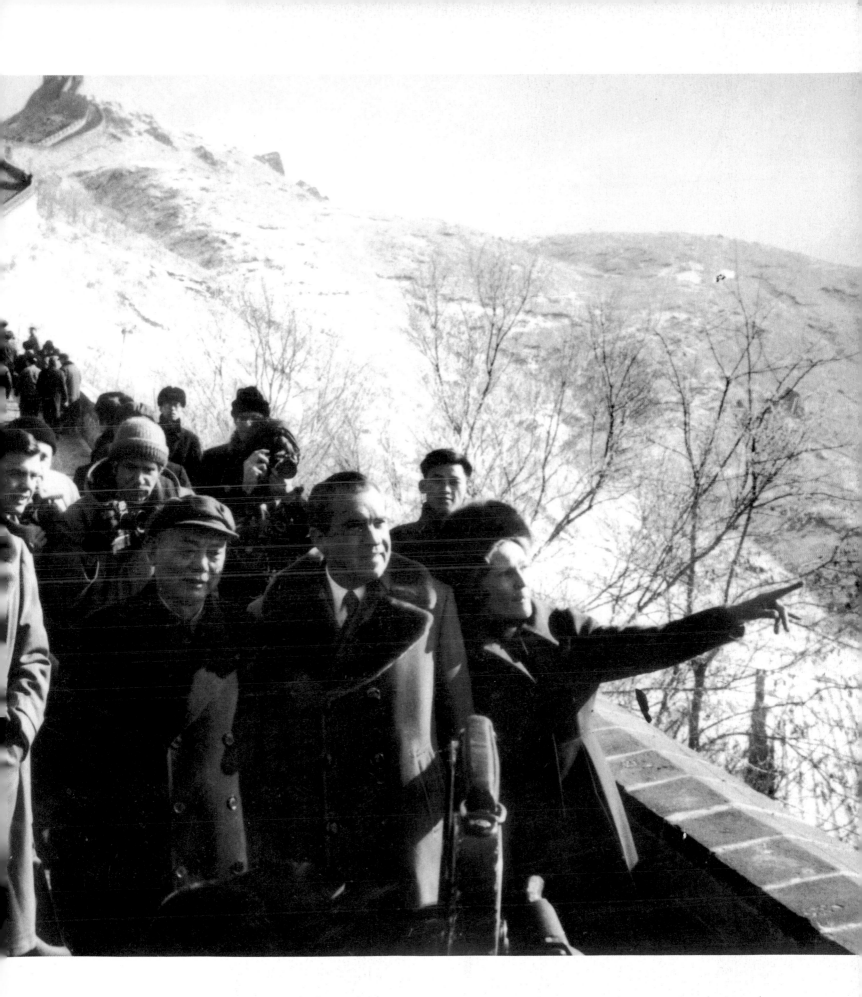

[September 5, 1972]

BLACK SEPTEMBER AND
THE MUNICH MASSACRE

At 4:30 on the morning of September 5, 1972, eight masked members of the Black September Organization (BSO) entered the Israeli quarters at the Munich Olympic village. They were dedicated to the cause of Palestinian liberation, and to the overthrow of King Hussein of Jordan.

Yossef Gutfreund, a 40-year-old Israeli wrestling referee, woke to see masked men with guns at his bedroom door. He threw his 300-pound body against the door, shouting "*Hevre tistalku*—Guys, get out of here!" This courageous action allowed two athletes to escape and another seven to hide. Two other members of the Israeli team were shot by the terrorists, who took nine hostages.

The BSO then made their demands. The first was that 234 prisoners be released from jails in Egypt and given safe passage from that country. They also wanted the release from Stammheim jail in Germany of Andreas Baader and Ulrike Meinhof, key members of the Red Army Faction terrorist group. Late in the day, the BSO added a further demand—their own safe passage to Cairo.

Two helicopters arrived at the village just after 10 p.m., and took the terrorists and the hostages to nearby Fürstenfeldbruck airbase. There two agents of the Israeli secret service Mossad, five West German snipers, and other police were waiting, with a Boeing 727. On arrival, four of the BSO held the helicopter pilots at gunpoint. Two others boarded the 727. Finding it empty, they knew that they had been tricked. Snipers then opened fire. Two members of the BSO were killed. At 12:06 a.m. on September 6, the remaining terrorists began killing the hostages. In all, 17 people died—11 members of the Israeli team, 1 West German policeman, and 5 of the 8 terrorists. By 1:30 a.m. the battle was over. The three surviving terrorists were arrested and imprisoned, but later released.

A German policeman at the Olympic Village, September 5, 1972

Covering terrorism

A war, previously confined to the Middle East, erupted in the heart of the Olympic Village in Munich during the games, symbol of international peace. The picture of the German policeman in plain clothes was taken by Dutch photographer Co Rentmeester, who was covering the games for *Life* magazine. Rentmeester was used to violence—he had covered the Watts Riots and the war in Vietnam.

"In all the decisions I have made in my public life,
I have always tried to do what was best for the Nation"

EXTRACT FROM PRESIDENT NIXON'S RESIGNATION SPEECH,
OVAL OFFICE, AUGUST 8, 1974

[August 9, 1974]

PRESIDENT NIXON RESIGNS

At the beginning of 1973, Richard M. Nixon was riding high. Internationally, he was seen as a world statesman—the man who had brought the Soviet Union and China to the negotiating table, and who had brought about a ceasefire in Vietnam. At home, he had just been reelected President in the greatest Republican victory of all time.

However, during the election campaign, Nixon's opponent, George McGovern, had complained about the "dirty tricks" of the Nixon Administration. Then rumors began to circulate about five men who had been arrested on June 17, 1972, for breaking into the Watergate Hotel headquarters of the Democratic National Committee in Washington, D.C. One of them was James McCord, a former employee of the CIA. In September, two former White House aides were indicted on charges of conspiracy regarding the break-in. They were E. Howard Hunt and the man who had been counsel to the Committee to Reelect the President, G. Gordon Liddy.

On January 30, 1973, Liddy and McCord were convicted. In March, McCord testified that Nixon's recently resigned Attorney General John Mitchell was involved. In May, Nixon made an extraordinary and badly timed television appearance defending himself. Within days, his former aides had implicated him before the Senate Ervin Committee that was investigating Watergate.

It took a year to persuade Nixon to release the White House tapes that were said to prove his involvement. At first he refused, pleading "executive privilege," but, in March 1974, the Watergate grand jury named Nixon as "an unindicted co-conspirator." On July 24, the U.S. Supreme Court ruled unanimously that Nixon must surrender the tapes. Preparations were made for his impeachment, but the President resigned from office on August 9, 1974.

Gjon Mili:
innovations in lighting

Gjon Mili was born in Albania in 1904 and moved with his family to the United States in 1923. He joined *Life* magazine in 1938 and served as a staff photographer until his death 50 years later. Mili was self-taught, and was the first photographer to use electronic flash and stroboscopic light to create photographs that were more than mere scientific novelties. He is best known for his portraits of Pablo Picasso and Pablo Casals in self-imposed exile from Spain, and for that of former Nazi Adolf Eichmann in captivity.

Ex-Nixon aide John Dean *(left)* gives testimony at the Watergate hearings.

PRESIDENT NIXON RESIGNS | 243

> "That day I thought, 'What the hell's the difference. We're all going to die here anyway.' ... Finally, we got out on the helicopters, and we were fired on as we left"

SALLY VINYARD, U.S. DEFENSE DEPARTMENT CIVILIAN, KNOWN AS "THE LAST WOMAN OUT", SAIGON, APRIL 1975

[April 30, 1975]

FALL OF SAIGON

I n March 1975, troops of the North Vietnamese Army (NVA) crossed the Thach Han River that had formed the demarcation line between North and South Vietnam since the ceasefire of January 1973. They pressed forward in overwhelming numbers. Despair settled on Saigon. A war that had lasted for almost 20 years, since the division of the country in 1954, was ending in crushing defeat.

On April 8, 1975, President Nguyen Van Thieu's palace was bombed by a South Vietnamese plane. Thieu left hurriedly on April 21, denouncing the United States as an "untrustworthy" ally. It was an unfair and ungracious charge. The Vietnam War had cost 58,000 American lives and $150 billion. The reaction of U.S. President Gerald R. Ford, on April 29, was to order the evacuation of all remaining American personnel in South Vietnam.

On the morning of April 30, the new President, Tran Van Huong, made a radio broadcast announcing the unconditional surrender of South Vietnam. The U.S. radio station in South Vietnam began to play "White Christmas," the previously agreed signal for American personnel to move at once to evacuation points.

Television viewers in the United States watched live scenes of chaos in Saigon as thousands of people fought for places in the last helicopters to depart from the roof of the U.S. Embassy. The fortunate evacuees were taken to waiting aircraft carriers in the South China Sea. Operation Frequent Wind, as it was known, became the largest helicopter evacuation in history, safely delivering 978 Americans and more than 1,000 Vietnamese from the embassy alone. The last 11 marines were lifted from the embassy at 1952 hours EST. Two hours later, North Vietnamese tanks smashed their way through the gates of the presidential palace. The war was over, and Saigon was no more. It had already been renamed Ho Chi Minh City.

A Chinook helicopter airlifts supplies and people, Xuan Loc, April 30, 1975.

Combat and chaos

Gerald Ford called it "the hardest day of my presidency." The images were unforgettable—of struggling masses fighting for places on the last few flights of Operation Frequent Wind, of chaos and confusion, of crowds scaling the railings around the U.S. Embassy. At the age of 17, Dirck Halstead became *Life*'s youngest ever combat photographer. He was in Vietnam as UPI's picture bureau chief at the time of the final evacuation from the embassy roof. Halstead went on to be *Time*'s White House photographer for 29 years.

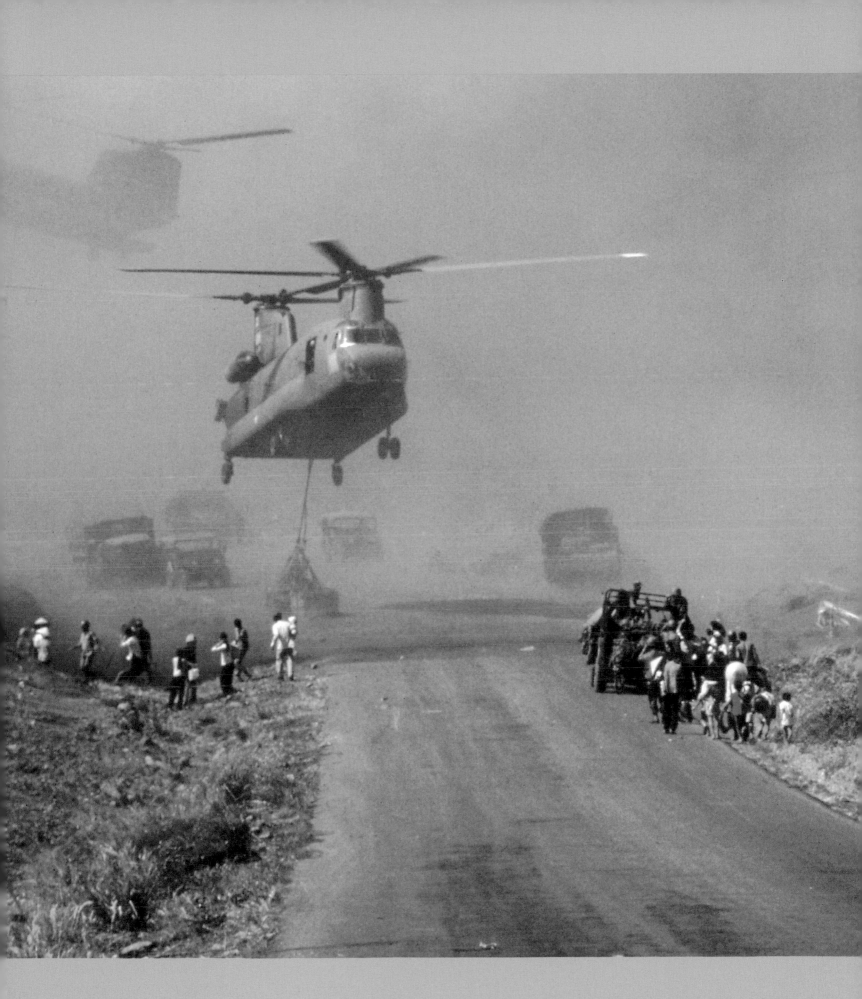

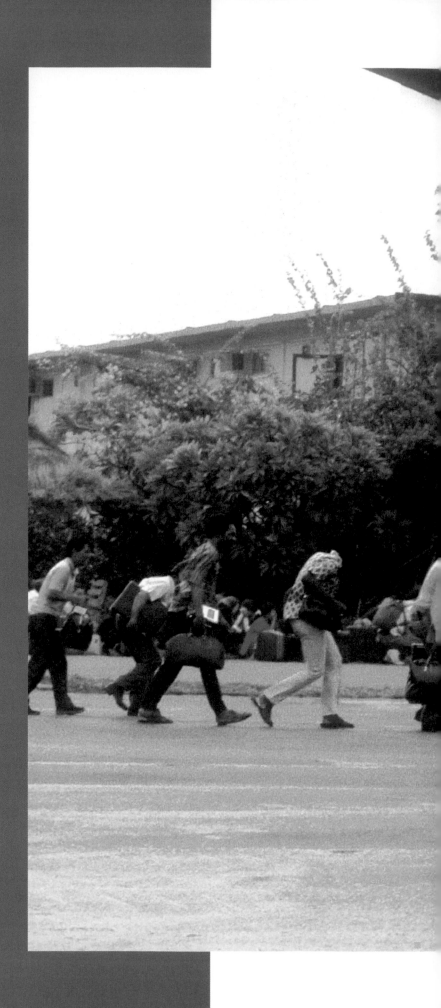

A Contemporary Note

Extract from White Christmas *by Dirck Halstead,* Time/Life *bureau, Saigon, April 25, 2005:*

R oy Rowan, the acting bureau chief for *Time* is holding a staff meeting. I look around the room. There is Mark Godfrey, a Magnum photographer who has joined us.

New instructions have been issued for us from both New York and the U.S. Embassy. *Time* has placed a lid on additional staffers coming into Saigon. They want us to reduce our numbers as quickly as possible. The orders from New York are clear... get the Vietnamese staff out, then pull down the rest of the staff. Only a skeleton staff will remain till the end. The Embassy has told the bureau chiefs that in the event of an evacuation of Saigon, the Armed Forces Radio Network will issue a special weather report stating that, "The temperature is 105 and rising!" At this signal, all western news personnel should report to their evacuation staging areas, which are being set up around town. We are told that the evacuation will be in full swing when Armed Forces Radio begins broadcasting Bing Crosby's "White Christmas."

U.S. civilians board a
helicopter, Saigon,
April 30, 1975.

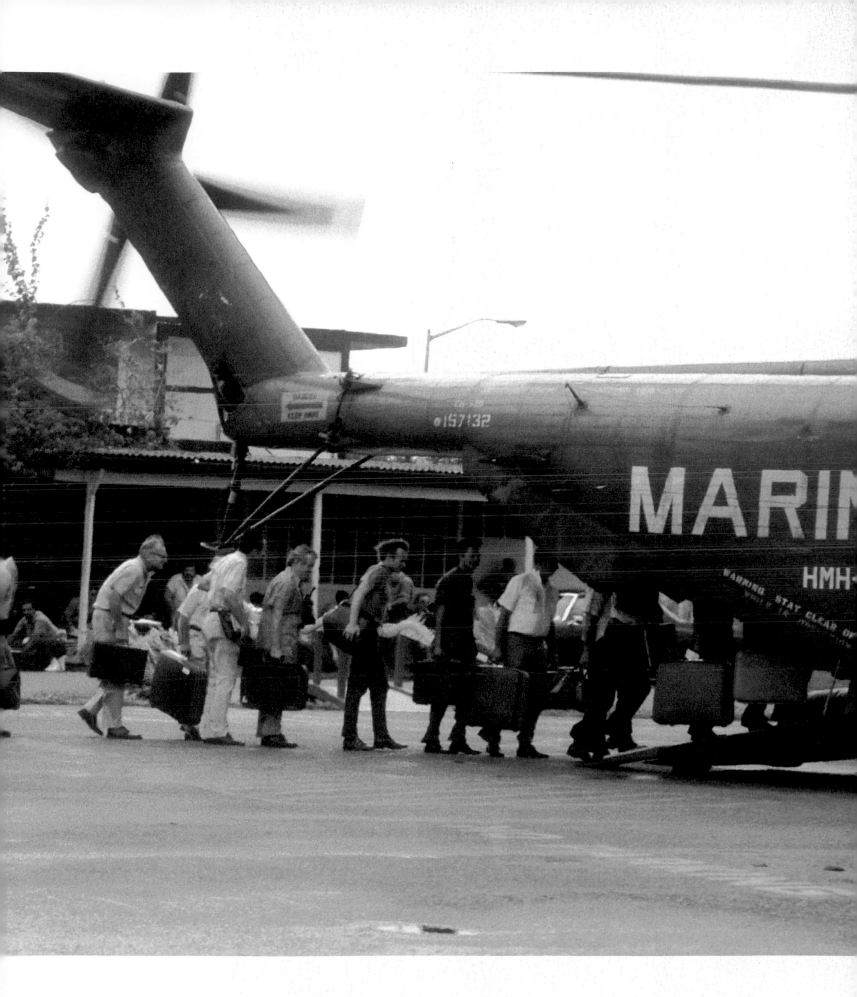

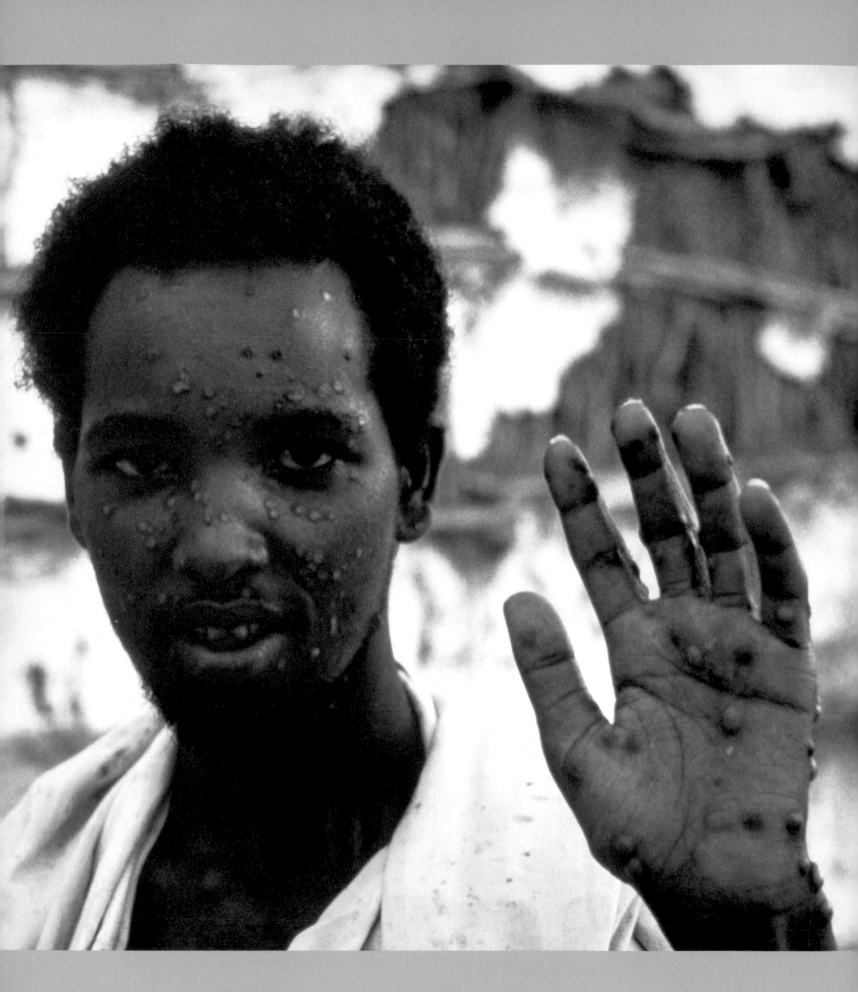

[October 26, 1977]

LAST CASE OF SMALLPOX

No matter how destructive humans are, they can seldom match the killing power of nature. Apocalyptic diseases such as cholera, typhus, the Black Death, and tuberculosis have long remained humankind's worst enemies.

Smallpox probably originated 3,000 years ago in India or Egypt. For thousands of years there was neither prevention nor cure, and some 30 percent of those infected died. The first hope of relief came with the discovery of vaccination, generally attributed to an English country doctor named Edward Jenner in 1798. One of the drawbacks of vaccination, however, is that it does not necessarily provide life-long immunity. In 1967—the year the World Health Organization (WHO) team, led by Donald Henderson, began a controlled smallpox eradication program—between 10 and 15 million people worldwide died of the disease.

Vaccinating enough people to impede the transmission of the disease was not easy. For instance, in India and Bangladesh, many people feared offending the goddess associated with smallpox. In Sudan, civil war made a coordinated program of vaccination almost impossible. Whenever a flood or a famine occurred, populations moved, and the disease went with them. In 1972, 35 people died in Yugoslavia when a pilgrim brought the virus back home with him from the Middle East.

Slowly but surely, the disease was pushed back, confined only to the Horn of Africa. On October 26, 1977, a 23-year-old cook named Ali Maow Maalin, living in the town of Merka, Somalia, was diagnosed with smallpox. Strangely, he had already been vaccinated: Happily, he recovered, to become the last known case of naturally occurring smallpox. On May 6, 1980, the WHO finally declared that the disease had been eradicated.

The last-known case of smallpox, Ali Maow Maalin, in October 1977.

Death of a disease

Somali Ali Maow Maalin raises his hand to better display the smallpox rash being documented by Dr. Jason Weisfeld, one of the doctors accompanying Dr. Donald Henderson on his search and containment mission to globally eradicate smallpox. Maalin, who had temporarily been a smallpox vaccinator, had not successfully been vaccinated himself. A brief exposure to two nomad children on their way to an isolation camp was enough to infect him with a minor case that was diagnosed on October 26, 1977. Maalin was then isolated until November of that year, the last known naturally acquired case of smallpox.

[January 7, 1979]

FALL OF POL POT

His real name was Saloth Sar (1924–1998), but he adopted the name Pol Pot from a nickname he was given while studying in Paris, France, in the 1950s: Politique Potentielle—potential politician. Whatever his name, Pol Pot was not a gifted student. He frequently failed his exams. Neither was he a great intellectual or thinker. He was, however, extremely successful in making his way to the top of any leftist organization with which he became involved, and in 1962, at age 37, he became acting leader of the Communist movement in his native Cambodia.

It was his first real taste of influence, for, although at that time the Cambodian Communist Party numbered only a few dozen members, it gave Pol Pot the opportunity to negotiate with the Communist Party of neighboring North Vietnam. By the mid-1960s, he was in a position to profit personally from the repressive actions of Cambodia's Prince Sihanouk. Pol Pot's party grew in numbers, and his power correspondingly increased, helped by a prolonged bombing campaign by the United States against Cambodia.

In January 1970, Sihanouk clashed with his own government and, in the political upheaval that followed, was persuaded by the North Vietnamese to back the Cambodian Communists. Four months later, North Vietnam invaded Cambodia, advancing to within 15 miles of the capital, Phnom Penh, before being pushed back. Pol Pot used this invasion for his own ends, turning on the Vietnamese and presenting himself as a true liberator and patriot of Cambodia.

With the backing of China, Pol Pot built up his own army to well over 100,000 recruits, at the same time creating financial backing for his operations by establishing new rubber plantations worked by slave labor. By 1973, Pol Pot and his party—now known as the Khmer Rouge—controlled two-thirds of rural Cambodia, and were

Khmer Rouge soldiers enter Phnom Penh, April 17, 1975.

The Killing Fields

The streets of Phnom Penh were about to become a dangerous place for anyone with a camera (resident or visiting) when Swedish photographer Sven-Erik Sjöberg took this picture on the day that Pol Pot's Khmer Rouge troops entered the city. The later experiences of one Cambodian photographer, Dith Pran, were dramatically recorded in the 1984 feature movie *The Killing Fields*. Pran endured beatings and forced labor before escaping in 1979 and fleeing to the United States, where he worked as a photographer for the *New York Times*.

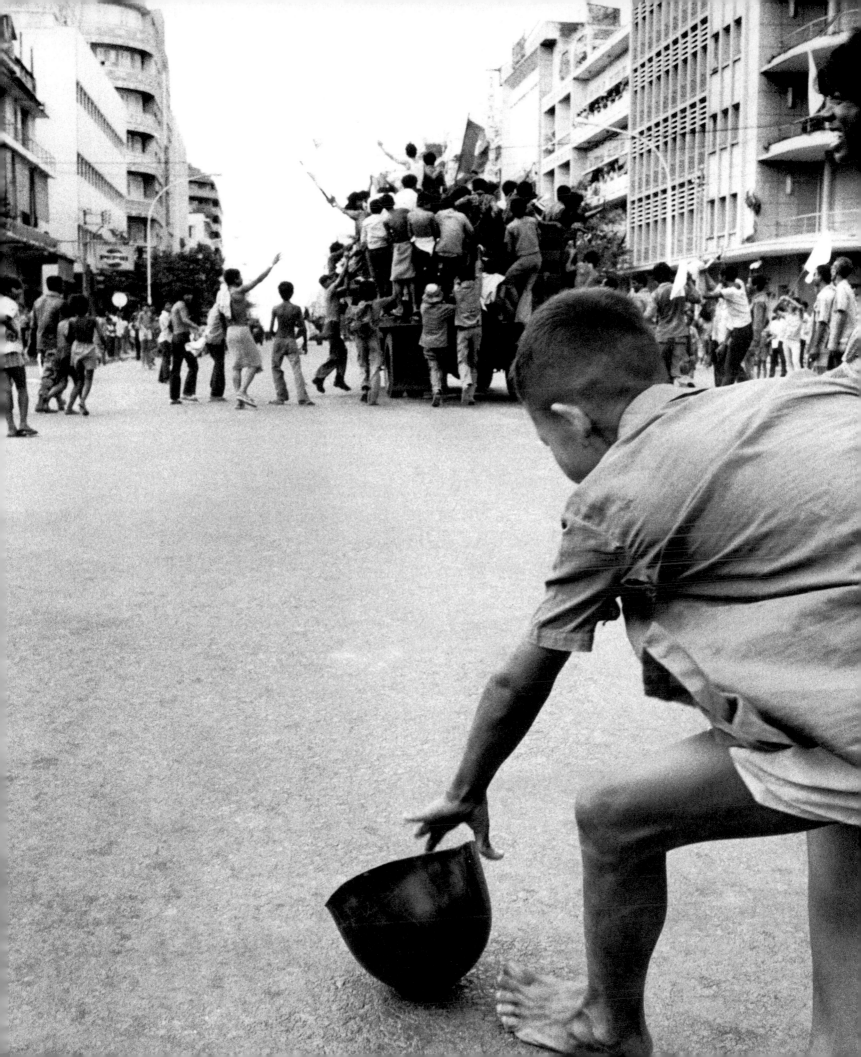

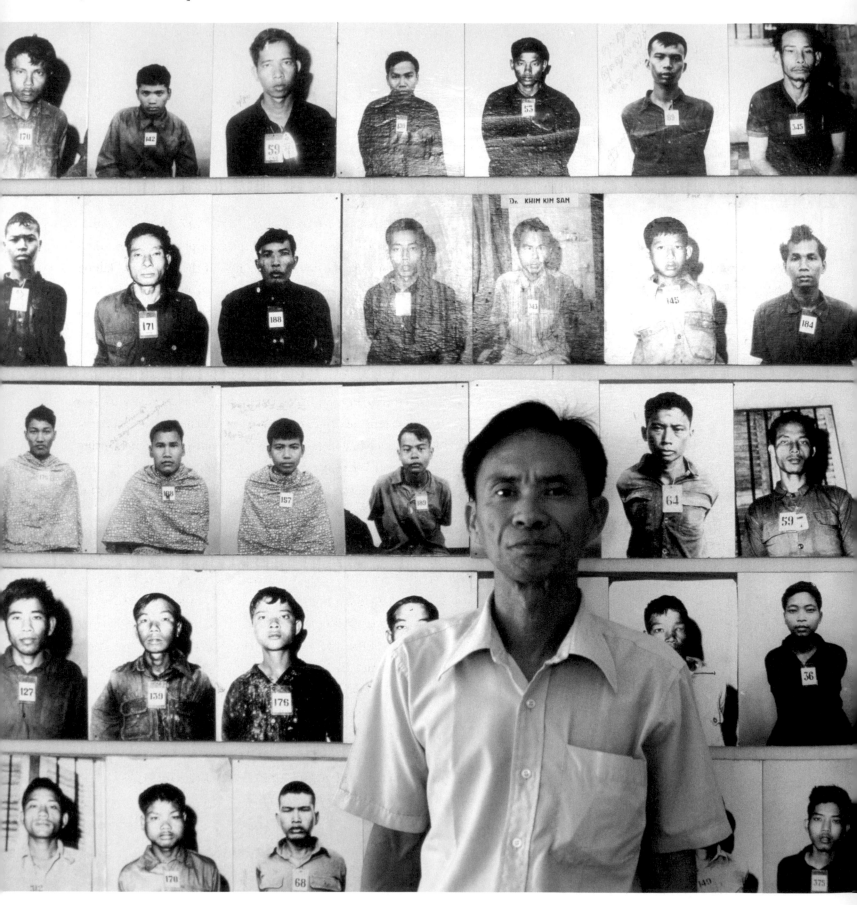

"What can we do to make the people love us? We must put ourselves in the position of the poorest of the poor, then the people will crowd around us and love us."

EXTRACT FROM *MONARCHY OR DEMOCRACY* (1949) BY POL POT

ready to take on the national army. On April 17, 1975, the Khmer Rouge captured Phnom Penh, whose entire population was then forcibly moved to the country. The first of the infamous "killing fields" was established—a clutch of camps where men, women, and children were beaten and killed for such offenses as not working hard enough, complaining about living conditions, having sex, and grieving over the death of friends or relations.

"Year Zero" was declared, and widespread massacres began, a mixture of ethnic cleansing, mass killings of the weak and disabled, and the indiscriminate slaughter of Buddhists, intellectuals, Westerners, and almost anyone whose appearance offended the regime. During the years that followed, in pursuit of Pol Pot's stated aim of creating a totally self-sufficient Maoist agrarian state, some two million people were killed, approximately one-quarter of the population.

Over the next few years, relations between the Khmer Rouge and the newly reunified Vietnam steadily deteriorated. Finally, on December 25, 1978, Vietnam launched a full-scale invasion of Cambodia (renamed Kampuchea by Pol Pot) to overthrow the Khmer Rouge. Phnom Penh was captured on January 7, 1979; Prince Sihanouk took the last flight out of the airport and headed for China. Pol Pot fled, and the Khmer Rouge retreated to the remote western region of Kampuchea to fight on for another 20 miserable years.

The Vietnamese installed a new government under Heng Samrin, composed of former members of the Khmer Rouge who had stood against Pol Pot's purges. The Vietnamese did not, however, pursue Pol Pot, as his continued existence justified their presence in the area. But the days of the dictator were over.

Ing Pech, one of seven survivors of Sleng prison, stands before pictures of some of the jail's 16,000 political prisoners.

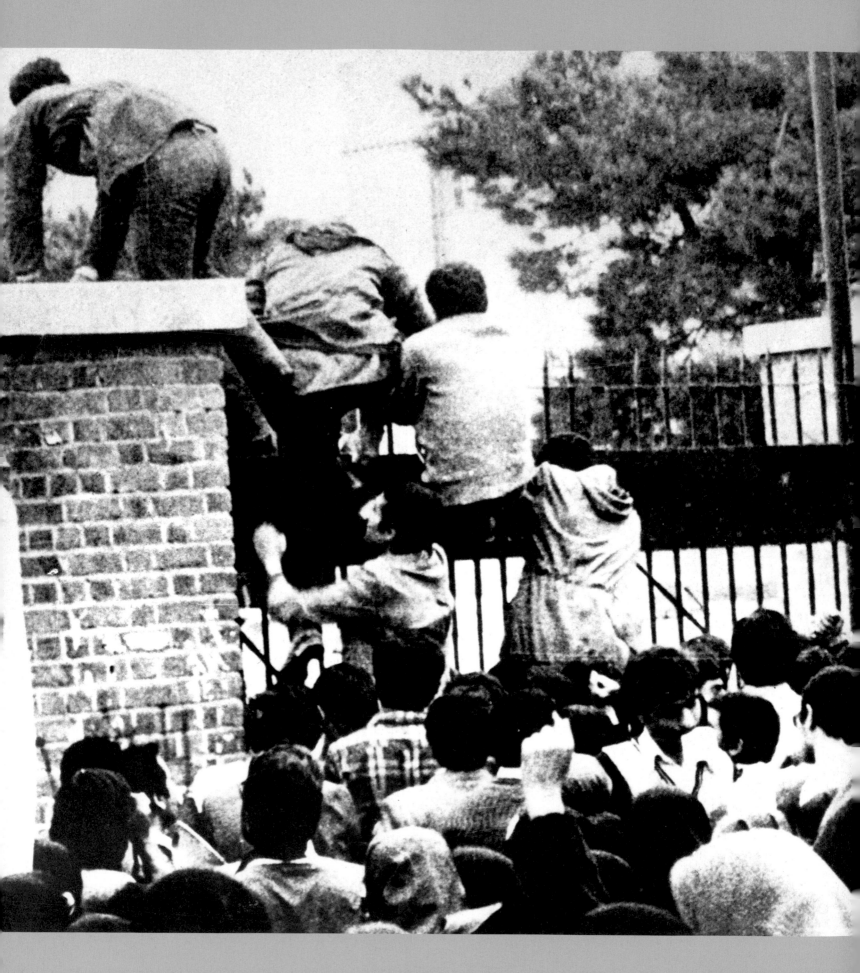

"This action has many benefits. ... This has united our people. Our opponents do not dare act against us"

AYATOLLAH KHOMEINI ON THE SEIZING OF THE U.S. HOSTAGES, NOVEMBER 4, 1979

[November 4, 1979]

IRANIAN HOSTAGE CRISIS BEGINS

On January 16, 1979, Shah Mohammed Reza Pahlevi, with his autocratic regime tumbling about him, left Iran, never to return. The man who replaced him was a Muslim cleric, the Ayatollah Ruhollah Khomeini (1900–1989), who had been living in exile for the previous 15 years. The shah had been seen as a friend by the West. Khomeini was expected to be a problem.

Khomeini landed at Tehran Airport on February 1, to be greeted by millions of ecstatic followers. Almost his first pronouncement was to the effect that Iran's final victory would come only when all foreigners had been driven out of the country. A fortnight later, the U.S. Embassy was attacked and two marines were injured. On May 26, Khomeini issued a blistering verbal attack on the United States, and the administration of President Jimmy Carter in particular.

During the summer, the new Iranian government was preoccupied by unrest in Tehran. Women protested that the restrictions placed on them made them second-class citizens. There were demonstrations against the closure of several newspapers. Perhaps partly as a distraction, revolutionary students seized the U.S. Embassy, taking 63 hostages. The attack took place on November 4, the anniversary of the shooting of students by the shah's soldiers in 1978.

On November 7, the hostages were threatened with death. On November 14, President Carter took steps to freeze Iranian assets in the West. Five months later, militants in Tehran declared that the hostages would be killed if the United States took military action to free them. On April 24, eight U.S. personnel were killed in a botched rescue attempt when a U.S. helicopter hit a Hercules transport plane.

Finally, on January 20, 1981, after 444 days, the crisis was resolved. The hostages were released. For them, it seemed like a miracle. For Carter, it came too late. His presidency had ended the previous day.

Students break into the U.S. Embassy in Tehran, November 4, 1979.

Iranian news

Captured by an unknown photographer, this image was made public by the Islamic Republic News Agency (IRNA). Originally called Pars Agency and later Pars News Agency, IRNA was established in 1934 under the government's Foreign Ministry as the official outlet for national and foreign news. By 1954, Pars Agency had expanded into broadcast radio. After the revolution it became the voice of Iranian theocracy and was renamed the Islamic Republic News Agency.

[August 31, 1980]

RECOGNITION OF SOLIDARITY

In 1980 the formal recognition in Poland of the independent, self-governing trade union Solidarnosc (known in the West as "Solidarity"), led by Lech Walesa (1943–), was of huge significance for both Poland and other Eastern-bloc countries. It marked the start of the spread of anticommunist ideas and movements that eventually led to the collapse of the Soviet Union.

Walesa was born into a working-class family in 1943. In his youth, he worked as a car mechanic, served in the army for two years, and then got a job as an electrician at the Lenin Shipyard in Gdansk. He first clashed with the Polish government in 1970, when he was one of the leaders of a workers' protest. Six years later Walesa was dismissed from the shipyard as a result of his union activities.

He continued, however, with his trade union work, seeking to set up free trade unions in opposition to the official ones run by the Polish Communist Party. The state security services kept an eye on him, and Walesa was frequently detained for questioning.

In the summer of 1980, the fledgling free and independent Polish trade unions confronted the government, and demanded the release from prison of 28 dissidents. A strike in support of the detainees was called at the Lenin Shipyard. Walesa, as spokesperson for Solidarity, had the backing of more than 10 million members. The workers responded. The yard shut down. Poland's Deputy Prime Minister, Mieczyslaw Jagielski, was forced to meet with Walesa, and subsequently to release the prisoners. Significantly, Jagielski also agreed officially to recognize Solidarity, diplomatically announcing that the strike had been called more in the hope of rectifying "mistakes," than of challenging "the principles of socialism." The main articles of the negotiations were drafted into the Gdansk Agreement, which Walesa and Jagielski signed on August 31, 1980.

Protest and progress

The picture of Lech Walesa addressing fellow workers at the Lenin Shipyard in Gdansk was taken by the Finnish photographer Jorma Puusa. The meeting took place just six days before the historic signing of the Gdansk Agreement, by which Solidarity was recognized by the Polish authorities. At the time, Puusa was a freelance photographer working for Lehtikuva, Finland's largest photo agency. Puusa stayed on in Poland, recording further developments in this story.

Lech Walesa rallies workers in Gdansk, August 25, 1980.

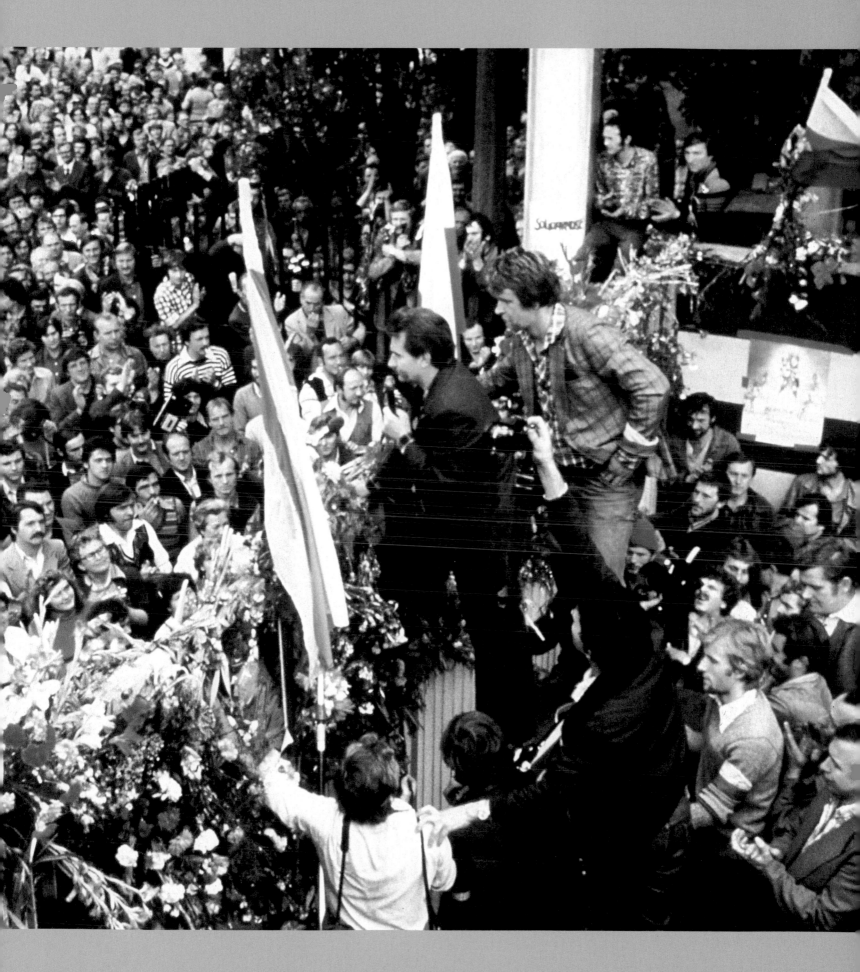

A Contemporary Note

An extract from Lech Walesa's speech accepting the Nobel Peace Prize in Oslo on December 10, 1983:

With deep sorrow I think of those who paid with their lives for the loyalty to Solidarity; of those who are behind prison bars and who are victims of repressions. I think of all those with whom I have traveled the same road and with whom I shared the trials and tribulations of our time.

We desire peace—and that is why we have never resorted to physical force. We crave for justice—and that is why we are so persistent in the struggle for our rights. We seek freedom of convictions—and that is why we have never attempted to enslave man's conscience nor shall we ever attempt to do so.

We are fighting for the right of the working people to association and for the dignity of human labor. We respect the dignity and the rights of every man and every nation. The path to a brighter future of the world leads through honest reconciliation of the conflicting interests and not through hatred and bloodshed. To follow that path means to enhance the moral power of the all-embracing idea of human solidarity.

I feel happy and proud that over the past few years this idea has been so closely connected with the name of my homeland.

Solidarity members at the Lenin Shipyard stand in line to confess to their local priest, August 28, 1980.

"The spring values of total O₃ (ozone) in Antarctica have now fallen considerably. The circulation in the lower stratosphere is apparently unchanged, and possible chemical causes must be considered."

JOE FARMAN, BRIAN GARDINER, AND JONATHAN SHANKLIN IN *NATURE*,
MAY 16, 1985

[May 16, 1985]

ALARM SOUNDS ON THE HOLE IN THE OZONE LAYER

Antarctica is cold, windy, and hostile. It is virtually a desert, but one that contains almost 70 percent of the world's fresh water and 90 percent of the world's ice. It is also the key to the world's health as a living organism. In the early 1950s, scientists from the British Antarctic Survey set up a series of projects in the Antarctic to monitor, among other things, the layers of the Earth's atmosphere, particularly the troposphere and the stratosphere.

The troposphere is where we live, the atmospheric layer in which rain, snow, and clouds are formed. The stratosphere lies immediately above the troposphere, and is visited only by astronauts and the passengers and crew of supersonic jet aircraft. The stratosphere is also home to a layer of ozone, which lies roughly 10 to 20 miles above the surface of the Earth. The layer was first identified in 1913 by two French physicists, Charles Fabry and Henri Buisson, and was studied for more than 30 years by British meteorologist G. M. B. Dobson, who set up a series of ozone monitoring stations.

Not until the 1970s was there any discernible hole in the ozone layer, and not until 1985 did scientists observe that it was getting bigger each year. Then, on May 16, 1985, Joe Farman, Brian Gardiner, and Jonathan Shanklin published some alarming findings in the scientific journal *Nature*. The perceived drop in ozone levels that had been detected was so great that, at first, the scientists believed their measuring instruments were faulty. Only when replacement equipment replicated the original readings were they convinced.

The immediate result of their discovery was the signing in 1987 of the Montreal Protocol, an international treaty designed to phase out the production and consumption of the chemical compounds that are believed to be responsible for the depletion of ozone in the stratosphere. The world has been watching and waiting nervously to see if the new policy will provide a cure.

Scientific visualization

Greg Shirah was lead animator in the team that produced this computer generated image of the Earth that graphically reveals the size of the hole in the ozone layer directly over Antarctica. The artwork involved uses raw scientific data and mathematical equations as source materials, producing the images through the medium of the computer. Shirah and his team produced the image while working for NASA in the Scientific Visualization Studio. It is estimated that more than 1 billion TV viewers have seen Shirah's work.

Oct 3 1985

The gaping hole in the ozone layer over Antarctica, October 3, 1985

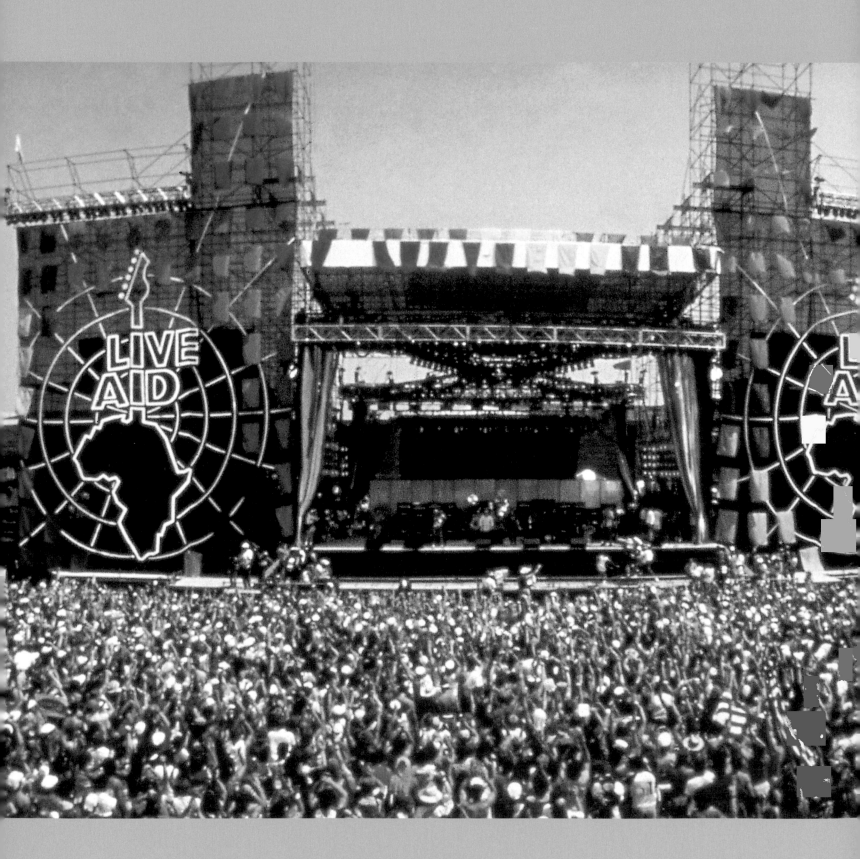

[July 13, 1985]
LIVE AID CONCERTS

The driving force behind the twin concerts that took place in Philadelphia, Pennsylvania, and London, England, on July 13, 1985, was a young Irishman, the lead singer of a rock band called The Boomtown Rats. One night in November 1984, Bob Geldof saw a graphic and distressing television news report of famine in Ethiopia. Within a couple of months, Geldof had persuaded fellow rock stars, record promoters, stores, studios, and distributors to join together in "Band Aid," an operation to produce and market a single entitled "Do They Know It's Christmas?" All the money the single made was to go to charity.

The singer and actor Harry Belafonte saw Geldof on TV, and set off at once to put together a similar American operation, called "USA for Africa." The song produced was called "We Are The World," and, in the words of *New Musical Express*: "It made Number 1 in just about every country in the world with electricity."

Television continued to play a leading role in the next stages of the story. Geldof visited Africa and put all his energy, experience, and contacts in the music business to work on the Live Aid project—an international, TV-linked, 16-hour, rock-and-pop marathon. It was originally scheduled for March 1985, but the twin concerts took longer than expected to organize, as no one wanted to be left out.

The lineup at Wembley Stadium, London, and JFK Stadium, Philadelphia, was astounding: Paul McCartney, Bob Dylan, The Rolling Stones, Phil Collins, David Bowie, Madonna, Joan Baez (who greeted fans with the words: "Good morning, children of the eighties—this is your Woodstock, and it's long overdue."), Tina Turner, U2. The concerts drew live audiences numbering 160,000. The TV audience was estimated at 1.5 billion. It was so successful and inspiring that it raised $70 million.

Live Aid concert at JFK Stadium, Philadelphia, July 13, 1985

Public response

The huge success of the twin Live Aid concerts in London and Philadelphia took even the organizers by surprise. The U.S. telephone system broke down when 700,000 callers simultaneously phoned to pledge money. Time/Life somehow failed to have a photographer of its own at JFK Stadium, Philadelphia, and was forced into the highly unusual situation of using this public domain photograph from the U.S. Department of State.

"Obviously a major malfunction ... [pause] ...
We have a report from the Flight Dynamics Officer
that the vehicle has exploded"

PUBLIC AFFAIRS OFFICER AT NASA DURING *CHALLENGER* DISASTER,
JANUARY 28, 1986

[January 28, 1986]

CHALLENGER DISASTER

Thousands had gathered around the launchpad at Cape Canaveral, Florida. Millions more were watching on television. The focus of their attention was the space shuttle *Challenger*, about to lift off on the first of 15 space missions planned by NASA for that year. It was a bitterly cold morning. Throughout the night teams of workers had been chipping ice from the launchpad and the support gantries. Some engineers had argued that, at temperatures lower than 12°C (53°F), the rings on the boosters could not be guaranteed to seal the surrounding joints. Nevertheless, the on-site contractors gave the launch the go-ahead.

Launch time was set back two hours to 11:38 a.m. EST. Countdown began. The three shuttle engines ignited with some seven seconds to go before launch. Right on time, the two solid rocket boosters were ignited, and the bolts anchoring *Challenger* to the launchpad were released with explosives. The shuttle commenced its majestic liftoff. For 74 seconds it rose into the cold blue sky, reaching a height of ten miles above the Earth's surface. The watchers on the ground cheered. *Challenger*'s commander, Francis R. Scobee, spoke to Mission Control: "Roger, go at throttle up." They were his last words. *Challenger* was consumed in an orange ball of fire, from which debris cascaded down into the Atlantic Ocean. A trailing cloud was created by the vaporization of the 385,000 gallons of liquid hydrogen and 140,000 gallons of liquid oxygen that *Challenger* was carrying.

In the days and weeks that followed, there was widespread speculation as to what might have gone wrong. Subsequent reports into the causes of the disaster stated that there had been no major explosion, but that there had been "localized combustion" when the external tank disintegrated.

The Stars and Stripes fly at half-mast in Washington, D.C.
Following pages: The *Challenger* explosion at 11:39 a.m., January 28, 1986

A nation mourns

Terry Ashe, a veteran contract photographer for *Time*, was on his usual beat covering Capitol Hill in Washington, D.C., the morning of the *Challenger* disaster. He was dropping off some film near the Capitol when the store owner said, "Terry, the shuttle just blew up!" Ashe raced back to the Senate Press Photographers' Gallery to witness a televised replay of the tragedy. Later, as he was passing the Washington Monument, he captured the American flags flying at half-mast using a telephoto lens.

"When I arrived at Chernobyl, I saw a large black fire with clouds,
an impression that will stay with me my whole life"

INTERVIEW WITH BORIS CHEAKLIN, HEAD OF RUSSIA'S KURSH ATOMIC POWER PLANT,
BBC, APRIL 26, 2001

[April 26, 1986]

CHERNOBYL DISASTER

The explosion that took place in Reactor No. 4 of the V. I. Lenin Memorial Chernobyl Nuclear Power Station in the Soviet Union on Saturday, April 26, 1986, was the worst accident in the history of nuclear power. The power plant suffered from a great many different problems: Overstretched resources; poorly coordinated bureaucracy; and overdependence on technology that was required to do too much, too cheaply.

Conflicting theories remain as to what caused the accident—human error on the part of the power plant operators, or design flaws in the reactor itself. On April 25, Reactor No. 4 had been shut down for maintenance. While this proceeded, tests were carried out on the reactor's free-running turbine to see if it could still produce enough electricity to power the safety systems. There was then an unexpected call from the city of Kiev for an increase in Chernobyl's electricity supply as a regional power station had gone offline. Chernobyl agreed, but kept the tests running with an inexperienced night crew. The fuel rods began to fracture, and then melted. Within a few seconds, the roof blew off and there was an explosion of fire. The radioactive fallout was immediate and intense. Workers in the reactor received lethal doses within minutes. Responding firefighters reported the radiation as "tasting like metal," and giving them pins-and-needles-like feelings all over their faces. Most died within a year.

Helicopter drops of clay, lead, sand, and boron were needed to extinguish the fire inside the reactor. By nightfall, orders were given to evacuate the nearby town of Pripyat. "Liquidators" volunteered to enter the inferno in order to prevent a thermal explosion. Meanwhile, radioactive clouds were spreading across the sky, raining radiation down on the surrounding countryside. The Ukraine, Belarus, and Russia are still affected to this day.

Vitali and Sasha Prokopenko, Gomel, Belarus, 20 years after the explosion

Aftermath of the explosion

It was not until several years after the initial explosion that the full horrors of the Chernobyl disaster in the Ukraine became apparent. In January 2006, photographer Tom Stoddart visited neighboring Belarus, where he took a portrait of Vitali Prokopenko and his nine-year-old daughter, Sasha. "This must be very difficult for you," said Vitali. "You have probably never seen anyone with such a big head, but to us she is our most beautiful daughter." Some 99 percent of the land in Belarus is still contaminated.

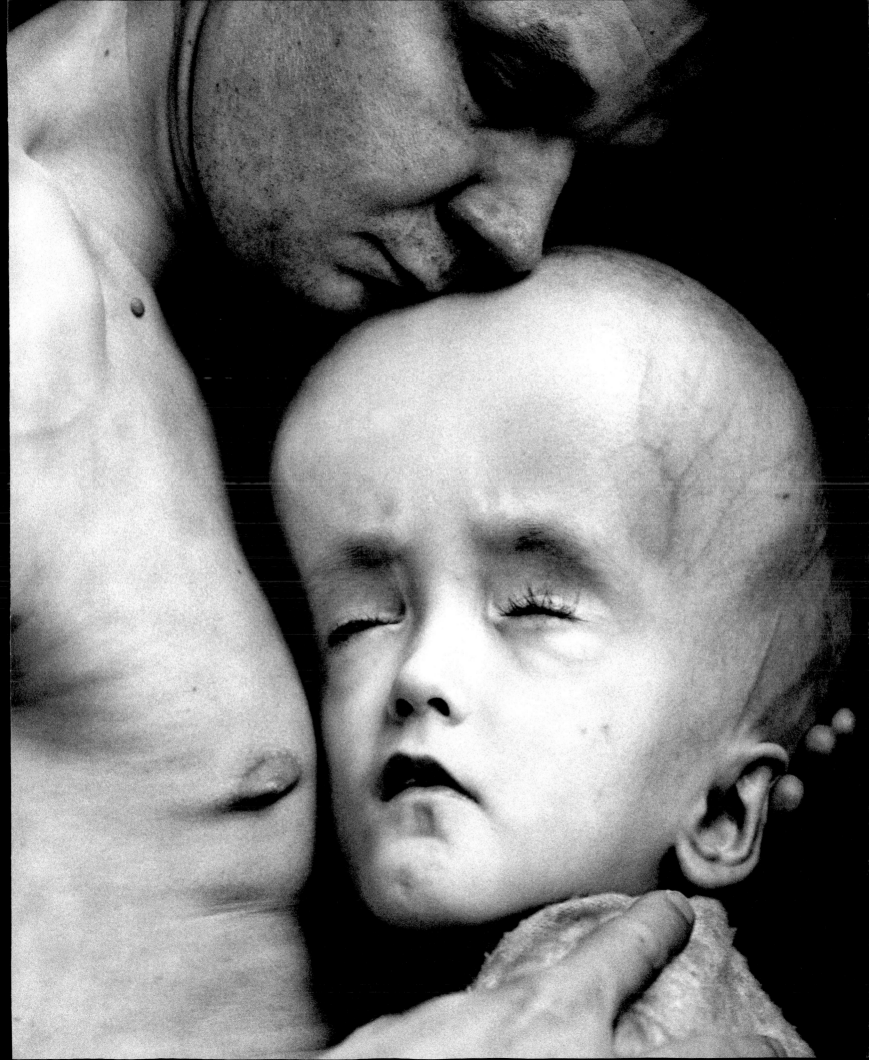

"People look for big miracles in terms of cures, but there are smaller favors that can come your way. ... We learned the lesson that life is precious."

ELAINE O'ROURKE, MOTHER OF AIDS VICTIM BRENDAN O'ROURKE, *SAN FRANCISCO CHRONICLE*, APRIL 4, 2005

[May 4, 1987]

WORLD HEALTH ASSEMBLY APPROVES AIDS STRATEGY

No one knows exactly when acquired immunodeficiency syndrome (AIDS) infected the human species. The first cases were reported in June 1981, but the human immunodeficiency virus (HIV) is believed to have originated years earlier. Scientists are said to have traced a case of AIDS back to the Republic of Congo in 1959. The transmission may have occurred when animals were butchered for meat in sub-Saharan Africa, and infected blood from apes contaminated cuts or wounds on the human skin.

What has been called the wake-up call for the West came with a *New York Times* report on June 5, 1981, that doctors in New York and California had diagnosed among gay men "41 cases of a rare and often rapidly fatal form of cancer," from which eight of the victims had died within two years.

There followed instantly a knee-jerk reaction of false assumption, panic, and prejudice. AIDS was said to be "the gay plague," a consequence of promiscuity. Wild predictions were made about the virility of the disease: It was said that merely to touch someone infected with AIDS would lead to death within a year; AIDS would kill 20 million people a year; it would sweep across the world, killing 25 percent of the population within a quarter of a century.

The turning point came in 1987. Pharmaceutical manufacturer Burroughs Wellcome produced the first drug to counter AIDS, an antiretroviral therapy that prevented HIV replicating in cells. Socially, the stigma of the disease was mitigated when Diana, Princess of Wales, publicly shook hands with AIDS sufferers. Although it was a small enough gesture by today's standards, at the time it was world-shaking. And politically, on May 4, 1987, the World Health Assembly approved a Global AIDS Strategy for international action to prevent and control HIV/AIDS.

Pope John Paul II hugs Brendan O'Rourke, September 17, 1987.

The face of compassion

On September 17, 1987, Pope John Paul II visited the Mission Dolores Basilica in San Francisco. There he met four-year-old Brendan O'Rourke. The little boy had been born prematurely and had contracted AIDS as a result of a blood transfusion. As the Pope passed by, Brendan called out "Viva Papa!" The Pope turned and embraced him, and José Moré, a photographer with the *Chicago Tribune*, took his photograph. Brendan died in 1993.

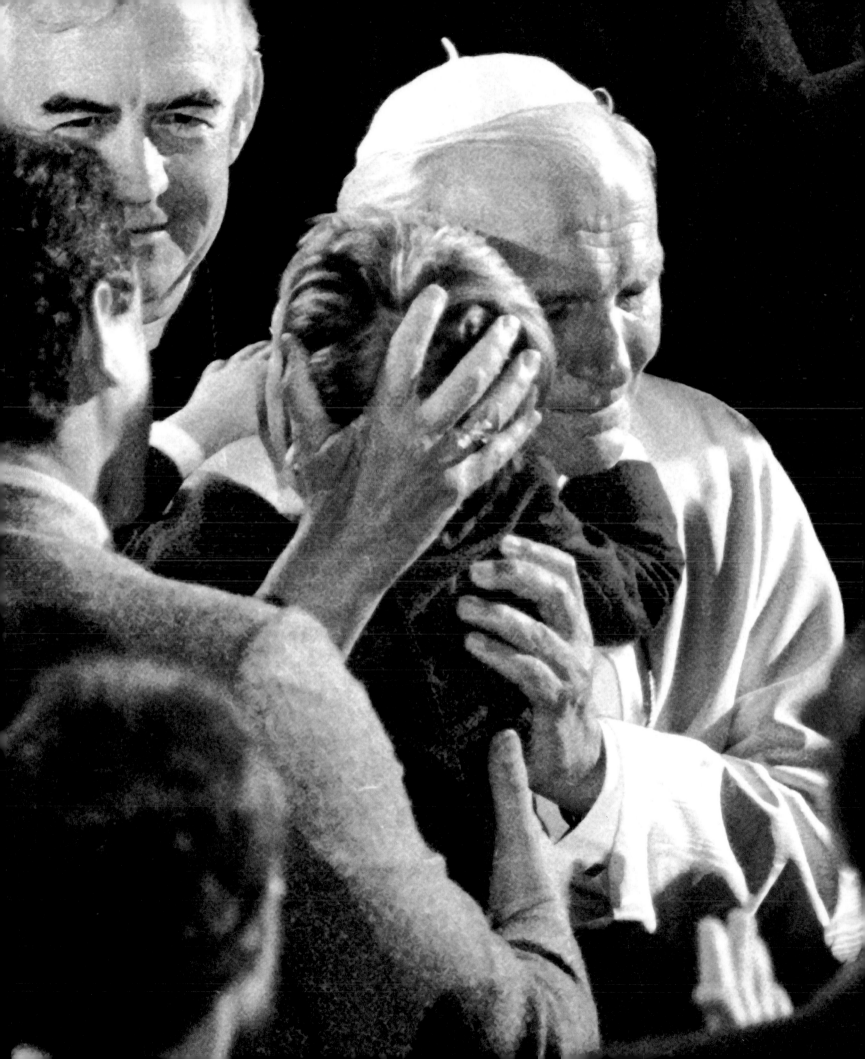

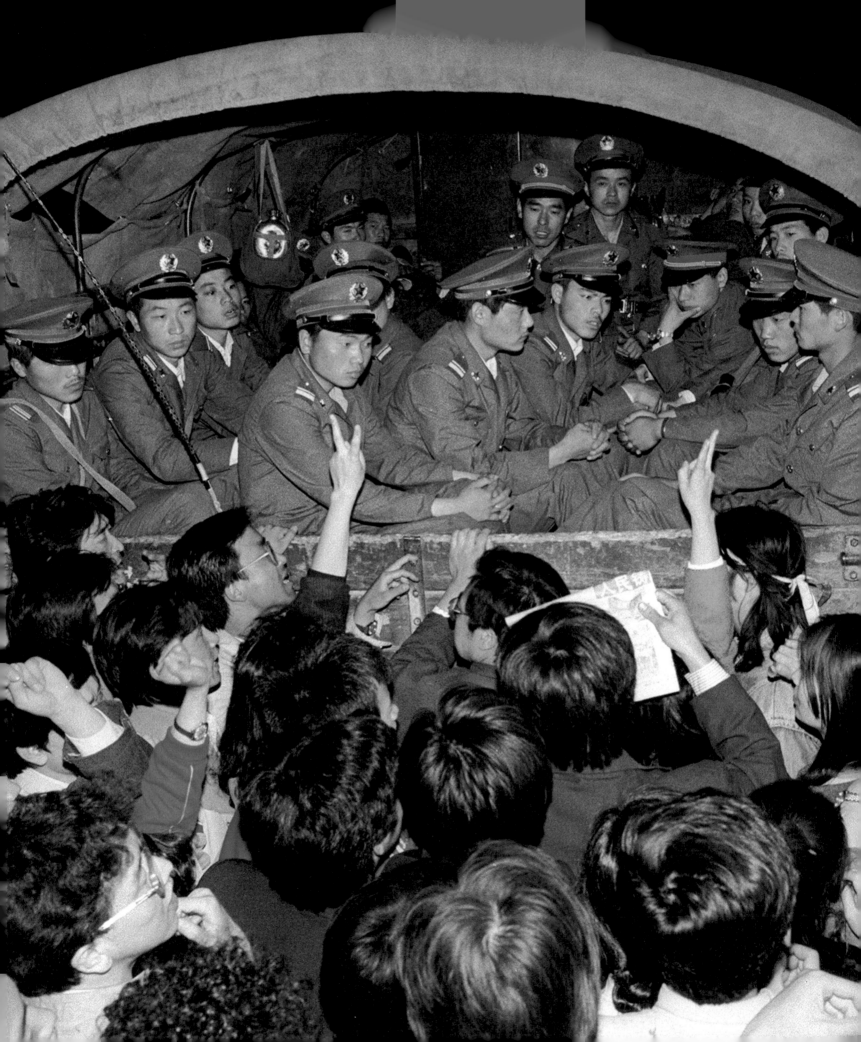

[June 4, 1989]

TIANANMEN SQUARE PROTEST CRUSHED

Many in Beijing and the rest of China believed it appropriate to stage some form of protest during the year that marked the 200th anniversary of the start of the French Revolution, the 70th anniversary of the May Fourth Movement, and the 40th anniversary of the founding of the People's Republic. The Chinese government, however, did not.

The obvious place for demonstrations was Tiananmen Square, a vast space that had provided the setting for Mao Zedong's proclamation of the People's Republic on October 1, 1949. It was a meeting place for students, where they could debate, and where there was enough electric light for them to continue studying their books long after dark. In spring 1989, the groups grew steadily bigger, the debates more intense. On April 26, the gatherings were labeled "counterrevolutionary turmoil" by the Communist Party press.

Students and others responded by spending more time in the square, which began to take on the appearance of a city-within-a-city. Foreign reporters and TV crews arrived in mid-May to cover the visit of Soviet President Mikhail Gorbachev, and also to be on hand should trouble break out.

It did. On May 20, the government declared martial law, and the army was ordered to remove all demonstrators from the area. On the night of June 3, troops made their way undetected to the perimeter of the square. Once in position, tanks drove their way through the barricades that the students had erected. By noon on June 4, the square was clear. The images flashed around the world were of a lone, heroic demonstrator facing down the tanks. The images not seen were those of the casualties. No official figures of those killed or wounded were ever released. The West could only speculate—perhaps hundreds, possibly thousands, were shot.

Demonstrators confront soldiers in a Beijing street, May 20, 1989.

Voices quelled by violence

Catherine Henriette from AFP was one of the Western photographers based in Beijing in the spring of 1989. She had already covered the meeting between the Chinese leader, Gen. Zhao Ziyang, and Mikhail Gorbachev on May 17, and some of the earlier unrest between students and police. On the night of May 20, Henriette was on the streets of the city, covering pro-democracy reaction to the imposition of martial law. It was then that she took the shot of soldiers in trucks being remonstrated with by demonstrators.

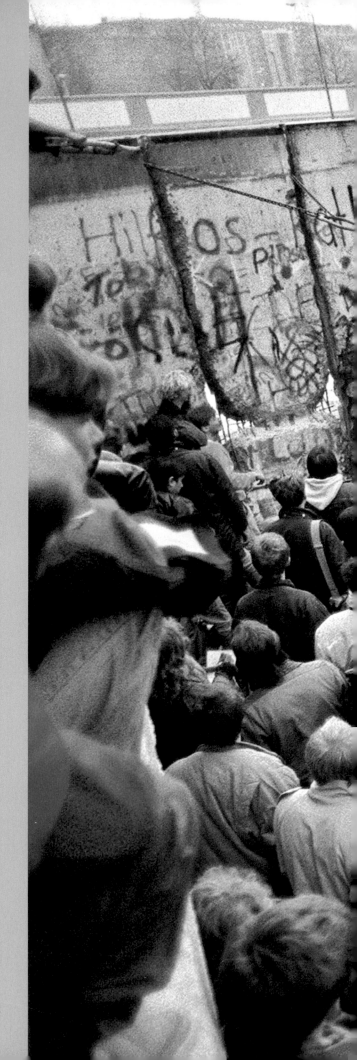

[November 9, 1989]

FALL OF THE BERLIN WALL

At the end of World War II, the ruined city of Berlin, the former capital of Germany, was divided into four zones, each controlled by a different power—the United States, Britain, France, and the Soviet Union. Over the years that followed, Berlin was divided into two sectors: East Berlin suffered under Soviet-imposed communism; West Berlin prospered under capitalism.

Passage between the two sectors was strictly regulated, although many East Berliners risked, and lost, their lives in bids to escape to the West. In August 1961, Walter Ulbricht and the government of East Berlin decided to replace barbed-wire fences and lines painted on the roads with a wall. By October 1961 the Berlin Wall was in place. Constantly guarded, the 28-mile barrier was too high to jump and dangerous to scale. The numbers of *Republikflucht* (escapes) from East to West Berlin fell from 2.5 million between 1949 and 1962, to just 5,000 between 1962 and 1989.

The Wall was a constant propaganda disaster for the East, a symbol of tyranny and repression. In 1987, U.S. President Ronald Reagan stood by the Brandenburg Gate on the border of East and West Berlin and challenged Mikhail Gorbachev, General Secretary of the Soviet Communist Party, to "tear down this wall." Reagan's slogan somehow captured the moment: There was growing support for the policy of *Ostpolitik*, rapprochement with East Germany, and even a desire for speedy reunification.

On August 23, 1989, Hungary removed restrictions on its border with Austria. The following month, some 13,000 East German tourists in Hungary escaped to the West by this route. Mass demonstrations in East Germany led to the resignation of the country's leader, Erich Honecker, who had previously predicted that the Wall would stand for "more than a hundred years." On November 9, the

Berliners demolish a section of the Berlin Wall, November 11, 1989.

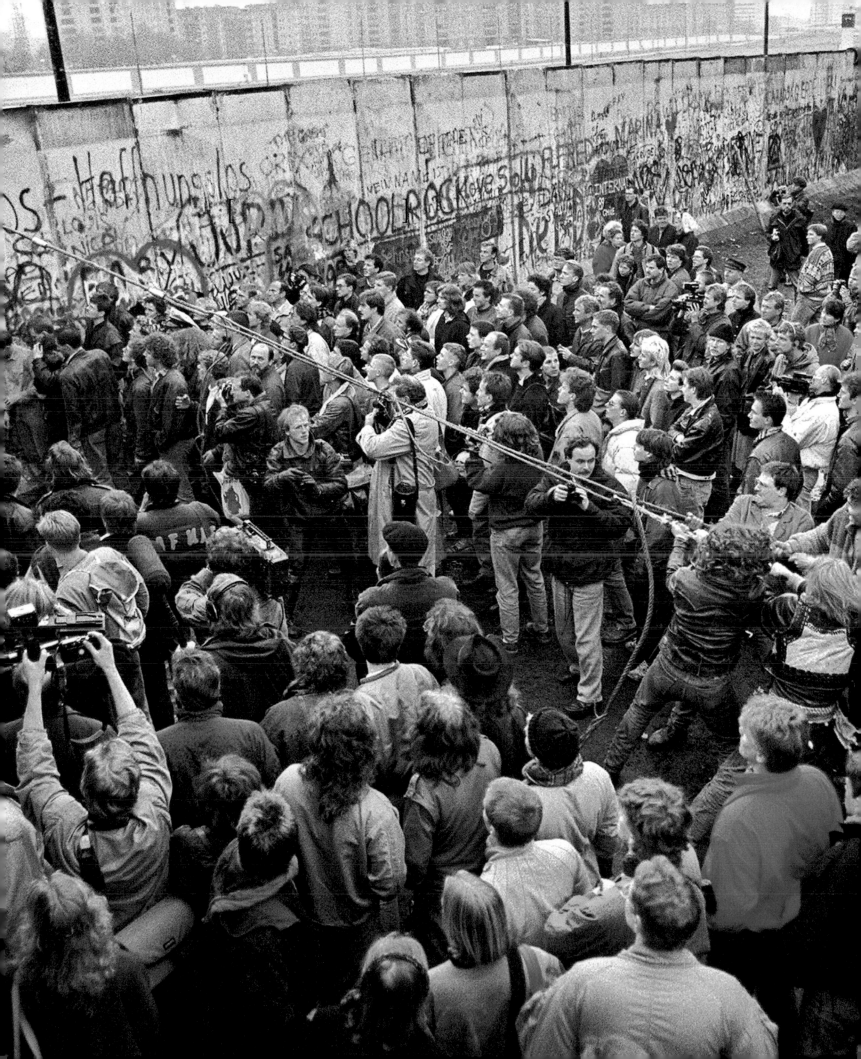

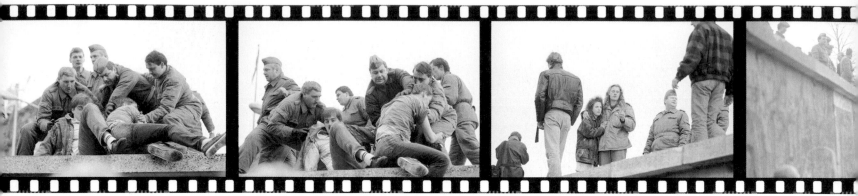

East German government, now under Egon Krenz, decided to allow refugees to leave East Berlin at any of the crossing points.

The exits were flooded with would-be emigrants. The guards could do nothing to check the flow from East to West. As cheering crowds gathered on the West Berlin side of the Wall to welcome their fellow citizens, souvenir hunters and those with a sense of history began chipping away at some of the 45,000 concrete blocks that had divided the city for 28 years. At first, the East German military made ineffective attempts to repair the damage done by the "wall-peckers," but there was little point to such activity.

On December 25, 1989, a concert was held in Berlin. An orchestra and chorus of musicians and singers from East and West Germany, the United States, Britain, France, and the Soviet Union performed Beethoven's *Choral* Symphony, substituting the word *Freiheit* (freedom) for the word *Freude* (joy) in the Ode to Joy of the final movement. Six months later, the East German military began the official dismantling of the entire Wall. By October 3, 1990, all that remained of the Wall were three short lengths, preserved as memorials to a divided past and as symbols of a united future.

Gerard Malie

French photographer Gerard Malie became an AFP staff photographer in 1985, staying on staff until his retirement in 2002. Originally in charge of regional coverage around Lyon, he then moved into the international venue. He turned his talent to conflict, covering the Romanian Revolution in 1989 and the first Gulf War in Kuwait in the early 1990s. On November 11, 1989, he was strategically positioned at Potsdamer Platz and captured the fall of the Berlin Wall. Malie always shot his stories with color negative film, which dramatically record the end of the Wall and the first moments of German reunification.

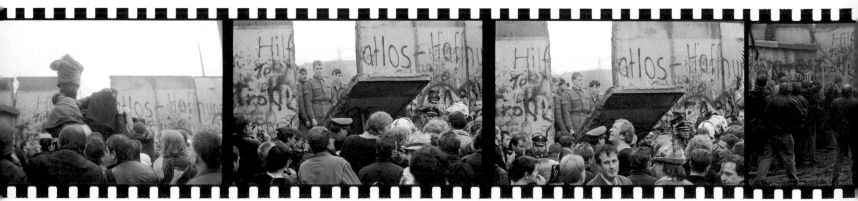

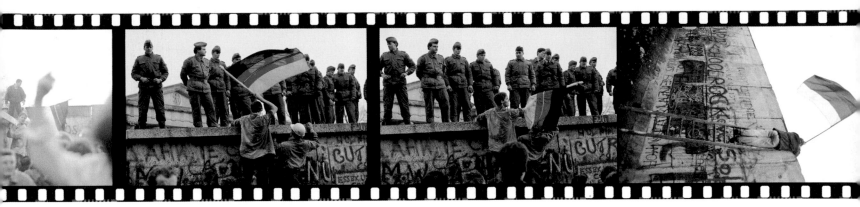

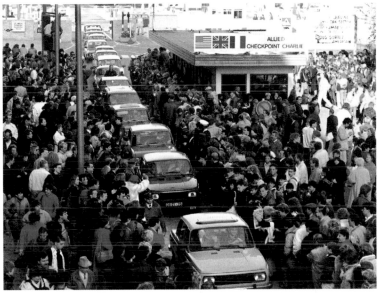

Left: A German border guard peers through a broken piece of the Berlin Wall on November 12, 1989. *Above:* A long row of East German Trabant cars passed through Checkpoint Charlie into West Berlin, November 10, 1989.

Following pages: In the early morning hours of November 12, 1989, East and West Berliners meet as part of the Berlin Wall comes down at Potsdamer Platz.

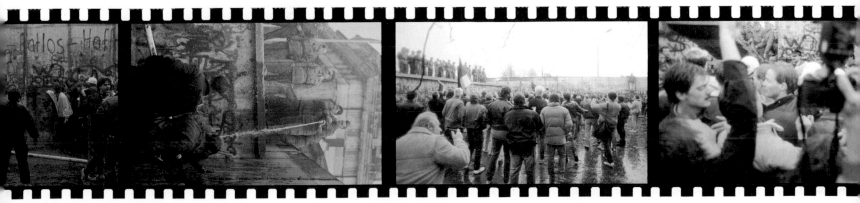

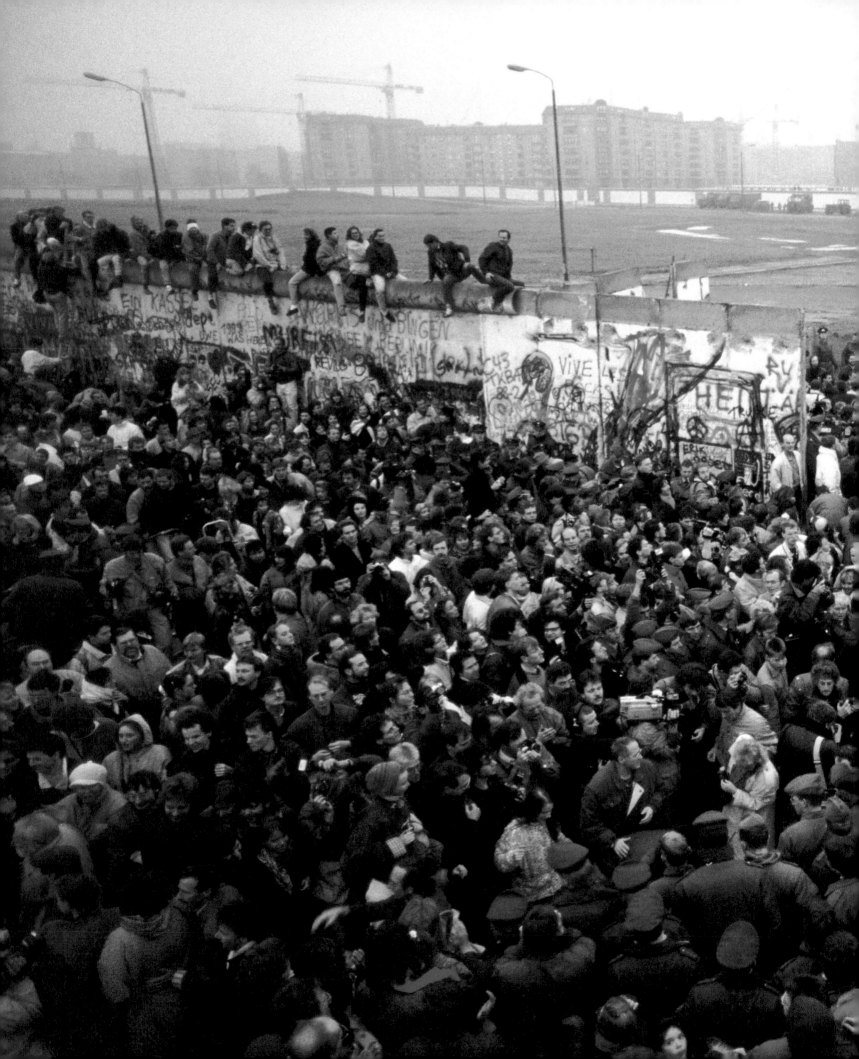

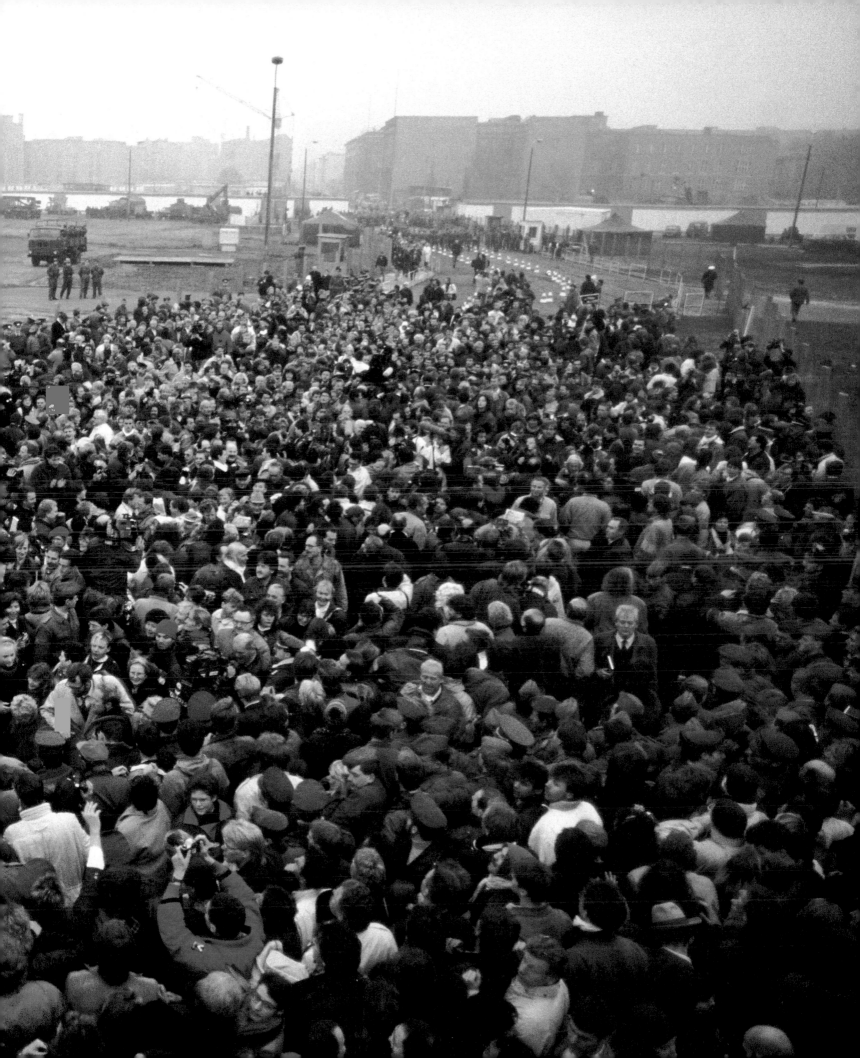

"Within twenty feet or so of the gate, the cameras started clicking, a noise that sounded like some great herd of metallic beasts"

EXTRACT FROM *LONG WALK TO FREEDOM* (1995) BY NELSON MANDELA

[February 11, 1990]

RELEASE OF NELSON MANDELA

Nelson Rolihlahla Mandela (1918–) spent most of the early 1960s on the run from the South African security forces. He was one of the leaders of the African National Congress and an implacable enemy of the system of apartheid. Following his capture, when he stood in the dock at the Rivonia trial of April 1964, charged with sabotage, Mandela declared: "I have cherished the ideal of a democratic and free society in which all persons live together in harmony and with equal opportunities." He was then sentenced to life imprisonment.

Mandela spent most of the next 26 years in jail on Robben Island, near Cape Town. He called them "The Dark Years," when the country was ruled by white supremacists. He endured long periods of isolation, and daily bouts of enforced manual labor, but he never lost sight of his goal—for all South Africans to live in harmony.

In December 1988, Mandela was moved without notice to Victor Verster prison, 35 miles northeast of Cape Town. There he was decently housed, supplied with a servant (a prison officer from Robben Island), and allowed access to friends, enemies, and colleagues. The government was hastily doing its best to prepare South Africa for a momentous event—his release. There remained one last issue between Mandela and his captors—the time and place of his return to the outside world. South African President F. W. de Klerk wanted to hurry matters, to fly Mandela to Johannesburg and officially release him there. Mandela refused. He would simply walk out of Victor Verster prison when he was ready.

When the moment arrived, a little before 4 p.m. on the afternoon of February 11, 1990, the world was watching. What it saw was a 71-year-old man raise his right fist in a salute he had not been allowed to make for almost 26 years.

Nelson and Winnie Mandela greet the world, February 11, 1990.

Photographing politics

Alexander Joe is a Zimbabwean photographer who was attracted as a child by what he believed was a photographer's "glamorous lifestyle." Within a short time, however, he was more interested in covering the political upheavals taking place around him in what was still Rhodesia. After working in London for various newspapers, Joe went to work in South Africa, and was one among the hordes of photographers waiting outside Victor Verster prison when Nelson Mandela took his first steps into freedom after almost 26 years.

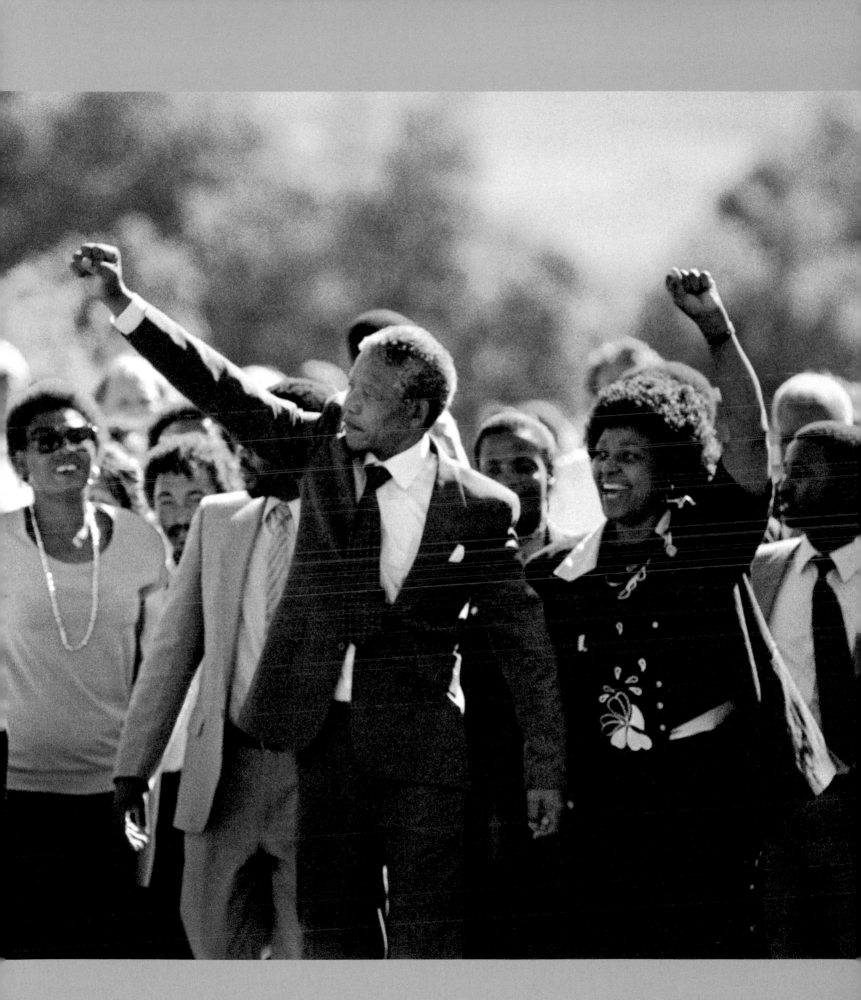

[August 6, 1991]

FIRST WEBSITE GOES ONLINE

At the end of the 16th century, German Emperor Rudolf II believed that it was possible to contain all human knowledge within the four rooms of a house he set aside for that very purpose. There he assembled rocks, stuffed animals, books, plants, crystals, lenses, and a recipe guaranteed to cure the plague. The building's curator wrote: "The collection should be nothing less than a theater of the universe. ... The exhibits act as keys which unlock the whole of human knowledge. ... The higher purpose is to honor God the Creator."

Four hundred years later, the eccentric emperor's dream could have been realized by anyone with a computer and access to the World Wide Web. The Web was the brainchild of Tim Berners-Lee (1955–), a British physicist who, in 1980, was working at the European Organization for Nuclear Research in Geneva, Switzerland. There he built a prototype system to facilitate the sharing and updating of information among researchers. Called ENQUIRE, it was the direct ancestor of the Web. The aim of ENQUIRE was to keep track of random associations like those one encounters each day.

The next stage would revolutionize communication in all its forms. This began with the first Website to go online, on August 6, 1991. By this time, Berners-Lee had developed HTML (hypertext mark-up language—the international language of the Web), and HTTP (hypertext transfer protocol—the means by which documents could be linked on computers across the Net).

Between 1991 and 1996, the number of Net users increased from half a million to 40 million, at one point quadrupling every three months. What had started as a tool for academics and researchers was now in the hands of the masses—the World Wide Web was free to access and, like the universe itself, was ever expanding.

A computer mosaic portrait of Sir Tim Berners-Lee, inventor of the Web

Computer-generated images

Although image processing techniques have not yet advanced to a stage where a computer can recognize objects in photographs well enough to use the objects for content retrieval, computers can at least create pictures using material with which they are familiar. The accompanying portrait of Sir Tim Berners-Lee is computer generated, and is made up of 2,304 web pages.

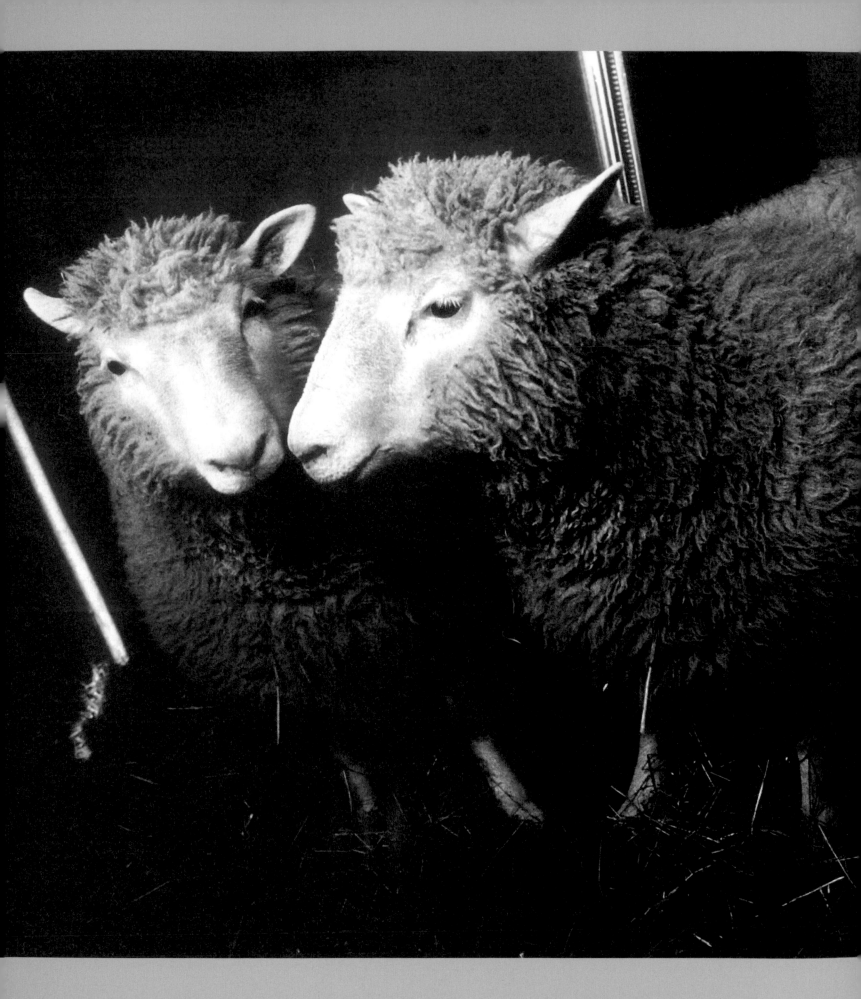

[February 22, 1997]

A CLONED DOLLY MEETS THE PRESS

Reproductive cloning had been taking place long before it hit the front pages of the world's newspapers. The first artificial production of the genetic twin of another organism took place in 1952, when a tadpole was cloned. Scientifically, it was a considerable achievement, but at the time tadpoles were neither an endangered species, an important source of food, nor likely to provide life-saving drugs. Until something larger, more cuddly, or tastier came along, the world's front pages would have to wait.

The wait ended on February 22, 1997, when Dolly the Finn Dorset sheep made her first public appearance. For more than a year, scientists had known that Dolly (or her like) was on the way. In a March 1996 issue of the scientific magazine *Nature*, Ian Wilmut and his team at the Roslin Institute in Edinburgh, Scotland, had published details of the work they were doing in transferring the nuclei from sheep cells into unfertilized sheep eggs from which the natural nuclei had previously been removed. The hope was that these eggs could later be implanted into sheep, and, following a normal gestation period, a lamb would be born. It was a complicated technique, requiring more than 250 nuclear transfers to produce the cloned lamb.

What made Dolly different from any other lamb born that spring weekend was that she had no father, and was an identical copy of another sheep. Dolly was also unique in that she had commercial godparents, sponsors who were interested in the notion of eventually using cloning to produce animals that would, for example, produce milk that contained valuable drugs.

For all the effort that went into her creation, Dolly's life was relatively short. Most Finn Dorset sheep live for 10 to 12 years. Dolly, crippled with arthritis and suffering from lung cancer, was put down at age five by lethal injection on February 14, 2003.

Photo opportunity for Dolly the sheep, February 1997

Stephen Ferry

Stephen Ferry, the freelance, award-winning documentary photographer who made this image, started his career at age 12, when he learned to develop and print black-and-white pictures at a local photography store. Ferry's interests in human rights, social change, the destruction of the environment, and major historic events led his photographic career into the international arena, mainly Latin America.

[August 31, 1997]

DEATH OF PRINCESS DIANA

The tragic facts are simple. On the night of Saturday, August 30, 1997, Princess Diana and her partner, Dodi Fayed, left the Ritz Hotel in Paris, France. It was not a leisurely departure. Swarms of paparazzi were gathered around the hotel, for Diana was the most famous woman in the world and Dodi was the son of one of the richest men in the world, Mohamed Al Fayed.

The pair left by a back door and were bundled into the back of their Mercedes-Benz S280. With them were Dodi's bodyguard, Trevor Rees-Jones, and the chauffeur, Henri Paul. The car took off at high speed, with photographers following on motorcycles. At the entrance to the underpass at the Place de l'Alma, the car swerved, struck the 13th pillar supporting the tunnel, and skidded to a stop.

Dodi Fayed and Henri Paul were declared dead at the scene of the accident. Diana survived for three and a half hours before dying at Pitié-Salpêtrière Hospital. Her death was announced at 5:30 a.m. on August 31, 1997, by French Interior Minister Jean-Pierre Chevènement and the British Ambassador to France, Sir Michael Jay.

In the years that followed, conspiracy theories multiplied. The chauffeur had been drugged, some said; others suggested that the British royal family was implicated in the deaths; several claimed it was a plot by MI5, the British secret service. Reports suggested that another vehicle, a Fiat Punto, was involved but had mysteriously disappeared. Many thought that the crash was the fault of the paparazzi.

What became clear in the week that followed was that no one—including the press, the British royal family, and the public—had the slightest idea of the profound effect that the death of Diana would have. In that week, the popularity of the monarchy plummeted, and there was a collective outpouring of grief that, for once, made the old newspaper headline "A Nation Mourns" ring true.

David Levenson: royal photographer

David Levenson is one of the few photographers who covered the life and times of Princess Diana from the early 1980s until her tragic death in 1997. After the wedding of Charles and Diana, Levenson followed the royal couple around the world, visiting over 50 countries and producing 16 picture books of the royal travels. This photograph was taken on September 6, 1997, as Diana's coffin was carried into Westminster Abbey for her funeral service.

Prince Charles, Diana's sons, her brother, and Prince Philip at her funeral

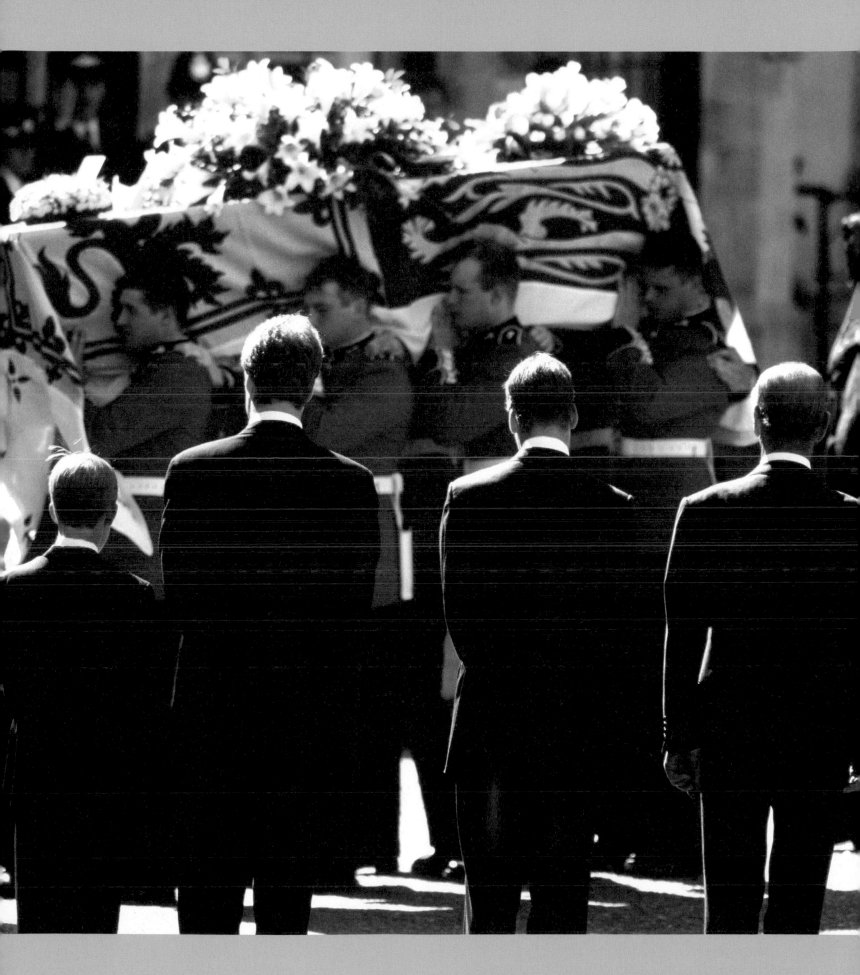

[December 19, 1998]

PRESIDENT CLINTON IMPEACHED

Sometime in the fall of 1995, a young White House intern named Monica Samille Lewinsky began an affair with the 42nd President of the United States, William Jefferson Clinton (1946–). Six months later, Lewinsky was transferred from the White House to the Pentagon, but the affair continued. Unhappy with the arrangement, Lewinsky began to confide in a colleague, Linda Tripp, who secretly began recording the phone conversations between herself and Lewinsky. In early January, Tripp told Kenneth Starr, an independent counsel investigating Clinton's involvement in the Whitewater real estate scandal, about the tapes.

On January 26, 1998, Clinton avowed "I did not have sexual relations with that woman, Monica Lewinsky." Starr then produced a report, outlining the possible case against the President for perjury. Clinton, meanwhile, repeated that "there is not a sexual relationship … or any kind of improper relationship," despite the information that Tripp had given Starr.

Impeachment proceedings began after the 1998 midterm elections, in which the Democrats made unexpected gains. On December 19, 1998, the House of Representatives voted to impeach Clinton on the grounds of perjury and obstruction of justice, the first President to be so arraigned since Andrew Jackson in 1868.

The Senate trial lasted for five weeks, ending on February 12, 1999. A two-thirds majority was needed to convict and remove the President from office. In the end, the perjury charge was defeated by 55 votes to 45; the obstruction of justice charge produced a tied vote, with 50 for and 50 against. Polls following the 2000 presidential election showed that the moral issue raised by "Monicagate" damaged the campaign of Clinton's former Vice President, Al Gore, and gained many votes for the eventual winner, Republican George W. Bush.

Bill Clinton denies his affair with Monica Lewinsky, January 26, 1998

Photographing Presidents

For over 20 years, Diana Walker was the official White House photographer for *Time* magazine, closely following Presidents Reagan, Bush senior, and Clinton. Walker began as an amateur, covering big events—the 1963 civil rights march at the Lincoln Memorial and the assassination of President Kennedy among them. As a professional, she was the only photographer in the room when Nancy Reagan entertained Raisa Gorbachev. Here she covers another dramatic occasion—Clinton's famous "Lewinsky denial."

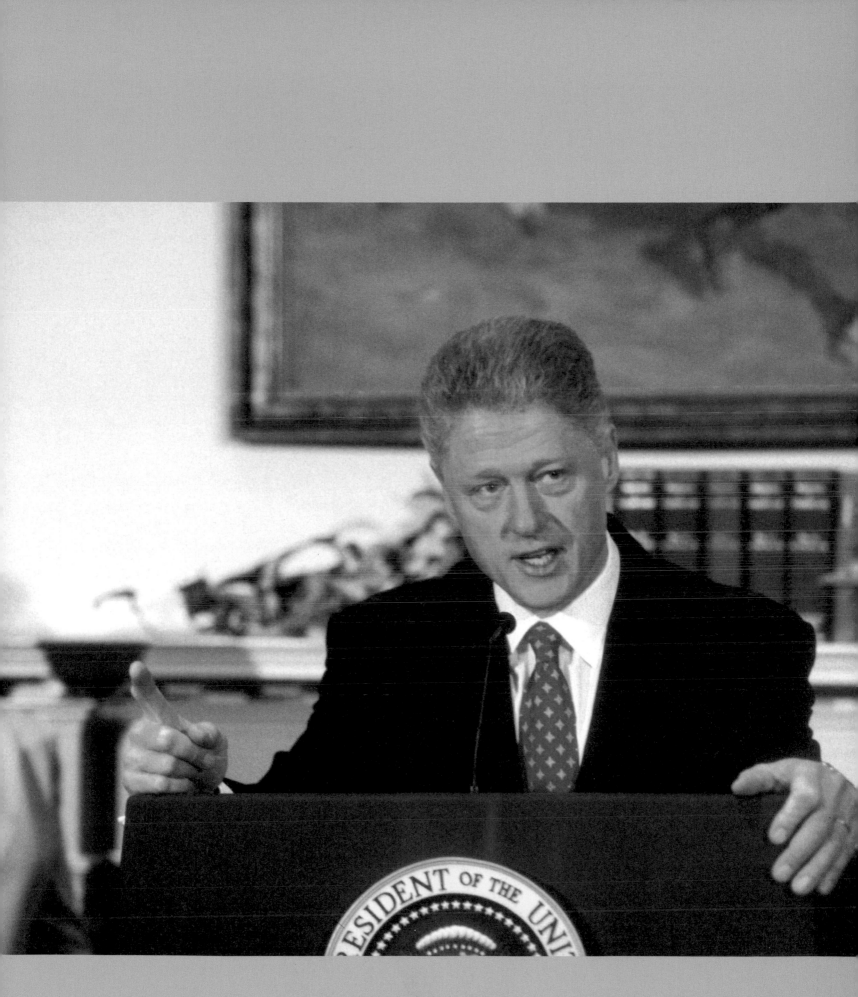

[September 28, 2000]

SECOND INTIFADA STARTS

On September 27, 2000, 19-year-old Sergeant David Biri of the Israeli Defense Force (IDF) was killed when a road side bomb exploded near the town of Netzarim in the Gaza Strip. On September 28, Ariel Sharon, leader of the Likud party in Israel's parliament, visited a part of Jerusalem known to Jews as Temple Mount and to Muslims as Haram al Sharif, a site sacred to both religions. Sharon was accompanied by members of his party and escorted by dozens of Israeli riot police. The stated purpose of Sharon's visit was to investigate complaints by Israeli archaeologists that Muslim religious authorities had vandalized ancient remains during the conversion of the Solomon's Stables area into a mosque.

Prejudice or persuasion enables some people to be sure which of these incidents sparked this intifada, the second major wave of violence between Palestinians and Israelis since 1967. Indeed, prejudice or persuasion also helps determine what the conflict is called: It is known as the Oslo War by those who see it as having been provoked by Israeli concessions as a result of the 1993 Oslo Accords, or Arafat's War by those who held the Palestinian leader responsible for the fighting that followed. Moreover, prejudice or persuasion decides whether it is called a war of national liberation or a terrorist campaign. Whoever or whatever caused the conflict, thousands died in the shootings, shellings, and suicide bombings that followed.

With such conflicting certainties of opinion, there is even disagreement as to what happened in any individual tragedy. On September 30, 2000, a 12-year-old boy named Muhammad al-Durrah was caught in the crossfire between Palestinians and IDF troops, in the area where Sergeant Biri had died. Years later, there is still disagreement as to whether Muhammad was killed by Palestinians or Israelis—and some even dispute that the boy is dead.

A Palestinian slings a stone at Israeli troops, Hebron, October 1, 2000.

Hossam Abu Alan

In October 2000, the Palestinian photographer Hossam Abu Alan was in Hebron (Al Khalil), working for the AFP and covering the Second Intifada during which he took this dramatic photograph of a Palestinian facing Israeli army jeeps. Eighteen months later, he was in captivity, having been arrested by the Israeli Defense Force at the Beit Einun checkpoint just north of the city. Abu Alan was handcuffed, blindfolded, and taken away. He was held prisoner for six months, before being dumped without explanation at the roadside. No explanation has been given for his arrest.

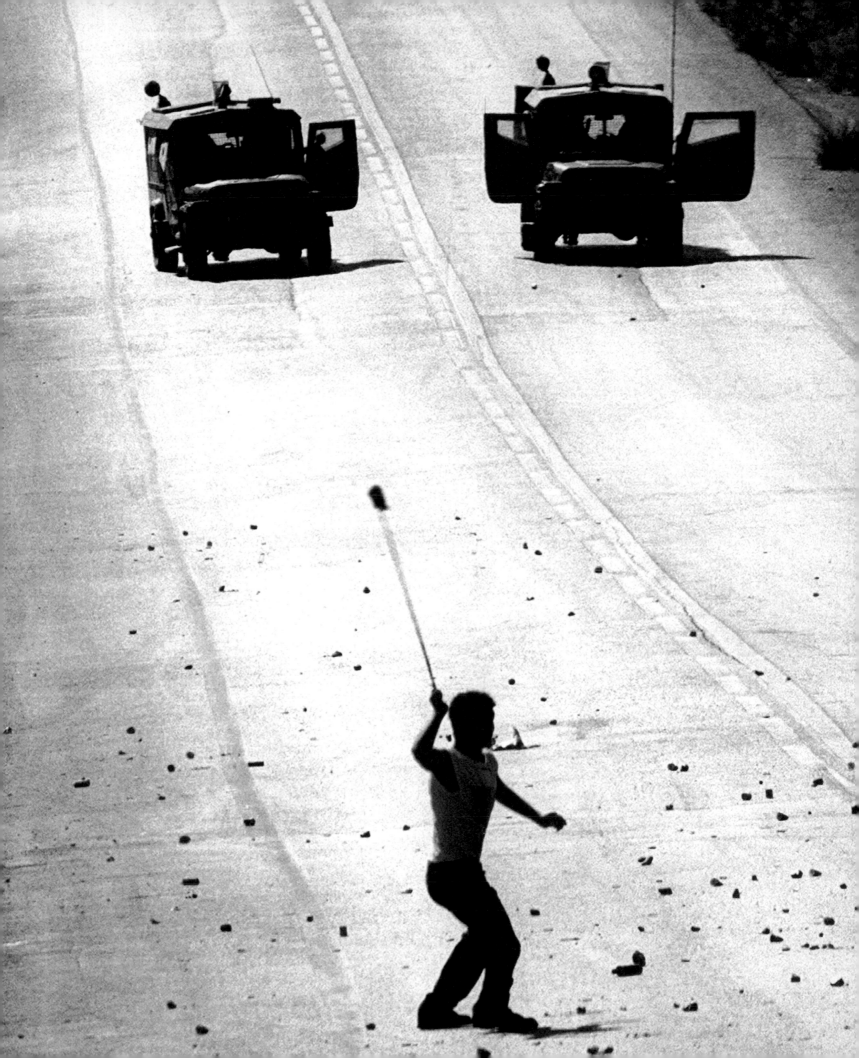

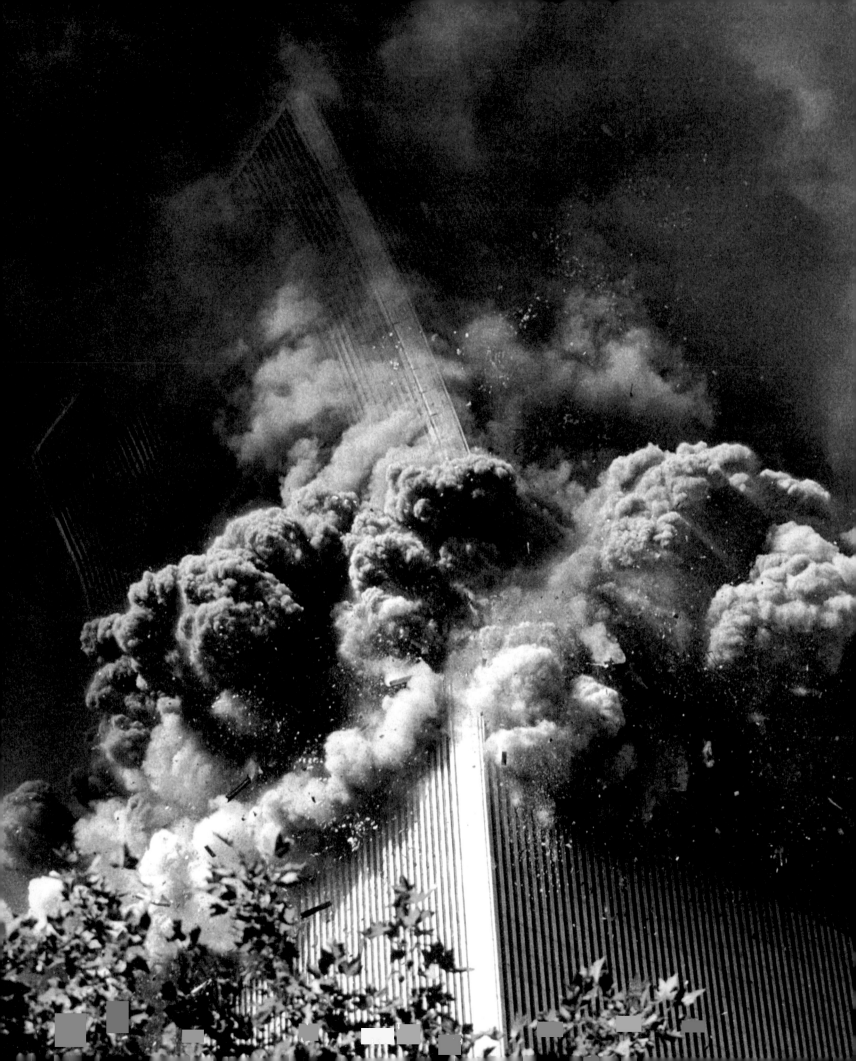

[September 11, 2001]

9/11

At 8:19 a.m. EST, flight attendant Betty Ong informed American Airlines that her Flight 11, a fully fueled Boeing 767 en route from Logan International, Boston, to LAX, Los Angeles, had been hijacked. The plane had already veered from its scheduled path, and was heading south. Eighteen minutes later, AA 11 was seen from another 767, United Airlines Flight 175 (UA 175), also heading from Boston to L.A. Within five minutes, UA 175 also was hijacked.

There was little time for those on the ground to react, and little time for passengers on AA 11 and UA 175 to realize what they faced. By 9:02 a.m. both planes had been piloted by the hijackers into the twin towers of the World Trade Center, New York City. AA 11 hit the north side of the north tower at 490 miles an hour; UA 175 hit the south side of the south tower at 590 miles an hour. Both planes exploded in fireballs. Between the impacts, there was just time for CNN to break into a commercial to report: "World Trade Center Disaster."

While those trapped inside the towers were frantically trying to evacuate the building, and TV and radio networks were running live coverage—millions saw the second crash on live TV—two more planes were hijacked. At 9:24 a.m., terrorists seized control of American Airlines Flight 77, a Boeing 757 from Dulles International, Washington, D.C., bound for Los Angeles. Four minutes later, United Airlines Flight 93 from Newark International to San Francisco was reported hijacked. AA 77 hit the western wing of the Pentagon at 9:36 a.m. All 64 people on board and 125 Pentagon staff were killed. UA 93 crashed at 10:03 into a field southeast of Pittsburgh, Pennsylvania, after passengers on board, aware of the fate of the other Boeings, fought to wrest control of their flight from the hijackers, who it was later determined had the Capitol as their target.

The south tower of the World Trade Center collapses at 9:59 a.m. EDT.

Thomas Nilsson: an all-purpose photojournalist

Thomas Nilsson was born in Stockholm, Sweden, in 1967. Here he trained and worked as a photographer, submitting pictures to various newspapers and magazines. From 1995 to 1996 he studied photojournalism at university before leaving Sweden for New York City in 1997. Nilsson is the all-purpose photojournalist, recording cityscapes, the lives of celebrities, and major news events. He gained awards for his coverage of Hurricane Katrina, and for his in-depth studies of the 9/11 disaster and its grotesque aftermath.

UA 175 hits the south tower.

President Bush is notified by Andrew Card.

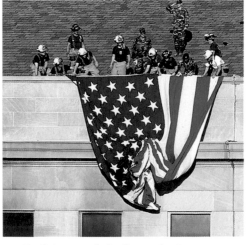

Flight arrival board at Los Angeles Airport

Following pages: Rescue workers survey the total devastation at ground zero—what little that remained of the World Trade Center after September 11, 2001.

By 10:00 a.m., global satellite links were beaming pictures around the world. On the Internet, many were already debating what had happened and why. The horror was witnessed by a large proportion of the world's population. For the first time ever, ordinary people had ringside seats as history unfolded. They had seen UA 175 crash. They now saw the south tower of the World Trade Center collapse, sending choking clouds of pulverized concrete and gypsum through the surrounding streets. And they watched in disbelief as the north tower also collapsed.

It was clear that the atrocities had been planned and orchestrated, and that they were a deliberate attack on American centers of political, financial, and military power. The scale of the operation suggested that this was not the work of lunatic anarchists or a

AA 77 hits the Pentagon.

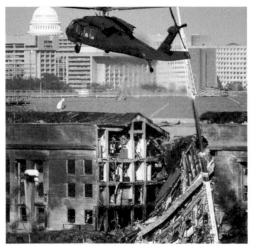

The Pentagon on September 12, 2001

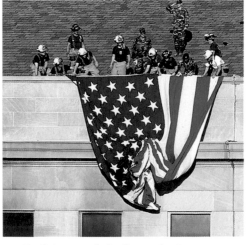

Firefighters unfurl a flag at the Pentagon.

Portraits of those missing after the disaster

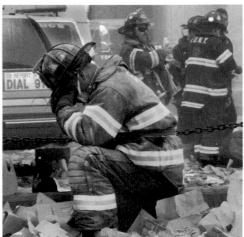

An exhausted firefighter at ground zero

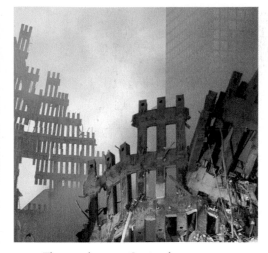

The wreckage on September 13, 2001

home-grown dissident, such as the Oklahoma Bomber. The method used, suicide killing on an unprecedented scale, led many to suspect that this was the work of Islamic fundamentalists. At 4 p.m. EDT, Osama bin Laden was named as the most likely suspect. That night, President George W. Bush wrote in his diary: "The Pearl Harbor of the 21st century took place today We think it's Osama bin Laden."

The events of that day changed the world. Five years later, air travel, homeland security, relations between the West and Islamic nations, the foreign policies of many countries, police powers, and the strain placed on traditional individual liberties were still overwhelmingly shaped and influenced by what has since been known as 9/11. Many believe the world will never recover; most believe it will never be the same. More than 3,000 innocent people died that day.

"I could see nothing, but I could hear the cries of the injured people echoing from the collapsed rubble"

RICHARD MICOK, WORKING ON THE 50TH FLOOR OF THE SOUTH TOWER, SEPTEMBER 11, 2001

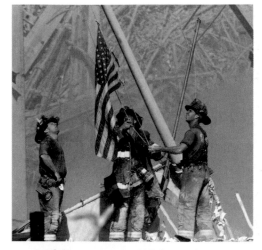

Firefighters raise the U.S flag at the WTC.

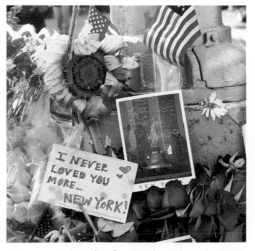

Flowers and cards of remembrance at the WTC

A rescue dog and firefighter

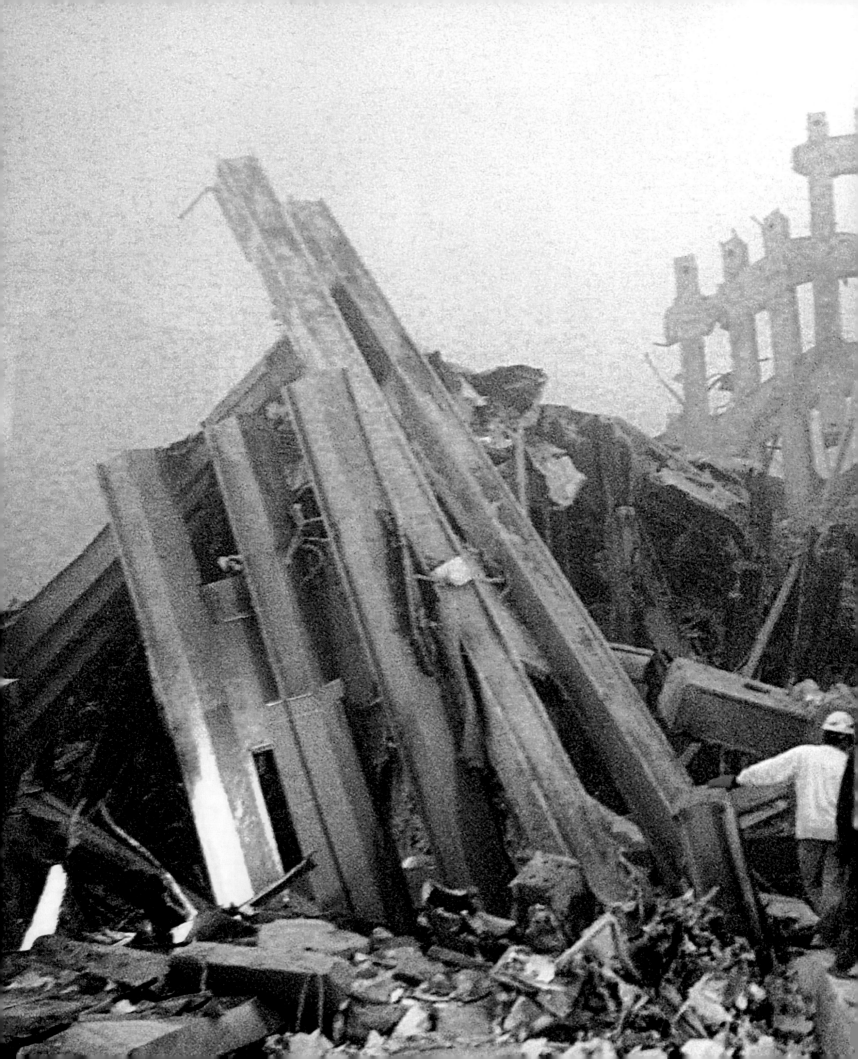

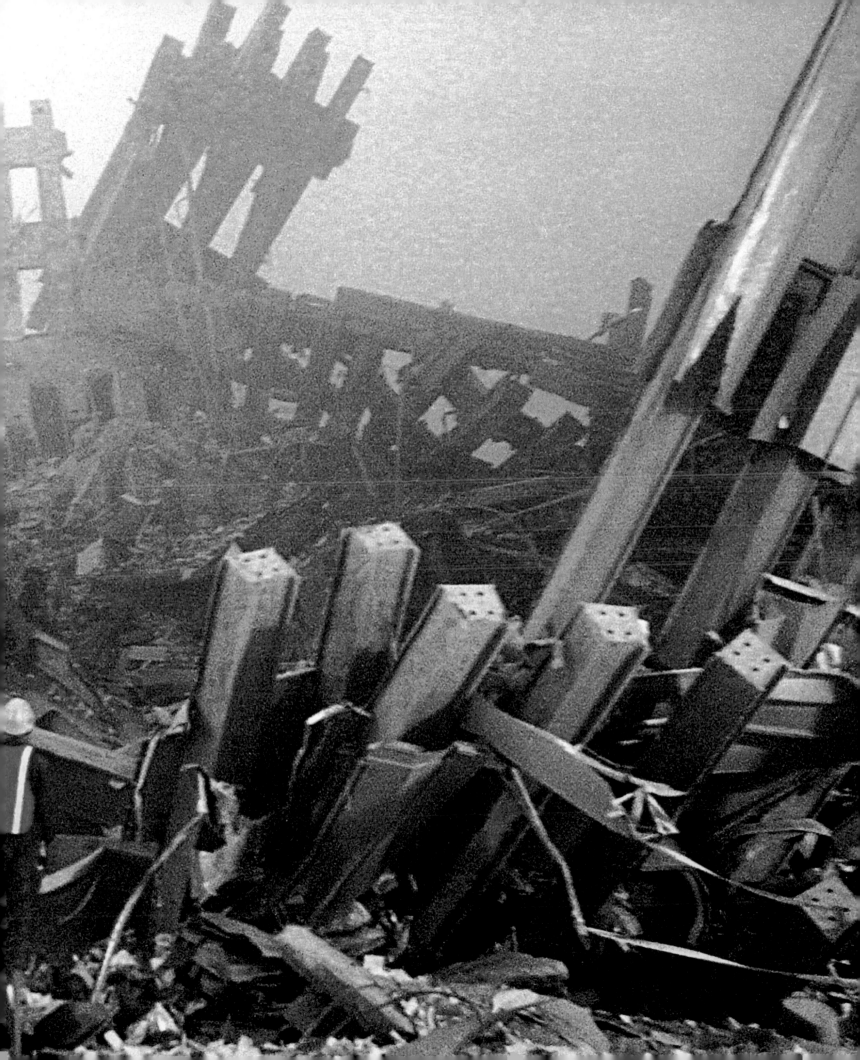

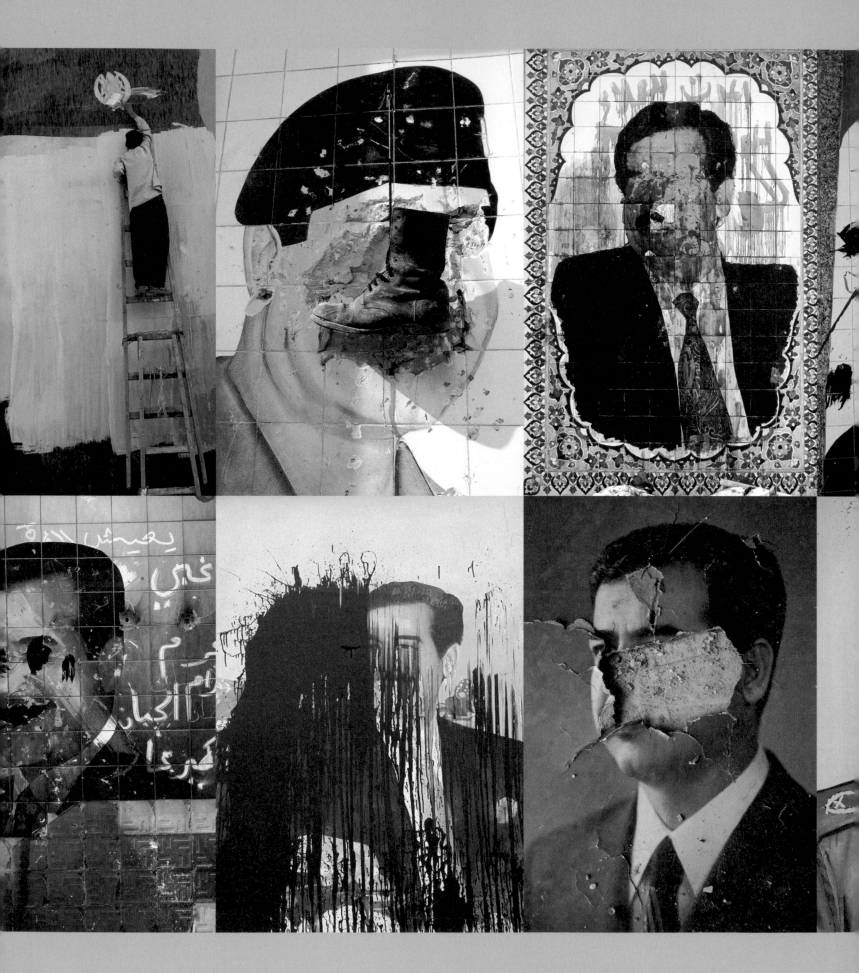

"In the name of God, the Compassionate, the Merciful ...
with the banner flying, raise your swords and rifles,
oh, our dear people"

EXTRACT FROM A SPEECH BY SADDAM HUSSEIN, BAGHDAD,
JANUARY 17, 2003

[March 20, 2003]

INVASION OF IRAQ

It was the first war in history to be played out in its entirety in front of film cameras—from countdown to invasion, from rapid conquest to the grueling misery of occupation of a country threatening to tear itself apart. Vietnam had been a killing field for years before TV beamed back pictures to the United States that caused Americans to add doubt to their already existing anxiety about what was going on. Even the coverage of the Persian Gulf war (August 1990–February 1991) showed only the final act of a drama that had already been in progress for some time.

But the camera captured a complete record of the war in Iraq: the prelude, with politicians and diplomats hurrying to and from the capital cities of the world in attempts to hasten or delay the conflict; the mounting crisis, as an intransigent regime in Iraq rejected weapons inspection proposals; the arrival in Washington, D.C., of a new administration determined to complete the unfinished business of 1991; the presentation of the case for war by, among others, British Prime Minister Tony Blair, and the ferocious arguments that followed; the summits and other meetings that attempted to support or override the resolutions of the United Nations; and the streets of the world thronged with angry demonstrators. All this activity was there to be seen on television screens, read in the pages of newspapers, or even downloaded onto mobile phones.

Then came the fighting: the early moves, with a U.S. "decapitation strike" on the regime of Saddam Hussein, launched on March 20, 2003. It seemed there was a plan, and that every move was part of it. For a few days, the war ran like a well-oiled machine—the "shock and awe" precision bombing of Iraqi government sites, the British invasion of the Faw Peninsula, the U.S. bombardment of the Ansar al-Islam enclave, the opening of a northern front in Kurdistan.

A collage of posters of Saddam Hussein taken from Baghdad walls

Alexandra Boulat

Alexandra Boulat studied graphic art and art history at the Beaux Arts in Paris, then worked as a photographer for ten years before co-founding the VII photo agency. As well as covering wars in Afghanistan, Yugoslavia, and the Middle East, Boulat has made a special study of the condition of women throughout the world. Her collage of defaced images of Saddam Hussein illustrates her stated aims as a photographer: "To tell the truth, to be journalistically sharp, and on the field, not to go for the obvious"

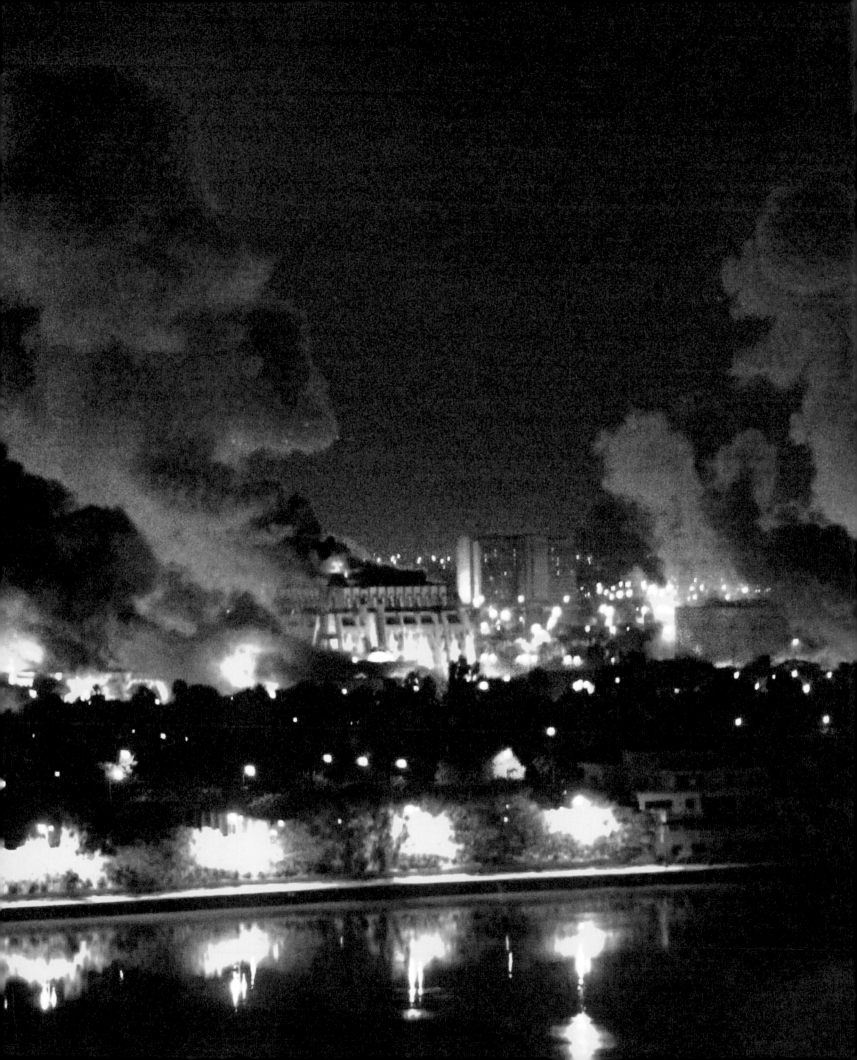

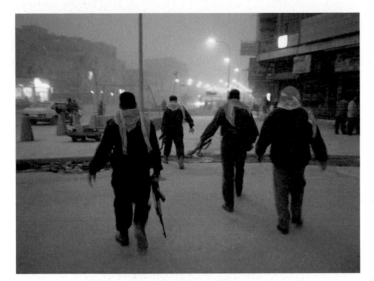

Iraqi troops patrol the streets of Baghdad, March 25, 2003.

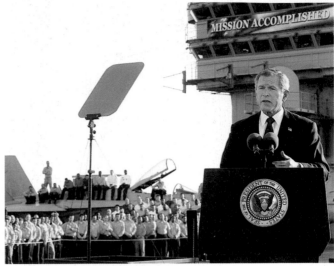

The U.S. President on board U.S.S. *Abraham Lincoln,* May 1, 2003

In just over three weeks, the rogue regime had been toppled, the country had been overrun, and the last major city (Tikrit) had fallen to U.S. forces. The head of an interim civil administration arrived in Baghdad. On May 1, 2003, U.S. President George W. Bush (1946–) declared that the military phase of Operation Iraqi Freedom had ended. The pictures of war were replaced by more humdrum images of a new order settling on a land that had been under the heel of tyranny since 1979, the year Saddam Hussein became Iraq's president and chair of the Revolutionary Command Council.

A new phase began. The hunt for Saddam generated new images, and when the tyrant was finally apprehended on December 14, 2003, his shame, surprise, and degradation were there for all to see in a moment of history in the making.

There were further phases, as Iraq drifted toward civil war. In May 2004, there were revelations of widespread abuse of prisoners by the occupying forces. On November 8, U.S. troops began a full-scale assault on Fallujah, a hotbed of resistance to the occupation. In May 2005, a deeply divided Iraqi parliament failed to elect a president, and in the same month a state of emergency was declared in Basra after the city suffered its worst period of violence since 2003. Then, on December 30, 2006, came more graphic and controversial images—the execution of Saddam Hussein at Camp Justice in northern Baghdad. Legitimate or illicit, it was there for all to see.

After all the full-color imagery of war, with no end in sight, the eyes of the world were beginning to suffer from battle fatigue.

"My fellow Americans, major combat operations in Iraq have ended ... the United states and our allies have prevailed. And now our coalition is engaged in securing and reconstructing that country."

PRESIDENT GEORGE W. BUSH,
U.S.S. *ABRAHAM LINCOLN,* MAY 1, 2003

The bombardment of Baghdad by American aircraft on the night of March 25, 2003

Following pages: Two U.S. soldiers take souvenir photos in front of giant stone statues depicting Saddam Hussein inside the Green Zone, November 22, 2005.

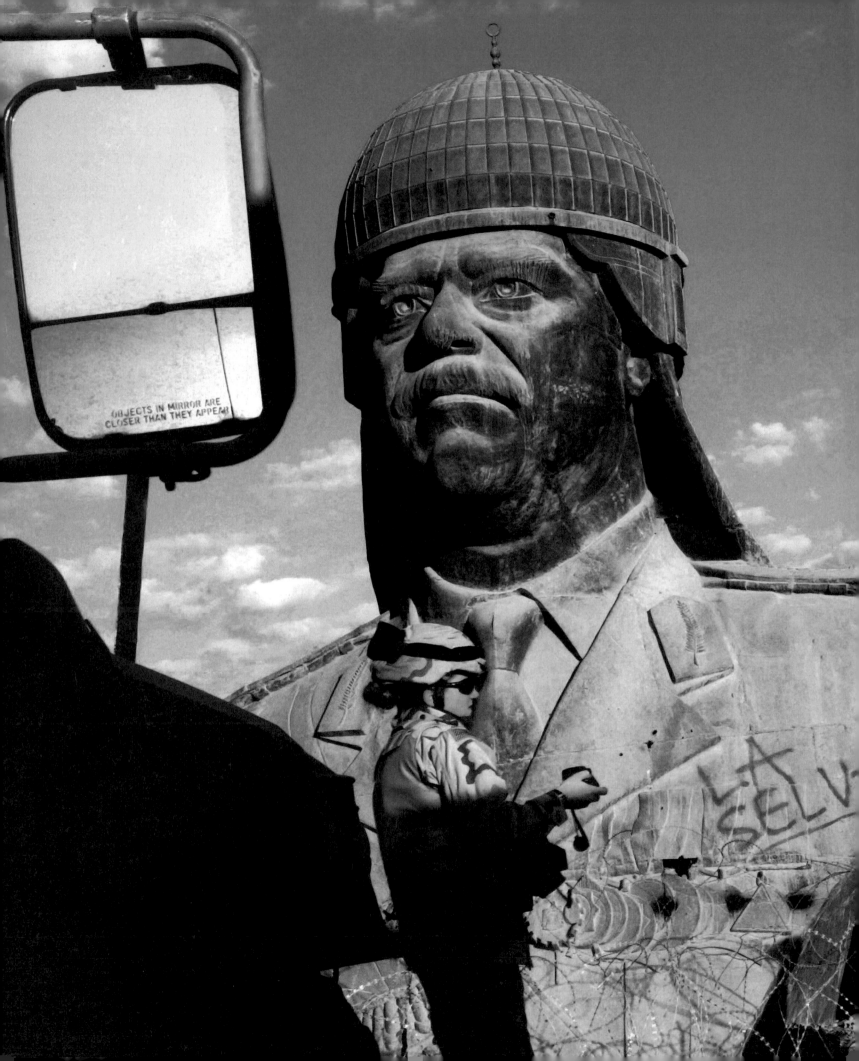

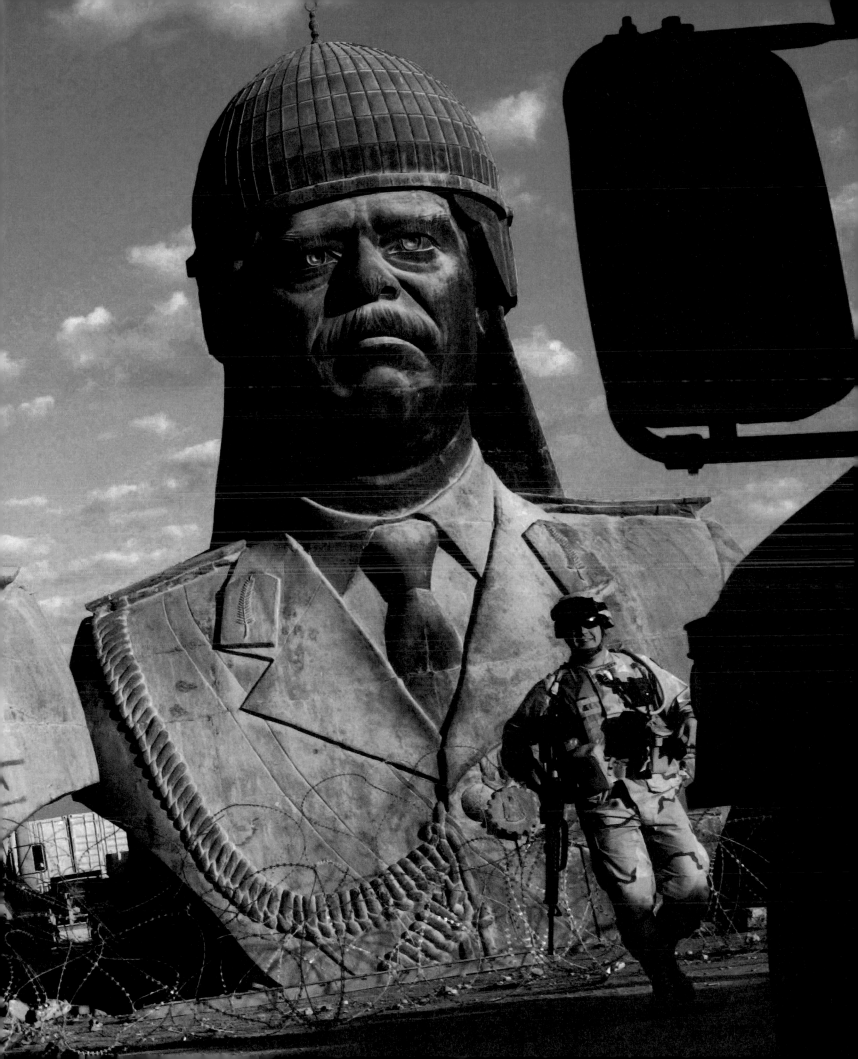

[December 26, 2004]

INDIAN OCEAN TSUNAMI

Scientists are unsure exactly how strong the Sumatra-Andaman Earthquake was, although it is generally reckoned to have been the fourth most powerful since 1900. It was certainly one of the deadliest of all time, second only to the Chinese Shaanxi Earthquake of 1556, which killed some 830,000 people.

The death toll for what is now generally called simply "The Tsunami" remains uncertain, but the giant waves are believed to have killed at least 283,000 people, from Indonesia to Kenya, and to have rendered well over a million homeless.

One-third of those who died were children. In some areas, four times more women than men were killed, simply because they were looking after children or waiting at home for the return of the male members of the household who earned their daily living by fishing.

The earthquake that preceded and caused the tsunami took place when almost a thousand miles of faultline slipped 50 feet where two tectonic plates meet—the India plate and the Burma plate. The epicenter of the quake was off the west coast of Sumatra, and came in two phases. The first phase

began at 7:58 a.m. local time on December 26, 2004, and involved a 250-mile-long rupture—the largest ever known—at the junction of the plates. This rupture traveled very rapidly, at a rate of 1.7 miles per second (6,300 mph) for 100 seconds, then paused for another 100 seconds before continuing. A second rupture, in the northern part of the Indian Ocean, developed more slowly, moving at 1.3 miles per second (4,700 mph) for about five minutes. Because it was slower, the tsunamis that it caused were much smaller and did less damage.

The effect of the rupture and the movement of the plates was to displace some 7.1 cubic miles of water, which triggered the series of tsunamis. A series of aftershocks followed, at their most severe over the next few hours, but continuing for several days.

A tsunami on this scale gives little warning of its approach. As it traveled over deep water, the 2004 tsunami formed what appeared to be no more than small "humps" on the surface of the sea, traveling at between 300 and 600 miles an hour. Hat Rai Lay beach, near Krabi, Thailand, December 26, 2004

The holiday island of Phi Phi, southern Thailand, 24 hours after the tsunami hit

Hat Rai Lay beach

In the photograph on the previous pages—the final in a sequence of three that made the world hold its collective breath—a frantic mother races toward her family to warn them of the tidal wave about to hit Hat Rai Lay beach, near Krabi in southern Thailand. Their fate was unknown until January 1, 2005, when mother Karen Svärd came forward in an interview with Swedish newspaper *Expressen*. "I was yelling at them to run, but they couldn't hear me." The wave caught up with them and they were swept underwater, but they finally managed to get their footing, and all survived.

As these humps reached the coastlines of Thailand, Sri Lanka, Indonesia, and India, they slowed to 20 to 30 miles an hour, but reared up higher and higher as the sea beneath them became shallower. By the time they hit land, the worst of the tsunamis were up to 100 feet high. They were still gaining in height as they smashed their way inland.

In some places, the only immediate warning was a sudden retreat of the sea from the land, leaving boats and millions of fish on the extended shore. This phenomenon, which unfortunately drew many curious people toward the danger, lasted only a short time before the sea raced back in the form of tsunamis.

The damage and the loss of life were appalling. Entire communities were swept away. Houses, boats, and even trains were hurled miles inland. Men, women, and children were torn from each other's arms. The fortunate managed to struggle to higher ground, or scramble to the top of a reasonably tall building. But for most, there was

Complete devastation at Nam Kem, Panga province, Thailand, December 30, 2004

no escape. Well over a million people lost their homes. The United Nations calculated that the relief operation would be the costliest in human history.

It took only 15 minutes from the earthquake to the time when the first tsunami waves hit land, but the terror lasted for seven hours, for the distances involved—from Indonesia to the East African coast— were immense. Even along the west coasts of North and South America, the tsunami produced measurably higher waves than usual.

The total energy released by the tsunami waves was reckoned to be the equivalent of twice the explosive energy used during World War II (including the atomic bombs). The quake itself was reckoned to be even more powerful—the equivalent to the total energy used by the United States over a period of 11 days—and powerful enough to alter (very slightly) the Earth's rotation. The shock waves were felt as far away as Oklahoma.

"The best way to describe this is that Banda Aceh looks like Hiroshima after the atomic bomb. It's totally destroyed. The have been flattened for miles and something like 100,000 people have been swept out to sea ..."

National Geographic PHOTOGRAPHER CHRIS RAINIER, INDONESIA, JANUARY 10, 2005

[August 29, 2005]

HURRICANE KATRINA

On August 23, 2005, a tropical depression developed over the southeast Bahamas. One week later, 80 percent of the city of New Orleans, Louisiana, was under water, 20 feet deep in places. More than 1.7 million people in the Gulf states had no electricity, hundreds of people had been killed, millions were homeless, and the President of the United States' ability to care for his people had been questioned—all a result of Hurricane Katrina.

The storm's progress across the Caribbean and the Gulf of Mexico was swift and destructive. On August 24, Katrina achieved tropical storm status. The following day, Category 1 Hurricane Katrina made landfall over south Florida, bringing five inches of rain to most of the area. The hurricane then built up strength over the warm waters of the Gulf of Mexico, moving first due west, then northwest, and finally north toward the Louisiana–Mississippi coastline. By the afternoon of August 26, Katrina had become a major hurricane. On Sunday, August 28, Katrina reached a maximum wind speed of 170 miles an hour, and maintained Category 5 status until its next landfall on August 29. Along with the wind, rain fell at a rate of an inch an hour over parts of Louisiana and Mississippi.

New Orleans, founded in 1718 on a swamp, lay just west of the eye of the hurricane. The downtown area was sandwiched between the waters of Lake Pontchartrain and the Gulf of Mexico. It was protected from flooding by a series of levees, which many engineers believed to be poorly constructed. The natural flood barrier created by silt at the mouth of the Mississippi River had been eroded and weakened by urban development, leaving New Orleans vulnerable to attack by floodwater. And the worst flood in the city's history soon followed in Katrina's wake.

Chronicling Katrina's aftermath

American David J. Phillip is a professional photographer whose work has spanned everything from the funeral of Kenneth Lay (founder of Enron) to illustrations for *The Perfect Wedding Guide*. While working for *Time* magazine, Phillip compiled a special portfolio of the aftermath of Hurricane Katrina, the most telling shots being taken from a helicopter, charting the distress and anger of the hurricane's victims.

Residents await rescue, St. Bernard, New Orleans, August 30, 2005.
Following pages: The remains of a church in Louisiana, September 11, 2005

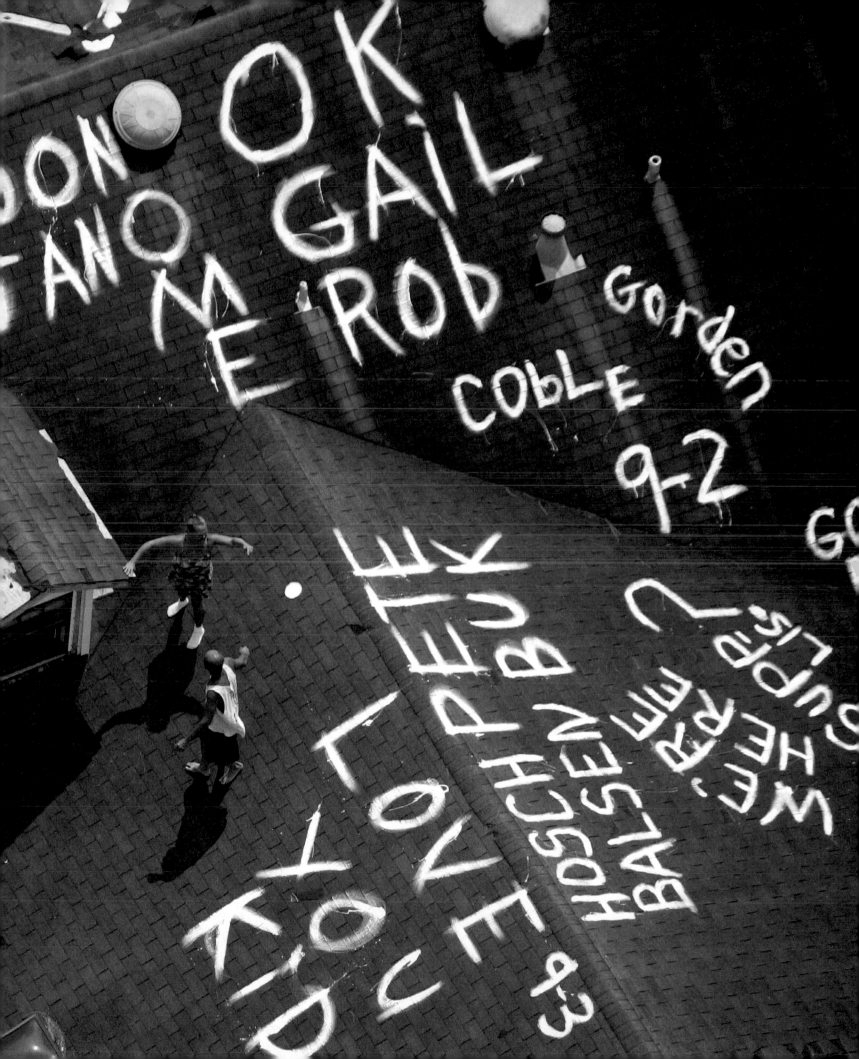

[Index]

THE FIRST ISSUE OF
PICTURE POST

The British weekly magazine *Picture Post* was first published in 1938. It was the creation of publisher Edward Hulton and Stefan Lorant, its editor until 1940 when he was replaced by Tom Hopkinson. The alliance between Lorant and Hulton was an unlikely one, for while Hulton was a staunch Conservative, Lorant was a Hungarian Jew, fiercely anti-Fascist, and inclined heavily to the political Left. In the issue of November 26, 1938, the magazine included an illustrated article roundly condemning the Nazi regime in Germany.

At the height of its success, *Picture Post* had an enormous circulation—1.5 million copies a week. To a large extent, this was due to the quality and quantity of its photographs. Tom Hopkinson described his photographers as "thoroughbreds," and they included Bill Brandt, Bert Hardy, Hans Baumann, Kurt Hubschmann, Leonard McCombe (who

later worked for *Life* magazine), Thurston Hopkins, Haywood Magee, Humphry Spender, Grace Robertson, and John Chillingworth. The magazine ceased publication in 1957, by which time it had sadly lost its way and, in the words of one of its finest writers—James Cameron—had "painlessly surrendered all the values and purposes that had made it a journal of consideration." There has not been its like in Britain since.

During *Picture Post's* lifetime, Hulton began to assemble the photographic archive that was to bear his name. He purchased other archives, including that of the London Stereoscopic Company, Augustin Rischgitz, Henry Guttmann, and Alex Stewart (the Sasha Collection). When the magazine folded, Hulton sold the archive to the British Broadcasting Corporation and it became the BBC Hulton Archive. Although lacking Hulton's zeal, the BBC added to the collection by purchasing the *Daily Express* and *Evening Standard* picture archives. In 1988, the now enormous collection was sold on and eight years later was acquired by Getty Images, the world's leading creator and distributor of visual content.

THE FOUNDING OF NATIONAL
GEOGRAPHIC SOCIETY

On January 13, 1888, 33 founders—scientists, scholars, military men—met at the Cosmos Club in Washington, D.C., to create "a society for the increase and diffusion of geographic knowledge." Out of this meeting came the world's first journal devoted to exploration and geographical discovery. In October 1888, the first issue of *National Geographic* magazine was printed and sent to 165 charter members.

In the January 1905 issue, editor Gilbert H. Grosvenor daringly filled 11 pages of the magazine with photographs of Lhasa in Tibet. Expecting to be fired, he was instead congratulated by National Geographic Society members. A pattern was established that continues to this day—that of presenting lavishly illustrated articles of a scientific nature

with popular appeal. In the more recent past, the magazine has extended its vision to include outspoken articles on important environmental and social issues from global warming to India's Untouchables.

Color illustrations appeared in the 1930s, pioneered by a young staff photographer named Luis Marden, who persuaded the magazine to switch to lightweight 35mm cameras using Kodachrome film. Since then, through the magazine, the National Geographic Society has accumulated an Image Collection that holds well over a century's worth of photographs. These images document and chronicle Earth's diverse peoples, life forms, and landscapes. The collection also features 14,500 early glass color plates, black-and-white historical material, maps, diagrams, and artwork. The special collections include those of Alexander Graham Bell, Hiram Bingham (12,000 black-and-white images from his 1911–1915 Peruvian expeditions), Robert Peary (6,600 images from his Arctic expeditions), and Edward S. Curtis (723 images of Native American cultures taken between 1900–1930).

[Illustration Credits]

6-7 Gerry Penny/Agence France Presse/Getty Images; 8-9 Central Press/Getty Images; 12-13 Alexandra Avakian/Woodfin Camp/Time & Life Pictures/Getty Images; 14-15 Mario Tama/Getty Images; 17 Robert E. Peary Collection/NGS Image Collection; 19 Getty Images; 21-3 Roger Fenton/Library of Congress, 21 LC-USZC4-9217, 22tl LC-USZC4-9361, 22tr LC-USZC4-9205, 23 LC-USZC4-9240; 24 Felice Beato/Getty Images; 27-8 Robert Howlett/Getty Images; 31-3 William England/Getty Images; 35 Timothy H. O'Sullivan/Library of Congress LC-B8184-7964-A; 36-41 Alexander Gardner/ Library of Congress (except 38b George Eastman House/Getty Images), 36 LC-USZ61-1938, 38tl LC-DIG-cwpb-04208 DLC, 38tm LC-DIG-cwpb-04216 DLC, 38tr LC-DIG-cwpb-04220 DLC, 39tl LC-DIG-cwpb-04213 DLC, 39tm LC-DIG-cwpb-04217 DLC, 39tr LC-DIG-cwpb-04218 DLC, 41 LC-DIG-cwpb-04230 DLC; 42 Andrew Joseph Russell/Library of Congress LC-USZ62-57524; 45 Roger-Viollet/Getty Images; 46 Getty Images; 48 ND/Roger-Viollet/Getty Images; 50-1 (top row) Jules Théophile Féau/Getty Images; 51b Getty Images; 53 Trager and Kuhn/Library of Congress LC-USZ62-104561; 54 W. & D. Downey/Getty Images; 56-7 Getty Images; 59-61 Reinhold Thiele/Getty Images; 63 John T. Daniels/Library of Congress LC-USZ62-6166A; 64 Albert Harlingue/Roger-Viollet/Getty Images; 67 F. Bezancon/Getty Images; 69 Getty Images; 71-73 Robert E. Peary Collection/NGS Image Collection; 74 George Grantham Bain Col./Library of Congress LC-USZ62-68650; 76 Getty Images; 79-83 Hiram Bingham/NGS Image Collection; 85 Sheil, Anthony Associates Ltd; 86 Topical Press/Getty Images; 88 Arthur Barrett/Getty Images, 90-1 Topical Press/Getty Images; 93 Milos Oberajger/Getty Images; 94 Armin Wegner/Getty Images; 96 Arthur G. Marshall/Getty Images; 99 Getty Images; 100 Keystone/Getty Images; 103-4 Getty Images; 107 Albert Harlingue/Roger-Viollet/Getty Images; 109 Maynard Owen Williams/NGS Image Collection; 110tl Edgar Aldrich; 110tr Ledger Photo Service; 111 Edgar Aldrich; 113 Pacific & Atlantic Photos Inc.; 114 Wide World Photos/Getty Images; 116-19 New York Times & St. Louis Post Dispatch; 120 Walter Bosshard; 123 Getty Images; 124-5 Pacific & Atlantic Photos Inc./Getty Images; 127 Getty Images; 129-31 Central Press/Getty Images; 132 Schostal Archiv/Imagno/Getty Images; 135-9 Getty Images; 140t Imperial War Museum; 140b CBS Photo Archive/Getty Images; 141 British Combine/NGS Image Collection; 142-3 Acme Newspictures Inc.; 144 National Archives ARC 295976/Time & Life Pictures/Getty Images; 147 Terry Ashe/Time & Life Pictures/Getty Images; 148-9 Georgi Zelma/Slava Katamidze Col./Getty Images; 150 Robert F. Sargent/National Archives 26-G-2343; 153 Galerie Bilderwelt/Roger-Viollet/Getty Images; 154 Margaret Bourke-White/Time & Life Pictures/Getty Images; 157 Alfred Eisenstaedt/Time & Life Pictures/Getty Images; 158t Cpl. Richard Cannon/USAAF/Time & Life Pictures/Getty Images; 158b FPG/Getty Images; 159 USAAF/Getty Images; 161 Margaret Bourke-White/Time & Life Pictures/Getty Images; 162 Keystone/Getty Images; 164 Agence France Presse/Getty Images; 165l John Phillips/Time & Life Pictures/Getty Images; 165r Keystone/Getty Images; 167 Walter Sanders/Time & Life Pictures/Getty Images; 168 J.R. Eyerman/Time & Life Pictures/Getty Images; 171 Carl Mydans/Time & Life Pictures/Getty Images; 173 March of Dimes; 175 Antony Barrington Brown/Science Photo Library; 177 Alfred Gregory/Royal Geographical Society; 178 Edmund Hillary/Royal Geographical Society; 179 Alfred Gregory/Royal Geographical Society; 181 Yale Joel/Time & Life Pictures/Getty Images; 182 CBS Photo Archive/Getty Images; 184-5 Don Cravens/Time & Life Pictures/Getty Images; 186-7 Robert W. Kelley/Time & Life Pictures/Getty Images; 189 Jack Esten/Getty Images; 190 Thomas D. McAvoy/Time & Life Pictures/Getty Images; 193 Dmitri Kessel/Time & Life Pictures/Getty Images; 194 Grey Villet/Time & Life Pictures/Getty Images; 197 Des & Jen Bartlett/NGS Image Collection; 199 Robert Sisson/NGS Image Collection; 201 Thomas J. Abercrombie/NGS Image Collection; 203 Paul Schutzer/Time & Life Pictures/Getty Images; 204 Julian Wasser/Time & Life Pictures/Getty Images; 207 Agence France Presse/Getty Images; 209 David S. Boyer/NGS Image Collection; 210l Library of Congress LC-USZ62-134844; 210r David Uhrbrock/Time & Life Pictures/Getty Images; 211 Getty Images; 213 Carl Mydans/Time & Life Pictures/Getty Images 214 Agence France Presse/Getty Images; 217 Agence France Presse/Getty Images; 218 John Downing/Express Newspapers/Getty Images; 221 Getty Images; 223 Gerard Klijn/Pictorial Parade/Getty Images; 224 Reg Lancaster/Express Newspapers/Getty Images; 227 Getty Images; 228 NASA; 228tl AS11-40-5876, 228tr AS11-40-5877, 228bl AS11-40-5880, 228br AS11-40-5879; 230-1 Consolidated News Pictures/Getty Images; 233-5 Bill Eppridge/Time & Life Pictures/Getty Images; 236 Ollie Atkins/White House/Time & Life Pictures/Getty Images; 239 Getty Images; 241 Co Rentmeester/Time & Life Pictures/Getty Images; 242 Gjon Mili/Time & Life Pictures/Getty Images; 245 Dirck Halstead/Time & Life Pictures/Getty Images; 247 Dirck Halstead/Liaison/Getty Images; 248 Jason Weisfeld, MD; 251 Sven-Erik Sjöberg/Pressens Bild/Agence France Presse/Getty Images; 252 David Alan Harvey/NGS Image Collection; 254 Islamic Republic News Agency/Agence France Presse/Getty Images; 257 Jorma Puusa/ Lehtikuva/Agence France Presse/Getty Images; 259 Marek Druszcz/Agence France Presse/Getty Images; 261 NASA/Goddard Space Flight Center Scientific Visualization Studio; 262 US Department of State/Time & Life Pictures/Getty Images; 264 Terry Ashe/Time & Life Pictures/Getty Images; 266-7 Dave Welcher/Getty Images; 269 Tom Stoddart/Getty Images; 271 José Moré/Chicago Tribune/Agence France Presse/Getty Images; 272 Catherine Henriette/Agence France Presse/Getty Images; 274-5, 276-7 (top and bottom row) Gerard Malie/Agence France Presse/Getty Images; 277ml Stephen Jaffe/Getty Images; 277mr Deutsche Presse Agentur/Agence France Presse/Getty Images; 278-9 Heimo Aga/Getty Images; 281 Alexander Joe/Agence France Presse/Getty Images; 282 Robert Silvers/www.photomosaic.com; 284 Stephen Ferry/Getty Images; 287 David Levenson/Getty Images; 289 Diana Walker/Time & Life Pictures/Getty Images; 291 Hossam Abu Alan/Agence France Presse/Getty Images; 292 Thomas Nilsson/Getty Images; 294tl Spencer Platt/Getty Images; 294tm Paul J. Richards/Agence France Presse/Getty Images; 294tr Gerard Buckhart/Agence France Presse/Getty Images; 294bl CNN/Getty Images; 294bm Rex A. Stuckey; 294br Luke Frazza/Agence France Presse/Getty Images; 295tl John Mottern/Agence France Presse/Getty Images; 295tm Mario Tama/Getty Images; 295tr Chris Hondros/Getty Images; 295bl Thomas E. Franklin/The Bergen Record/Getty Images; 295bm Beth A. Keiser/Agence France Presse/Getty Images; 295br Ira Block/NGS Image Collection; 296-7 Doug Kanter/Agence France Presse/Getty Images; 298 Alexandra Boulat/NGS Image Collection; 300 Mirrorpix/Getty Images; 301tl Alexandra Boulat/NGS Image Collection; 301tr Stephen Jaffe/Agence France Presse/Getty Images; 302-3 Mauricio Lima/Agence France Presse/Getty Images; 304-5 Agence France Presse/Getty Images; 306 Roslan Rohman/Agence France Presse/Getty Images; 307 Romeo Gacad/Agence France Presse/Getty Images; 309 David J. Phillip/Agence France Presse/Getty Images; 310-11 Joe Raedle/Getty Images; 318t IPC Magazines/Picture Post/Getty Images; 318b National Geographic magazine cover photo by Yousuf Karsh

100 Days in Photographs:
Pivotal Events that Changed the World
Nick Yapp

Published by the National Geographic Society
John M. Fahey, Jr., *President and Chief Executive Officer*
Gilbert M. Grosvenor, *Chairman of the Board*
Nina D. Hoffman, *Executive Vice President;*
 President, Book Publishing Group

Book Division Staff
Kevin Mulroy, *Senior Vice President and Publisher*
Leah Bendavid-Val, *Director of Photography Publishing*
 and Illustrations
Marianne R. Koszorus, *Director of Design*
Barbara Brownell Grogan, *Executive Editor*
Susan Blair, *Project/Illustrations Editor*
Carol Norton, *Designer*
Jennifer Thornton, *Managing Editor*
Gary Colbert, *Production Director*

Manufacturing and Quality Management
Christopher A. Liedel, *Chief Financial Officer*
Phillip L. Schlosser, *Vice President*

Endeavour Staff
Charles Merullo, *Publisher*
Mark Fletcher, *Managing Editor*
Henry Russell, *Editor*
Liz Ihre, *Proofreader*
Jennifer Jeffrey, *Indexer*
Tea Aganovic, *Designer*
Ali Khoja, *Photo Editor*

Endeavour London Ltd
21–31 Woodfield Road
London W9 2BA
info@endeavourlondon.com

Acknowledgments
This book was produced by Endeavour London Ltd in conjunc-
tion with the National Geographic Society and Getty Images.

Our thanks to the following:
Getty Images: Sarah McDonald, Matt Green, Rene Aranzamendez
Time & Life Pictures: Joelle Sedlemeyer
Agence France Presse: Vaclav Neumann, Susan Williams
Roger-Viollet: Christele Billaud

National Geographic Books would like to gratefully acknowledge
the following staff and non-staff for their invaluable contribu-
tions to *100 Days in Photographs*: Bill Bonner, Archivist, Image
Collection; Nancy Marion, Photo Librarian; and Jane Sunderland,
Editor.

Founded in 1888, the National Geographic Society is one of the
largest nonprofit scientific and educational organizations in the
world. It reaches more than 285 million people worldwide each
month through its official journal, National Geographic, and its
four other magazines; the National Geographic Channel; televi-
sion documentaries; radio programs; films; books; videos and
DVDs; maps; and interactive media. National Geographic has
funded more than 8,000 scientific research projects and supports
an education program combating geographic illiteracy.

For more information, please call
1-800-NGS LINE (647-5463)
or write to the following address:

National Geographic Society
1145 17th Street N.W.
Washington, D.C. 20036-4688 U.S.A.

Visit us online at www.nationalgeographic.com/books

For information about special discounts for bulk
purchases, please contact National Geographic Books Special
Sales: ngspecsales@ngs.org

For rights or permissions inquiries, please contact National
Geographic Books Subsidiary Rights: ngbookrights@ngs.org

Library of Congress Cataloging-in-Publication Data
Yapp, Nicholas.
 100 days in photographs : pivotal events that changed the world /
Nick Yapp.
 p. cm.
 Includes bibliographical references and index.
 ISBN 978-1-4262-0197-4 (alk. paper)
1. World history--Pictorial works. 2. History, Modern--Pictorial
works. I. Title. II. Title: One hundred days in photographs.
D21.1.Y36 2007
909.8--dc22

ISBN : 978-1-4262-0197-4

Printed in Italy